The GETTYSBURG CYCLORAMA

The Turning Point of the Civil War on Canvas

Chris Brenneman and Sue Boardman
Photography by Bill Dowling

SB

Savas Beatie
California

Photo credits (others are noted for each individual entry):
SBC: Sue Boardman Collection
BD: Bill Dowling
GF: the Gettysburg Foundation
CB: Chris Brenneman
LOC: Library of Congress

Library of Congress Cataloging-in-Publication Data

Brenneman, Chris, author.
The Gettysburg cyclorama : the turning point of the Civil War on canvas / By Chris Brenneman and Sue Boardman ; with Bill Dowling, photography. -- First edition.
pages cm
Includes bibliographical references.
ISBN 978-1-61121-264-8 (alk. paper)
1. Philippoteaux, Paul, 1846-1923. Battle of Gettysburg (1884) 2. Gettysburg, Battle of, Gettysburg, Pa., 1863, in art. I. Boardman, Sue, author. II. Title.
ND2881.P49B74 2015
759.13--dc23
2015000715

Published by
Savas Beatie LLC
989 Governor Drive, Suite 102
El Dorado Hills, CA 95762
Phone: 916-941-6896 / (E-mail) sales@savasbeatie.com

05 04 03 02 01 5 4 3 2 1
First edition, second printing

Savas Beatie titles are available at special discounts for bulk purchases in the United States by corporations, institutions, and other organizations. For more details, contact Special Sales, P.O. Box 4527, El Dorado Hills, CA 95762, or please e-mail us at sales@savasbeatie.com, or visit our website at www.savasbeatie.com for additional information.

❧ *Contents* ❧

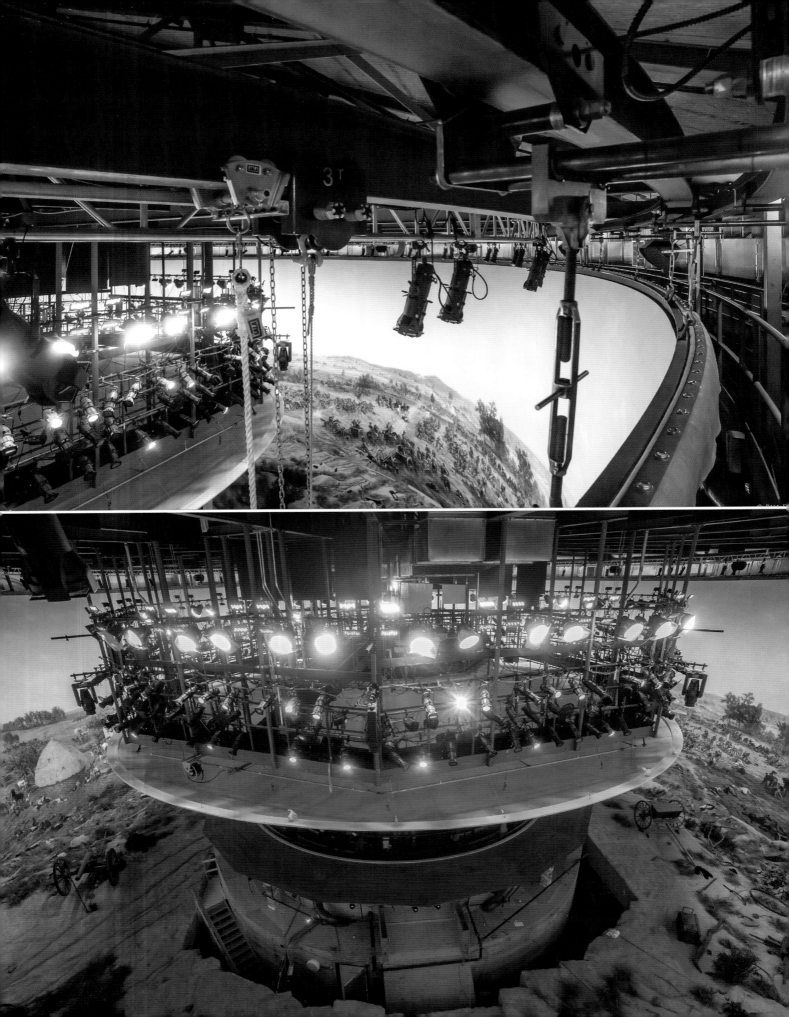

Foreword

THOUSANDS OF BOOKS and articles have been written about the battle of Gettysburg. Almost every topic has been thoroughly scrutinized many times over. However, one topic has been largely ignored: Paul Philippoteaux's cyclorama painting *The Battle of Gettysburg*. There are currently only two books in print about this fascinating historical document and work of art. The first, *The Gettysburg Cyclorama* by Dean S. Thomas[1], is an excellent source of information. However, since it was written in 1989, it does not cover many of the new discoveries that were made during the restoration that took place from 2003 to 2008. The pictures in the book are rather small and show the painting in its deteriorated condition. To address some of the newer discoveries, Sue Boardman and Kathryn Porch wrote *The Battle of Gettysburg Cyclorama, A History and Guide* in 2008.[2] This admirable book contains many new discoveries that were made during the restoration of the Gettysburg Cyclorama. This book also contains updated pictures of the cyclorama in its restored condition. While *A History and Guide* (which we will refer to as *BGC/AHG*) is very good, there are still many more aspects of the cyclorama painting that I felt were worth exploring. In 2011, I met with Sue Boardman and we decided to write a more detailed exploration of the cyclorama painting. Some of our reasons for writing this book are detailed below.

Interest in the Gettysburg cyclorama has increased since 2008, when the fully restored painting opened in the new Gettysburg Military Park Visitors Center. Before the restoration, the painting was not nearly as impressive as it is today. The painting was so dark and damaged that even objects in the foreground were distorted, let alone extremely distant objects. Now that the painting has been restored, many of the details are once again visible, and modern photography allows us to see with great clarity distant objects that are barely visible with the naked eye.

The efforts of the National Park Service (NPS)

Left: Pictures of the cyclorama taken from the catwalk above the painting (2013). *BD*

over the past 20 years to restore the landscape to its 1863 appearance have opened up vistas that are very similar to the views in the painting.

In order to help plan his great work, the artist came to Gettysburg and paid local photographer William Tipton to take a series of landscape photographs. The Tipton photographs were reproduced in this book for several reasons. First, the Tipton photographs are important documents of the early appearance of the battlefield, and are important for that reason alone. Second, the process of photographing the landscape was an important part of the creation of the cyclorama. Finally, as noted above, the battlefield currently has very similar foliage to what can be seen in the Tipton photographs. With the advantages of modern digital photography, we are able to examine distant objects and document their location in the painting.

When the four versions of the Gettysburg cyclorama opened in Chicago, Boston, Philadelphia, and New York, viewers could buy souvenir programs that contained a key. The key was a circular drawing that denoted various people and objects in the paintings. Some of the descriptions would be changed to market the paintings to the local crowds. No one has ever tried to go through all of the historic program keys to identify every named object in the painting until now. These early programs are historic documents. They show us how the painting and the battle have been interpreted during different time periods (and even in different cities).

New discoveries have been made about the painting. By using modern and historic photography, the authors have identified many new people and places in the painting. We have also discovered more information about some of the men that helped paint the cyclorama, and the entire process of creating a cyclorama. This book is meant to expand upon the information in *BGC/AHG*, and cover some new discoveries that were made after 2008.

The painting is so massive and awe-inspiring that the authors thought a book with large pictures would be

a great way to explore the painting at one's own pace. Close-up photographs will allow the reader to examine the intricate details of the painting. The authors also hope that readers take the book to the battlefield and compare the painting with the actual terrain.

Photography is a major element of the creation of a cyclorama, and our study of the painting. To help with our photographs, we brought in professional photographer, and fellow Licensed Battlefield Guide, Bill Dowling. In Chapters 1-3, Sue Boardman explores the process of creating a cyclorama, the history of the Gettysburg cycloramas, and some of the more unusual facets of the cyclorama. Chapter 4 will focus on one of our most interesting discoveries: the fact that the Boston cyclorama was modified in 1889. The remaining chapters contain my analysis of the painting and the various historic keys. My co-authors were consulted to help confirm some of the narrative, especially where judgment calls were required. As the reader, keep in mind that we were analyzing a work of art and some of

our determinations may be subjective and open to interpretation. In areas where there were several possible interpretations, we tried to give multiple options.

Finally, to add to the confusion, there were almost no primary sources to help us interpret what the artist was thinking. To date, we have not discovered Mr. Philippoteaux's diary; if one existed, it would be a gold mine. Much of the existing information comes from newspapers and other sources that are not always reliable. Many descriptions of the painting give conflicting reports. Some of the other important sources, the souvenir programs, were changed in different cities to market the painting to the local audience. This book attempts to answer questions about the painting using the best sources available. New information may come to light, and many of the mysteries might never be fully answered. It is the goal of this book to spark interest and provide more understanding of the amazing work of art that is *The Battle of Gettysburg* Cyclorama.

⇜ *Introduction* ⇝

BEFORE WE GET started, a few notes are in order as to some of the terms we will be using in this book. Paul Philippoteaux was the main artist who created the massive cyclorama painting *The Battle of Gettysburg*, which is now on display at the Gettysburg National Military Park Visitors Center. To save space, we refer to Paul Philippoteaux as "the artist" and the cyclorama now on display as "the painting" or "the cyclorama." The battle of Gettysburg is referred to as "the battle." The National Park Service is referenced as "the NPS," and the Park itself is called "the battlefield." The battle of Gettysburg lasted three days—July 1, 2, and 3—1863. We note these days as "the first day," "the second day," or by date (July 2).

The painting focuses on the massive Confederate attack against the center of the Union line on July 3. This book is not meant to be a tactical breakdown of the actions of the third day of the battle. However, for those readers who are not familiar with the battle, we give a brief synopsis of the three days of

fighting with a focus on the third day. If you are seeking more information, there are dozens of books that go into great detail on this subject. Key areas and terms that are used again and again in the narrative will appear in quotes. Locations or individuals that are visible in the painting are underlined the first time they are mentioned.

The most basic unit of a civil war army was the "regiment," consisting of approximately 250-350 men at the time of the battle. Each regiment was divided into 10 companies of approximately 25-35 men. Three to five regiments would be grouped together into a "brigade" of approximately 1,500 men. Two to five brigades would be grouped together into a "division." The Southern army usually had more brigades per division than the Union, thus a Southern division was larger than a Union division (usually about 7,000 as compared to about 3,500). Three divisions were grouped into a "corps." At the battle, the Southern army had three corps with approximately 20,000 men

in each corps—plus cavalry and artillery—for a total of approximately 75,000 men. The Union army had seven corps with approximately 11,000 men in each corps—plus cavalry and artillery—for a total of approximately 90,000 men. Union units were given a numerical designation (I Corps, 2nd Division, 3rd Brigade) while Confederate units were usually named after their commander (Longstreet's corps, Pickett's division, Armistead's brigade). The artillery would be grouped together into a "battery" of either four (Confederate) or six (Union) cannon.

The battle of Gettysburg is viewed as one of the most pivotal battles of the American Civil War. After two years of conflict, the war had gone on far longer than anyone would have imagined in 1861. After a string of victories, <u>Gen. Robert E. Lee</u> decided to move his Confederate "Army of Northern Virginia" into Pennsylvania. Even though the South had been winning battles, the superior resources of the North would eventually wear out the South if the war continued to drag on. Lee reasoned that another Confederate victory, especially on Northern soil, might end the war. Lincoln was under immense political pressure. The peace movement was growing in the North. Lincoln fired a string of generals who had been bested by Lee. Only three days before the battle, <u>Maj. Gen. George Gordon Meade</u> was placed in command of the Union "Army of the Potomac." Both generals knew the result of the upcoming battle could determine the fate of the nation.

On July 1, 1863 the two armies met near the town of Gettysburg. Ten roads converge on the town, making it an important spot for the movement of large armies. On the first day, neither side expected a major battle. Once the combat began, however, the battle got larger and larger as more men arrived on the scene. Heavy fighting broke out west and then north of the town. By the end of the day, the Confederates breached the Union lines. Northern troops were forced back through the town to <u>Cemetery Hill</u>, <u>Culp's Hill</u>, and <u>Cemetery Ridge</u>. The victorious Confederate forces were too tired and disorganized to continue to attack the battered Union Army. Although the first day was a Confederate victory, Union forces managed to hold the high ground on the southern edge of town.

Overnight, the bulk of the armies arrived on both sides. General Meade decided to concentrate his army on the high ground south of town. Meade's intended line started at Culp's Hill, ran around Cemetery Hill, down Cemetery Ridge, and was anchored at <u>Little Round Top</u>. This Union line, when drawn on a map, was shaped like a large fish hook. General Lee decided to attack the flanks (or ends) of the Union army. Forces under Lt. Gen. James Longstreet, using <u>Seminary Ridge</u> for cover, moved to attack the southern end of the Union line (the Union left flank). Lee's men, under Lt. Gen. Richard S. Ewell, were under orders to demonstrate in the area of Cemetery Hill and Culp's Hill (the Union right flank). Ewell's men were to convert their demonstration into an attack if an opportunity arose.

Right before the Confederate attack began, Union Maj. Gen. Dan E. Sickles decided to move his men out from the Cemetery Ridge line to a more advanced position at the <u>Peach Orchard</u>. Sickles's movement endangered the entire Union line. As Longstreet's men started a massive attack on the southern end of the Union line, Meade was forced to send reinforcements to stop wave after wave of Southern attacks. The combat raged around Little Round Top, <u>Devils Den</u>, <u>The Wheatfield</u>, and the Peach Orchard. Finally, with the setting sun, the last of the Confederate attacks were repulsed on the Union left and center. In order to stop these attacks, General Meade was forced to remove troops from other parts of his line. Pursuant to orders, General Ewell's men attacked Culp's Hill and East Cemetery Hill. As the day ended, the Confederate attack on East Cemetery Hill was driven back. On Culp's Hill, Ewell's men made a lodgment on the side of the hill, but the Union managed to hold the crest. Day 2 was the bloodiest day of the battle, but neither side gained a decided advantage.

Going into the third day, Lee planned on renewing his attacks on the ends of the Union line. General Meade consolidated his forces, and sent troops back to Culp's Hill to remove the Confederate threat on the Union right flank. At first light, the fighting started on Culp's Hill, and after over seven hours of fighting, the hill was finally secured by Union forces. With his attack on Culp's Hill thwarted, Lee realized that his original plan to attack the ends of the Union line would not work. He decided to come up with a new plan—to attack the Union center on Cemetery Ridge. He would use his only fresh troops, the three brigades of <u>Maj. Gen. George E. Pickett's</u>

division of General Longstreet's corps to spearhead the attack. To augment this force, he added men from Lt. Gen. A. P. Hill's corps. On Pickett's left, Lee attached four brigades under the command of Brig. Gen. J. Johnson Pettigrew (Pettigrew's division) and two brigades commanded by Maj. Gen. Isaac R. Trimble (Trimble's division). To support the right flank of the attack, brigades under Brig. Gen. Cadmus M. Wilcox and Col. David Lang (Wilcox's brigade and Lang's brigade) would follow the main attack. The troops from General Hill's corps had seen heavy fighting on the first two days of the battle and were not at full strength. General Longstreet would be in overall command of this attack. Some histories of the battle call this "Longstreet's assault" or "the Pickett, Pettigrew, Trimble Charge," but today this charge is popularly known as "Pickett's Charge." Although the first two names are more accurate, we use this latter term for the remainder of the narrative.

At approximately 1:00 p.m., the Confederates started a massive artillery bombardment designed to weaken the Union center. We will refer to this phase of the action as "the bombardment" or "the cannonade." Approximately 150 Confederate cannon opened fire, and about 80 Union guns fired back. By some accounts, the massive cannonade lasted for nearly two hours. The Confederates concentrated their fire on the center of the Union line near a clump of trees, now known as the "Copse of Trees." A "stone wall" runs from south to north in front of the Copse of Trees and then runs east for about 100 yards before turning north again. The turn in the wall created what is now known as "the Angle." We will refer to everything inside the wall as being part of the Angle. At approximately 3:00 p.m. the artillery fire stopped, and the Confederates started their infantry attack. About 12,000 men stepped out of the woods on Seminary Ridge and began to march towards Cemetery Ridge. The line of men was almost a mile wide when the attack began. As they crossed the fields, the attacking force started to converge on the center of the Union line near the Copse of Trees and the Angle in the stone wall.

As they approached the Union position, the Confederates were raked by artillery and small arms fire. Despite heavy losses, the seemingly unstoppable wave of men continued forward. At the Angle, Confederates under the command of Brig. Gen. Lewis A. Armistead managed to break into the center of the Union line. Union troops rushed in and the fighting became hand-to-hand. General Armistead was mortally wounded leading his men. This spot, the point of the Confederates farthest breakthrough, came to be known as The High Water Mark of the Confederacy. Eventually, Union reinforcements overwhelmed the Confederate attackers. Pickett's Charge failed, and over half of the attackers were killed, captured, or wounded. Once the Confederate troops were driven out of the Angle, the charge and the battle were effectively over. Lee's losses were so great that he could not continue attacking the Union army. The next day, the Confederate army began its retreat back to Virginia. For the next two years of the war, Lee was forced to fight a more defensive style of warfare. Eventually, the superior resources of the North wore down the Confederate armies until the war ended in 1865.

We will refer to "the High Water Mark" as not only a moment in time (as in the moment when General Armistead was wounded) but also as a place (approximately the location of Armistead's wounding inside the Angle). Not only does this moment represent the turning point of the battle of Gettysburg, but it came to be known as the turning point of the entire Civil War. Therefore, it is no surprise that the artist selected the High Water Mark to be the focus of the Gettysburg cyclorama. The artist chose a viewpoint on Cemetery Ridge just east of the Angle. The viewer of the painting is looking down into the chaotic fighting right at the moment of Armistead's wounding.

Although the artist selected this moment in time, he did take some liberties. The painting is allegorical in nature; it is meant to tell the story of the entire charge. Some of the incidents displayed in the painting happened just before, or just after, the High Water Mark. We will try to note this "artistic license" when it is apparent. It is also important to note that the existing accounts of the charge do not agree on the exact timing of the various parts of the attack. Due to smoke and the "fog of war" no one can say for certain exactly what happened, except in their immediate front. While the cyclorama was not a perfect snapshot of the battle, it does do an excellent job of portraying many incidents that did happen on that July afternoon.

~<e Acknowledgments e>~

THIS BOOK WOULD not have been possible without help and guidance from numerous individuals. I would like to thank everyone who I consulted and who gave me advice during the writing of this book. I have discussed the cyclorama with so many individuals that it is not possible to name everyone, but I will try to thank as many as possible. I would like to start by thanking my wife Laura and my daughter Mary. My wife, Laura, has always supported me and my love for history, and without her help none of this would be possible. I would like to thank my daughter, Mary, for inspiring me to do great things. I also thank my parents, Terry and JoAnn Brenneman, for supporting me in all my endeavors, and my grandparents, Corky and Lois Brenneman, for bringing me to Gettysburg as a child in the 1970s and 80s.

Many thanks go to the Gettysburg Foundation. This nonprofit foundation is responsible for preserving and restoring the Gettysburg Cyclorama in conjunction with the National Park Service. Their work has made the painting available for generations of future viewers. Without help from the Gettysburg Foundation, the cyclorama painting might have deteriorated to the point that it no longer would have been able to be restored to its former glory. Further thanks to the Gettysburg Foundation for being my employer and allowing me countless hours viewing the amazing cyclorama painting; the authors would like to thank the Foundation for allowing us access to the painting in order to take excellent pictures of this remarkable work of art.

I would also like to thank all of my co-workers at the Gettysburg Foundation. My supervisors, Sheilla Combs and Cindy Small, were very supportive of my work. Other co-workers deserve thanks, who, like me, have spent hundreds of hours viewing the cyclorama and are familiar with the intricate details of the painting. I would like to especially thank Tom Osborne for editing the book and Linda Ingalls for proofreading my chapters. Fellow co-workers also helped me notice the fact that the painting was changed during its lifetime. I would like to thank John Casey for being the first to notice the changed battery wagon and Scott Ashton for being the first to notice the fact that General Meade was not originally in the painting. Other co-workers who helped give me ideas for the book included, but are not limited to Fred Brantlinger, Warren Brockett, Kathleen Heggan, Violet Heinning, Devon Moore, Maryann Oelkers, Kyle Pfalzer, and Nancy Rohrbaugh.

Special thanks to my co-author Sue Boardman; her love of the cyclorama painting is truly contagious. Her book, *The Gettysburg Cyclorama: A History and Guide,* and her cyclorama lectures made me want to learn even more about this amazing painting. Sue's collection of historic keys and photographs gave me the materials to organize the key to the painting. Throughout the process of writing this book, I consulted Sue on the more unusual facets of the cyclorama and its history. Our other contributor, photographer and licensed guide, Bill Dowling, also deserves thanks. Since this book is largely a visual study, his excellent photographic skills were instrumental in creating the finished product.

Many thanks go out to my fellow licensed battlefield guides. I consulted with numerous guides as I tried to locate various units and terrain feature in the cyclorama painting. I would especially like to thank Timothy H. Smith for helping me on numerous occasions. Tim's knowledge of the terrain and especially the farms in Gettysburg was invaluable. Without his help I could not have located many of the farms, especially the ones that were built after the war but before the cyclorama was painted. Tim's book *Farms at Gettysburg; The Fields of Battle* was an important resource during the writing of this book. Tim was also instrumental in helping me locate pictures of farms as an employee of the Adams County Historical Society. Many other guides helped answer questions that I had during the writing of this book. I would like to thank Elwood (Woody) Christ for helping me with information on other farms in Gettysburg, especially the William Johns farm and the Bliss farm. Thanks to Rich Kohr for information on the Sherfy barn and Daniel Webster Flagler. Fred Hawthorne helped me with information on the Gibbon Tree and several monuments. Numerous other guides

also gave me helpful advice including Dave Donahue, Jim Hueting, Gary Kross, Renae MacLachlan, Paul Marhevka, Christina Moon, George Newton, Tony Nicastro, Deb Novotny, and John Zervas.

The authors would also like to thank the rangers at the Gettysburg National Military Park for being an invaluable asset during the process of creating this work. We would like to thank Superintendent Bob Kirby and Assistant Superintendent Brion Fitzgerald for allowing us to take terrain photographs from a raised platform at the High Water Mark. Special thanks go out to park archivist Greg Goodell for allowing us access to the pieces of the New York cyclorama in the park's collection. Greg was also very helpful in giving us some insights on and photographs of the Waterloo Cyclorama. We would also like to thank John Heiser for giving us access to the park's cyclorama files and helping with the introduction. Other rangers that helped with this process include Matt Atkinson, Clyde Bell, Troy Harman, and John Nicholas. National Park Service volunteer Lawrence Keener-Farley was very helpful with information on the various types of battle flags used during the battle.

We would also like to thank Ted Savas for working to make this book possible and the entire staff at Savas Beatie. We would especially like to thank marketing specialist Sarah Keeney, Editor Susan Gabrielle, and graphic designer Ian Hughes.

My co-author Sue Boardman would like to thank the following for their generous assistance in preparing this work: Gettysburg National Military Park Archivist Greg Goodell, Museum Specialist Paul Shevchuk and Andrew Newman, Museum Technician; Museum Consultants Beth Trescott and Karen Bohleke; fellow cyclorama historians Suzanne Wray and Gene Meier; Linda Gervens, Ann Marie Mege Doutrich, Bill Lenz and Francis Hegoburu, descendants of cyclorama landscape artist Salvador Mege; Chief Conservator David Olin of Olin Conservation, Inc.; Philippoteaux biographer Yasmina Boudhar; cyclorama co-historian Katie Porch; researcher John Burns; Gettysburg Foundation administrators Joanne Hanley, President, and Brian Shaffer, Director of Facilities; Co-authors Chris Brenneman and Bill Dowling; colleagues Elle Lamboy and Heidi Myers; and the most significant person of all, Ken Boardman.

Individual citations were not used for the Chapters 1–3. A significant amount of research regarding cycloramas in general and the Gettysburg cyclorama in particular was gathered during the conservation project between 2003 and 2008. Some of it was based on common knowledge about existing cycloramas found worldwide and therefore is not cited here. Certain pieces of information were found to be repeated in a number of sources and cannot be cited to a single source. Where conflicting information was found, a reasonable assessment was made as to which source was correct. Where information pertains to historical events as they apply to the Gettysburg cyclorama, the authors, as Licensed Battlefield Guides, relied on our own expertise in regard to the Civil War and battle of Gettysburg history to provide historical context. the sources used for the first three chapters are listed at the start of the bibliography.

1 Dean S. Thomas, *The Gettysburg Cyclorama: A Portrayal of the High Tide of the Confederacy* (Gettysburg, PA, 1989).
2 Sue Boardman and Kathryn Porch, *The Battle of Gettysburg Cyclorama: A History and Guide* (Gettysburg, PA, 2008).

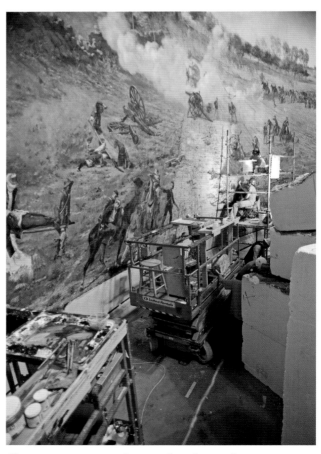

Conservators at work restoring the cyclorama (2008). *BD*

❦ Cycloramas: The Basics ❧

CYCLORAMAS ARE VERY large, panoramic paintings shown in the round. The word panorama simply means "to see all." The term cyclorama actually refers to the environment in which the panorama is exhibited.

Cycloramas first appeared in Europe after the 1750s, but they enjoyed their greatest popularity in the late 1800s. In the mid-1800s, large panoramic paintings were sometimes shown in a format known as the moving panorama. The viewer would stand or sit before the canvas. The panorama was unrolled from the left spool and rerolled on the right as it passed in front of the audience. In the United States, moving panoramas were shown throughout the 1850s and 1860s. Soon after, the newer format of showing the large paintings in the round began. Americans began using the term cyclorama to differentiate a circular panorama from a moving one. The cyclorama craze took the country by storm.

The creation of a cyclorama was a massive production. When finished, it typically measured slightly less than 50 feet high and 400 feet in circumference and weighed about 6 tons. The process, when completed, provided both an artistic and a technical presentation which allowed viewers to enjoy an immersive experience that placed them, through a multi-dimensional illusion, into the environment depicted on the canvas around them. As the medium of cyclorama painting evolved, the method was refined until the perfect illusion was achieved, an illusion described by one viewer as being "so true to life that it could be confused with reality."

Creating the aforementioned illusion required that a number of physical features be in place. The building itself, called a rotunda, was specifically designed in size and shape to complement the viewing of the cyclorama painting. Polygonal in shape, the roof was fitted with a series of small glass panes near its outer edges to allow sunlight to filter down onto the upper portion of the canvas, just as natural daylight would illuminate the actual outdoor landscape. For evening shows, gas lighting from above served the same purpose.

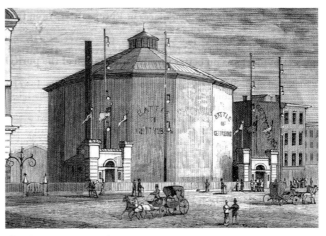

Cyclorama rotunda.
Scientific American, NY 1886 Vol. LV #19

The painting was hung from a circular beam or pipe near the ceiling but did not touch the floor. A second circular pipe was inserted into a wide hem at the bottom edge of the painting from which weights were suspended. This hanging system caused the center weave of the painting under tension to bow inward, creating a hyperbolic shape, with the center of the painting about a foot closer to the viewer on a center platform than the top or bottom. It was not the design of the artist to create a hyperbolic shape—it was a result of the weave (bias) of the canvas and its massive weight. But cyclorama artists learned to work with the peculiar shape to create a multi-dimensional look, which gave the appearance of the landscape stretching out for many miles.

Moving panorama.
Theo Davis in St. Nicholas Magazine

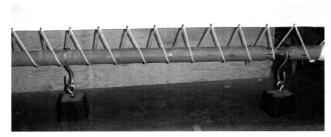

Ring and weights at bottom of canvas to provide tension and maintain uniform hyperbolic shape. *SBC*

Viewing a hyperbolic canvas. *SBC*

The viewing platform was in the center of the room, about 15 to 20 feet above ground level and about 40 feet from the painting in all directions. A draping, light-colored canopy hung down from the center of the ceiling with its widest part over the platform just high enough to prevent the viewer from seeing the upper edge of the painting and roof structures above. By blocking these structural intrusions, the illusion was more easily obtained. The canopy also served to limit the amount of light from above.

A diorama, or three-dimensional landscape, filled the space between the bottom edge of the painting and the viewing platform, thereby extending certain terrain features. Fence lines and roads that began on the painted canvas were continued into the foreground with real rocks, rails, and rutted dirt, helping to complete the illusion.

By blurring all boundaries between the real and created worlds through the use of the circular canvas, diorama, and canopy, the viewers experienced a sense of immersion as they stepped from dimly lit stairs into the center of the realistic scene.

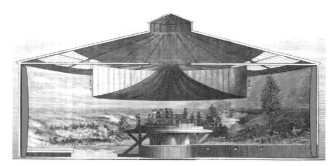

Cross-section of the cyclorama gallery showing elements necessary to create the illusion.

Scientific American, NY 1886 Vol. LV #19

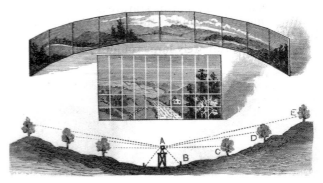

Taking photographs of the landscape.

Scientific American, NY 1886 Vol. LV #19

There were a number of steps necessary in preparation for the execution of a great cyclorama.

Studying the Subject

Scenic landscapes, great works of literature, and epic battles were the themes chosen for most nineteenth century cycloramas. After selecting a subject, the lead artist set out to obtain as much detailed information as possible about the event and/or physical setting. He visited the location, made sketches, studied maps, interviewed participants and photographed the terrain. Upon the spot of ground chosen as the point of view, a platform was erected, its height equaling that of the proposed audience stage. A circle of stakes, with a forty-foot radius, were driven into the ground around the platform using ropes to measure the distance from the center of the platform to the individual stakes. This measurement was less than half the diameter of the cyclorama canvas. Three series of photographs were taken of the surrounding landscape, one set focusing on the foreground, one on the mid-ground and one on the distant landscape. Together, they captured for the artist a fully detailed landscape from which to copy his cyclorama. The artist's preparation often took more than six months to complete.

Creating Preliminary Drafts

Upon returning to his studio—a building resembling the rotunda in which the finished painting would be exhibited—the lead artist prepared a first plan or 'study' of the cyclorama. This smaller version was done in 1:10 scale, making it approximately 40 feet by 5 feet in size. This smaller canvas was covered in white paper, upon which the lead artist began to create his composition in charcoal. The landscape outline was laid down first,

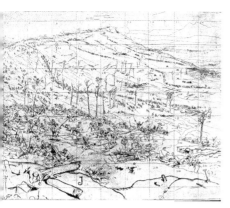

The artist's sketch with grid lines.

Battles & Leaders, Vol. 3

Hanging the large canvas.

Theo Davis in St. Nicholas Magazine

followed by figures, and in the case of military themes, military equipment and horses. Corrections were made by rubbing off the charcoal and reworking the composition until the desired effect was produced. The sizes of the figures changed depending upon where in the composition they appeared—larger in the foreground and smaller as they approached the background areas, which aided in giving the illusion of depth. Next, a pen-and-ink drawing was made over the charcoal outlines, thus creating a perfect scaled miniature sketch of the proposed work. A grid was drawn over the pen and ink sketch, dividing it into ten sections, with the sections then further divided into equal-sized blocks, giving the appearance of graph paper. Each block was designated by a letter, representing the section, and also by a number. This was done to aid the artists in enlarging the drawing and transferring it to the larger blank canvas, which was also divided into an equal number of sections and blocks. Thus each square on the canvas was exactly ten times larger than those of the preliminary drawing.

Before work began on the large canvas, the lined pen-and-ink drawing was traced onto the smaller canvas, and a separate, fully finished oil painting was completed by the lead artist. This served as a color guide for his team of assistants. When completed, the full-color study represented a detailed miniature of the finished cyclorama, including the buildings, roads, fences, landmarks, and the placement of military units and their implements of war.

Preparing the Canvas

The large canvas, approximately 50 feet by 400 feet,

was carefully stretched and hung in the circular studio. The linen, somewhat heavier than that used for smaller paintings, was specially woven in Belgium on carpet looms in sections 27 feet wide. These sections were neatly stitched together before being shipped to the cyclorama studio. As mentioned above, the canvas was nailed to a large circular beam by riggers who hauled it up and shook out the great folds. The lower ring was attached and weights were hung every three feet to achieve the stretch and shape necessary for the creation of the painted illusion.

Erecting the Scaffolds

After hanging the canvas, iron rails or tracks were laid down close to it upon which movable scaffolds of different heights built on wooden platforms or cars were placed. These rolling wooden towers, from between ten and fifty feet in height, were composed of a number of platforms which were reached by stairs. Such an arrangement enabled members of the artistic team to reach all parts of the great canvas. Six of these cars with scaffolds were necessary to paint one cyclorama.

Priming the Canvas

Next, the canvas was 'sized' with a weak solution of watered-down glue and then primed with a ton or more of 'whiting,' usually powdered chalk or gypsum. (Today's artists use the term "gesso" in place of "whiting.") It formed the surface upon which the artists painted the final work in colorful detail.

Multi-level scaffold moving along rails at base of canvas. *Scientific American, NY 1886 Vol. LV #19*

The Gettysburg Cyclorama: The Turning Point of the Civil War on Canvas

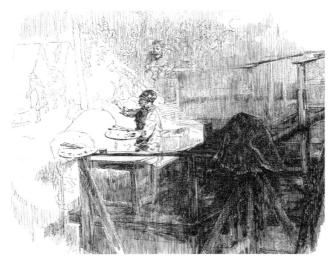

Projecting the sketch and tracing it onto the canvas.

Theo Davis in St. Nicholas Magazine

Transferring the Image

Each section of the original pen and ink drawing was photographed onto glass plates. Several sets of prints were made from them to guide the team of artists. Then the glass plates, by means of several lenses and strong light, were used to project an enlarged image onto the primed canvas which, as mentioned before, was similarly lined off into sections and squares. In this way, the original drawing was magnified and copied into the corresponding squares of the primed canvas. Because the canvas was so much larger than the drawing, the projected image often appeared to contain too few figures, so many more characters had to be added later to the scene.

Painting the Cyclorama

The lead artist supervised the work of the team, with each member lending his special talent to the process. There were artists who specialized in painting horses, others who created military figures, one who only painted faces on the figures painted by someone else. There were usually two or more landscape artists and at least two who worked only on the sky portions of the painting. It was not unusual for one artist to paint the figure of a mounted officer and then move away so another artist could fill in the face. Shortly, a third artist would rapidly paint the horse under the soldier figure. Most of the artists who worked on American cycloramas were European immigrants, predominately of German and French descent. Many of them remained in America and sought other work after the cyclorama craze passed. It was not uncommon to find them painting backdrops for theater productions in opera houses.

Paints were high quality oil, using natural pigments. One of the most expensive was the rich yellow color known as cadmium, but was in fact cadmium sulfide. In the 1880s, it cost about $50 for enough to fill a 32-ounce can, and they would use several cans per painting. Cadmium selenide was a bright red pigment. The combination of the two cadmiums produced the orange pigment. Brown paints were umbers derived from iron oxide while some of the green pigments were copper arsenate derivatives. The colors were vibrant and proved to be resilient over time. However, many of them would be considered toxic by today's hazardous material standards.

A central platform of the same height as the exhibition rotunda's viewing platform, was a staple of the cyclorama studio so that artists were able to periodically observe the effect and progress of their work. The studio environment was a place for collaboration among the members of the artistic team. Just as often, it was populated with war veterans who came to admire, critique, and pose with their accoutrements while the artists sketched them into the landscape. Some of them had taken part in the scenes represented on the canvas, and made helpful suggestions to correct or complete the artists' notes. For the most part, Civil War cycloramas provided well-documented visual history for those who viewed them.

Transporting the canvas

When the painting neared completion, carpenters began to build a huge spool upon which to roll the

Posing for the artists in the studio.

Theo Davis in St. Nicholas Magazine

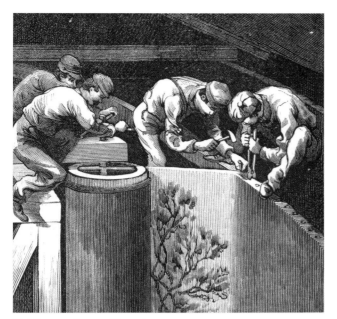

Rolling and unrolling the great canvas.
Scientific American, NY 1886 Vol. LV #19

bushes, and grass used in the foreground were living when first installed, but soon dried out, making them particularly flammable.

Hundreds of loads of earth were carted into the rotunda, along with fence rails, sod, logs, and sand. For war scenes, a variety of battle equipment and debris were gathered to await their skillful distribution on the battleground. After the painting was installed, the foreground elements were so artfully arranged that they joined with the painting to appear as one landscape. Accounts from spectators relate that it was nearly impossible to determine at any point which elements were real and which were part of the painted scene.

canvas, and an equally huge crate to transport it to an exhibition site. The highest tower used to paint the canvas was cleared of artist's paraphernalia and converted to hold the spool upright. The weights and lower ring were removed from the canvas and one seam of the painting was opened. The edge of the canvas was nailed to the spool, and as the canvas was loosened from the top ring, it was slowly and steadily rolled onto the upright spool. If all went as planned, in two hours the huge painting was rolled face in onto the spool. A cable was passed through the spool and used to lower the six to seven ton cyclorama into the shipping crate. Shipping was by rail on flat platform cars. Upon arrival at its destination, a track system resembling the one in the studio was installed to facilitate installation of the painting in the exhibition rotunda.

Setting up in the exhibition gallery.
Theo Davis in St. Nicholas Magazine

Assembling the Illusion

While awaiting the arrival of the painting, men employed by the primary artist were preparing the material for the diorama or artificial foreground, and constructing the platform upon which it was to be built. This was done by following the irregular contours shown on the original cyclorama drawings. It is interesting to note that the lumber used for the diorama platform was treated with a silicate compound to keep moisture out and make it fire-proof. This would have been important, since many of the trees,

Laying in the diorama elements.
Theo Davis in St. Nicholas Magazine

~≈ *Cycloramas in America* ≈~

THE FIRST TRUE cyclorama shown in America was of European origin. This cyclorama, the *Siege of Paris*, was created by the father and son team of Henri Felix and Paul Dominique Philippoteaux. It was shown in Philadelphia (1876-1878); Boston (1878-1879); San Francisco (1879-1882); New York (1882-1884); Chicago (1884-1886); New York again (1886-1887); and Los Angeles (1888). It was well-received by American

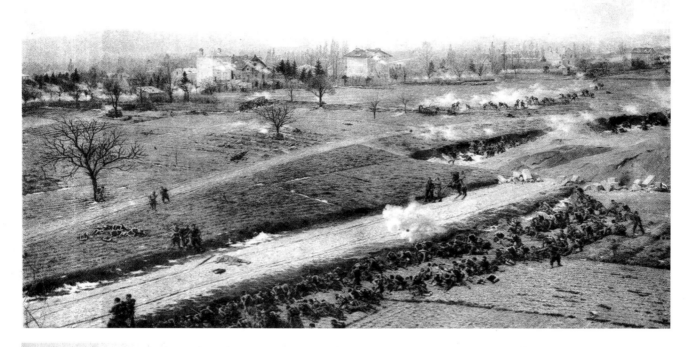

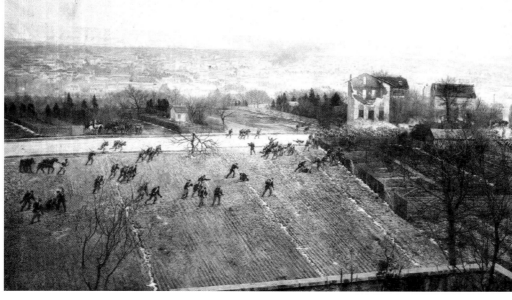

Scenes from *Siege of Paris* Cyclorama by Henri F. and Paul D. Philippoteaux. *SBC*

Lead artist Paul D. Philippoteaux. *SBC*

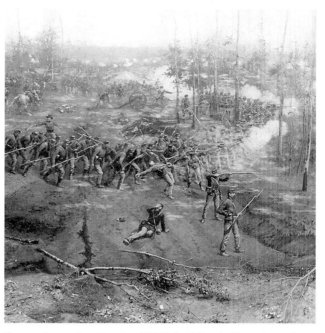

Scene from the *Battle of Shiloh* ("Gen's Prentis and Hurlbuts troops in the Hornets' Nest") by Theophile Poilpot from stereo view by H. H. Bennett.
H. H. Bennett Stereoview; SBC

audiences and its popular success attracted the attention of Chicago entrepreneur Charles Willoughby.

Charles Louis Willoughby (1838-1919) was born in Hooksett, N.H., and entered the retail business at a young age, first in Lowell, Massachusetts and later in New York and Ohio. In 1870, the firm of Willoughby and Hill was founded in Chicago and cleared $50,000 it its first year of business. Although Willoughby and his partner lost the store in the Chicago fire of 1871, they recovered quickly by obtaining goods from clothing brokers in New York and selling out of farms and sheds. By the 1880s, Charles was a wealthy merchant and entrepreneur.

Willoughby saw the *Siege of Paris* in Boston, according to a descendant's account, and set out to bring an American-themed cyclorama to his own city. He sought out the artists whose work was, by this time, known and appreciated: Henri and Paul Philippoteaux. Although Henri F. Philippoteaux was known to have worked on at least one of the four Gettysburg cycloramas that resulted from this business relationship, it appears that son Paul was the lead artist in all of them.

Paul Dominique Philippoteaux (1846-1923) was born in Paris and educated at the College Henri IV and at the Ecole des Beaux Arts in Paris. He also studied art in the studios of his father, as well as those of Leon Cogniet and Alexander Cabanal. Philippoteaux made

numerous sketches for Guizot's *History of France* and may be known to American readers for his illustrations contained in the works of Alexander Dumas and Jules Verne. He gained a reputation as an artist of other cycloramic paintings, including the *Crucifixion*, exhibited at St. Anne de Beaupre in Quebec, Canada (which is still on display), along with, as noted, the *Siege of Paris* in association with his father.

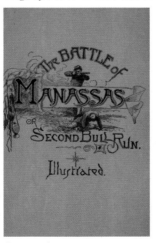

Souvenir program cover for the *Battle of Manassas or Second Bull Run* Cyclorama. *SBC*

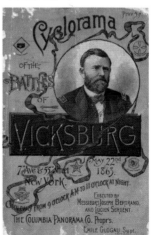

Souvenir program cover for the *Battle of Vicksburg* Cyclorama. *SBC*

The Gettysburg Cyclorama: The Turning Point of the Civil War on Canvas

Scene from the *Battle of Chattanooga: Storming of Missionary Ridge* Cyclorama from Kilburn stereoview. *SBC*

As mentioned earlier, the subject of most cycloramas included scenic landscapes, great works of literature, and epic historical events, most often with religious or military themes. In America, it was the Civil War of 1861-1865 that provided inspiration for most cyclorama paintings which were ultimately created and exhibited throughout the country, including those made in other studios by competing artists.

The phenomenal success of the Gettysburg cycloramas inspired the creation of some three dozen Civil War battle paintings over the next decade. Shiloh, Second Bull Run, Vicksburg, Lookout Mountain, and Atlanta were just a few of the battles dramatically depicted in cycloramic format. There were also nearly a dozen knock-offs of the original Gettysburg painting. But Philippoteaux's original four cycloramas were unquestionably the first, best, and most popular of the genre.

The Battle of Gettysburg Cyclorama:
Chicago Version

Sometime in 1881, Charles Willoughby offered a $50,000 commission to Paul Philippoteaux to create the first uniquely American cyclorama depicting the climactic moments of Pickett's Charge which occurred on the third and final day of the battle of Gettysburg.

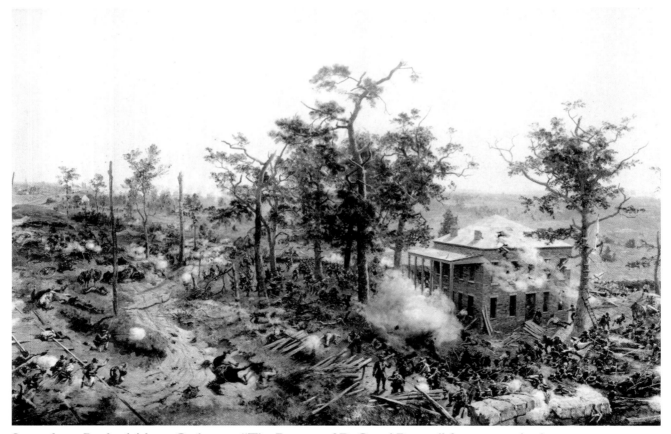

Scene from *Battle of Atlanta* Cyclorama "The Recoup of DeGress' Battery" from souvenir photogravure. *SBC*

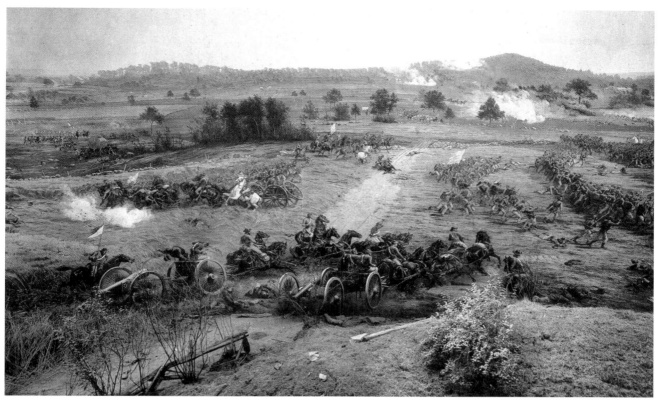

Scene from *Battle of Gettysburg* Cyclorama, Chicago version, looking south. *SBC*

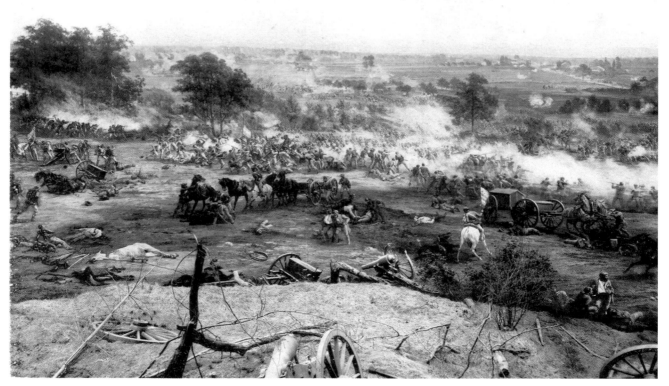

Scene from *Battle of Gettysburg* Cyclorama, Chicago version, looking southwest. *SBC*

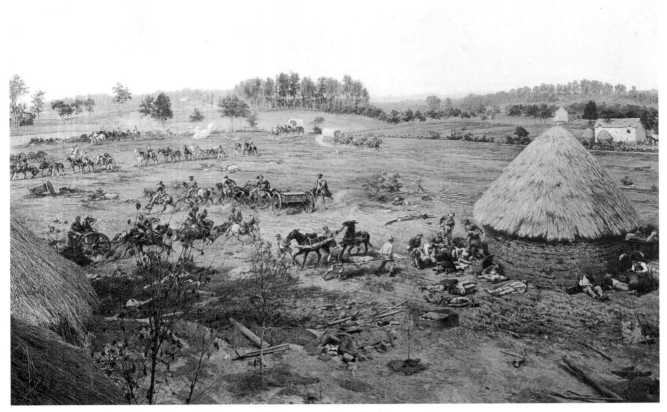

Scene from *Battle of Gettysburg* Cyclorama, Chicago version, looking northeast. *SBC*

Created for the city of Chicago, it was the first of four similar versions resulting from the partnership between the businessman and the artist.

Once Willoughby secured the commission with Philippoteaux, he and the artist, along with several other investors, formed the National Panorama Company for the purpose of bringing the *Battle of Gettysburg* cyclorama to Chicago. This was the first of several stock companies created to finance exhibitions in this and several other cities. He also selected the location, on the corner of Wabash Avenue and Hubbard Court, where the company erected the exhibition rotunda.

Once the subject was selected, Philippoteaux began his preparatory work for the grand painting. In an interview published in the *New York Times* in May 1882, the artist remarked that he was in that city to call on Union General Winfield Hancock, who had given him "a number of interesting details." He also spent some time sketching artifacts in the museum at Governor's Island, and in interviewing Generals Alexander Webb and Abner Doubleday. He went to Washington to study battle maps in the War Department files and spent several weeks in Gettysburg making detailed notes and sketches of the terrain. One of the earliest battlefield guides at Gettysburg, local Civil War veteran William Holtzworth, proudly reported that he took the artist on an extensive battlefield tour to help him understand the battle.

Early battlefield guide William D. Holtzworth (1843 – 1891), Civil War veteran and resident of Gettysburg, took Philippoteaux on tour of battlefield. *SBC*

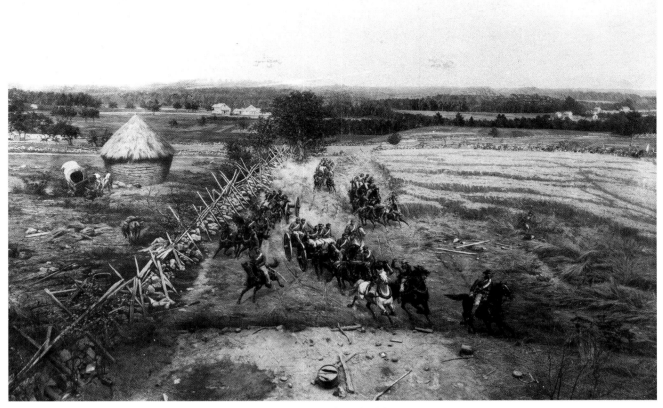

Scene from *Battle of Gettysburg* Cyclorama, Chicago version, looking east. *SBC*

Under Philippoteaux's careful direction, noted Gettysburg battlefield photographer William H. Tipton produced a series of photographs of the landscape from a point near the Copse of Trees on Cemetery Ridge. These panoramic images were taken from a high wooden platform, the same height as the platform from which the painting would be viewed by spectators during the painting's exhibition. It is believed that Tipton and Philippoteaux did not employ the traditional method of taking three sets of images. Only one set, capturing the entire landscape from the mid-range, is known to exist.

There is no written record describing the exact height of the working platform or the viewing platform, although it is assumed that they were equal. It seemed to be a discretionary measurement chosen by the artist based on whatever elevation offered the best conceptual view of the horizon in the landscape. This elevation, when translated to the canvas, became the direct sightline for viewers in the cyclorama gallery. In the spring of 2012, the co-authors of this work, Brenneman and Boardman, along with professional battlefield photographer Dowling, attempted to

William H. Tipton (1850 – 1929), Gettysburg battlefield photographer, commissioned by Philippoteaux to photograph landscape from Cemetery Ridge for cyclorama. *SBC*

Tipton's 1882 photograph looking south with modern comparison (2012), looking south. *BD*

Tipton's 1882 photograph with modern comparison (2012), looking south by southwest. *BD*

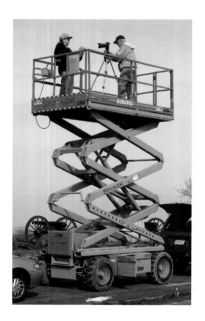

Co-authors Chris Brenneman and Bill Dowling, working from the approximate height of Philippoteaux's platform, capture modern comparison views (picture taken by Sue Boardman 3/8/12). *SBC*

discover the approximate height of Philippoteaux's platform. Armed with a set of Tipton's 1882 photographs, a scissor lift was secured and positioned on Cemetery Ridge. For several hours, the lift was repositioned, raised and lowered as the historic images were compared with the modern landscape, resulting in the determination that Philippoteaux's platform was approximately fifteen feet high. Several of the historic images and modern comparison photographs are included here. Subsequent measurements by the authors determined that the modern viewing platform is also approximately 15 feet high.

Upon completing his preliminary studies, Philippoteaux left America to continue the creative process as outlined earlier. Existing research is unclear about where in Europe the first version of the

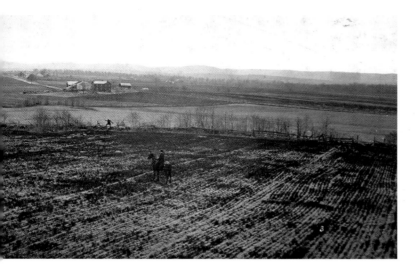

Tipton's 1882 photograph with modern comparison (2012), looking southwest. *BD*

Tipton's 1882 photograph looking north with modern comparison (2012), looking north. *BD*

Gettysburg cyclorama was made. Some accounts place the artist in his rotunda studio, *rue de la Loi*, in Brussels, Belgium, while other accounts state that he worked in his *Marlier Frères* studio in Paris. On May 6, 1883 the Belgian magazine *L'Art Moderne* (Modern Art) reported that, "the new panorama by Paul Philippoteaux, whose genre is most admirable, was on display at the roundabout, rue de la Loi, before leaving for Chicago where it will present one of the most murderous episodes of the secession war to the eyes of the North Americans." It is improbable that the huge painting was made in Paris and then transported to Brussels to be displayed before heading to Chicago. Yasmina Boudhar, a French doctoral student researching the careers of both Henri and Paul Philippoteaux, concluded that although the painting was most likely created in

Brussels, it was reported in souvenir programs accompanying cyclorama exhibitions to have been made in Paris because of the American perception that Paris was the world capital of the arts at that time. Further evidence to support a Belgian origin shows that the large lengths of canvas necessary to make a cyclorama were produced on carpet looms in Brussels.

Philippoteaux's next step was to assemble his artistic team. Various sources state that his team numbered up to twenty painters, but over the course of creating the four versions, probably no more than eight or ten were working at any given time. Each artist specialized in a given area of the work. At least two landscape artists were employed, in addition to those for whom horses, uniforms, portraits, or sky fell within the scope of their expertise. Most of

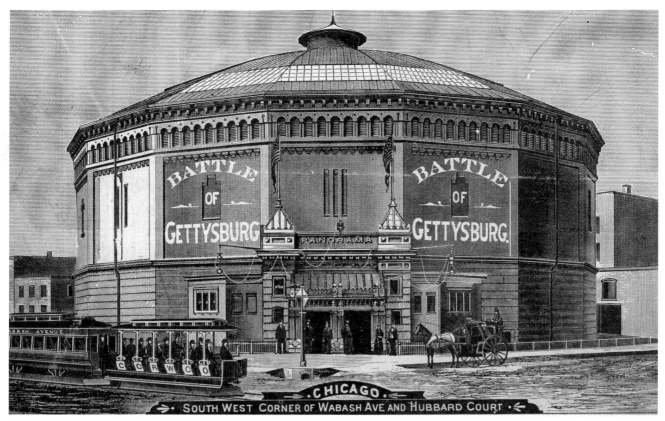

Philippoteaux's artists were of French or English descent, and many of them continued to work with him on the *Gettysburg* versions painted in the United States. Although the names of several artists who worked on one or more of the four versions are known, it is impossible to determine exactly which artists worked on which paintings with two exceptions. In the descriptive brochure for Philippoteaux's cyclorama *Jerusalem on the Day of the Crucifixion*, it is stated that Parisian painters Salvador Mège and Ernest M. Gros worked with Philippoteaux on "all of his cycloramas which have been seen in America." Other artists identified as having worked with Philippoteaux at one time or another include Englishman E. J. Austen; C. A. Corwin and O. D. Grover of Chicago; painters John H. Twachtman and John O. Anderson, both born in Cincinnati, Ohio; and Marion Knight, also an American. Joseph Bertrand and Lucien Pierre-Sergent were also mentioned in one 1885 source as having worked on the Chicago painting. Some of these artists would go on to create *Gettysburg* cycloramas for other companies after leaving Philippoteaux's employ. One such company, Gross & Reed in Englewood, Ill., hired a number of Philippoteaux's former artists.

Rotunda on South West corner of Wabash Ave. and Hubbard Court, Chicago. *SBC*

The landscape artists were thought to carry the most skill in the creation of a cyclorama. A review in *L'Art Moderne* magazine, published in Brussels in May 1883, remarked about the *Battle of Gettysburg* painting that "what really constitutes the highest beauty and is superior to anything seen up to this time is the landscape. The sky is of a prodigious clearness and truth. When one raises the eyes the illusion is marvelous..."

As the first version of the *Battle of Gettysburg* cyclorama neared completion in Europe, a special building—the rotunda—was being erected on the corner of Wabash Avenue and Hubbard Court in Chicago by the architectural firm of Bauer & Hill. Its unusual appearance drew comments in the press: Chicago's *Inter Ocean* newspaper reported, in December 1883, that "in order to give this grand work its full effect, the artist has erected a fine fireproof duo-octagonal building...at a cost of $40,000, which is 134 feet in diameter and is 96 feet high. The walls are windowless, the light coming in only from the roof in daytime, while at night the building is brilliantly illuminated by electric light."

By November 1883, the National Panorama Company, the stock company formed by Charles Willoughby and eight others, had formally purchased the completed painting from the artist for $200,000, and the Saturday before opening the exhibition to the general public, the managers held a private preview and reception for prominent citizens and members of the press. As reported by the Chicago *Journal* on December 22, 1883, they "were not only charmed but astonished with what they saw....[I]t only remains to be said that the universal verdict of those who have seen it is that the artist has rendered art in Chicago a great service in placing it on exhibition. The Battle of Gettysburg has at once taken a first position among the standard attractions of the city."

The great success of Philippoteaux's painting became apparent almost immediately. The newspapers continued to give it high praise as visitors flocked to see it in the weeks and months that followed. Civil War veterans in large numbers visited the cyclorama to see if the watershed event of their lives had been effectively captured on canvas. In a July 1884 issue of *Frank Leslie's Illustrated Newspaper*, a journalist remarked that "the enthusiasm of the old soldiers—and there were thousands of them—who gaze upon this panorama is unbounded." Many of them shared their acceptance of the painting with the artist, and a few offered critiques of its historical inaccuracies. For example, in this first version, veterans remarked that some of the uniforms looked French, and that General Armistead was shown mounted on a horse although he crossed the field on foot that day. A number of these interesting details will be covered in a later chapter.

General John Gibbon, a division commander in the Union Army's 2nd Corps, visited the cyclorama in mid-1884, and shortly thereafter wrote to fellow officer Henry Hunt, chief of the Union artillery during the battle, saying, "Whilst in Chicago I went to see the battle of Gettysburg three times, and you may rest assured you have got a sight to see before you die. It is simply wonderful and I never before had an idea that the eye could be so deceived by paint and canvas....You enter the building by a dark passageway and staircase and reach a platform and the effect is startling for apparently you look out upon the field of Gettysburg from a point just behind the middle of my Div. The perspective and representation of the landscape is simply perfect and I say nothing more than the truth when I tell you it was difficult to disabuse my mind of the impression that I was actually on the ground."

Visitors to the *Battle of Gettysburg* exhibition had the opportunity to purchase, for five cents, a souvenir program containing background information about the battle, a biography of the artist, a number of advertisements for local businesses, and a fold-out key to the painting, that assisted the viewers in understanding what they were seeing. Later issues of the program contained opinions of the press and listed names of Civil War veterans who visited the exhibition.

The Gettysburg cyclorama in Chicago enjoyed a remarkably popular ten-year run. According to a letter written by the company managing the painting, over two million people saw the painting in those ten years it was on display, and its stockholders were paid $420,000 in dividends after expenses, or about $25,000 per year for the first ten years it was exhibited.

Cover of souvenir program for early *Battle of Gettysburg* Cyclorama exhibitions in Chicago, circa 1883-1884. *SBC*

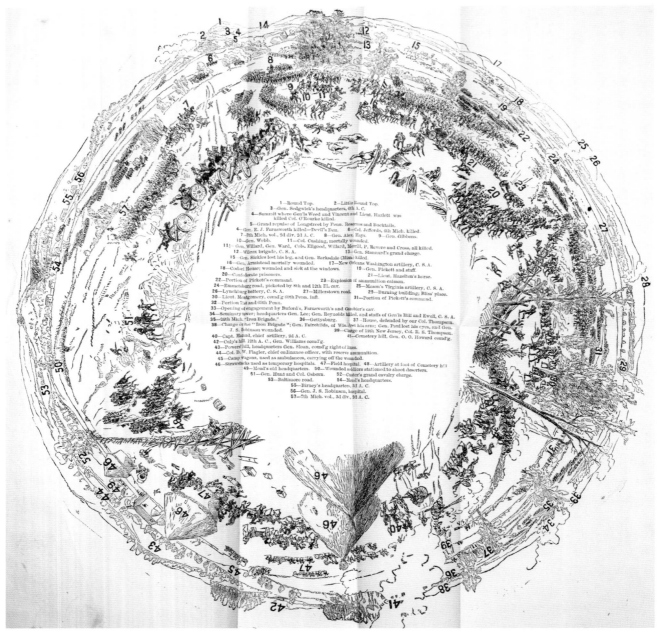

Diagrammatic key to the Chicago cyclorama. *SBC*

Prevailing history held that the Gettysburg cyclorama in Chicago closed briefly to be refurbished in time to reopen for the Chicago World's Fair (World's Columbian Exposition) in 1893. New research suggests that the painting did indeed close in 1892, but then left Chicago, reappearing in a venue in Indianapolis in 1893. An article on March 30, 1893 in the *American Nonconformist*, published in Indianapolis, states, "The great cyclorama painting, Battle of Gettysburg, by Paul Philippoteaux, is now on exhibition in Indianapolis….It is the original cyclorama painting which has been on exhibition in Chicago for the last ten years." The Chicago World's Fair opened on May 1 and closed October 30, 1893. It is most unlikely that the painting, newly arrived in Indianapolis, would be removed just a month later and set up again in Chicago in time to attract fair patrons. The documentation seems to indicate that it was probably not in Chicago during the World's Fair.

By October 4, 1894, the same Gettysburg cyclorama was shown at the Sioux City Interstate Fair, where it was displayed for ten days in a temporary building. Here, too, the claim was made that this was the original Chicago cyclorama. An article in the Alton

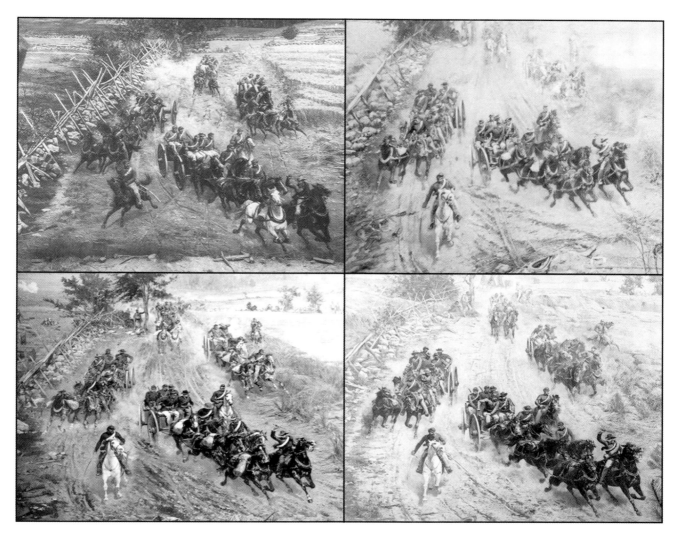

From top left in clockwise direction, scene of Wheeler's Battery coming into action from Chicago, Boston, Philadelphia and New York versions. *SBC*

(Iowa) *Democrat*, dated October 6, 1894, reported, "The Battle of Gettysburg, which has been on exhibition in Chicago for the past ten years, has been removed to Sioux City where it is now open and will remain as one of the greatest attractions during the Inter-State Fair." By the mid-1890s, interest in cycloramas had significantly waned and many of them, like this one, were making the circuit as temporary venues, often at state fairs and expositions.

It appears that the Chicago version of the Gettysburg cyclorama did not leave Sioux City intact. On November 10, 1894, the Omaha *World Herald* carried this story: "A Great Picture Destroyed—During a heavy wind storm the roof of the temporary building containing the....painting of

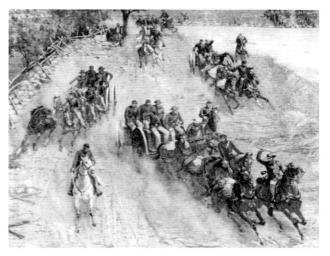

Scene from the Wake Forest copy by E. J. Austen, former artist with Philippoteaux's team who later worked for a competing studio in Chicago making buckeye (knock-off) copies of Gettysburg cycloramas. *SBC*

The Gettysburg Cyclorama: The Turning Point of the Civil War on Canvas

the battle of Gettysburg was blown off and great rents torn in the picture. It was also soaked with rain, which afterward froze stiff. The picture is most irreparably damaged."

There *was* a Battle of Gettysburg cyclorama in Chicago during the World's Fair—but which one? An article in the Philadelphia *Inquirer* dated March 20, 1892, supports the idea that it was the Boston version rather than the Chicago one. The Boston painting was under contract to Philadelphia for all of the year 1891, but stayed on exhibit there for an additional six months because the building to receive it next was not yet ready. The article closed by saying, "the wonderfully realistic cyclorama of Gettysburg is...to be removed in a very short time...a building is being erected in Chicago for it, as an attraction for the World's Fair."

After the fair ended in Chicago, a Gettysburg cyclorama (presumably the Boston version) continued on exhibit in that city for a little while longer. The cyclorama venue no longer appears in amusement listings at the Hubbard and Wabash location after 1895. By October of that year, the National Panorama Company, in the face of low patronage, began to dispose of all of its property. The cyclorama remained on display by special arrangement, unadvertised, until November 24, 1896, and then it closed for good. Please see additional discussion in the next section on the Boston cyclorama to understand its story.

Over the next 25 years, the rotunda in Chicago was used as an armory, a boxing arena, a vaudeville theater, a temple, and a theater again. It was demolished in 1921 to make way for a two story Masonic hall.

By the 1890s, many Gettysburg cycloramas, both originals and copies made by other studios, were being shown in temporary and semi-permanent venues around the country, which makes it nearly impossible to discern the ultimate fate of a particular painting. What is offered here is the latest research, which may change as a result of future study.

For example, as recently as 2007, it was thought that Philippoteaux's Chicago cyclorama was shown at both the 1893 and the 1933 World's Fairs, and was rediscovered in a warehouse there in the 1960s, eventually ending up in storage at Wake Forest University. Now it appears that the original Chicago version of the painting was not shown at either of these venues. Careful comparison of photographs of the Wake Forest painting against existing photographs of all four *Battle of Gettysburg* cycloramas now confirms that it was a copy inspired by Paul Philippoteaux's master works, but it is not one of them. More discussion about some of the many reproductions of Philippoteaux's paintings appears at the end of this chapter.

The Battle of Gettysburg Cyclorama: Boston Version

Within months of opening Chicago's cyclorama exhibition at the end of 1883, Willoughby commissioned a second version of the *Battle of Gettysburg*, to be permanently located in Boston, Massachusetts.

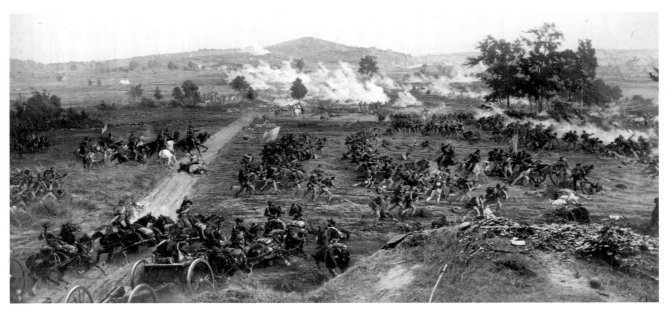

Scene from *Battle of Gettysburg* Cyclorama, Boston version, looking south; by Allen & Rowell. *SBC*

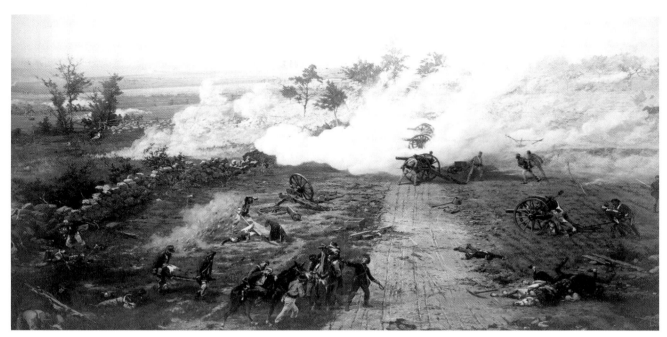

Scene from *Battle of Gettysburg* Cyclorama, Boston version, looking north; by Allen & Rowell. *SBC*

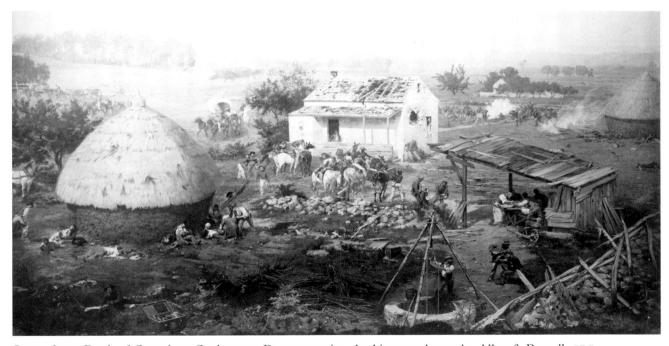

Scene from *Battle of Gettysburg* Cyclorama, Boston version, looking northeast; by Allen & Rowell. *SBC*

Willoughby had spent time in early 1884 traveling abroad to visit cycloramas. The Chicago *Sunday Tribune*, March 2, 1884, carried the headline, "C. L. Willoughby: An Account of the Principal Monster Paintings in Europe and America." The article went on to report that, upon his return the previous day, Willoughby was asked by a reporter to describe what he saw: "I made what might be called a flying trip….I was gone thirty-five days, only fourteen of which were spent in Europe—in London, Paris, and Antwerp. I visited, including two in New York, twelve panoramas, and ten of them were failures so far as the stockholders were concerned. The parties who placed the stock, however, made money. Among the twelve, four were 'Sieges of Paris,' including one in New York painted by Philippoteaux Sr. It paid for a month or two, and then

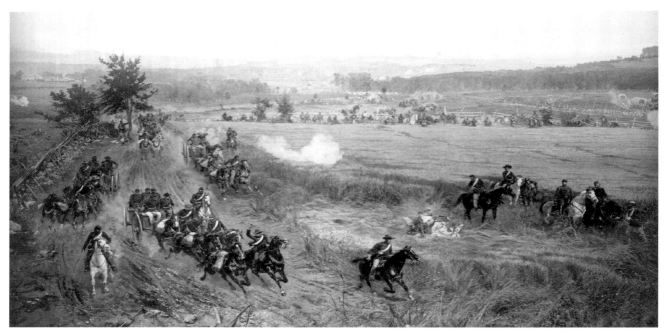

Scene from *Battle of Gettysburg* Cyclorama, Boston version, looking east; by Allen & Rowell. *SBC*

the receipts dropped to nothing. The American people take no interest in foreign battles….I was about the only visitor at any of them—I could see in a moment why they were failures. There was nothing of interest, compared with the Chicago panorama of the Battle of Gettysburg, which is undoubtedly the most beautiful in the world…." It is possible that this trip was the inspiration for offering three more commissions for Gettysburg cycloramas. The artist would complete one per year over the next three years.

For his Boston commission, Philippoteaux worked with his team of artists in Paris, where he completed most of the work before shipping the huge canvas to America. In a newspaper article located in the Boston Public Library, it was noted that, "After the painting was laid in, and needed only the finishing touches and final corrections, Philippoteaux brought it to Boston, where the canvas was set up in the building…which was created especially for the purpose. Here many of the surviving generals of the Civil War were asked to inspect and criticize the work. After receiving their suggestions, the painter and his staff of assistants made changes that brought the work to an almost perfect exactitude in its historical sense."

Sometime in early 1884, Philippoteaux planned to move his entire operation to America, in part because the duty costs he was required to pay to ship the massive canvases across the ocean were prohibitively high—reportedly as high as thirty percent. However, he had not yet acquired his New York studio in Mott Haven in time to begin work on the Boston cyclorama.

As Philippoteaux and his artists worked, Willoughby relayed comments to him from Chicago, noting inaccuracies in the first version that were pointed out to him by Civil War veterans. Some of these were

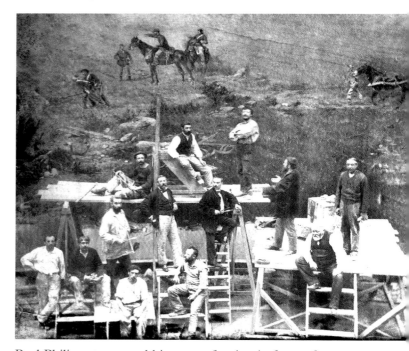

Paul Philippoteaux and his team of artists in front of the nearly completed Boston version. *Francis Hegoburu*

Hospital scene and Meade's Headquarters in Chicago version. *SBC*

Close-up image of Leister Farm House which served as Meade's Headquarters; by William H. Tipton, circa 1880s. *SBC*

Hospital scene and Meade's Headquarters in Boston version. *SBC*

Hospital scene and Meade's Headquarters in Philadelphia version. *SBC*

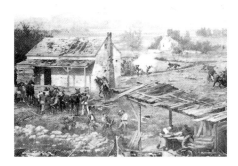

Hospital scene and Meade's Headquarters in New York version. *SBC*

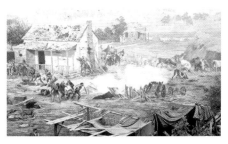

corrected in the Boston painting while some were not changed until the last two versions were made.

The most notable change was the inclusion of the building representing General Meade's headquarters. Shown here is a section of the Chicago painting looking due east, in the direction of the Taneytown Road. The Leister farm, which served as Meade's headquarters during part of the battle, was, and still is, located along the west side of the road, and should appear between the road and the larger straw stack in the painting. According to an interview with Charles Cobean, manager for the cyclorama when it came to Gettysburg, the omission of the farmhouse was noted by veterans who saw the Chicago painting and who were also familiar with the battlefield. In response, Willoughby requested that Philippoteaux include it. The artist informed him the landmark was not visible from his focal point on the landscape, but Willoughby insisted that it be included because of its apparent importance to the veterans. Philippoteaux requested a photograph of the farmhouse which William Tipton provided. The artist included it in all three of the remaining versions of his Gettysburg cycloramas. While the resulting white building in the painting is fairly accurate in size and shape, its location is not; it is located too far forward on Cemetery Ridge and faces west instead of south. Also, the original farmhouse was wood, not stucco as it appears in the painting.

Another significant observation made by the veterans was the fact that General Lewis Armistead, the

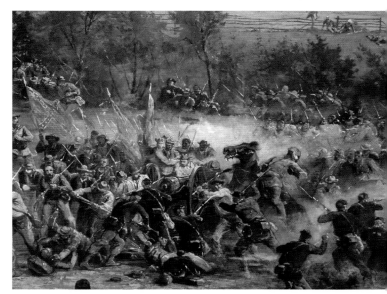

Scene showing General Armistead mounted on a horse during Picket's Charge (Boston version). *SBC*

only Confederate brigade commander who crossed the stone wall during the charge on July 3, was not mounted on a horse that day. Although the correct information was relayed to Philippoteaux by Willoughby as work progressed on this version of the painting, it was too late to make the change. Armistead does appear on foot in the last two of the four versions.

In April 1884, Willoughby made application to the inspector of buildings for the City of Boston to construct an exhibition building at 541 Tremont Street. The rotunda still exists but it now stands behind a brick facade with only its roof visible from the street. It was designated a Nationally Registered Historic Place in 1974.

The Boston painting opened in December 1884 and was again preceded by a special preview and reception of dignitaries and other prominent citizens. As in Chicago, the Boston version of the *Battle of Gettysburg* enjoyed great success. *The Sunday Herald* offered rave reviews in its coverage, stating, "Of the painting as a work of art, there is no dispute....The figures are singularly life-like and animated; and in fact, the whole picture is full of action. It is difficult and in some places impossible to tell where the canvas leaves off and the artificial foreground begins. The atmosphere is simply marvelous in its fidelity to nature....The painting draws forth that...particularly truthful remark that it must be seen to be fully appreciated."

On December 26, *The Daily Advertiser* reported, "The execution of this truly colossal work is a marvel

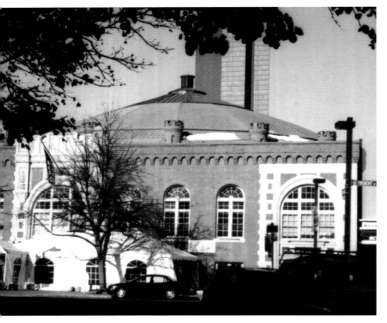

Modern view of the cyclorama rotunda on Tremont Street. *Suzanne Wray*

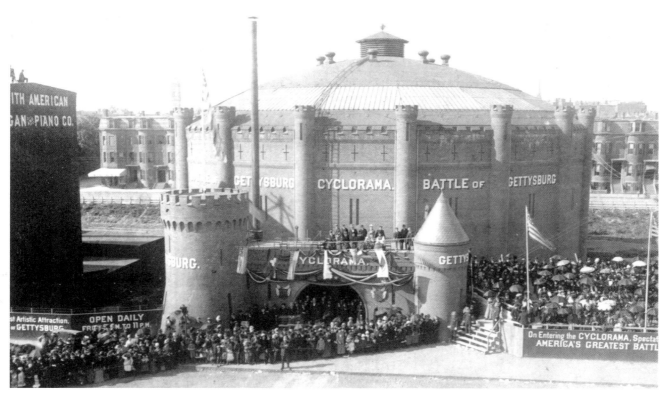

The rotunda at 541 Tremont Street, Boston. *SBC*

28

Cover of early souvenir program. *SBC*

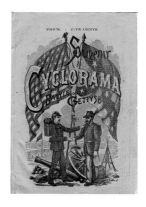

of artistic learning and sentiment, as well as of accuracy in every historical and topographical particular. In a word, this is a great piece of work….The industry and system, the patience and fineness in the little things, and the breadth and spirit of the whole effect are very remarkable and admirable."

On December 30, *The Sunday Globe* remarked that "You will find [it] hard work to convince yourself that you are not standing on the top of Cemetery Ridge in the very center of the position occupied by the troops on the Northern army on that memorable day in July, nearly twenty-two years ago. Looking over the brow of the hill on which you are standing, you see spread out before you the battlefield so vivid and life-like." As in Chicago, Civil War veterans were frequent visitors to the viewing platform and could often be heard discussing their battle experiences.

The souvenir program sold to visitors in Boston was similar in size and format to the one sold in Chicago and the key was nearly identical, even though the artist made a dramatic change by including Meade's headquarters surrounded by a hospital scene with a stone well, a wooden lean-to, and a surgeon and his assistant caring for a wounded soldier. These changes are only reflected in the Boston key by removing the large haystacks but without adding the other detail. It was simply more cost efficient to use the original key from the Chicago cyclorama. By comparing photographs taken between 1886 and 1948, the authors discovered that General Meade and his staff were not in the Boston painting when it opened in 1884. Upon further research, they were able to document the date of this important addition. It will be discussed in more detail in Chapter 4.

The Boston version of the *Battle of Gettysburg* continued on permanent exhibition in that city until December 31, 1888. By March 1889, the Boston

painting was removed from the rotunda on Tremont Street for restoration and alteration. The work was probably done in the Mott Haven studio. In the meantime, the cyclorama *General Custer's Last Fight* replaced it, running from March to mid-August. The newspapers reported, "The cyclorama of the Battle of Gettysburg, after having been thoroughly rejuvenated and greatly improved….is again placed before the public. One of the most noticeable alterations is the placing of the figure of Gen. Meade more in the foreground than before…..The picture will remain on exhibition…for a brief period." A new souvenir

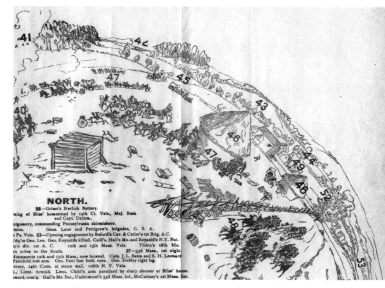

Section of Boston key showing area of hospital scene and Meade's Headquarters. *SBC*

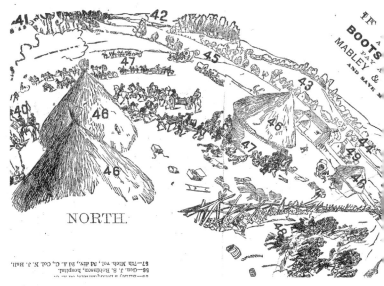

Section of Chicago key showing area of hospital scene and Meade's Headquarters. *SBC*

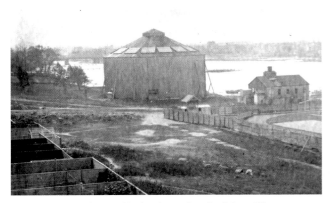

Philippoteaux's studio in America in Mott Haven area of Bronx along the bank of the Harlem River circa 1880s. *Francis Hegoburu*

program was produced, prominently displaying Meade in the cover art.

Just a little over a year later, on December 31, 1890, the Gettysburg cyclorama closed in Boston permanently. Its management entered into an agreement with the city of Philadelphia to exchange the Boston version of the Gettysburg cyclorama with that of *Jerusalem on the Day of the Crucifixion* for one year. The Philadelphia *Ledger*, in a full-page advertisement proclaimed, "This is NOT the cyclorama that was exhibited here some years ago, but the grandest and most costly of all."

The painting would never return to Boston. It was held over in Philadelphia a little longer than anticipated, until July 1892, while the building intended to house it was being prepared. According to the Philadelphia *Inquirer*, the Boston version of the cyclorama was going to be an attraction in Chicago during the World's Fair.

Until recently, the history of this painting included a gap for the years between the time it left Philadelphia and its return to a vacant lot behind the rotunda on Tremont Street. But the possibility of it being sent to Chicago for the 1893 Columbian Expo was not considered since it was thought that the Chicago version was in Chicago at that time. It would not be difficult to understand why the Boston painting would supplant the Chicago version for an event as grand as the World's Fair. There were a number of errors in the Chicago painting, and the artistic style was not quite as mature as its Boston successor. The additions made to it in 1889 would have made it superior for interpretation as well.

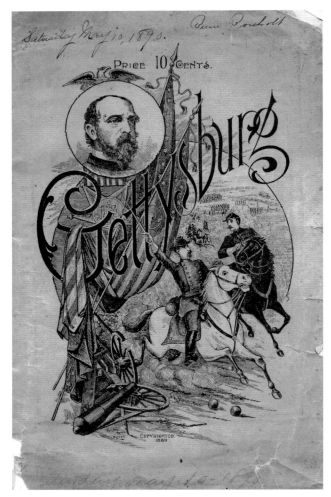

Later cover of souvenir program reflecting the addition of Gen. Meade to the painting. *SBC*

Assuming the painting remained in Chicago until the drop in interest necessitated its closure, much of its "lost" history has been found. There may have been an additional exhibition between 1896 and its arrival back in Boston but no mention of it has been found in the research literature. Based on its poor condition when next viewed (in 1910), it may have been shown in a less professionally staged venue. This is based on the fact that, when it was uncrated in 1910 after being stored for years on the Boston lot, it was found to have been cut horizontally into two sections so that the bottom portion was a little over 27 feet high and the sky portion was 19 feet high. If it had returned directly back to Boston, it should have still been intact, since the Philadelphia and Chicago rotundas would have been able to accommodate the full-sized painting. Or, it may have simply been cut for ease of removal from the building in Chicago since the era of cyclorama

Broadside advertising the Boston version of the cyclorama in Philadelphia, early 1891, informing public that it is not the Philadelphia version displayed there several years earlier. *SBC*

exhibition had clearly passed by then. Many cyclorama stock companies were in receivership, with assets being auctioned at sheriff's sales, sold off, or otherwise disposed of. In any case, sometime around 1896, the Boston painting was noticed on the vacant lot behind the Boston rotunda, rolled up in a 50' wooden crate in an open shed. There, it was damaged by vandalism, fire, and rain.

A small article in the Boston *Globe* dated March 11, 1901, stated: "The famous panorama of the Battle of Gettysburg...is going to rack and ruin in a lot at the corner of Clarendon Street and Warren Avenue....[A] tiny pitched roof extends over the box, but the weather has played sad havoc with both the roof and the box, and the probabilities are that the canvas is pretty well damaged, for it has been in this place for a number of years."

The Boston *Evening Telegraph* reported on March 14, 1901, that the box "....was surrounded by rubbish....The sleet and snow and sun and rain had beat upon it, warping the thin roofed boards and opening the knotholes and cracks for rain to soak in. Boys have torn away a board here and there, which has permitted further injury. The leaky, weather-beaten box is really a sort of mausoleum of greatness."

Boston's *Evening Transcript* from March 16, 1901, added, "Interest in the great cycloramic painting, 'The Battle of Gettysburg,' has been revived through recent discovery that the great canvas, which once was viewed with admiration by thousands upon thousands of people, is now seemingly going to ruin because of the conditions under which it is stored in this city...where it has remained for five or six years, or perhaps even longer, subjected to all the conditions of weather."

If the above article is correct, then the painting left Chicago in late 1896 and arrived on the Boston lot shortly thereafter, where it remained until newspapers reported on it again in 1901. Records indicate that the rotunda on Tremont Street was sold in 1899 to the New England Electric Vehicle Transportation Company. It seems unlikely that the painting was sent back to that location after that date, since the original cyclorama company no longer owned the property.

The *Evening Transcript* article continued, "It is said at the office of the George Frost Company, corner of Tremont and Clarendon Streets, that the storage box made its appearance upon this vacant lot in a somewhat mysterious way. The company's offices overlook the lot and one morning the clerks and others in the office discovered that during the previous night the box had been dumped behind the factory..... The long box has been on fire two or three times in the years it has lain in the lot. Early last summer was the latest incident of this kind, and at that time the firemen played the hose well all over the box and into it, boards having been removed from the top....An oiled skin or cloth is wrapped about the canvas and in the box, stored with it, are muskets and other paraphernalia which, as many will recall, formed a part of the foreground...."

Stockholders in the Boston Cyclorama Company, which had taken financial control of the painting in 1885, dissolved in 1904. The *Battle of Gettysburg* cyclorama painting remained on the vacant lot in Boston until 1910. It is not known what inspired the Newark department store owner, Albert Hahne, to purchase it that year, thereby saving it from further destruction. The acquisition, however, was probably instigated by Thomas T. Fryer, a dealer in fine art and rare books, who knew of the painting and spoke of it to Hahne.

Upon learning of the painting, Albert Hahne sent a representative to Boston, with the request to view it and report back to him. In a letter written from the Parker House in Boston dated November 8, 1910, the agent informed Hahne that the canvas was to be unrolled the following day in order to look it over. In the meantime, he had arranged for a carpenter to make wooden rolls on which to wrap the canvas for transport, and met with individuals regarding documents and bills of sale.

In a letter sent the following day, the agent informed him that Hahne was the new owner of the *Battle of Gettysburg* cyclorama and went on to describe the painting itself: "We have unrolled about 125 feet which has been cut into four pieces. Two pieces 27 feet wide and two only 19 feet wide, the latter being the sky....Figured each roll to weigh between 700 and 800 lbs." Several notations in pre-1900 documents actually estimate the weight of the painting to be about 5,700 pounds or a little less than three tons.

The cyclorama was shipped to New Jersey and hung in sections at the Hahne & Company's new store at 609 Broad Street in downtown Newark. An advertisement in the Newark *Evening News* on February 7, 1911, stated, "Tomorrow, after months of arduous labor and the expenditure of a great sum of money, we will reveal to the public the greatest painting of the 'Battle of Gettysburg' ever put on canvas....This picture is hung in the great Grand Court of the store from the dome to below the fourth floor. It stretches almost entirely round both courts, being 352 feet long in all...."

Hahne employed photographer Harry G. Potter to take photographic prints of each part of the painting. These photographs are in the Gettysburg National Military Park collections and reveal the significant deterioration suffered by the painting up to that time.

In mid-June 1911, at the suggestion of General Daniel Sickles, the cyclorama, in sections, was sent by Hahne to the Armory of the 12th Infantry National Guard of New York located at 62nd Street and Columbus Avenue in New York City. It was displayed there in much the same way as it was in Hahne's store. This and subsequent exhibitions were managed by Mr.

Hahne's Department Store at 609 Broad Street in Newark; the store had a four-story atrium.
Old Newark Website

Descriptive flyer for the exhibition of the Gettysburg cyclorama in Hahne's store, 1911. *SBC*

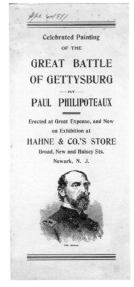

Cover of photograph album containing images by H. G. Potter for Albert Hahne; album is part of Gettysburg National Military Park collections.
NPS (Andrew Newman)

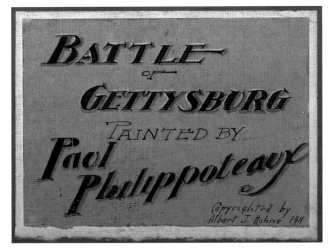

Fryer, the arts dealer who originally located the canvas for Hahne. In the literature accompanying this exhibit, it was noted that "there is an effort being made to have (the painting) placed in a permanent building on or near the historic battlefield which it portrays." This is the first hint of its future in Gettysburg.

In August, the sections of painting were moved to the Fourth Infantry Maryland National Guard Armory on Fayette Street in Baltimore. While on exhibit there in late September, the painting was viewed by LaSalle Corbell Pickett, the widow of Confederate General George Pickett, one of the leaders of the charge depicted on the canvas. This unannounced visit was the first time Mrs. Pickett had seen the *Battle of Gettysburg* cyclorama.

Sometime during the spring of 1912, the cyclorama painting was hung in the ballroom of the Pension Office Building in Washington, DC. While on

Mrs. LaSalle Corbell Pickett. *WorldPress.com*

Right: Philippoteaux self-portrait in cyclorama painting. *BD*

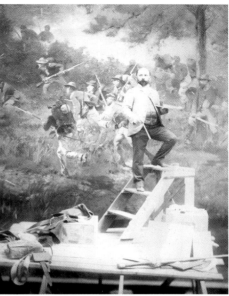

exhibit there, it was viewed by Pension Office employee C. O. Howard, son of General O. O. Howard, who suggested that the painting should be on permanent display at Gettysburg. It would be accomplished in time for the 50th anniversary of the battle in 1913.

In June 1912, a stock company was incorporated and began the construction of a wood and tile building on a lot leased by Dr. W. O'Neal on East Cemetery Hill. The company quickly failed due to financial complications but was reorganized with Albert Hahne, a major investor in the corporation, as its director. Hahne leased the painting to the corporation for an indefinite period of time.

The diameter of the newly constructed exhibition building was 120 feet and the height of its walls was 28 feet. The roof bore skylights and ventilation portals. No other cooling or heating source was installed. This may

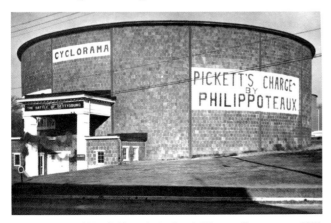

"Temporary" building (1912-1962) on Cemetery Hill constructed to house Gettysburg cyclorama. *SB*

Above right: Photograph of Philippoteaux standing in front of his self-portrait, 1884. *NPS*

have been due in part to the premise that this building was to be temporary in nature, and that it was hoped the Federal Government would build a magnificent and permanent building worthy of the painting at some future time.

The building opened in May with Fryer serving as the initial custodian and lecturer. An article in the Gettysburg *Times* on May 8, 1913, described the exhibition:

The world famous Philippoteaux painting of the Battle of Gettysburg arrived in Gettysburg....After many years of endeavor to provide a permanent home for the masterpiece...it seems that one at last has been found, and that at Gettysburg, where many have always thought it would be permanently located. The painting is in eleven sections and is twenty eight feet in height…[it] was so heavy that a number of trips in a large wagon were required to convey the various sections from the freight depot to the cyclorama building.

Charles M. Young, a Gettysburg College student who would later become a well-known painter, did some touch-up work to damaged parts of the painting while it was being hung in the building. No diorama was created since the building was to be a temporary home for the painting. Newspaper coverage of the 50th anniversary of the battle and the reunion of the Blue and Gray veterans revived the story of the painting's glory in the early years of its existence.

Handwritten inscription from Philippoteaux to Willoughby. *NPS (Andrew Newman)*

About a year after the painting's arrival in Gettysburg, Paul Philippoteaux visited the battlefield at the request of Mr. Fryer. The purpose of the trip was to certify that this painting was indeed his work. The artist indicated that the red-bearded figure of a Union officer standing under the small pine tree with the sword across his knee was a representation of himself and served as his signature. Evidence of this is in the form of a photograph in the Gettysburg National Military Park archives which shows Philippoteaux standing on a ladder, palette and brush in hand, in front of his likeness in the painting. It was inscribed to "Ch. Willoughby, souvenir of affection, Paul Philippoteaux, Boston 1884."

The cyclorama continued to be shown during the spring, summer, and autumn months at the Cemetery Hill location until 1939, when it provisionally became the property of the federal government under an agreement with the heirs of the Hahne estate. Three years later, it came fully under the jurisdiction of the National Park Service. Incredibly, it would remain in its 'temporary' building for nearly twenty more years.

By 1948, the 64-year-old painting was in rough condition and deteriorating rapidly due to neglect and improper hanging methods. In a Gettysburg *Star & Sentinel* article dated July 31, Park Superintendent J. Walter Coleman was quoted as saying, "...the painting had 'bellied' so badly and supports had rotted away to such an extent that there was some fear that some morning the huge painting might be found on the floor of the cyclorama instead of hanging from the walls." New York artist Richard Panzironi was engaged to complete an emergency on-site stabilization, which consisted of gluing linen bands to the back side of the canvas and drawing it back, then stapling it to wooden supports. This reinforcement was ultimately detrimental to the painting. As the glue dried it shrank, causing the canvas to pucker and hang in folds. The lower edge touched the floor which not only caused it to fray and rot, but prevented the natural hyperbolic shape from occurring, thus distorting the layered landscape. Some new canvas was added to the bottom of the painting and a continuation of the scene painted on it to fit with terrain features, but none of this restored the hyperbolic shape. Some new paint was added to areas where loss had occurred as a result of neglect, improper handling, and unstable environmental conditions.

During the 1950s, a National Park Service initiative known as "Mission 66" provided for a new building initially intended to serve as a visitor center and cyclorama gallery. Construction began in 1959

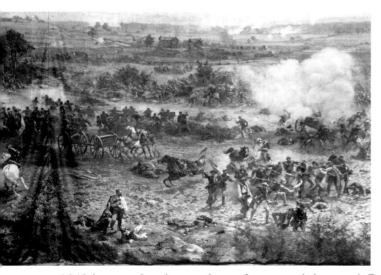

1948 images showing sections of worn and damaged Gettysburg cyclorama. *NPS*

Mission 66 cyclorama building (1962–2013). *NPS*

and was completed in 1962. In anticipation of moving the painting into this new venue, a major conservation project was undertaken by National Park Service Painting Conservator Walter Nitkiewicz. By this time, deep cracks, flaking and paint loss could easily be seen. The canvas was dry and brittle, and showed tears, splits, and folds. One large area was completely missing, which caused a break in scenic continuity.

Nitkiewicz opened the pre-existing seams and made further vertical cuts in the canvas for ease of handling. Using the latest conservation techniques of the day, he dampened, flattened, sized and relined the canvas using melted wax and resin. The relining was done while the painting lay flat, eventually causing the seams to misalign after re-hanging due to its former hyperbolic shape. The painting's lower edge rested on the floor promoting the development of vertical folds and eventual separation from the lining. As before

mentioned, a cyclorama is meant to hang from a ring at the top and weights are suspended from a ring at the bottom to maintain its natural hyperbolic shape. However, at this time the painting was hung straight down like a shower curtain. Fluctuating humidity due to lack of climate control in the new building led to further distortions and paint loss.

The uneven upper edge of the canvas was trimmed for remounting, resulting in additional loss to the original sky area. Some of this old canvas was stitched to the bottom of the painting and painted to match landscape features formerly completed via three-dimensional objects in the still-absent diorama. The missing sky and missing vertical portion were not replaced. A considerable amount of repainting was done to some areas of the painting by Charles A. Morgenthaler, a commercial artist and illustrator from Hallsville, Missouri.

Additional efforts to slow the deterioration of the aging canvas in 1975 and again in the late 1980s failed to resolve the myriad of problems which threatened to finally consume it. The gallery roof leaked periodically, allowing rain water to run down onto the painting. The lacquer covering the painting's surface yellowed. A layer of soot, emitted over the years from the ventilation system, darkened the surface of the painting and dulled its colors. No elevated platform, overhead canopy or diorama were installed, and there were just a few feet of sky visible above the horizon, so no cycloramic effect could be achieved. By the 1990s, the painting was so aesthetically compromised that it did little to inspire its viewers. The illusion it was once

Condition of painting, not in cycloramic format, 2005. *GF*

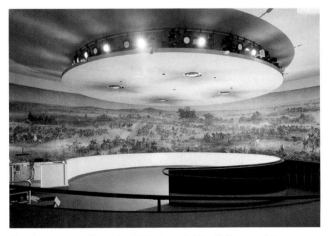

Cyclorama gallery in Mission 66 building, without diorama or canopy. Painting is missing much of the sky. *NP*

capable of creating could only be read about in century-old accounts.

With legislative approval of the Gettysburg National Military Park's 1999 General Management Plan, the fortunes of the *Battle of Gettysburg* cyclorama finally began to change for the better. One of the nation's leading conservation firms, Olin Conservation, Inc., was engaged to undertake the largest conservation project to date in North America. David Olin, Chief Conservator, is known for his expertise in conserving and restoring a number of nationally significant historical works of art. He and colleague Perry Huston assembled an impeccable team and began the multimillion dollar conservation project in 2004.

All of the problems mentioned previously, and many more, were addressed by Olin's team during the cyclorama treatment project. The painting not only suffered from critical structural issues, it had a number of aesthetic ones as well, some of which were unusual. For example, a rock wall visible to the left as the viewer faces north should have been straight and parallel to the road running alongside it. Due to previous damage and odd reconstruction of the canvas at some point in the past, the wall contained two additional ninety-

Conservation team, 2005-2008. *SBC*

degree angles that were not present when the painting was new. There were numerous examples of similar content issues which were professionally addressed by the conservation team. Many of these will be discussed in later chapters.

The conservation process was slow and arduous. It is not the intent to discuss the steps in detail in this book, but to simply give a sense of the great amount of labor involved. All that had been previously done to the painting in prior attempts to conserve it had to be undone before the latest efforts could begin. The painting was cleaned several times and studied closely for irregularities such as those mentioned above. To facilitate the realignment of its original sections, old seams were reopened. Old backing, glue, and wax were stripped off, brittle patches were removed, and new patches added. Approximately three feet of old canvas from the old sky area that had been added to the bottom was removed entirely. Layers of paint added over the years were removed. Glue residue was painstakingly scraped from the back of the canvas a square inch at a time. Hundreds of small areas where paint had been lost were filled in to smooth and level

David Olin, Chief Conservator, Olin Conservation, Inc. of Great Falls, VA. *Ray Matlock*

Odd wall alignment in pre-restored painting. *SBC*

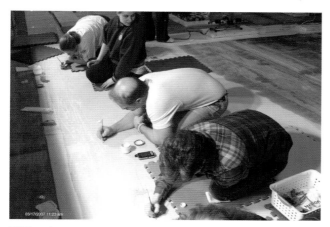

Filling in areas where paint loss had occurred before final in-painting. *SBC*

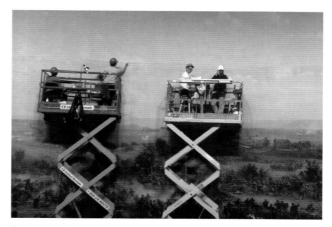

Painting the reconstructed sky area. *SBC*

the surface in preparation for inpainting (the process of reconstructing lost or deteriorated parts of paintings).

Missing areas were replaced and repainted using contemporary photographs taken of the painting when it was exhibited in Boston. Restoring the appearance of the missing sky was challenging because no one living had ever seen the painting with the sky intact. Fortunately, the historical record mentions the appearance of the sky that July day. Additional visual clues were gleaned from the artist's original work; his scale studies, representing two-thirds of the larger composition, were located in the Chicago History Museum. The study paintings were vibrant and contain all of the main elements found in the larger work. Philippoteaux's signature is clearly visible in the lower right margin of each canvas. These two studies, along with written accounts from participants, were the

historical evidence needed by the conservation team to restore the long-missing sky.

One of the most interesting features of the conservation process, from the authors' perspective, was the use of Infrared Reflectography (IR). Used to examine the surface of the ground layer of a painting, even if it is covered by more than one layer of paint, IR was employed by the conservators on the Gettysburg project to find the underdrawings beneath several paint layers. The process works because light in the near-infrared region of the spectrum can pass through the paint and is then reflected by the marks used to make the underdrawing. IR provided for the conservators the knowledge of the size of the grid pattern projected on the blank canvas by Philippoteaux and his team (discussed in Chapter 1), which in turn allowed them to extrapolate the original size of the overall painting.

Newly restored sky area before final painting. *SBC*

Through this method, it was determined that the 359-foot painting on display in Gettysburg was actually 377 feet when it was on exhibit in Boston. One 14-foot section, to the right of the artist's self portrait, had to be almost completely recreated. Several smaller sections along original seams were also missing. The painting is now fully restored to its original size and configuration.

Some of the historic diorama, or three-dimensional foreground, is visible in 1886 photographs, and that greatly assisted in the recreation of the modern one. The ground form was constructed, painted, and populated with landscape elements and reproduction pieces representing typical debris of battle.

By mid-July 2008, the painting was reconstructed, weighted, reshaped, and retouched, and the new diorama completed. With the illusion restored, all that remained was to relive the glory days of the Boston version of the *Battle of Gettysburg* cyclorama.

Using infrared Reflectography to find the underdrawing beneath the layers of paint. *GF*

Missing areas discovered through the use of infrared reflectography. *GF*

Recreation of a lost section of the painting – sketching the missing details. *SBC*

Recreation of a lost section of the painting - in progress. *SBC*

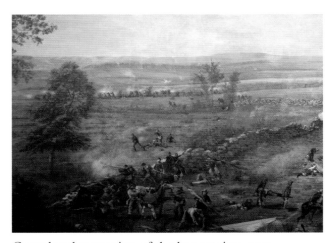

Completed recreation of the lost section. *SBC*

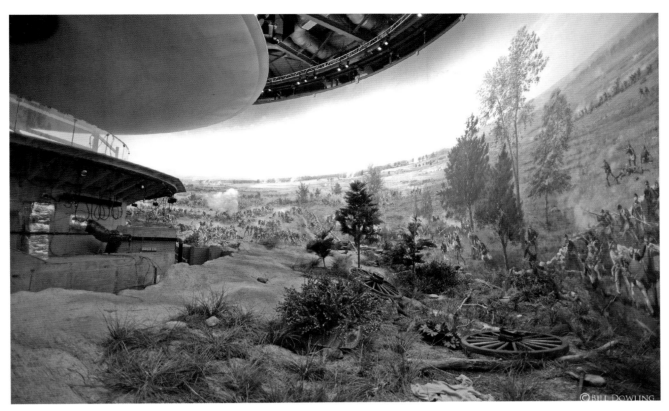

The diorama from the ground level. *BD*

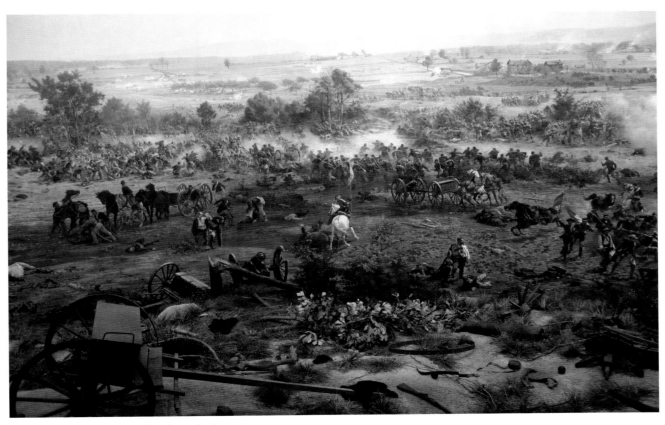

The diorama from the viewing platform. *SBC*

The Battle of Gettysburg Cyclorama: Philadelphia Version

By the time Philippoteaux began work on his last two versions of the *Battle of Gettysburg* cycloramas, his American studio, located in Mott Haven in the southwestern section of the Bronx, was operational. Upon completion, the third version was shipped to Philadelphia where it opened to the public October 13, 1885, with the usual preview by dignitaries and special guests. The city's rotunda stood at the corner of Broad and Cherry streets. The painting style of the Philadelphia cyclorama most closely resembled the Boston version. When Boston's painting opened, the Chicago key was used, although it had not been updated to reflect the changes Philippoteaux had made in response to veterans' comments. The key was redrawn for the Philadelphia version to better reflect the actual content of that painting. When Boston's painting came to Gettysburg for exhibition in 1913, the Philadelphia key was used because it closely reflected both paintings.

Cycloramas had become so popular by early 1886 that a second rotunda was built in the city, at Chestnut and Twenty-Second Street, and was showing *The Storming of Missionary Ridge* at the same time *Gettysburg* was still being shown at its original location. *Missionary Ridge* was created by the American Panorama Company in Milwaukee.

In July 1887, less than a year after it arrived in Philadelphia, *Gettysburg* was moved to Cincinnati, where it was set up in preparation for its re-opening that fall. Major Charles Hale, a veteran of the battle of Gettysburg, served as lecturer on the platform during exhibitions for at least the first three years of this painting's exhibitions. Hale served with the 5th New Hampshire Infantry during the battle, and was already known on the lecture circuit for his popular delineations on many battles of the war. As soon as the Philippoteaux *Battle of Gettysburg* cyclorama opened, Hale became its main platform lecturer.

While the painting was being moved to Ohio, Hale spent many weeks at Gettysburg serving as a battlefield guide. When conducting tours for groups on the field, he distributed a handbill advertising the reopening of

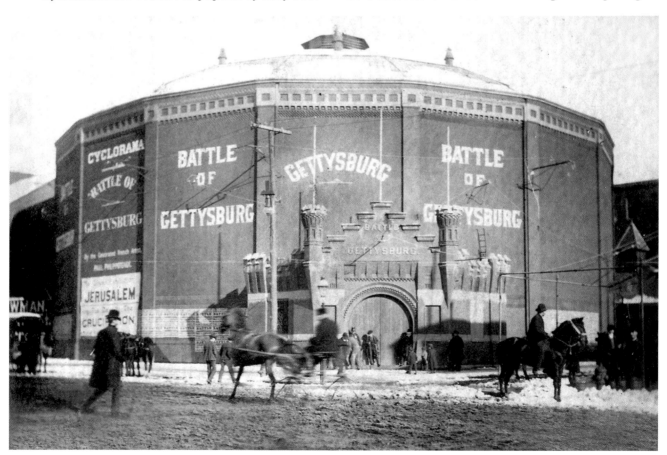

The Philadelphia rotunda at Broad and Cherry streets. *Francis Hegoburu*

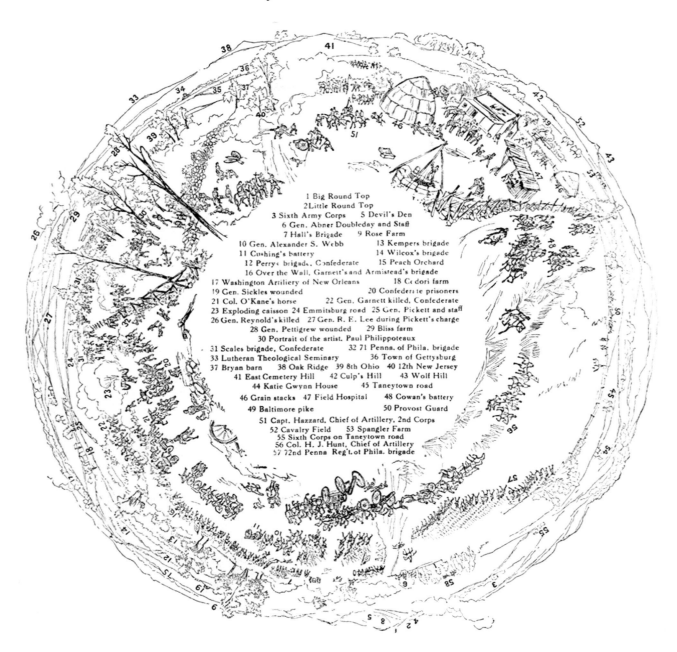

1 Big Round Top
2 Little Round Top
3 Sixth Army Corps 5 Devil's Den
6 Gen. Abner Doubleday and Staff
7 Hall's Brigade 9 Rose Farm
10 Gen. Alexander S. Webb 13 Kempers brigade
11 Cushing's battery 14 Wilcox's brigade
12 Perry's brigade, Confederate 15 Peach Orchard
16 Over the Wall, Garnett's and Armistead's brigade
17 Washington Artillery of New Orleans 18 Codori farm
19 Gen. Sickles wounded 20 Confederate prisoners
21 Col. O'Kane's horse 22 Gen. Garnett killed, Confederate
23 Exploding caisson 24 Emmitsburg road 25 Gen. Pickett and staff
26 Gen. Reynold's killed 27 Gen. R. E. Lee during Pickett's charge
28 Gen. Pettigrew wounded 29 Bliss farm
30 Portrait of the artist, Paul Philippoteaux
31 Scales brigade, Confederate 32 71 Penna. of Phila. brigade
33 Lutheran Theological Seminary 36 Town of Gettysburg
37 Bryan barn 38 Oak Ridge 39 8th Ohio 40 12th New Jersey
41 East Cemetery Hill 42 Culp's Hill 43 Wolf Hill
44 Katie Gwynn House 45 Taneytown road
46 Grain stacks 47 Field Hospital 48 Cowan's battery
49 Baltimore pike 50 Provost Guard
51 Capt. Hazzard, Chief of Artillery, 2nd Corps
52 Cavalry Field 53 Spangler Farm
55 Sixth Corps on Taneytown road
56 Col. H. J. Hunt, Chief of Artillery
57 72nd Penna. Reg't. of Phila. brigade

The key to the Philadelphia cyclorama. *SBC*

the cyclorama painting in October. He also encouraged Ohio veterans who had been in the battle to gather anecdotes for use during his lectures in Cincinnati.

The painting enjoyed a successful run in Cincinnati, and was a main attraction at the Ohio Centennial celebration in July 1888. In October 1888, a Grand Army of the Republic gathering was held in the city and the cyclorama was a popular attraction for the veterans.

In early 1889, the cyclorama was closed in preparation for its removal to St. Louis. A newspaper article on March 8, 1889, reported, "While workmen were engaged tearing down the building containing the cyclorama of the Battle of Gettysburg this morning preparatory to its removal to St. Louis the heavy roof fell, burying several men in the ruins. Two men are believed to be fatally injured." Another paper ended the story by stating, "The picture belongs to C. L. Willoughby of Chicago."

While it appears the third version of Philippoteaux's *Battle of Gettysburg* cyclorama was destroyed in the building collapse, there were several

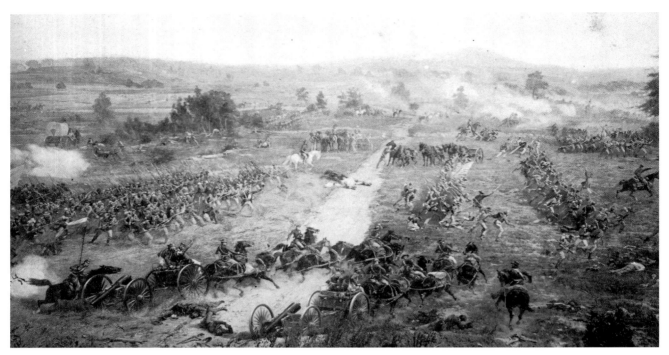

Scene from *Battle of Gettysburg* Cyclorama, Philadelphia version, looking south; by Newell & Son. *SBC*

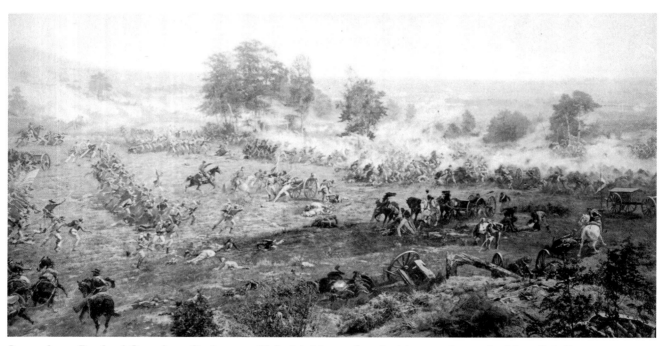

Scene from *Battle of Gettysburg* Cyclorama, Philadelphia version, looking southwest; by Newell & Son. *SBC*

references to Philippoteaux's Gettysburg cycloramas in later years that could not be any of the other three (they were still in their original locations). A thorough search of St. Louis newspapers after March 1889 did not turn up evidence that the painting ever arrived in that city. By August 12, demolition of the rotunda in St. Louis began in order to make way for construction of a new theater on the site.

The next possible location for the Philadelphia version seems to be Baltimore. On September 4, 1889, a *Battle of Gettysburg* cyclorama reported to have been created by Philippoteaux opened in a rotunda at Maryland and Mount Royal avenues near Charles Street. The souvenir program accompanying the

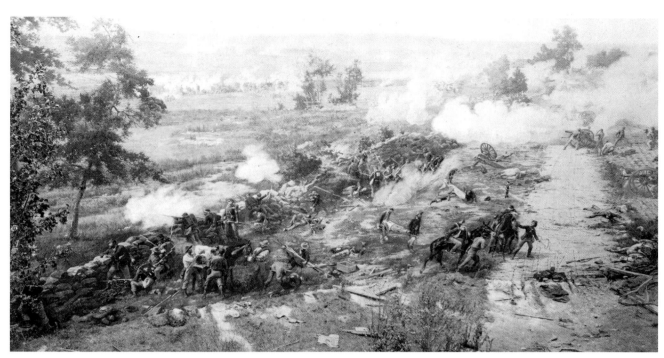

Scene from *Battle of Gettysburg* Cyclorama, Philadelphia version, looking north; by Newell & Son. SBC

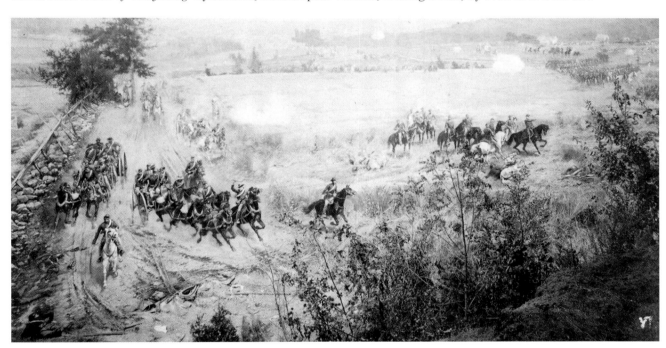

Scene from *Battle of Gettysburg* Cyclorama, Philadelphia version, looking east; by Newell & Son. SBC

exhibition is identical to the ones used in New York City (opening in 1886 and discussed in the next section) and Washington, D.C. They were all published by the Brooklyn *Eagle* newspaper and use the same key to the painting. This would not be unusual since all of the stock companies associated with the Philippoteaux venues were set up by the same people and would use the same resources to produce the material. Even the souvenir paper flags advertising the Gettysburg exhibitions in Boston, Philadelphia, and Baltimore were the same. These types of similarities seem to hold value as a way to sort the reproductions from the originals. The program covers and souvenirs were different than those in Philippoteaux venues.

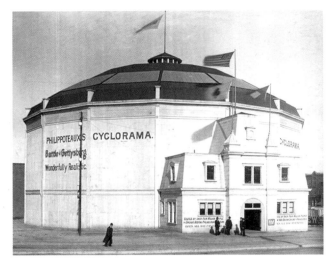

The rotunda in Cincinnati at Seventh & Elm streets. *NPS*

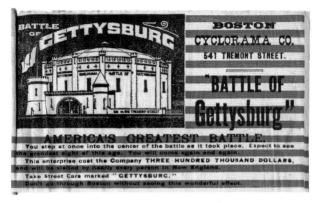

Souvenir paper flag for the *Battle of Gettysburg* Cyclorama in Boston. *SBC*

The Gettysburg cyclorama in Baltimore closed August 2, 1891. From this point, the whereabouts of the Philadelphia version of the cyclorama is unclear. Its next possible appearance, although difficult to prove definitively as yet, may be in Buffalo, New York. Once again, a claim was made that it was a Philippoteaux creation. This claim, made by William Wehner, trustee of the Buffalo company and owner of a Milwaukee panorama studio, is significant because, as you will see in the next section's discussion on replicas and buckeyes, Wehner was very critical of the other companies producing Gettysburg cycloramas and would not have exhibited one made by them. In addition, the Buffalo firm had a business relationship

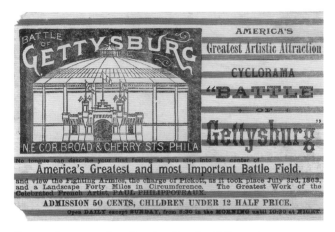

Souvenir paper flag for the *Battle of Gettysburg* Cyclorama in Philadelphia. *SBC*

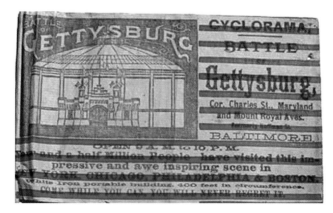

Souvenir paper flag for the *Battle of Gettysburg* Cyclorama in Baltimore. *SBC*

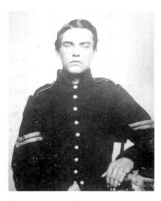

Charles A. Hale, 5th New Hampshire Volunteer Infantry, 1861–1865. *NPS*

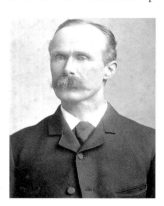

Charles A. Hale, Battlefield Guide and Lecturer for the Gettysburg cyclorama (Philadelphia version). *NPS*

with Philippoteaux, who had produced a Crucifixion and Niagara Falls cyclorama for the company.

After about two years in Buffalo, the painting was placed on exhibit in Niagara Falls, where it was destroyed in a fire in January 1894.

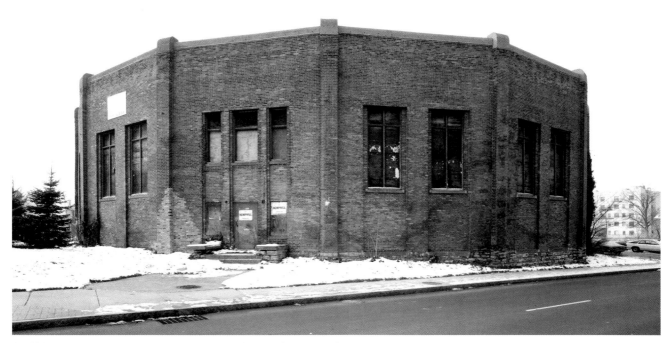

Buffalo cyclorama rotunda on Franklin Street; fell into disrepair until taken over by WPA (Works Progress Administration) in 1937. *LOC*

The Battle of Gettysburg Cyclorama:
New York Version

The fourth and final version of Paul Philippoteaux's *Battle of Gettysburg* cyclorama was also created in the Mott Haven studio. It opened October 15, 1886, to an audience of invited guests who attended the sneak preview at the rotunda at City Hall Square in Brooklyn. The Brooklyn *Eagle*, on October 2, reported:

When the Old Dutch Church property was purchased last spring and ground was broken for the new structure, few people had any conception of the magnitude of the enterprise. As the work progressed and the large iron structure gradually grew into shape...a better idea of what it was to be was gained....The canvas is the largest ever painted for a cyclorama. It is 50 feet wide and over 400 feet in length, presenting over 20,000 square feet of surface. It was painted by Mr. Philippoteaux and assistants at his big cylindrical studio on One Hundred and Forty Ninth Street, New York. It weighs over four tons and was delivered at the building rolled on a huge iron cylinder....To transport it from the Harlem studio, one of the large trucks upon which the Brooklyn Bridge cars were delivered was used. To get it into place within the building required the work of twenty men for five days.

The paper covered the opening event in its October 16 edition: "At 2 o'clock yesterday afternoon the doors of the building...were thrown open. The proprietors, Mr. Edward Brandus and Mons. Philippoteaux...issued a large number of personal invitations to city officials, members of the press and prominent society people....[N]early 2,000 persons visited the exhibition between the hours of 2 and 5 P.M."

As in previous openings, a number of influential officers were in attendance. Generals Doubleday, Sickles, Slocum, Carr, and Graham (all veterans of the battle) and numerous commanders of the Grand Army

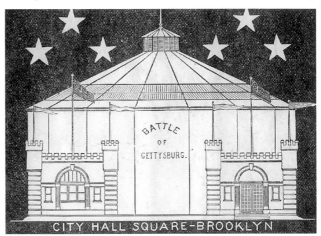

Woodcut from souvenir program illustrating the Brooklyn rotunda. *SBC*

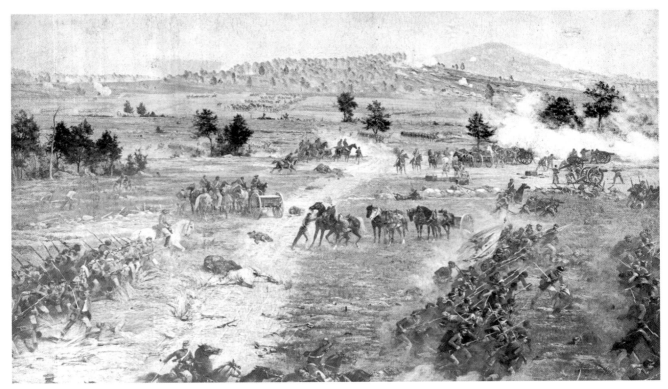

Scene from *Battle of Gettysburg* Cyclorama, New York version, looking south; by S. Duryea. *SBC*

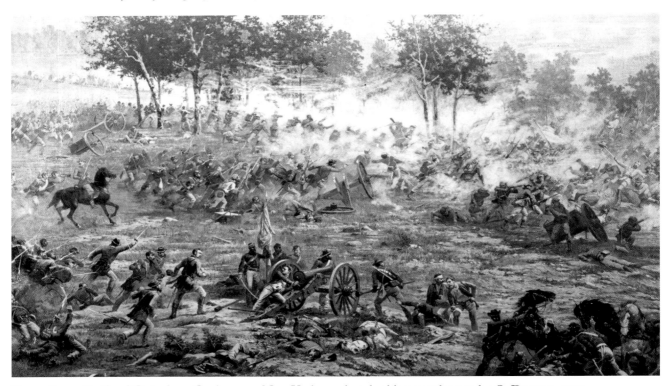

Scene from *Battle of Gettysburg* Cyclorama, New York version, looking southwest; by S. Duryea. *SBC*

veterans' posts of Brooklyn were on hand to admire, critique, and celebrate the work. The newspaper article described another veteran in attendance that day:

"Captain John F. Chase, the battle scarred veteran, who has been retained as lecturer at the cyclorama, was arrayed in a neat uniform and delivered his description

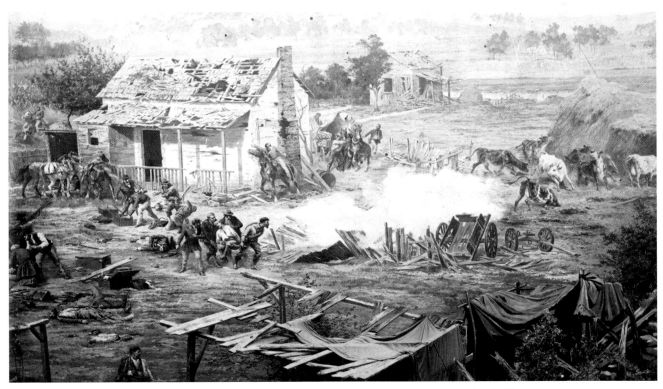

Scene from *Battle of Gettysburg* Cyclorama, New York version, looking northeast; by S. Duryea. *SBC*

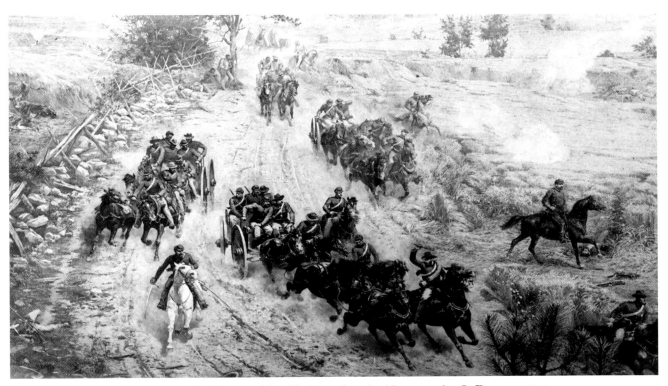

Scene from *Battle of Gettysburg* Cyclorama, New York version, looking east; by S. Duryea. *SBC*

of the great painting in a very credible manner. It was his first appearance before the public as a speaker, but his heart was in his work and he described the points of the painting in an interesting and entertaining manner."

Captain Chase served in the Battle of Gettysburg with the 5th Maine Battery which was positioned on

Steven's Knoll. On July 2, during the attack against Cemetery Hill, Chase received a devastating wound which cost him his right arm and left eye. He bore an additional 48 wounds from shrapnel and lay on the battlefield for two days before being picked up by a burial detail. His post-war business card shows him wearing the Medal of Honor he received for his heroic service in the Battle of Chancellorsville.

As with the other versions of the Gettysburg cyclorama, souvenir programs were available for purchase and contained much the same material, including the fold-out key to the painting. This key, like the one for Philadelphia's painting, closely matched the painting.

Research indicates that this painting, unlike the first three, was not intended to be permanently displayed. Advertisements during the opening weeks of exhibition clearly state the cyclorama was to be in Brooklyn for a limited time. By August of the following year, its brief run was ending and plans to move it to Union Square in New York City were underway.

Just before Christmas in 1887, the rotunda in Union Square, at 4th Avenue and 19th Street, opened its doors to the public with a special preview for dignitaries, officers, and veterans of the late war. The souvenir program resembled the one used in Brooklyn right down to the pen and ink drawing on the front cover. It was reprinted periodically, and only the advertisements and the color of the cover changed,

with one notable exception. During the painting's run in Union Square, a veterans' event in the city, celebrating the 25th anniversary of the Battle of Gettysburg, inspired the management to produce a special cover bearing a beautiful colored lithograph by Forbes Company of Boston and New York. Portraits of Generals Meade, Pickett, Lee, and Hancock appeared beside Union and Confederate flags, along with other symbols of commemoration and remembrance. Anyone visiting the cyclorama on July 1, 2 or 3, 1888 would have received this special souvenir. The late 1880s was a time for many reunions among the veterans, a fact that was reflected in this special cover.

The painting remained on display in Union Square until November 1891. Shortly after it was withdrawn, a non-Philippoteaux *Gettysburg* cyclorama painting was shown at Madison Avenue and 59th Streets. A number of non-Philippoteaux copies were known to have existed, and were referred to in contemporary literature as "buckeyes." These will be

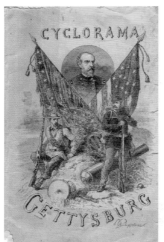

Front cover of the souvenir program for the Gettysburg cyclorama in Brooklyn. *SBC*

Section of the New York key showing area of hospital scene and Meade's Headquarters. *SBC*

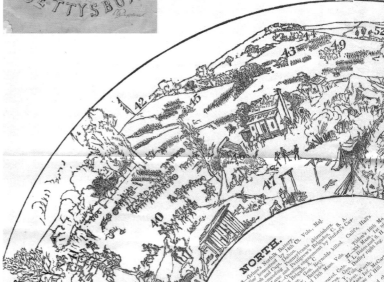

Above left: Business card for wounded Civil War veteran John F. Chase, lecturer and manager of the Gettysburg cyclorama (New York version). *SBC*

Above right: John F. Chase as manager of the New York *Battle of Gettysburg* cyclorama. *NPS*

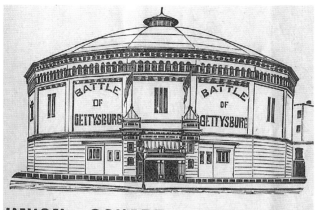

UNION · SQUARE, · NEW · YORK

Illustration of rotunda at Union Square, 4th Avenue & 19th Street, New York City. *SBC*

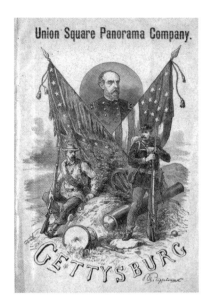

Front cover of the souvenir program for the Gettysburg cyclorama in Union Square. *SBC*

Special anniversary cover for Gettysburg cyclorama during exhibition on July 1-3, 1888. *SBC*

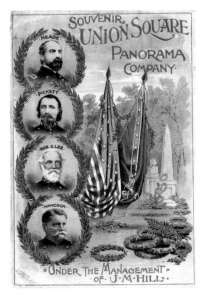

Front cover of the souvenir program for the Gettysburg cyclorama in Washington, DC. *SBC*

discussed in more detail later in this chapter. New York City had yet a third rotunda where other Civil War battle and religious cycloramas were exhibited.

In 1892, the New York version of the *Battle of Gettysburg* cyclorama could be found in Washington D.C., in a rotunda at the corner of 15th Street and Ohio Avenue known as the Bull Run building, since that was the first cyclorama exhibited there. The souvenir program for the Gettysburg cyclorama in Washington was identical to the one used for the Union Square exhibition except for the cover and first page, which were changed to reflect this new location. It was also published by the Brooklyn *Eagle* newspaper, just as the programs were for the two New York locations.

The painting remained in Washington until July, 1894. By this time, nearly a dozen non-Philippoteaux Gettysburg cycloramas produced in other studios were advertised in cities around the country, making it difficult to track the original Philippoteaux paintings and their locations.

However, John Chase, the lecturer for the New York version, provided a clue to help track this particular painting. There were a number of venues throughout the rest of the decade that mention John Chase in attendance as lecturer, manager, proprietor, or owner. He accompanied the New York painting to a number of gatherings of the Grand Army of the Republic (an organization made up of honorably discharged Union veterans) in Harrisburg and Gettysburg, Pennsylvania, in 1894. Between late 1894 and 1897, he took it to county fairs, and state and national expos in Pennsylvania, Ohio, Georgia, and

One of two framed pieces of the New York version, *Battle of Gettysburg* Cyclorama in GNMP collections. *BD*

Tennessee. Many of these venues were held in large tents. It appears that he actually acquired ownership of the work in 1894 when it went into receivership for outstanding debt, and continued to show it until 1898. That year Chase was living in Florida, which became the gathering point for United States troops heading for Cuba during the Spanish American War. The Tampa *Tribune* dated May 3, 1898, reported, "Capt. J. F. Chase of St. Petersburg, the battle scarred veteran of the late war, will place on exhibition at the camp of the United States troops, his magnificent cyclorama of the Battle of Gettysburg. This is something worth seeing, and will no doubt prove quite interesting to the soldiers."

Physical evidence proves that the New York version of the *Battle of Gettysburg* cyclorama was eventually cut into pieces that were framed and distributed to veterans' posts to display in their meeting halls. Several of these pieces are in the Gettysburg National Military Park collections and in private hands. It seems like a fitting end to this magnificent painting that it was owned by Civil War veterans.

The "Buckeyes" and Other Non-Philippoteaux Gettysburg Cycloramas

There were two distinct classes of non-Philippoteaux, Battle of Gettysburg cycloramas produced beginning in 1885. One class includes unauthorized, but high-quality copies, which would have been hard to distinguish from the four originals. A number of these were made in studios in Chicago associated with H. H. Gross.

The other class included copies that were quite inferior in artistic style. Some of these were crude and had the appearance of being made by house painters rather than skilled artists. These were referred to as "buckeyes" in the late 1800s and early 1900s. The Dictionary of American Regional English defines the term as, "One whose work is of low quality or the inferior work itself. It is based on the 'buckeye' being an inferior tree, useless for building, fencing and even fuel. [The term] was first used for bad lawyers and doctors…and then for a painter who painted for department stores and cheap picture shops and later for cheap oil paintings made for auctions." The term is no longer used. Hence, while all unauthorized copies were reproductions, they were clearly not all created equal.

Such was the cyclorama craze in America that, even before the final two of the four *Battle of Gettysburg* cycloramas by Paul Philippoteaux were completed, the Gross & Reed Panorama Company located in Englewood (now part of Chicago) was making reproductions of them. Some of the artists employed by Gross and his associates had formerly been employed by Philippoteaux himself, and had worked on one or more of his Gettysburg paintings. With intimate knowledge of Philippoteaux's work, and possibly possession of a set of master drawings, it would not have been difficult to reproduce excellent copies of the originals. For three years, beginning in September 1885, the company produced as many as ten copies of the popular work as well as copies of Philippoteaux's *Crucifixion* panorama. Between 1886 and 1890, the cities of Minneapolis and St. Paul; Milwaukee; Omaha; Peoria, Illinois; Denver; Portland; Detroit; Pittsburgh; and Kansas City, Missouri all exhibited a *Battle of Gettysburg* cyclorama not authorized by Philippoteaux.

A newspaper article attributed to the Chicago *Herald*, titled "The Extensive and Profitable 'Buckeye' Panorama Business" and dated October 3, 1886, reported:

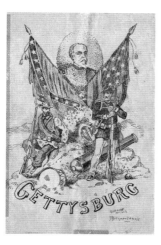 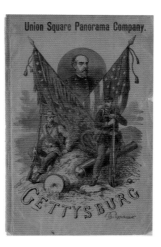

Front cover of the souvenir program for the Gettysburg cyclorama in St. Louis in 1904. *SBC*

Front cover of the souvenir program for the Gettysburg cyclorama in Union Square. *SBC*

Chicago is the center of the panorama business…[and] is a more extensive one than most people imagine it to be. There are several panorama factories in town, or near by….[P]ainters are always at work upon panoramas—not creations, but copies of works already known to fame. Gettysburg is the favorite and it is estimated that there are now in existence something like two dozen copies of this famous panorama. The copies are known to the trade as 'buckeyes,' though the origin of the term in this application is as yet a mystery. These 'buckeyes' cost all the way from $2,000 to $20,000 apiece, and some of them are fine copies of the original….Some of the first 'buckeyes' manufactured were turned out by house and sign painters, and sorry jobs they made of them, too.

The article continued:

A queer feature of the business is that the painters of these 'buckeyes' pay the proprietors of the originals nothing for the privilege of copying. Photographs are on sale of all sections save one of the Gettysburg panoramas, the exception being the view of the wheat field. The copiers buy these photographs, slyly take notes as to the coloring while pretending to look at the canvas, and in the same manner make hasty and crude sketches of the wheat field.

Although the newspaper piece would lead us to believe that the copies were fraudulent and noticeably inferior, in fact some of the reproductions were so good

they were often thought to be the originals and there were no copyright laws protecting art work at that time. Use of the term "buckeye" in the article was intended to imply that the Englewood studio's output was grossly inferior and unworthy of patronage. As it turns out, the appearance of the article was a deliberate attempt to slander the Gross & Reed studio by another panorama company in Milwaukee. The visiting public appears not to have shared the article's sentiment, as the reproduction cycloramas were almost as popular as the originals. The animosity between the studios continued for some time, and involved critical newspaper ads, articles, rebuttals, and handbills distributed outside exhibition halls. Cyclorama exhibitions were primarily commercial enterprises, and the competition for the attention (and money) of the viewing public was fierce.

While Paul Philippoteaux did not approve of his work being copied without his approval, he did not take legal steps to stop it. This may have been due to the fact that copyright laws at the time were clear about protecting the rights of authors and mapmakers; however, they were not clear about the ownership rights of artists until the late 1880s. Associates of Philippoteaux shared his dismay. The New York *Herald-Tribune* published an article in March 1888 titled "Philippoteaux's Work Unfairly Copied" which stated, "The management of the Cyclorama of the Battle of Gettysburg is much annoyed over the amount of plagiarism to which Philippoteaux's masterpiece is subjected. Already a number of more or less badly executed copies of the painting have been made….The fact that the paintings are plagiarisms…is shown by the repetition of certain characteristic features and by the general arrangement and grouping. The management is almost daily compelled to interfere with some presumptuous artist taking sketches of the painting."

Later, advertisements for some of the reproductions began to use the word "replica" to describe them, often including praise for the original work. For the Gettysburg cyclorama shown at the St. Louis World's Fair in 1904, the cover of the souvenir program was clearly copied from the original New York cover, including Philippoteaux's signature in the lower right corner. A closer look reveals additional words above the signature which read "K. Moore after Philippoteaux."

If the studios sometimes seemed unclear about the sources of their many inspired works, the promoters of these massive enterprises were often deliberately so.

The Gettysburg Cyclorama: The Turning Point of the Civil War on Canvas

Around 1890, promoter Emmett W. McConnell, known as the "Panorama King," began to show a number of battle cycloramas, including several of Gettysburg, many of which were produced in Chicago and Milwaukee studios. He was an ambitious entrepreneur with a flair for marketing, often making statements that were ambiguous about the origins of his wares.

McConnell claimed to have owned the original Philippoteaux *Gettysburg* cyclorama made for Chicago, which led to decades of confusion about its ultimate disposition. As recently as 2007, the Gettysburg cyclorama stored at Wake Forest University was thought to be that painting. McConnell exhibited it at several state fairs and expos including the Philadelphia Sesquicentennial in 1926 and the Dallas State Fair in 1930. Its final venues were the Chicago World's Fair in 1933 and the Texas Centennial Expo in 1937. It was then packed up and placed in a warehouse in Chicago. He later stated in an interview that the original Gettysburg

was destroyed in a fire and the one he exhibited beginning in 1895 was a Philippoteaux replacement. In fact, it was created by E. J. Austen, an artist who worked with Philippoteaux on one or more of the originals before moving to Chicago to work in the studio of Gross & Reed. It was there that he created the Gettysburg cyclorama shown at the 1933 Chicago Expo. The painting remained in storage in Chicago until North Carolina artist Joe King discovered and purchased it in 1965. Upon King's death, the painting was willed to Wake Forest University and remained under their ownership until it was sold to investors in 2007. The true origins of the painting were discovered during the conservation of the Boston version of the Gettysburg cyclorama. Photographic evidence not only showed that it was not the original Chicago painting, but also that the quality of some of the other reproductions was good enough to be taken for the original. Cycloramas truly were popular forms of mass entertainment in the decade of the 1880s

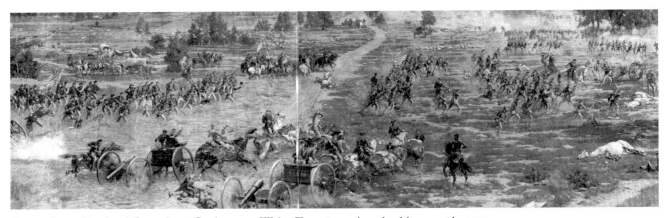

Scene from *Battle of Gettysburg* Cyclorama, Wake Forest version, looking south. NPS

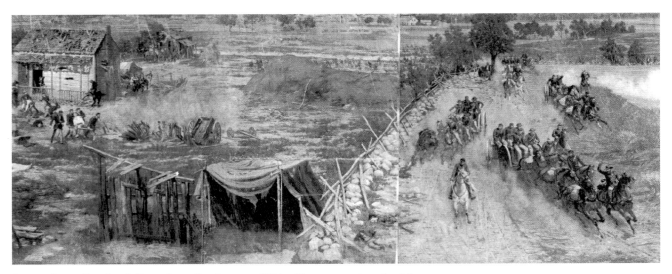

Scene from *Battle of Gettysburg* Cyclorama, Wake Forest version, looking east. NPS

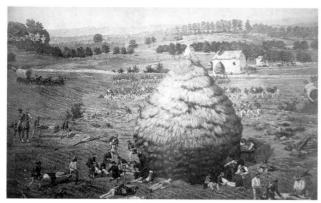

Scene from *Battle of Gettysburg* Cyclorama, Gross & Reed (Minneapolis) version, looking northeast. *SBC*

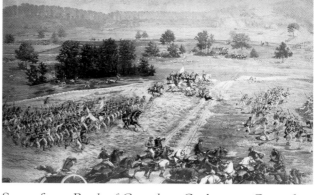

Scene from *Battle of Gettysburg* Cyclorama, Gross & Reed (Minneapolis) version, looking south. *SBC*

Close-up of Philippoteaux's signature and the signature of the man who copied it. *SBC*

but their popularity waned almost as quickly as it had risen, due in part to the invention of the motion picture camera. Once the big paintings were no longer shown in permanent rotundas, they were taken on the road to more or less temporary venues around the country. By the end of the century, they began to disappear at a rapid rate, falling victim to constant handling, poor storage conditions, and general wear and tear. Those that weren't lost to windstorms, fires, and building failures were recycled as theater backdrops or left to rot. Only the *Battle of Atlanta*, made in Milwaukee, the second *Battle of Gettysburg* by Philippoteaux, now at Gettysburg National Military Park, and the Wake Forest reproduction are known to have survived.

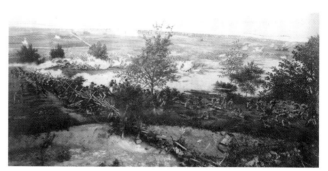

Scene from *Battle of Gettysburg* Cyclorama, unknown version, looking west. *SBC*

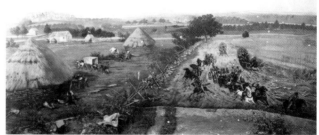

Scene from *Battle of Gettysburg* Cyclorama, unknown version, looking east. *SBC*

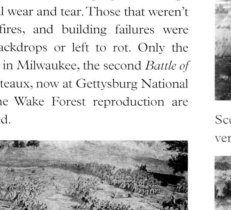

Scene from *Battle of Gettysburg* Cyclorama, Gross & Reed (Sydney & Melbourne) version, looking south. *SBC*

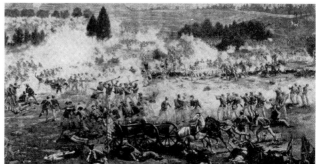

Scene from *Battle of Gettysburg* Cyclorama, Gross & Reed (Sydney & Melbourne) version, looking southwest. *SBC*

The Battle of Gettysburg *Cyclorama at Gettysburg – Tidbits*

THE *BATTLE OF GETTYSBURG* cyclorama, on exhibit today at the Gettysburg National Military Park, is the version that opened in Boston in 1884. Since it is the only one of the original four that survived, it is the one most studied for its artistic style and content. Much of the historical information depicted on the canvas will be presented later in this book. This chapter covers some interesting things that appear in the painting but are not part of the July 3 battle story. Rather, they are part of the story of the painting itself.

Artists' Portraits

As mentioned in Chapter 2, a very interesting feature of the *Battle of Gettysburg* cyclorama is the distinct way it was signed by the artist. Instead of his signature placed somewhere on the canvas, Paul Philippoteaux painted his likeness into the scene itself. This custom, sometimes referred to as "inserted self portrait," was not uncommon in Philippoteaux's day. It has been traced back as far as ancient Egypt but appeared with greater frequency during the Middle Ages and the Renaissance period. Portraits of specific individuals, including the artist, were often placed toward the edges

of the work and apart from others in the main body of the composition. The real people upon whom the portraits were based may have simply been serving as models, or they may have been deliberately placed to document their role in creating the work. Philippoteaux stands just to the right of the area representing the Bloody Angle, at the base of a large pine tree. He sports a distinct red beard and holds a sword across his thigh.

At least one, and possibly several, other artists appear in the painting. Salvador Mège, a landscape painter on many of Philippoteaux's American cycloramas, appears in the foreground of the painting

Above: Artist Salvador Mège in cyclorama painting. *BD*

Artist Paul Philippoteaux in cyclorama painting as his signature. *BD*

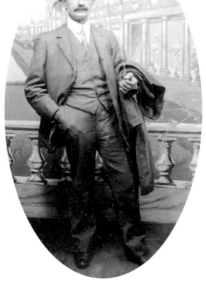

Left: Salvador Mège in San Francisco in 1915, setting up a non-Philippoteaux *Gettysburg* cyclorama for the Pan-Pacific Expo.

Francis Hegoburu

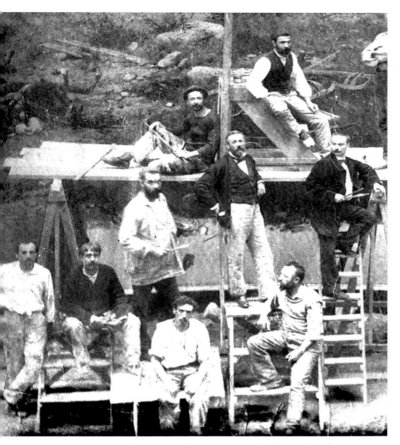

Section of photo of the team of artists showing Philippoteaux on the far right (on tall ladder), Mège in front right below Philippoteaux, and another artist (second from left) who may also appear in painting.
Francis Hegoburu

in the section where the viewer looks toward Seminary Ridge. He is wearing a white shirt and his arm is in a sling (he appears close to the action while the battle is still underway, making it unlikely that he would already have had his wounds treated). He faces the viewer, seemingly unengaged in the activity depicted behind him. We were able to identify Mège when our research uncovered a portrait which he posed for 30 years later in San Francisco. At the time he was working for a company setting up a non-Philippoteaux *Gettysburg* cyclorama for the Pan-Pacific Expo. He is also shown in the right foreground of a photograph of cyclorama artists, sitting on a short ladder near Philippoteaux's right leg. He is gazing to his right. In the same group photograph, the man second from the left in the dark sweater sitting on a short ladder may also appear in the painting. Unfortunately we do not know the name of this artist. His boyish haircut, a highly unusual style

during the 1860s and only slightly more common in the 1880s, can be seen on the figure near Mège's left leg in the cyclorama painting. He is lying on the ground clutching his chest. It is possible the other two figures near Mège in this area of the painting are artists as well.

Other Non-Battle-Related Portraits

When artist Paul Philippoteaux, with one or more assistants, came to Gettysburg to study battlefield terrain and sketch the landscape, they crossed paths with Peter and Robert Bird (or Byrd, as it was sometimes spelled). The brothers were residents of Romulus, Michigan, and veterans of the 24th Michigan Voluntary Infantry as part of the famous Iron Brigade. The brothers may have been in Gettysburg for a reunion or just visiting the field where many of their comrades paid the ultimate sacrifice. Whatever the reason for their presence there in May 1882, they were interviewed and sketched by Philippoteaux or one of his assistants, leading to their inclusion in all four of the *Battle of Gettysburg* Cycloramas. The pair is shown in the area between the Copse of Trees and the Angle, bearing the wounds they received in the fighting on July 1. On the right is Peter, bearded, with a leg wound. Robert is shown on the left, his arm in a sling and his

Robert and Peter Bird as they appear in the Gettysburg cyclorama. *BD*

Peter Bird circa 1912. *Ron Bird*

head bandaged. They were 21 and 18 years old at the time of the battle but appear in the painting as they might have looked when they met Philippoteaux 19 years later. According to Ron Bird, great grandnephew, a copy of the sketch of the brothers was given to Robert, who hung it on his parlor wall for many years. Peter Bird is shown here as he appeared later in life. As is the case with Salvador Mège, the brothers are depicted in the painting facing the viewer, seemingly uninvolved in the battle raging behind them, with their wounds already dressed although the battle is still at its peak.

As the viewer faces the hospital scene on the east side of Cemetery Ridge, a figure can be observed giving aid to a wounded soldier leaning against the straw stack to the left of the white farmhouse. He is wearing a brown suit and he is facing the wounded

Possibly President Lincoln, according to oral history. *BD*

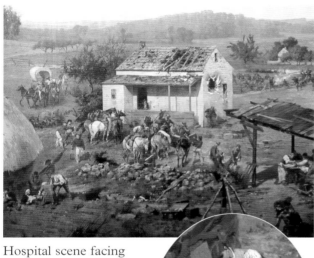

Hospital scene facing east. *SBC*

Figure of a surgeon, possibly Dr. Study. *SBC*

Figure of a surgeon, possibly Dr. Study or the doctor who identified the other figure as Study. *SBC*

man. Another surgeon can be seen nearby, operating on a wounded man's leg under a crude wooden lean-to. Oral history identifies one of the figures as Dr. David Study, a 60-year-old Gettysburg physician who lived on Cemetery Hill at the time of the battle. As the battle raged and the casualties mounted, he gave freely of his time to aid the wounded. His identification in the painting was supposedly made in 1913 by a man who claimed to be the surgeon under the lean-to. There is no hard evidence as to which surgeon is Dr. Study, or who the surgeon under the lean-to is. The man near the haystack is wearing civilian clothes but his partial baldness and white hair make him appear older than 60. Since the surgeon who claimed to be the one under the lean-to never identified himself by name, we will probably never know for certain if he was actually there or knew of Dr. Study's whereabouts during the battle.

Dr. Study's presence in the hospital scene is logical—he was the brother of Lydia Leister, the woman who owned the white house that served as Meade's headquarters. Lydia herself may have been the original source for the information that Study was present at her farm during the charge.

Another piece of oral history, which has come down through a number of people associated with the painting, suggests that a likeness of President Abraham Lincoln appears in the painting near the well in the hospital scene. Just to the left of the lean-to and walking toward it, two soldiers are shown bearing a wounded man, one holding the man under the shoulders and the

other grasping his legs behind the knees. The face of the pale wounded man bears a striking resemblance to Abraham Lincoln, being carried in a fashion similar to how he was borne to the Petersen House on the night of his assassination. Although no documentation has yet been found that Philippoteaux did indeed paint Lincoln into the Gettysburg cyclorama, the image has been pointed out for many years.

Straw stacks

The large straw stacks which can be prominently seen in the eastern view of the painting near the hospital scene are often criticized as being entirely European in style. In fact, the farmlands of Adams County were settled by German and Scotch-Irish immigrants who would have brought their traditional stacking methods with them from their homelands. A number of similar straw stacks in the immediate vicinity have been documented through contemporary photographs. Tipton images of the Leister farm (General Meade's Headquarters), circa 1867, and the Nathaniel Lightner farm (General Slocum's Headquarters), circa 1870s, clearly show this style of straw stack was in use during the battle era.

The stacks in the painting differ somewhat from those in the photographs because of the neatly trimmed sides in the former. This may be explained by looking closely at the ground to the right of the stack nearest to the fence. Several soldiers can be seen tying straw into bundles, possibly for use as bedding by those caring for the wounded. Also, it was a common practice to fence livestock into the same enclosures holding the straw stacks, which allowed the animals to eat away at the lower portions of them. While the stacks in the painting may appear to be a little too neat and tidy, they do represent a reasonable impression of reality.

The Leister Barn circa 1867, showing similar straw stacks. *SBC*

Nathaniel Lightner Farm on Baltimore Pike, circa 1870s. *SBC*

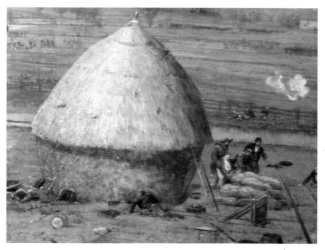

Straw stack to the right of Meade's Headquarters. Note bundles of straw on the ground to the right. *BD*

General scene to the east showing "European" straw stacks. *BD*

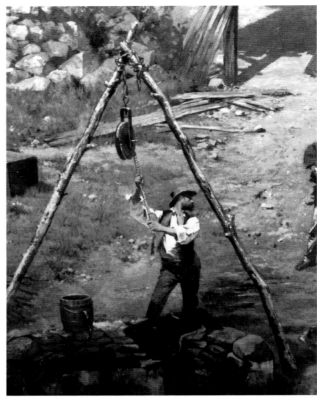

Signal flags on Little Round Top. *BD*

Signal station on Cemetery Hill. *BD*

Signal Flags

The U. S. Army Signal Corps was established on June 21, 1860, and throughout the Civil War it developed into an effective visual communications system using flags and torches. Signal flags were used with good effect during the battle of Gettysburg. Two signal stations are accurately shown in the cyclorama painting, on Little Round Top and Cemetery Hill, attesting to the degree of detail achieved by Philippoteaux and his team.

Well Tripod and Rope

For nearly the entire time the painting was exhibited in Gettysburg (1913 to 2008), visitors looking toward the hospital scene saw a well with a two-legged tripod and rope that didn't reach into the water. At last, through the

Well before restoration completed – no tripod leg or rope. *SBC*

Rope as it integrates with canvas. *SBC*

Well after restoration completed. *SBC*

recent conservation and restoration process, these and other visual oddities have been corrected. Real pieces of rope were attached to the painting in order to extend the painted ropes into the well. The third leg of the tripod and the outer half of the well are part of the newly reconstructed diorama. Looking at the well from the viewing platform, the viewer now sees a seamless image, so realistic it is almost impossible to tell which part of the scene is real. It is just one example of the wonderful illusion a cyclorama is capable of if properly presented.

Fences

A significant part of the story of the last day of battle at Gettysburg involves the obstructive nature of the post and rail fences bordering the Emmitsburg Road, and how they caused a large number of Confederates to fall trying to get beyond them. Yet the painting shows no such fence on either side of the road west of the Angle, although some do appear much farther north. A study of William Tipton's 1882 image looking west from the

Angle to Seminary Ridge clearly shows the fences just as they are described by veterans who participated in the charge. Philippoteaux expended considerable effort in getting the details of the terrain correct by interviewing those who were present. Knowing he had eyewitness accounts and high-quality images to work from, not to mention his own on-site sketches, it is puzzling that the artist omitted this fundamental piece of the visual story.

Although not nearly as important, but nonetheless just as interesting, is the section of fence in the background of the landscape looking toward the east, just to the right of the hospital scene. Representing the provost guard as they wait for prisoners to be brought to this area behind the Union line, the soldiers are massed in significant numbers until the viewer's eye reaches the left end of the fence line. No guards can be seen, at least not from the vantage point of the viewer. Upon very close inspection, the outline of a half-dozen soldiers can be

Emmitsburg Road west of the Angle showing absent post-and-rail fences. *SBC*

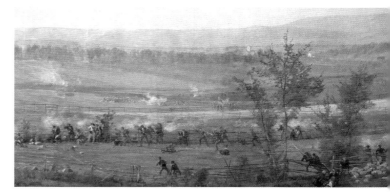

Area north and west of the Angle showing post-and-rail fences. *SBC*

1882 Tipton photograph showing fences along the Emmitsburg Road west of the Angle. *SBC*

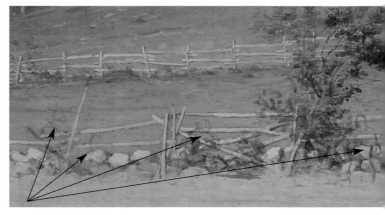

Area to the right of the hospital scene and stone wall, showing unpainted outlines of soldiers along post-and-rail fence. *SBC*

discerned. The sketched figures were never painted in by the artists. Either the paint layer is sufficiently thin to allow the lines to show through, or the graphite pencil marks used to sketch the projected images onto the blank canvas have bled through over the years. Such ghost-like images are known as pentimenti.

"Ins" and "Outs" of the Tipton Photographs

Tipton's 1882 photographs provided remarkable detail to assist Philippoteaux in the creation of the *Battle of Gettysburg* cyclorama. However, they were taken nineteen years after the battle, and therefore required some eyewitness interpretation to note post-battle changes in the landscape. Some of these interpretative updates seemingly did not occur as there are things left out of the painting and others left in that make for interesting discussions among historians today.

There were several landmarks, like the fences along the Emmitsburg Road (mentioned previously) that appear in the Tipton photographs but were not included in the painting. Unlike the fences, most, but not all, were correctly omitted. In 1869, a resort hotel was built between Herr's and McPherson's ridges. The

Katalysine Springs Hotel was four stories high with an additional 2½ story tower. In the Tipton photograph facing west, it can be seen in the distant landscape above the smaller of the two dark juniper trees. Philippoteaux did place many distant landmarks in the

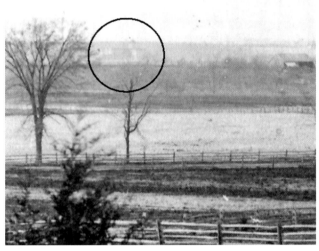

Close-up of Tipton 1882 image looking northwest; Springs Hotel visible on the distant horizon. *SBC*

Katalysine Springs Hotel, built in 1867-68. *SBC*

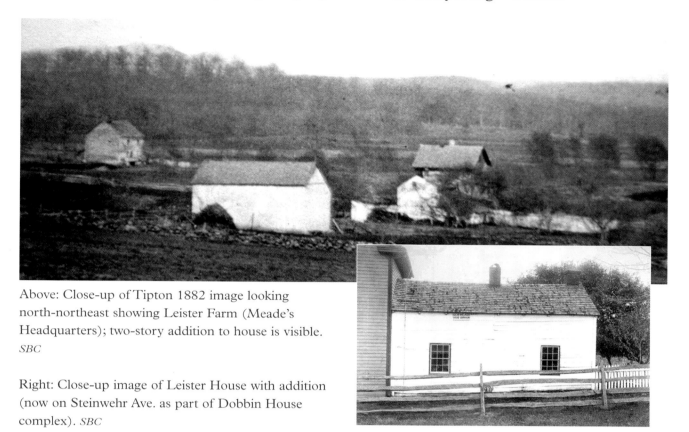

Above: Close-up of Tipton 1882 image looking north-northeast showing Leister Farm (Meade's Headquarters); two-story addition to house is visible. *SBC*

Right: Close-up image of Leister House with addition (now on Steinwehr Ave. as part of Dobbin House complex). *SBC*

painting, including ones that may not have been in existence in 1863, but this one appears to be correctly omitted. There are two interesting possibilities for the omission—besides the obvious one—that he knew it wasn't there. He painted a large leafy tree in roughly the spot on the canvas where the building would have been visible, so there may simply have been no reason to include it or, it actually was included and was lost with the 14 feet of canvas covering this area which was destroyed before the painting came to Gettysburg. Souvenir images of the painting taken in 1886 do not overlap to form a continuous scene so there are visual gaps, making it impossible to verify the inclusion or omission of the Springs Hotel.

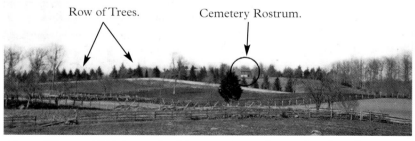

Row of Trees. Cemetery Rostrum.

Above: Tipton 1882 image looking north-northeast showing Cemetery Hill, rostrum in National Cemetery and row of pine trees along Cemetery boundary planted in 1870s. *SBC*

Above right: Rostrum in National Cemetery, built in 1879 and visible in 1882 Tipton image. *SBC*

Right: Row of pine trees visible in painting but rostrum correctly omitted. *BD*

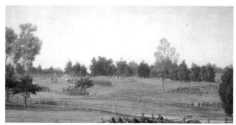

In the view looking due east in Tipton's photograph, the barn and house of Lydia Leister are clearly visible. But the house does not look as it did in 1863. Sometime in the late 1870s or early 1880s, a two-story addition was built onto the eastern end of the historical structure. Tipton captured it before it was removed and rolled on logs to Steinwehr Avenue where it serves today as the Gettystown Inn Bed & Breakfast (part of the Dobbin House complex). In all four versions of the painting, the artist correctly depicts the Leister house with only one story.

In the Tipton image looking northeast toward Cemetery Hill, the photographer captured the 1879 rostrum in the National Cemetery but the artist

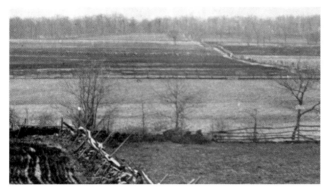

Close-up of Tipton 1882 image looking west from the Angle; farm road visible in mid-ground connecting Emmitsburg Road to Seminary Ridge and beyond. *SBC*

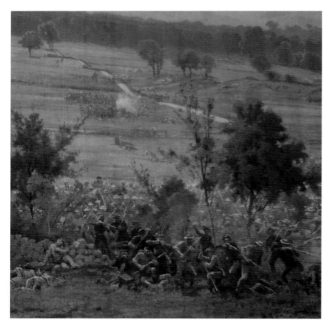

The same road as it appears in painting; it does not appear on maps representing the 1860s landscape. *BD*

correctly omitted it. However, he did not omit the neat row of trees bordering the Taneytown Road which were part of the 1872 landscaping of the cemetery.

In Tipton's photograph looking west, just to the right of the rail and rider fence that helps form the famous Angle in the Union line, the viewer can see a farm lane connecting the Emmitsburg Road to something on or beyond Seminary Ridge. It appears too far away from the Bliss farm to have been associated with it. It is possible that it connected the Pitzer farm on the west side of Seminary Ridge to the main road. Nevertheless, it does not appear in any of the maps produced by military personnel in the decade following the battle but it does appear in the Gettysburg cyclorama.

The Brian farm near Zeigler's Grove on the southwest slope of Cemetery Hill figured prominently in the battle story. It appears in Tipton's photograph, in the view facing north, looking much as it did in 1863. However, in the painting, the barn and small outbuilding are shown on the west side of the road but the house on the east side is missing. Only the orchard is there. It is possible that the Brian house was obscured by smoke in the original painting. This part of the painting may have been modified in 1889 and artist did not remember to show the Brian house (see Chapter 4).

Other interesting details like these will be covered in later chapters.

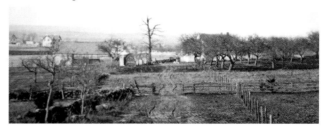

Close-up of Tipton 1882 image looking north toward Brian Farm. Barn (on left) and house (in orchard) visible. *SBC*

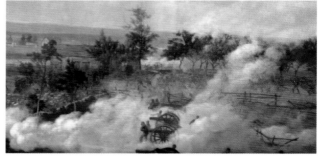

Brian Farm in cyclorama painting; barn and outbuilding visible, house absent. *BD*

Notes on Changes to the Original Painting

PERHAPS THE MOST exciting recent discovery about *The Battle of Gettysburg* cyclorama is that it was changed at some point during its lifetime. Almost like George Lucas' special editions of *Star Wars*, the artist and promoters made changes to the painting several years after it was first shown. By examining souvenir photographs that were taken shortly after its debut in Boston in 1884, we have found several parts of the painting that have been changed. Recently discovered information proves that the painting was modified in

1889. We will examine these changes, and offer some theories as to why it was changed.

As the artist was creating his four different versions of the cyclorama, it seems as though he was listening to feedback and trying to improve his work. As discussed in Chapter 2, the Boston version of the painting was started in Paris and the finishing touches were added in the Boston rotunda. The artist asked for suggestions from prominent veterans before he made these finishing touches. However, we do not know what

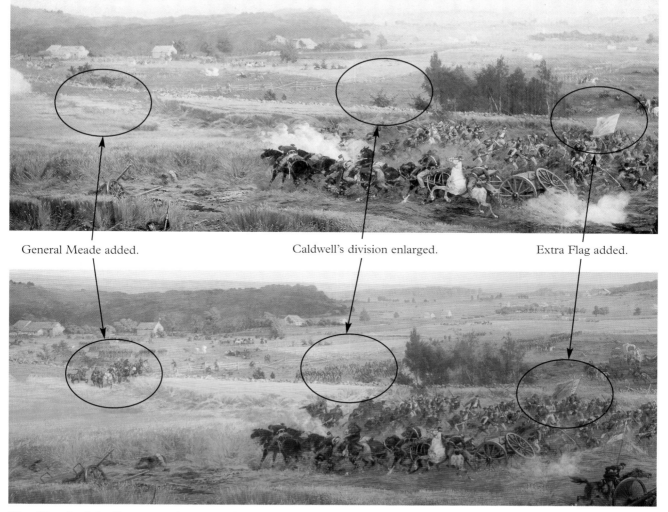

General Meade added. Caldwell's division enlarged. Extra Flag added.

Top: Detail of the Boston cyclorama, 1886. *SBC* Above: Modern view of same area. *BD*

improvements were made at this time because the souvenir photographs were taken after the painting debuted. Other suggestions from the audience were eventually incorporated into the final two versions of the painting. An example of this process would be that General Armistead is incorrectly depicted on horseback in the first two versions, but then correctly depicted on foot in the last two versions of the painting. These improvements culminated with the final version that was made for New York City, which debuted in 1886. Paul Philippoteaux claimed that it was the best and most detailed cyclorama that he ever created.[1]

As we look into the changes that were made to the Boston version of the painting, we will see that many of these changes correspond with improvements that

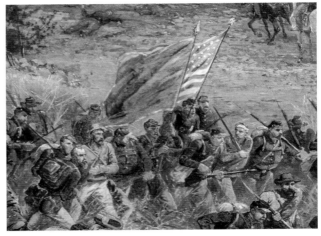

Detail of extra state flag. *BD*

were made for the New York version. It is also interesting to note that many of the new descriptions that were added to the New York key seem to mention units from the New England states. The authors theorized that the artist was using feedback from the Boston version to modify the New York version and improve the key. It is also possible that the promoters wanted to market the New York painting to visitors from the New England states. As we go through the descriptions in the key section of this book, we will mention many of these New England references in the New York key.

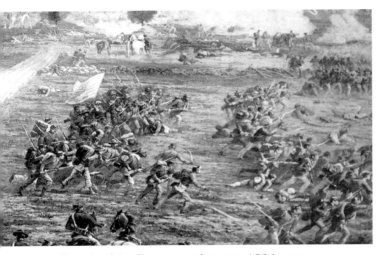

Detail of the Boston cyclorama, 1886. *SBC*

Photographic evidence showed that Maj. Gen. George G. Meade was not originally depicted in the Boston cyclorama. Photos taken between 1884 and 1886 clearly showed an empty wheat field at the General's location in the painting. Examination of the keys and historic photographs of the other versions show that New York was the first that definitely included General Meade. The New York key was the first to actually name General Meade in the painting. Earlier keys mentioned different buildings as Meade's headquarters, but there were no descriptions of the general, nor numbers in the drawing in that part of the painting. The New York key drawing was also the first that clearly identified Meade in that area. Historic photos of the New York version clearly showed Meade and his staff. Viewers probably asked about General Meade, leading the artist to incorporate him into the last version of the painting. Eventually, the artist added Meade and his staff to the Boston painting. It is also possible that the artist chose to modify this part of the painting because there was not much action in this area

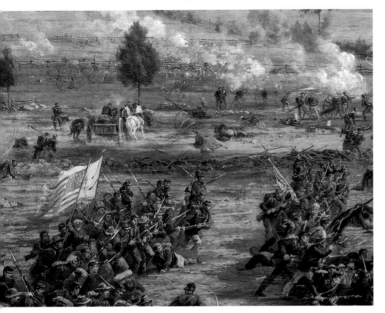

Modern view of same area. *BD*

and he wanted to liven up an otherwise quiet part of the painting.

Historic photos of the Boston version also showed changes to Brig. Gen. John C. Caldwell's division, which was close to Meade. It looks like many more troops were added to the division's right side. Like the addition of General Meade, this change may have been made to liven up an otherwise empty part of the painting. Also, the spectators probably complained there were too few troops displayed to represent an entire division. In this area, photographs of the New York painting showed Caldwell's division as being larger than originally displayed in the Boston painting. Once again, it seems as though the artist was trying to incorporate improvements to the New York version into the Boston painting.

In a nearby area, four more flags were added to some of the troops charging toward the angle. In the historic keys, these troops were identified as part of or Colonel Hall's entire brigade. The key descriptions in this area seemed to change from city to city and can become very confusing. In the original Boston painting, only two United States flags are visible. A blue state flag was added next to the U.S. flag near the back of the brigade, and a white state flag was added near the other U.S. flag. The New York key showed the 7th Michigan and the 19th Massachusetts in this area. This description would correspond with the new blue (Michigan) and white (Massachusetts) state flags. Once again, changes to the Boston painting seemed to match the New York painting. In front of the 19th Massachusetts, two more flags were added with another line of men. These two flags are not unfurled and are hard to identify. One is a U.S. flag and the other is a blue state flag. This unit seems to be the 42nd New York. We will discuss these four flags in more detail later when we analyze the corresponding sections of the painting (see View #0, B and View #1, C).

The final change was made in the area of the High Water Mark. In the original version, a battery wagon was being withdrawn from the Angle to escape the Confederate breakthrough. This wagon with a triangular roof was changed into a cannon at some later date. A battery wagon contained a portable forge and was used to make repairs to damaged cannon. In combat, these wagons would have been kept to the rear. Some of the spectators probably complained that it was shown too far forward. Photographs of the first three

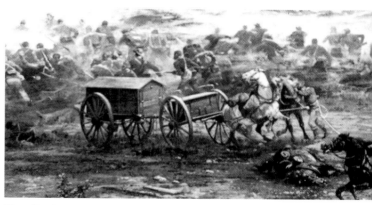

Detail of the Boston cyclorama, 1886. *SBC*

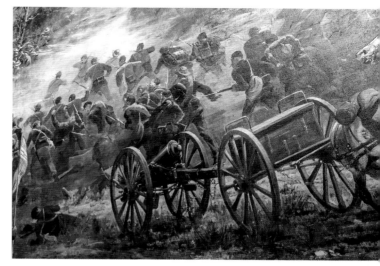

Modern view of same area. *BD*

versions of the painting clearly show this wagon. The triangular roof of this wagon is also visible in the original key drawings for the first three versions. In the New York version, this wagon was turned into a caisson, and both the historic photographs and the key drawing reflect this change. It seems likely this change was also made as part of the artist's efforts to make the New York version as accurate as possible. In the Boston painting, this battery wagon was turned into a cannon. During the recent cleaning of the painting in January 2013, the conservators were able to find the outline of the original battery wagon under the paint.

In the historic photographs of the Boston version, there appeared to have been more smoke in the area of Arnold's battery (see View #6, D). It is possible that this was one of the areas in which more troops may have been added to the painting. It is possible that other minor modifications were made to the Boston painting, but the historic photographs do not have

enough resolution to check every detail. For example, some of the extremely distant troop formations were probably added in 1889. Other features that may have been added are the signal flags visible on Little Round Top and Cemetery Hill (see View #1, N and View #7, K). Unfortunately, these flags are too small to see on the historic photographs.

It seems that most of these changes were made to address feedback the artist was receiving about the painting. Since veterans of the battle were among the spectators, customer input would be quite valuable. The authors think it is a testament to the artist that he would incorporate this information in order to make his work more accurate. It is also important to note that by 1889, the cycloramas were starting to wane in popularity. The promoters were trying to do all that they could to boost ticket sales.

Now that we have discussed what was changed and why, the question becomes *when* was it changed? At first, the authors could only speculate as to when and why the Boston painting was changed. Luckily, we were able to find an interesting advertising leaflet (see next page) in the NPS archive.[2]

Soon after finding this leaflet, the authors were able to find another brief advertisement in the *Boston Herald*, dated August 22, 1889. In this article it states: "The cyclorama of the 'Battle of Gettysburg' after having been thoroughly rejuvenated and greatly

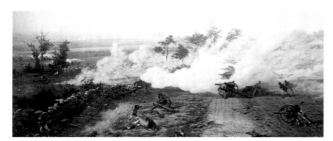

Detail of the Boston cyclorama, 1886. *SBC*

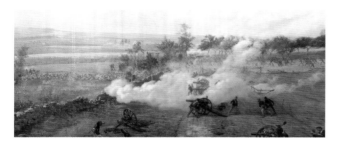

Modern view of the same area with less smoke visible. Note: the Brian house should be visible to the right of the barn. *BD*

improved by the addition of 40,000 figures upon the great canvas, 40 cannon and a number of state and regimental flags, is again placed before the public. One of the most noticeable alterations is the placing of the figure of Gen. Meade more in the foreground than before, and the new foreground to the picture adds greatly to its beauty. The picture will remain on exhibition day and evening for a brief period."

These two discoveries helped answer most of our questions about the changes that were made to the painting. As theorized by the authors, the leaflet tells us that the owners of the Boston rotunda were indeed taking "notes of the sayings of the multitudes" in order to improve future versions of the painting. Philippoteaux, as part owner of the company that exhibited these paintings, would have had access to these notes. When the artist made the New York version, he must have used these suggestions from the Boston platform. It is no surprise that many of the suggestions about how to enhance the painting involved New England units. The souvenir program from the Boston rotunda included a list of soldiers who had visited the cyclorama. An examination of this list uncovered several individuals who visited the painting in Boston and ended up being named in the New York key. The list includes General A. P. Martin (see View #1, Q) and Carleton Coffin (see View #9, F). Many of the other veterans who visited the Boston painting served in regiments that were described for the first time in the New York key.[3] In the upcoming analysis of the different parts of the painting, many of these New England references will be mentioned. When the Boston painting travelled to Philadelphia in 1891, they made a new key that used the Boston key drawing, but the descriptions from the New York key. These descriptions included many of the new details that were added to both the Boston and the New York paintings.

It is also interesting to note that both advertisements mention extra flags and more soldiers. The advertising flier noted that one of the chief complaints about the painting was "not enough troops." One must keep in mind that in the 1800s, there were no truth-in-advertising laws, and the wording of "the addition of 40,000 figures" is undoubtedly an exaggeration. Today, even after more troops were added, there are only approximately 20,000 men and horses in the painting. The figure of 40 extra cannon is also too high. Newspaper articles and advertisements frequently contained exaggerations,

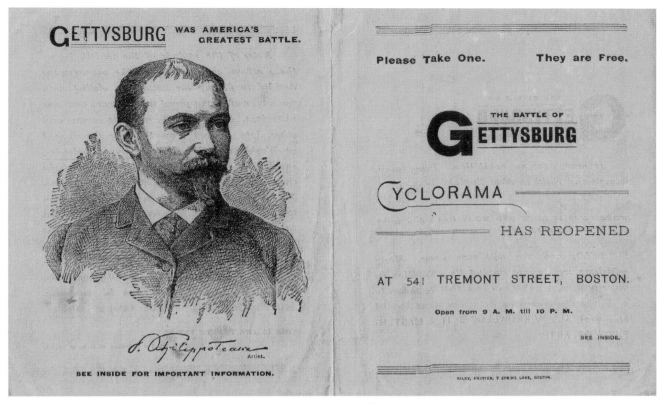

Front and back of a pamphlet advertising the reopening of the Boston cyclorama. *GNMP*

Inside of a pamphlet advertising the reopening of the Boston cyclorama. *GNMP*

especially where the cycloramas were concerned.

Another fascinating reference in these advertisements refers to General Meade as being "more in the foreground than before." If this is true, then where was he before? The authors suspect that the speakers on the platform probably told visitors that Meade was among the extremely distant figures near the Peter Frey farm (see View #0, E).

One question that the authors cannot answer for certain is who made the changes to the painting? The advertising leaflet has a picture of Philippoteaux on the back, but says the changes were made by "eminent artists." Did Philippoteaux actually do the painting or did some other artists add the new figures? From an examination of Philippoteaux's different artistic projects, we can see that it was possible that he made the changes. We know that the artist set up a studio in Mott Haven New York in 1885 to paint the last two versions of the painting. The final version (New York) was finished near the end of 1886. After finishing his Gettysburg cycloramas, Philippoteaux created a cyclorama of Niagara Falls in 1887. He also painted a series of large paintings about the life of General Grant that debuted in 1888 at the Old South Church in Boston. This series included *The Battle of Fort Donelson*, *The Battle of Shiloh*, and *Lee's Surrender*. All three of these paintings are now on display in Lowell, Massachusetts at the Pollard Memorial Library. In 1890 Paul Philippoteaux made the first of several journeys to Cairo and Alexandria, Egypt and did not return to the United States for several years.[4] We know that Philippoteaux spent several months touring the country showing his Grant series, but there would have been time for him to have been involved with the modifications to the Boston cyclorama before he left the United States.

In March of 1889, the Boston cyclorama was taken down and a cyclorama of *General Custer's Last Fight* replaced it in the Boston rotunda (see Chapter 2). During this time, the modifications to the Boston painting were probably made in the Mott Haven studio. Since Paul Philippoteaux owned a share of the Boston cyclorama, he would have had an interest in promoting the painting and keeping visitation levels

high. However, the use of the phrase "eminent artists," instead of naming Paul Philippoteaux, indirectly suggests that the changes were done by other artists. If the painting was modified in New York, then some of Philippoteaux's assistants probably helped with the additions to the painting. Philippoteaux might have been involved in supervising his various assistants, but may not have put brush to canvas.

Finally, it is interesting that after the changes, the promoters bragged that this version was now "by far the finest in the United States." In 1891, after the painting was moved to Philadelphia, an advertising broadside noted: "This is not the Cyclorama shown here some years ago, but the grandest and most costly of all" (see broadside in Chapter 2). Clearly, the promoters felt that the Boston version was superior to the Philadelphia version of the painting. Perhaps this is why the Boston version was taken to the 1893 World's Fair in Chicago in (as discussed Chapter 2). It is the authors' opinion, based on comparisons with the historic pictures of the other versions, that the Boston version was artistically superior. However, to be fair, black and white pictures may not do justice to the other versions. Perhaps Philippoteaux had more experienced assistants available in Paris than at the other studios. It is also possible that the artists may have been rushed to complete the last two versions as quickly as possible. Once the Boston version was modified to reflect some of the improvements that were made to subsequent versions, the authors feel that the promoters were justified in declaring it "the finest in the United States."

[1] Paul Philippoteaux, December 31, 1886. Letter to the Editor in New York *Century Magazine*, Century Company Records 1871-1924, Box 129, New York Public Library, Manuscripts and Archives Division.
[2] Promotional flier, donated by Chris Geddes to Gettysburg National Military Park, Archives #B-65.
[3] Souvenir Program, Boston 1884-1891, *Cyclorama of the Battle of Gettysburg*, Gettysburg, PA, 2008.
[4] Yasmina Boudhar, *On the track of a 19th century French artist of international renown: Paul Dominique Philippoteaux (1846-1923)*. History of art fifth year graduation thesis, under the supervision of professors Claire Barbillon and Michael Colardelle.

Notes on the Key to the Battle of Gettysburg by Paul Philippoteaux

IN THE FOLLOWING pages we examine the intricate details of the *Battle of Gettysburg* cyclorama. When these paintings were displayed in the 19th century, viewers could buy a souvenir program for the painting. These programs included biographical information about the artist, critical reviews, descriptions of the battle, and a fold-out circular drawing called a key. The circular drawing had numbers which denoted important people and places in the painting. Inside the round drawing there was a brief description of each numbered area. In order to make a complete modern guide to the *Battle of Gettysburg* cyclorama, the authors performed a detailed analysis of these historic keys. It was our goal to find every person or place listed in these keys. These historical keys were then compared with modern photographs of both the terrain and the painting. Maps, official reports, and other books about the battle of Gettysburg were also consulted. By drawing on as many sources as possible, the goal of the upcoming sections of this book is to provide the most comprehensive key to Paul Philippoteaux's masterpiece ever created.

The painting has been divided into ten sections, which correspond with the ten photographs taken by William Tipton in 1882. Modern comparison photographs of the corresponding areas were taken from the same perspective by Bill Dowling in the spring of 2012. Tipton's photographs included a number visible in the lower right hand corner (from 1 to 0). The authors suspect that Tipton probably started with View #1 and ended with View #0. View #1 would be the easiest place to start because it faces Big Round Top, the most prominent landmark in the area. However, areas of overlap between View #0 and #1 require them to be analyzed together. For narrative purposes, we will start with View #0 facing south by southeast, and proceed in a clockwise fashion around the cyclorama to View #9. The various people, places, and groups of soldiers will be delineated with letters on our key. The letters on the key will generally cover the foreground first, then the background, with the letters going from left to right. The next ten chapters will cover the ten sections of the painting (View #0 through View #9) and discuss each item in our new key to the painting.

In order to better understand the painting today, and how it has been seen throughout its history, it is necessary to discuss the various keys that have been made over the years. We will start by discussing how and when the different historic keys were made. We will also discuss other sources that were used to help us create our new key to the painting.

When the first version of the *Battle of Gettysburg* by Paul Philippoteaux was unveiled in Chicago, the key had a drawing that closely matched the Chicago painting. The descriptions in this key would be the basis for all the others. Most of the information in this key must have come from the artist's research. As noted in Chapters 1 and 2, Philippoteaux interviewed several Union generals, toured the battlefield with a guide, and studied maps and records at the War Department. Once he finished his studies, he returned to Europe to begin work on the painting. He would not have had access to many people familiar with the American Civil War during this time. The artist used feedback from the audience and made changes to subsequent versions of the painting.

In examining the Chicago key, we found several references to troops and officers of local interest to people from Chicago or the Midwest. It seemed that the artist and the promoters of the paintings were very market savvy. We will try to note this "local marketing" as much as possible. The Chicago key is also interesting because the drawing shows a large haystack that was part of the diorama. Historic accounts tell us that the stairs leading up to the platform emerged out of this large haystack.

The first version was a smashing commercial success, and a second version was immediately commissioned for display in Boston. The Boston

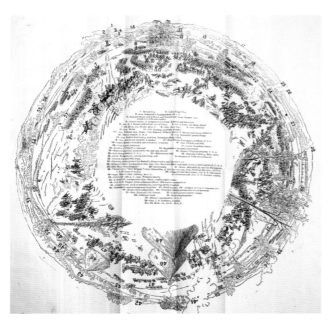

Chicago key (see larger image on page 22). *SBC*

version of *Battle of Gettysburg* is the version currently on display at the Gettysburg National Military Park Visitor Center, and the subject of this book. This second version was started in France (outside of Paris) and the finishing touches were probably done in the Boston rotunda (see Chapter 2). Unfortunately, there was no new key for this version. Instead, the promoters simply copied the Chicago key's descriptions of objects word for word. One change was made to the key's drawing: the Boston version did not have the large haystack as part of the diorama, so it was removed. In its place, what appears to be a lean-to was added to the drawing. Historic photographs of the Boston version show a lean-to on the diorama. Like the haystack on the Chicago diorama, this is probably where the steps to the cyclorama entered the viewing platform. The cyclorama of the *Battle of Waterloo* that is still on display in Belgium also has the stairs to the platform emerging from a very similar lean-to.

A comparison between the key drawing and the actual painting shows numerous other discrepancies that were not fixed. We know that the promoters requested that Philippoteaux change the location of General Meade's headquarters (see Chapter 2). This change to Meade's headquarters was not reflected in the key drawing. There was also a well and a hospital scene in the Boston version that was not in the key drawing. This lack of an accurate key for the Boston version made interpretation of the painting more

difficult. To add to the difficulties in studying the Boston version, changes were made to the painting itself in 1889 (see Chapter 4). Many of these changes were made as a result of feedback that the artist and promoters received about the painting. Unfortunately, we do not know about every detail that was changed. In the historic photographs of the painting before it was modified, we cannot make out details in the extreme distance. For the purposes of this book, the painting was compared with all of the historic and modern keys in order to make an interpretation of what is actually displayed in the painting.

After painting the first two versions, the artist set up a cyclorama studio in the United States near New York City. The artists immediately began the third (Philadelphia) version of the cyclorama. The copies painted in the United States have several modifications that make them different from the Boston version. General Armistead was correctly shown on foot instead of on horseback (see View #2, F). Also, General Hancock and his staff were moved to the field of wheat where General Hunt was located in the Boston version (see View #1, B and View #9, D). General Hunt and his staff were moved to the area north of the viewing platform near the position of Captain Hazard in the Boston version (see View #9, D and View #7, A). The promoters made a new key and key drawing for the Philadelphia version. This new key updated some of the descriptions, and removed some of the references to Midwestern units. The new drawing accurately reflected most of the changes that had been made to the painting since the Chicago key drawing. General Meade's headquarters was shown at its advanced (westward) location. Also, the well was more accurately displayed in the drawing. Because of these changes, the Philadelphia key drawing most closely resembled the actual Boston painting. After the NPS acquired the painting in 1942, they used this drawing for some of their keys to the painting. One change that was not fixed on the key drawing was the fact that General Armistead still appeared to be mounted. Photographs of the Philadelphia painting show that he was now depicted on foot.

The New York version of the *Battle of Gettysburg* was the fourth and final copy painted by Philippoteaux and his team. A new key and key drawing were made for this painting. The key drawing was redone to accurately reflect the New York version. For example,

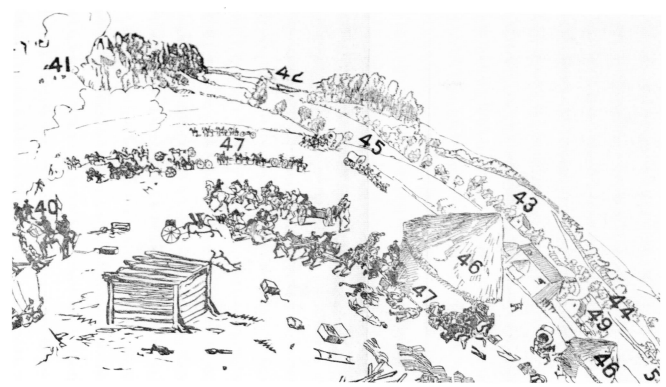

Detail of the Boston key. *SBC*

General Armistead was clearly depicted on foot. The New York key had the most thorough descriptions of any of the keys. It is entirely possible that some of the veterans even visited the studio and posed for some of the images (View #1, B). The artist and promoters later bragged that this was Philippoteaux's most accurate painting ever. It seems as though the artist was using the "notes of the sayings of the multitudes" that were being taken at the Boston cyclorama in order to improve the New York version. More people from the New England states were mentioned in the New York key than local New Yorkers. We will discuss many of these New England references as we analyze the key. It seems that the improvements that were made to the New York copy also corresponded to the changes that were later made to the Boston version. For example, the New York key was the first that actually listed General Meade, who was added to the Boston version in 1889. Interestingly, the New York key descriptions were used with the Boston version of the painting after it was modified in 1889. This use of the New York key descriptions with the modified Boston painting helped to confirm the authors' theory that the changes were made in order to keep the two versions of the painting on par with each other.

The keys that were used in Gettysburg at the East Cemetery Hill building and the Mission 66 building

Hut on the diorama at the Waterloo cyclorama that helps to conceal the stairs onto the viewing platform. *Photo by Greg Goodell*

will be referred to as the "old Gettysburg keys." Most of these keys used the Philadelphia key's drawing (because it most closely matched the real Boston painting), but the descriptions of several areas were changed. The old Gettysburg keys were the first keys to point out the artist's self-portrait (see View #5, A). They were also the first keys to mention the 72nd Pennsylvania, which may have been a case of local marketing (see View #0, B). A sample of one of the old Gettysburg keys can be found in the back of *BGC/AHG*.

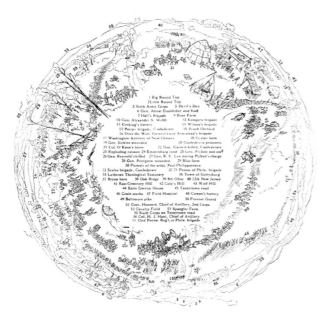

1 Big Round Top
2 Little Round Top
3 Sixth Army Corps 5 Devil's Den
6 Gen. Abner Doubleday and Staff
7 Hall's brigade 9 Rose Farm
10 Gen. Alexander S. Webb 13 Kempers brigade
11 Cushing's battery 14 Wilcox's brigade
12 Perry's brigade, Confederate 15 Peach Orchard
16 Over the Wall, Garnet's and Armistead's brigade
17 Washington Artillery of New Orleans 18 Codori farm
19 Gen. Sickles wounded 20 Confederate prisoners
21 Col. O'Kane's home 22 Gen. Garnett killed, Confederate
23 Exploding caisson 24 Emmitsburg road 25 Gen. Pickett and staff
26 Gen. Reynold's killed 27 Gen. R. E. Lee during Pickett's charge
28 Gen. Pettigrew wounded 29 Bliss farm
30 Portrait of the artist, Paul Philippoteaux
31 Scales brigade, Confederate 32 71 Penna. of Phila. brigade
33 Lutheran Theological Seminary 36 Town of Gettysburg
37 Bryan barn 38 Oak Ridge 39 8th Ohio 40 12th New Jersey
41 East Cemetery Hill 42 Culp's Hill 43 Wolf Hill
44 Katie Gwynn House 45 Taneytown road
46 Grain stacks 47 Field Hospital 48 Cowen's battery
49 Baltimore pike 50 Provost Guard
51 Capt. Hazzard, Chief of Artillery, 2nd Corps
52 Cavalry Field 53 Spangler Farm
55 Sixth Corps on Taneytown road
56 Col. H. J. Hunt, Chief of Artillery
57 72nd Penna Reg't of Phila. brigade

Philadelphia key (see larger image on page 41). *SBC*

The modern NPS key is used in *BGC/AHG* and on the large display in the mezzanine at the Gettysburg National Military Park Visitor Center. The modern key attempts to reconcile differences between the historic keys and the actual painting. This key, however, only covers the most important people and places. Also, this key seems to be conservative in nature. For example, the image of Lincoln is not listed because only oral tradition supports his inclusion in the painting (View #8, D). The goal of this book is to greatly expand the Park Service key. There are a few areas in which this book will offer an interpretation that differs slightly from the NPS. In most cases, however, the authors will adhere to the NPS interpretation.

Finally, it is important to note that the painting was allegorical in nature. It was meant to tell the story of Pickett's Charge, and not to capture an exact moment in time. Many of the incidents that are depicted in the painting did not happen at the exact same moment in time. Probably about 15 minutes of action was compressed into one "snapshot" that became the painting. The artist had to use some artistic license to show as much action as possible on one piece of canvas. We must take these factors into account when interpreting the painting. Furthermore, as a work of art, it is open to multiple interpretations that can change with every viewer. The authors will try to note what factors they used to make their interpretations of the painting. The artist, no doubt, helped make the historic keys, so we will use these designations first. Other grey areas will be filled in by using maps and records of the battle. In some cases, where multiple interpretations are possible, the authors will note where they had to speculate or add their personal opinions.

In order to create the new key to the painting, the authors tried to use as many sources as possible. All of the historic and modern keys were examined in order to attempt to find every object in the painting. To add to our own personal observations of the painting, modern photographs were examined which gave us a close-up view of extremely distant objects. These observations were then compared with the historic Tipton photographs of the landscape from 1882 and the modern photographs of the landscape from 2012. The authors also spent many hours walking the area and making notes from the actual battlefield. All of these observations were compared with the historic pictures of the cycloramas from the 19th Century. Another important reference was the excellent map of the battlefield that was made by Thomas Desjardin.[1] The authors used this map to confirm the location of many of the distant farms and terrain features on the battlefield, especially some of the farms that are no longer standing. *The Adams County Atlas of 1872*[2] was also helpful for checking some of the farms that may have been built between the time of the battle and the Tipton photographs. Troop positions and the order of battle were confirmed using Philip Laino's *Gettysburg Campaign Atlas*.[3] The order of battle was also double-checked using Trudeau's *Gettysburg: A Testing of Courage*.[4] The authors further discussed many items with our fellow Licensed Battlefield Guides and Park Rangers. Fellow guides Timothy Smith and Elwood "Woody" Christ were particularly helpful with almost all of the distant farmsteads on the battlefield. Since these sources were used for virtually every item in the key, we will not be citing them with every entry. Footnotes will be used whenever a specific book or other source was used to discover more about a particular place or object.

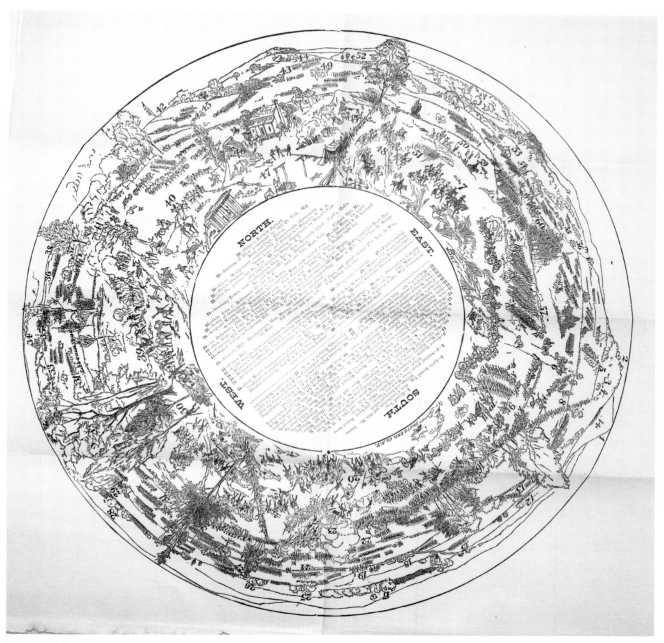

New York key. *SBC*

[1] Thomas Desjardin, Gerald Bennett, Charles Fennell, Scott Hartwig, Harry Pfanz, Timothy Smith, and Wayne Motts, *The Battle of Gettysburg*, Friends of the National Parks at Gettysburg project (Gettysburg, PA, 1998).

[2] *Adams County Atlas of 1872*, "Research Print, Cumberland, Middletown, Cashtown, 1872," (South Portland, ME, 2014).

[3] Philip Laino, *Gettysburg Campaign Atlas*, (Dayton, OH, 2009).

[4] Noah Andre Trudeau, *Gettysburg: A Testing of Courage*, (New York, NY, 2002).

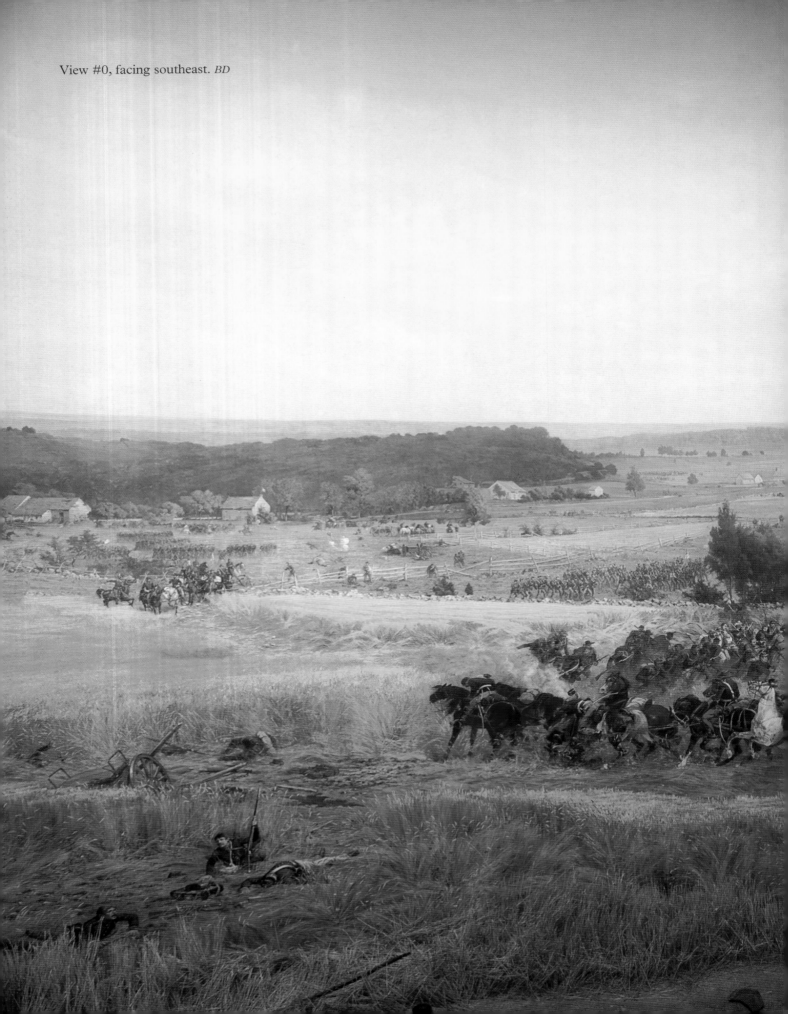

View #0, facing southeast. *BD*

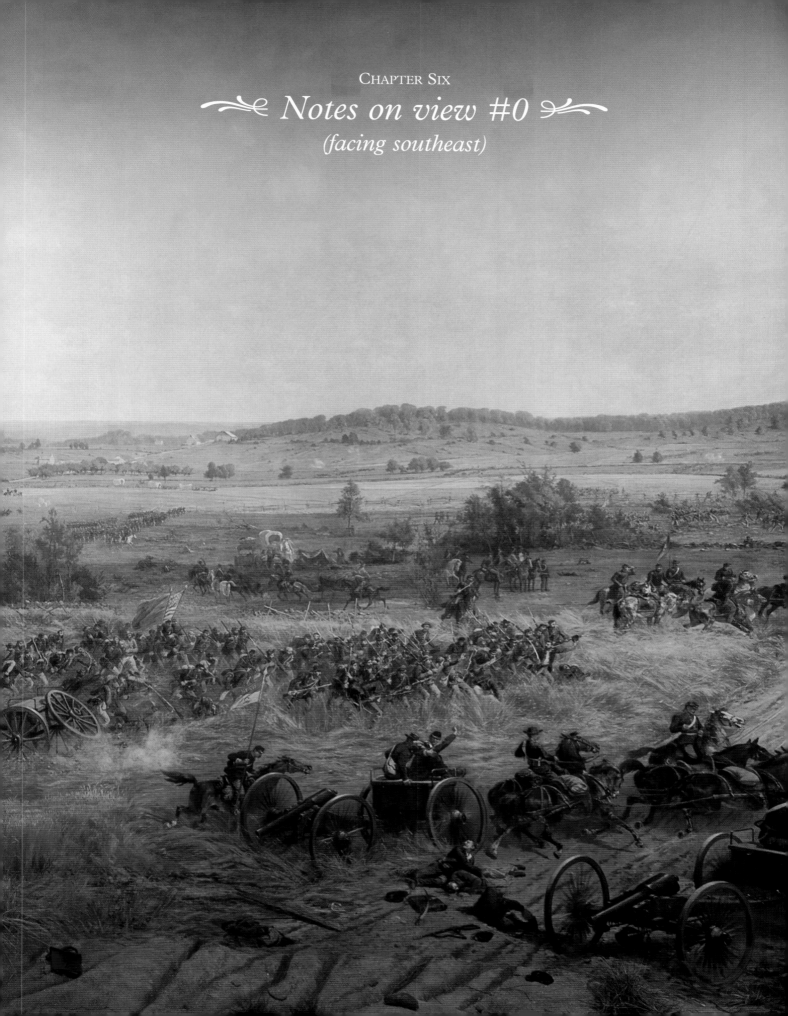

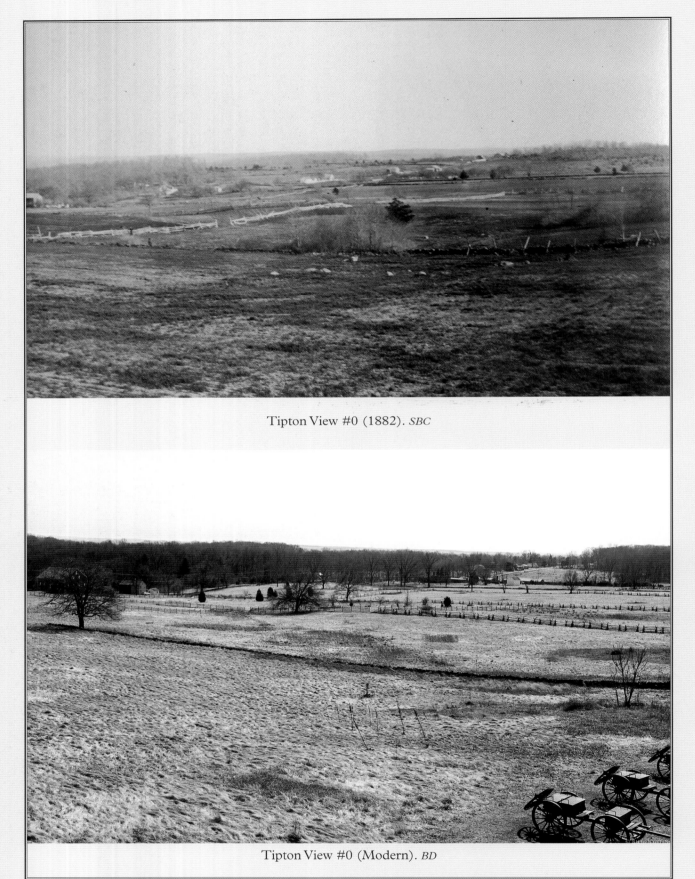

Tipton View #0 (1882). *SBC*

Tipton View #0 (Modern). *BD*

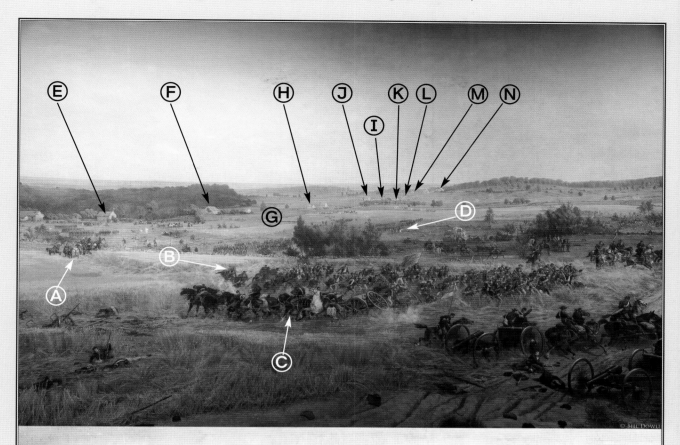

⊸≪ KEY ≫⊶

Ⓐ Major General George Gordon Meade, Commander of the Army of the Potomac, and Staff

Ⓑ 72nd Pennsylvania Infantry Regiment

Ⓒ Caisson Withdrawing

Ⓓ Brigadier General John C. Caldwell and the 1st Division, II Corps

Ⓔ Peter Frey Farm

Ⓕ John Fisher Farm

Ⓖ Taneytown Road

Ⓗ Solomon Cassatt Farm

Ⓘ Isaac T. Shriver Farm

Ⓙ William Patterson Farm

Ⓚ Jacob Hummelbaugh Farm

Ⓛ Granite School House Lane

Ⓜ Sarah Patterson Farm

Ⓝ Michael Frey Farm

The Gettysburg Cyclorama: The Turning Point of the Civil War on Canvas

(A) **Major General George Gordon Meade, Commander of the Army of the Potomac, and Staff**
During the cannonade that preceded Pickett's Charge, dozens of artillery shells were landing in the area of the Lydia Leister house. This heavy fire forced General Meade to move to General Slocum's headquarters between the Lightner farm and Powers' Hill (see View #9, J and N). When the artillery fire stopped, Meade started moving toward the Union center.[1] The painting depicts General Meade and his staff arriving near the High Water Mark at the end of Pickett's Charge. General Meade's staff would have included his son, George Meade, Jr.

As discussed in Chapter 4, General Meade was added to the painting in 1889. Of note is that Meade owned a brown horse, named Old Baldy, and a black horse, named Blackie. We know that he did not ride a white horse on July 3, as was depicted in the painting.[2] It is the author's opinion that Philippoteaux used white horses to help the viewer more easily find important generals, especially ones who were depicted fairly far away. We will see many other generals on white horses as we continue to examine the painting.

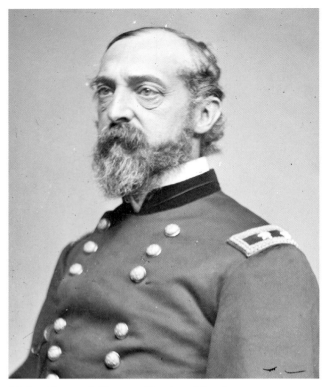

Major General George Gordon Meade. *LOC*

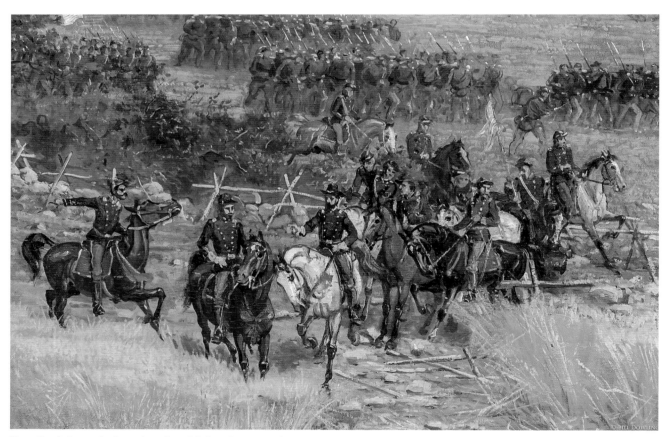

Detail of the painting showing Major General George Gordon Meade, commander of the Army of the Potomac, and staff. *BD*

General Meade's Equestrian Statue at Gettysburg. *BD*

The preserved head of General Meade's horse, Old Baldy, from the Philadelphia Grand Army of the Republic Museum. *SBC*

Ⓑ 72nd Pennsylvania Infantry Regiment

In this area, a unit can be seen charging from east to west into the Angle at the climax of Pickett's Charge. The blue state flag was added next to the United States flag in 1889 (see Chapter 4). The modern NPS key identifies this unit as the 72nd Pennsylvania. After studying the original keys, the authors have found that the designation of this unit may be open to interpretation. In some of the historic keys this unit could be meant to represent the 7th Michigan. On the historic keys, the description of this unit was linked to the description of the 19th Massachusetts (View #1, C). The number seems to represent a brigade sized unit (3 to 5 regiments). All the original keys described a part, or Hall's entire brigade in this area. Hall's brigade was comprised of the 7th Michigan, the 42nd & 59th New York, and the 19th & 20th Massachusetts. To add to the confusion, different units from Hall's brigade are mentioned in different cities.

The units in this area seem to be examples of local marketing. Since this is one of the most easily visible regiments in the painting, it is logical that it would be highlighted as a local unit. In the Chicago key, this unit was listed as "7th Mich. Vol., 3rd div., 2nd A.C., Col. N. J. Hall comd'g." The 7th Michigan would have been the only Midwestern unit in the area, so it would make sense to highlight them for the Chicago audience. This description was not accurate, however, because the 7th Michigan was actually part of the 3rd Brigade of the 2nd Division of the II Corps. In reality, the 7th Michigan would have moved into the Angle from the south through the Copse of Trees (View #2, I), and would be hard to see in their actual position. Another example of the promoters using this spot for local marketing can be found on a buckeye key that was used in Minneapolis in which the 1st Minnesota was located in this area. This unit, like the troops from Michigan, would have also moved into the Angle from the south.

The 72nd Pennsylvania was first identified on the old Gettysburg keys that were made at the East Cemetery Hill building. The NPS acquired the painting in the 1940s, and they have used this designation ever since. In other cities these troops were used to market the painting to the local audiences, the owners of the building on East Cemetery Hill being no exception. The operators of the original Gettysburg building might have been under some pressure to

identify the 72nd Pennsylvania. With the painting being permanently located in Gettysburg, it would have been hard to ignore a Pennsylvania unit that was known to have played an important role in the repulse of Pickett's Charge. It is further possible that the 72nd might be represented among the troops who are closer to the Angle (see View #2, C) but none of the original keys specifically named this unit. The NPS description may also make the most sense when studying the actual position of the regiments at the time of the High Water Mark. We will discuss the positions of the regiments in this area further in View #1, C.

The blue state flag may have led some people to believe that this unit was the 72nd Pennsylvania. Michigan, however, also has a blue state flag. Further investigation revealed that at the time of the battle, the 72nd Pennsylvania was only carrying one flag. At Gettysburg they were carrying a regimental color which was all blue with the state symbol on one side and the national arms (an eagle) on the reverse. The 72nd was not carrying a national flag. Most of the other Pennsylvania units would have had a national flag and a state flag. The state flag would have resembled a U.S. flag with the Pennsylvania state symbol in the blue area where the stars are normally displayed.[3] As we will see, the artist was not always accurate with his depiction of the flags in the painting (see View #2, B and View #3, D).

A mounted officer is visible just south of the first line of this unit. This officer could be Lt. Col. Amos E. Steele, Jr. of the 7th Michigan who was wounded near the end of the attack.[4] This officer could also represent

Lt. Col. Theodore Hesser, who took command of the 72nd Pennsylvania after Col. DeWitt C. Baxter was wounded on July 2.[5]

© Caisson Withdrawing

Civil war artillery was moved around using several teams of horses. There would have been six horses attached to a two-wheeled vehicle called a limber (see View #3, G). The limber also contained a box that held ammunition for the cannon. The limber would have been attached to the cannon when moving, to create a four-wheeled vehicle. In addition, each cannon would have had a caisson, a four-wheeled vehicle with three ammunition boxes and a spare wheel. Thus, on the move, each cannon required twelve horses. Each group of cannon, or battery, would have included an extra wagon with blacksmith supplies called the battery wagon (see View #7, B and View #3, A).[6]

The caisson depicted in this area was probably from Cushing's battery (View #2, B). Early in the cannonade, Lt. Alonzo H. Cushing sent three of his six caissons to the rear for safety. Unfortunately, they moved to the area of the Leister house (see View #8, H). There was so much artillery fire raining down on this area that they were moved again to the area of Granite School House Lane (View#0, L). At the end of the bombardment, these caissons were returned to the High Water Mark area to replace several of the caissons that were destroyed by artillery fire.[7]

The cyclorama painting does an excellent job of illustrating the four types of artillery projectiles that were used in the battle. In this area, we can see the

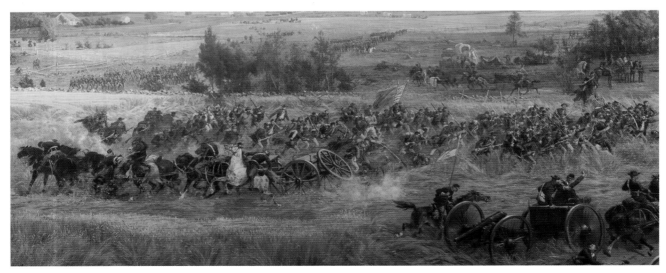

Detail of the painting showing the 72nd Pennsylvania and a caisson withdrawing. *BD*

effects of shell and case shot. Both of these types of ammunition had a timed fuse. When the cannon went off, the flames from the powder that launched the projectile would light a fuse. This fuse would burn for a certain number of seconds and then the missile would explode in mid-air. Pieces of the projectile would rain down on the enemy and cause damage. A shell was a hollow projectile. When it exploded, the outer shell would break into pieces that would fly through the air. Case shot was a hollow projectile with small iron balls (called shrapnel) inside. When case shot exploded, even more pieces of iron would fly through the air, causing more damage. In this scene, you can see white puffs of smoke from the exploding projectiles, and several men around the caisson and in the infantry unit nearby are being hit by flying shrapnel or shell fragments.

There were two other types of artillery ammunition: solid shot and canister.[8] The effects of these projectiles are clearly illustrated in View #5, C (canister) and View #6, C (solid shot).

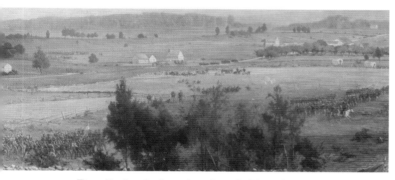

Detail of painting showing Caldwell's Division. *BD*

D Brigadier General John C. Caldwell and the 1st Division, II Corps

This is another area where the painting was changed in 1889 (see Chapter 4). Perhaps there did not appear to be enough men in this area to be an entire division, so more troops were added. General Caldwell, pictured on a white horse, was one of Hancock's three division commanders. His

Brigadier General John C. Caldwell. *LOC*

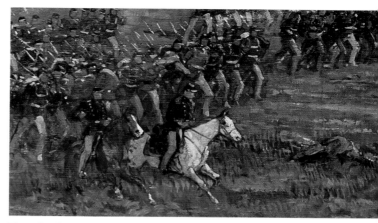

Detail of the painting showing General Caldwell on a white horse. *BD*

division included the famous Irish Brigade. The 1st Division suffered heavy casualties in the Wheatfield on July 2. On July 3, Caldwell's division was held in reserve.

E Peter Frey Farm

At the time of the battle, a tenant named Brown rented the farm from Mr. Frey. After the war, the farm was purchased by Basil Biggs, a famous black resident of Gettysburg.[9] The house is still there today and it is kept close to its 1863 appearance by the National Park Service. The barn was rebuilt in the late 1800's and does not look the same as it does in the painting. Interestingly, one of the surviving pieces of the New York cyclorama shows the Peter Frey barn and some nearby troops.

In the historic Chicago and Philadelphia keys, this farm was erroneously labeled as "General Meade's

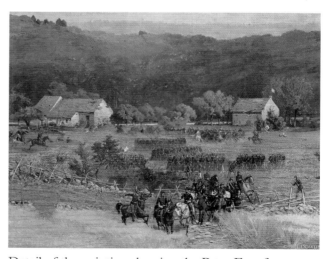

Detail of the painting showing the Peter Frey farm. *BD*

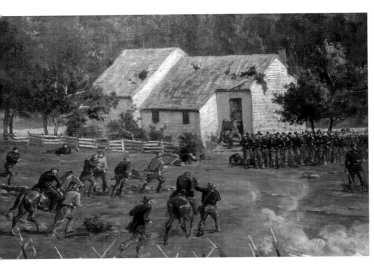

A surviving piece of New York version, showing the Peter Frey farm. *BD*

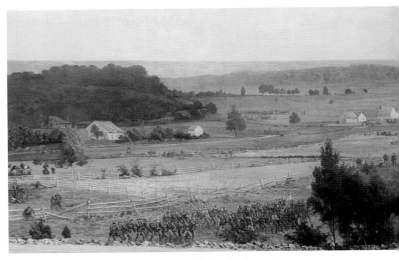

Detail of the painting showing the John Fisher farm. *BD*

Headquarters" or "Meade's 2nd Headquarters." In the New York key it was labeled as "General Meade's Headquarters at Cassalt's *[sic]* Mill." The Cassatt farm was nearby (see H), but did not have a mill and was not Meade's headquarters. It is possible that this reference referred to objects which were farther in the distance. During the bombardment, Meade moved his Headquarters to the Lightener farm (see View #9, J) which was close to McAllister's farm and mill (see View #9, K).

In reality, this farm was used as a headquarters by Brig. Gen. John Gibbon (see View #1, E). In a *Boston Herald* advertisement for the changes that were made to the painting it stated: "One of the most noticeable alterations is the placing of Gen. Meade <u>more in the foreground than before</u>" (emphasis added).[10] Although he was not labeled on the keys, it is possible that visitors were told that General Meade was one of the extremely distant figures in this area.

This farm was also used as a field hospital. A flag is visible on top of the Frey house. Since the flag is so far distant, it is possible that it is meant to be either a hospital or a headquarters flag. Almost all of the farms along the Taneytown Road were used as hospitals or aid stations on the second and third day of the battle.[11]

Ⓕ John Fisher Farm

This farm no longer exists. In the painting, the Fisher farm appears to be on the east side of the Taneytown road. According to historic maps, it was actually on the west side of the road. If it still stood today, it would be

just south of the Peter Frey farm on the west side of the Taneytown Road.

Some mounted troops and a battery can be seen between this area and the Peter Frey farm (see E). These troops may have included "Gen. Pleasanton's cavalry Headquarters guard with Fuller's Mass. Bat." who were mentioned in the New York key in the area of the Hummelbaugh farm (see K).

Ⓖ Taneytown Road

In 1863, ten roads led into the town of Gettysburg, radiating out from the center of town like the spokes on a wheel. This road network made Gettysburg an ideal spot for massing Civil War armies. Once the battle started on July 1, these roads made a larger battle at Gettysburg almost inevitable. The Taneytown Road was a dirt road that headed south from Gettysburg towards Baltimore and Washington. As one of only two roads controlled by the Union army on July 3, the Taneytown Road was a vital line of supply and communication.

Ⓗ Solomon Cassatt Farm

The original Cassatt farm no longer exists. The NPS owns a small yellow house and a barn that is near the site of the original farm.

Ⓘ Isaac T. Shriver Farm

The original Shriver farm no longer exists. If it still stood, it would be located close to the start of the walking trail, across the Taneytown Road from the NPS maintenance building on Pleasanton Avenue.

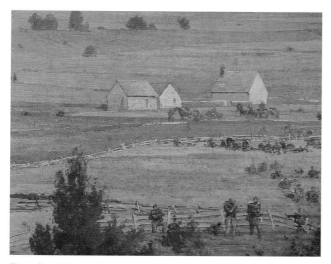

Detail of the painting showing the Solomon Cassatt farm. *BD*

William Patterson farm, modern. *BD*

Ⓙ William Patterson Farm

At the time of the battle, the Patterson farm included a house on the east side of the Taneytown Road and a barn on the west side of the road. The house still stands and is kept in its 1863 condition by the National Park Service. The barn no longer exists, but stone walls and some orchard trees are visible near the site of the old barn. During the fighting on July 2, the Union II Corps established a field hospital at this farm. Later, the hospital was moved farther to the rear to escape artillery fire. In the Chicago and Philadelphia keys, this site was listed as being General Birney's headquarters. Major General David B. Birney took command of the III Corps after General Sickles was wounded on July 2. Birney's official report does not say where he established his headquarters on July 3. After the battle, Brig. Gen. Marsena R. Patrick used the farm as the headquarters for the provost guard (see View #9, E).[12]

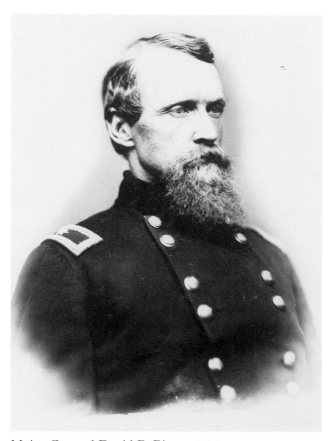

Major General David B. Birney. *LOC*

Brigadier General Marsena R. Patrick. *LOC*

Ⓚ Jacob Hummelbaugh Farm

This farm currently includes three buildings (the house, the barn, and one out-building) that are kept in their 1863 appearance by the National Park Service. This house was used as a hospital during the battle. The most famous patient was General Barksdale who died there and was buried next to the house.[13] In the Chicago key, it noted "Gen. J. S. Robinson, hospital" which seems to be local marketing. The Chicago key also mentioned General Robinson in an area to the north (see View #6, N). At the time of the battle, Col. James S. Robinson was the commander of the 82nd Ohio, XI Corps. Colonel Robinson was wounded on July 1 on the north side of town near Heckman's Battery.[14] We know that the Union II Corps used this area as a field hospital on July 2 and July 3. On this day, Robinson was probably in the XI Corps hospital behind Powers' Hill at the George Spangler farm (see L).[15] Of interest is that he was labeled as a general when he was only a colonel at Gettysburg. By the end of the war, Robinson attained the rank of general. After the war, he became an Ohio Congressman from 1881 to 1885.[16] When the Chicago cyclorama opened in 1883, he would have been a well-known figure to spectators who would have called him general. The fact that the promoters in Chicago took the time to mention Robinson twice shows how a person's status after the war influenced whether or not they were mentioned in the keys.

On the New York key, the Hummelbaugh farm was labeled as "Gen. Pleasanton's cavalry Headquarters guard with Fuller's Mass. Bat." After the battle, Maj. Gen. Alfred Pleasanton established his headquarters there until July 6.[17] Pleasanton's HQ were probably farther south of this area on July 3 (he does not have a HQ marker on the field). Pleasanton was directly supervised by Meade during the battle, and spent a lot of time at Meade's HQ. It was quite possible that his HQ guard was nearby. In the Boston version, there appears to be some mounted troops and a battery close to the Peter Frey and the John Fisher farms (E and F). These troops may have been closer to the Hummelbaugh farm in the New York version. On the field today, there are several cavalry and horse artillery markers around the Hummelbaugh farm. Lieutenant William D. Fuller's battery was the 3rd U.S. Light Artillery: Battery C (not a Massachusetts battery), which was part of Capt. John C. Tidball's 2nd Horse Artillery Brigade. Fuller's battery marker is farther south directly across the Taneytown road from the start of Granite School House Lane (L). There are also several other distant units on the Taneytown road that could either represent these units or reinforcements from the artillery reserve. They are so far distant that no details can be clearly determined.

Detail of the painting showing the farms located to the south on the Taneytown Road (I, J, K. L, M and N). *BD*

Notes on view #0 (facing southeast)

Ⓛ Granite School House Lane

This farm lane started at the Taneytown Road and ran behind Powers' Hill (View #9, N) to the Baltimore Pike (View #9, L). Along the way, it passed a granite school house that gave it its name (not visible in the painting). Because this lane ran behind the Union line, it was a perfect route for shifting troops from one end of the line to the other. Granite School House Lane was especially important on July 2 when the Union V Corps used this route to help repulse Longstreet's attack on the Union left. This area behind the lines was also a major staging area for Union supplies and the reserve artillery. There was a large hospital located off of this road at the George Spangler farm (not visible).

During the bombardment that preceded the infantry attack on July 3, some of the reserve artillery had to be moved farther to the rear because Confederate shells were over-shooting and landing in this area. The reserve artillery cannot be seen in the painting, but several units are depicted moving up the Taneytown Road that could have just come from this area (see K).

Ⓜ Sarah Patterson Farm

To the left of the Michael Frey farm (N), a small house can be seen in the painting. This building was probably part of either the Jacob Swisher or the Sarah Patterson farm. Both of these farms were south of Michael Frey on the Taneytown Road, and have hospital signs today. At this angle, the Swisher farm was probably hidden by Weikert's hill (View #1, K). We are probably seeing part of the Sarah Patterson farm, which is farther back from the Taneytown Road than Swisher. However, it is too small in the Tipton photographs to positively identify, and the view on modern photographs is blocked by trees and modern buildings.

Ⓝ Michael Frey Farm

The original Michael Frey farm no longer stands. At the time of the battle, the farm house was located on the east side of the road. Today, there is a more modern structure at this site with a hospital marker. The barn was located on the west side of the road and no longer stands. The barn, clearly visible in the painting, would have been located near where the horse path crosses the Taneytown Road today.

[1] Edwin B. Coddington, *The Gettysburg Campaign: A Study in Command* (New York, NY, 1968), 495–496.

[2] Old Baldy is on display at the Grand Army of the Republic Museum and Library (4278 Griscom Street, Philadelphia, PA). Blackie was Meade's show horse, Freeman Cleaves, *Meade of Gettysburg* (Norman, OK, 1960), 339.

[3] Richard A. Sauers, *Advance the Colors* (Harrisburg, PA, 1987), 195–196.

[4] Reports of Maj. Sylvanus W. Curtis, in *The War of the Rebellion: A Compilation of the Official Records of the Union and Confederate Armies*, 128 vols. (Washington, D.C., 1880-1901), Series 1, vol. 27, pt. 1, 448.

[5] Reports of Brig. Gen. Alexander S. Webb, *OR* 27, pt. 1, 427.

[6] Philip M. Cole, *Civil War Artillery at Gettysburg: Organization, Equipment, Ammunition, and Operations* (Orrtanna, PA, 2002), 101-110.

[7] Kent Masterson Brown, *Cushing of Gettysburg: The Story of a Union Artillery Commander* (Lexington, KY, 1993), 236 and 242.

[8] Cole, *Civil War Artillery at Gettysburg: Organization, Equipment, Ammunition, and Operations*, (Orrtanna, PA, 2002), 121–133.

[9] Timothy H. Smith, *Farms at Gettysburg: The Fields of Battle* (Gettysburg, PA, 2007), 37.

[10] Advertisement, *Boston Herald*, August 22, 1889.

[11] Gregory A. Coco, *A Strange and Blighted Land- Gettysburg: The Aftermath of Battle* (Gettysburg, PA, 1995), 194.

[12] Smith, *Farms at Gettysburg: The Fields of Battle*, 35; Reports of Maj. Gen. David B. Birney, *OR* 27, pt. 1, 485.

[13] Ibid, 36.

[14] Harry W. Pfanz, *Gettysburg-The First Day* (Chapel Hill, NC, 2001), 264.

[15] Coco, *A Strange and Blighted Land—Gettysburg: The Aftermath of Battle*, 207-209.

[16] Ezra J. Warner, *Generals in Blue* (Baton Rouge, LA, 1964), 406–407.

[17] Denise Carper and Renae Hardoby, *The Gettysburg Battlefield Farmsteads Guide* (Gettysburg, PA, 2000), 58

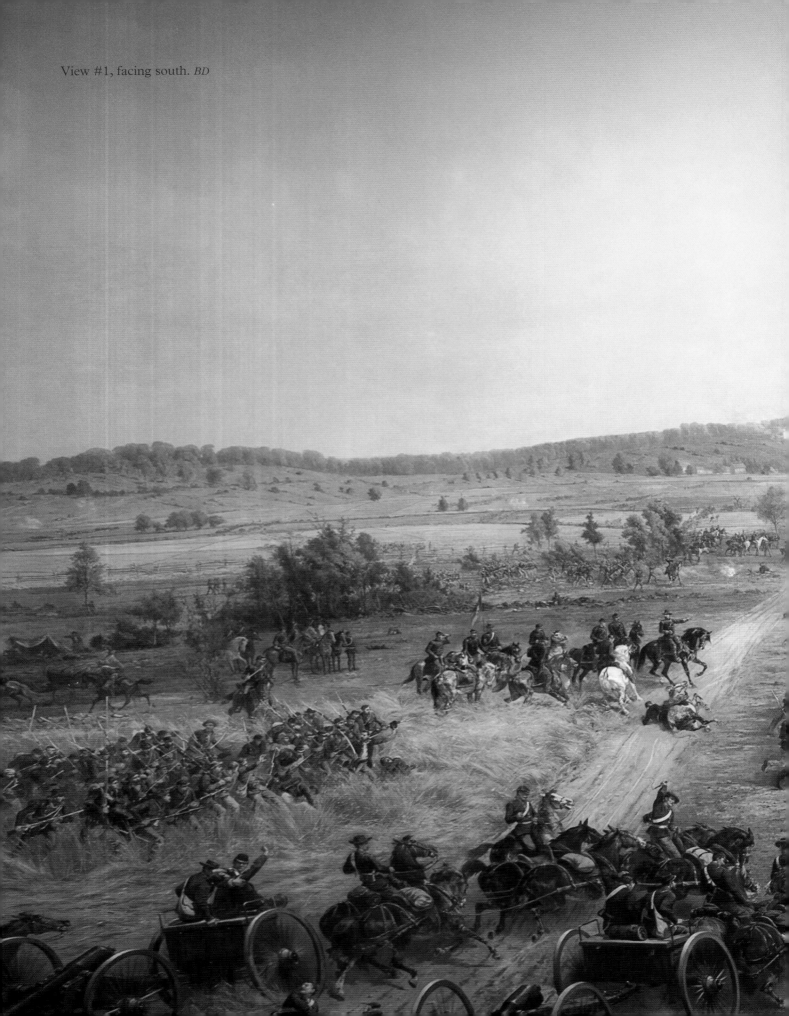

View #1, facing south. *BD*

❧ Notes on view #1 ❧
(facing south)

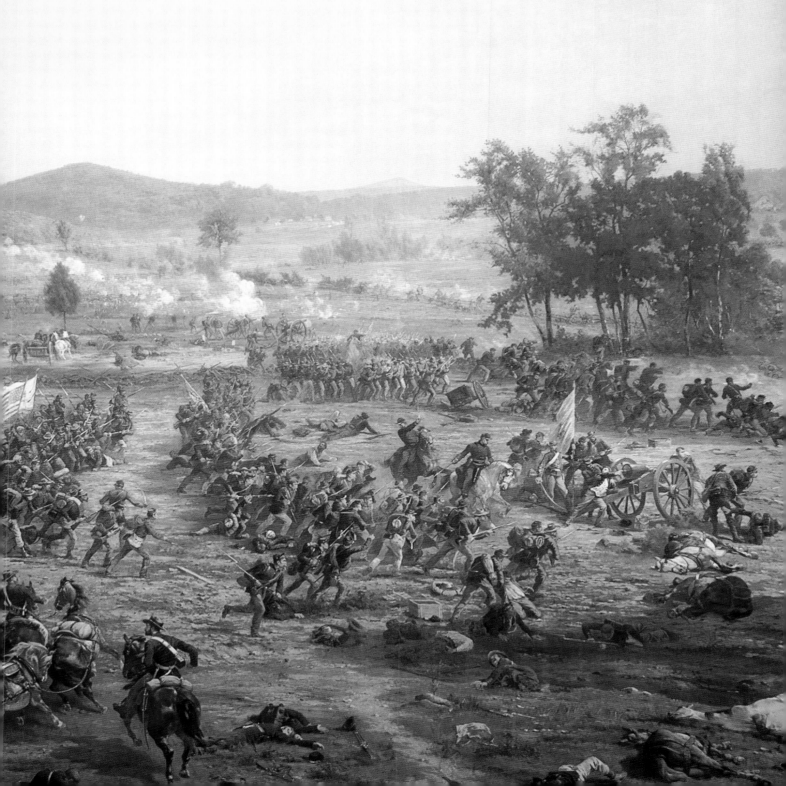

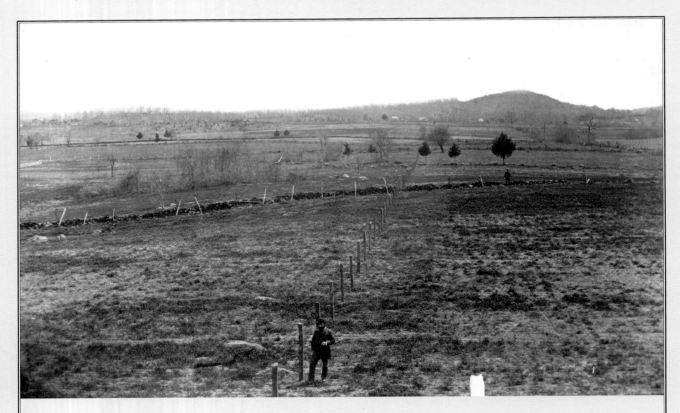

Tipton View #1 (1882). *SBC*

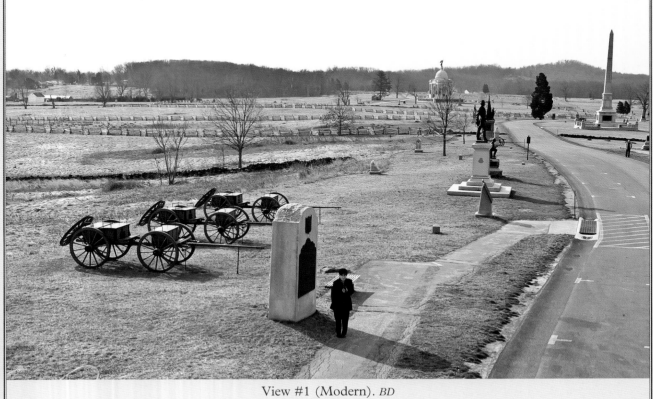

View #1 (Modern). *BD*

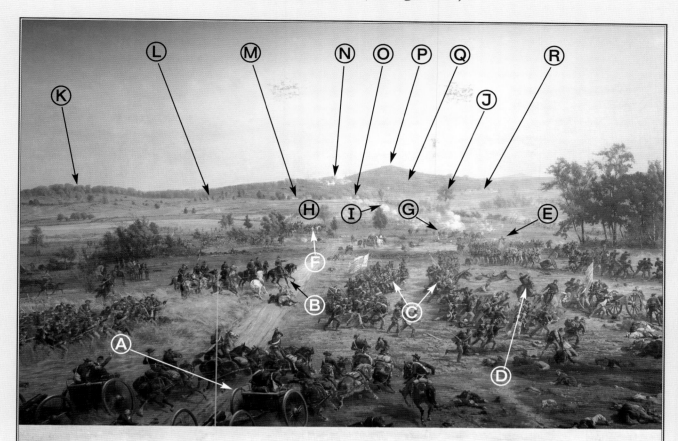

⇜ KEY ⇝

Ⓐ A Portion of Wheeler's 13th New York Battery Coming into Action

Ⓑ Major General Winfield Scott Hancock, Union II Corps Commander, and Staff

Ⓒ 19th Massachusetts Infantry Regiment Following the 42nd New York Infantry Regiment

Ⓓ Officer on a Brown Horse near Webb (Colonel Norman J. Hall)

Ⓔ Brigadier General John Gibbon, Commander of the 2nd Division, II Corps

Ⓕ Major General Abner Doubleday and Staff

Ⓖ Artillery Battery South of the Copse of Trees

Ⓗ Location of the Pennsylvania State Memorial

Ⓘ Artillery Line, Commanded by Lt. Col. Freeman McGilvery

Ⓙ The Gibbon Tree

Ⓚ Weikert's Hill

Ⓛ Munshower's Hill

Ⓜ George Weikert Farm

Ⓝ Little Round Top

Ⓞ John T. Weikert Farm

Ⓟ Big Round Top

Ⓠ Houck's Ridge

Ⓡ George Trostle Farm

Ⓐ A Portion of Wheeler's 13th New York Battery Coming into Action

In this area, an artillery battery can be seen moving to the south. Another section of this battery is also visible moving toward the viewer in View#9, A. A rider with this battery carries a *guidon* (small flag) which reads "NYSM, C" for New York State Militia, Battery C. However, this designation does not match any of the batteries that were present at Gettysburg. In the historic pictures from 1884, it is not possible to read the writing on the flag. This could be another detail that was changed in the painting in 1889, as discussed in Chapter 4. The Chicago key simply stated, "Artillery battery coming into action." The Philadelphia and New York keys labeled this unit as Wheeler's 13th New York Battery.

Older Gettysburg keys labeled this unit as Cowan's battery. Cowan's battery moved into this area near the end of the cannonade to replace Brown's battery (see G) which was badly damaged during the bombardment. However, Cowan was initially located in the area of the Pennsylvania monument, and would have moved into the area from the south.[1] Wheeler's battery was also sent to support the Union forces near the end of the cannonade, and they would have been

Detail of the painting showing an artillery guidon (NYSM, Battery C). *BD*

Detail of the painting showing Wheeler's battery. *BD*

Parrott rifle on the battlefield at Gettysburg. *BD*

3" Ordinance rifle on the battlefield at Gettysburg. *BD*

Bronze Napoleon on the battlefield at Gettysburg. *BD*

moving from north to south. Wheeler's battery was moved from a reserve position behind Cemetery Hill to the area of the Pennsylvania Monument (see H and I).[2] It is possible that the letters on the flag were not readable until the restoration was completed. The modern NPS key changed the designation back to Wheeler's battery.

All of the cannon depicted in the painting appear to be Parrott rifles. These guns were made of cast iron, with a wrought iron band around the rear of the barrel to give that area more strength. The rifled barrel gave these cannon better range and accuracy than smoothbore cannon. During his research, the artist visited Governor's Island and studied the arms and equipment used during the Civil War. It seems as though the Parrot rifle was the only type of cannon that he studied. In reality, none of the batteries in the historic keys actually used Parrott rifles. Wheeler's and Cowan's batteries would have used 3-inch Ordinance rifles. These guns were similar, but they were made entirely of wrought iron and did not have the reinforcing band at the rear of the barrel. Both types of iron rifles are painted black to keep them from rusting. Some of the other batteries depicted in the painting had smoothbore cannon. These cannon, mostly called Napoleons, were made of bronze, and would have been gold in color. Today, the bronze cannon on the field have turned green from exposure to the elements. When we see other batteries in the painting, we will note the actual type of cannon that was on the field July 3.[3]

Ⓑ Major General Winfield Scott Hancock, Union II Corps Commander, and Staff

General Hancock was one of the most important officers in the battle of Gettysburg. On the first day, he arrived at the end of the fighting and helped rally the defeated Union troops on Cemetery Hill. On the second day, Hancock sent reinforcements to threatened parts of the Union line at critical times. On the third day, his corps faced the brunt of the Southern attack. Paul Philippoteaux interviewed General Hancock as part of his research during the creation of the cyclorama.[4]

During the cannonade, he rode up and down the line to inspire his men. In his official report he stated that "the air was filled with projectiles, there being scarcely an instant but that several were seen bursting at once."[5] During the charge, he rode from the northern end of his line to the southern end where he was wounded (see J). In the painting, Hancock was shown pointing in the direction of his pre-war friend, General Lewis Armistead (see View #2, F). Because Hancock covered so much ground during the attack, the artist could have placed him at several different locations along the Union line. To be totally realistic, however, Hancock should be farther south at the moment of Armistead's wounding. We can attribute his position to artistic license. The artist obviously wanted the viewer to be able to clearly see such an important player in the action.

In subsequent versions of the painting

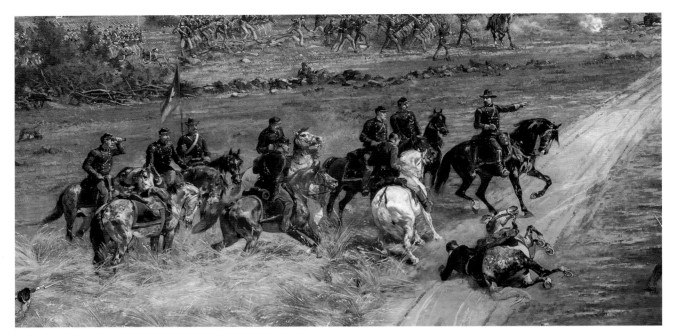

Detail of the painting showing General Hancock and staff. *BD*

(Philadelphia and New York), the artist moved General Hancock and his staff to the field of wheat directly east of the viewing platform. Hancock is in the position that is occupied by General Hunt in the Boston version (see View#9, D). In the New York version, Hancock's staff was identified as Major Mitchell, General Bingham, Colonel W. P. Wilson, Captain Miller and Captain Parker. In the souvenir photographs of the New York version of the painting, the faces of those officers can be more clearly distinguished than in the Boston version. The New York version was painted in the United States, just outside New York City. It is entirely possible that the officers either posed for or submitted pictures for Philippoteaux and his team to use during the creation of the New York painting.

In the official reports of the battle, Hancock cited

Major General Winfield Scott Hancock. *LOC*

several of these officers for gallantry. He noted "Maj. W. G. Mitchell, my senior aide-de-camp…who distinguished himself on several perilous occasions during the battle; Capt. I. B. Parker, aide-de-camp, and Capt. W. D. W. Miller, aide-de-camp, twice severely wounded on the 2d, behaved with their usual gallantry, and added to the esteem their fine conduct as gained for them on many fields."[6] Captain Miller was probably in the hospital on July 3, due to his wounds on July 2, so he should not be pictured in this scene.

General Hancock also cited "Capt. H. H. Bingham…behaved with great gallantry, and shared all the dangers of the field."[7] Captain Henry H. Bingham was the officer that found Hancock's friend Brig. Gen.

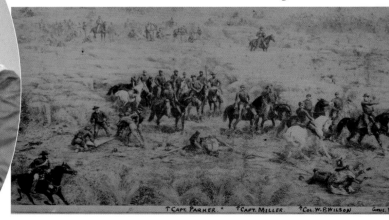

Souvenir photograph from the New York cyclorama showing General Hancock and staff with the staff officers' names written on collectors slide. *SBC*

Lewis A. Armistead after the battle. The severely wounded Armistead gave a Masonic signal for help, and Bingham came to his aid (see View #2, F). This scene is depicted today on the Masonic Friend to Friend Memorial in the National Cemetery Annex. It is also interesting that in the key, Bingham was listed as "General." Although he was a captain at the time of the battle of Gettysburg, he was promoted to general by the end of the war. In the 1880s when the cycloramas were first shown, he would have been known as General Bingham.[8]

Finally, General Hancock is one of the only officers in the painting who is not on a white horse, but in reality he did ride a light-colored horse. In Hancock's biography it says:

> As soon as the enemy's skirmishers made their appearance, General Hancock rode along the line to encourage the men and see that everything was in a state of preparation. It was quite remarkable that the General's favorite horse, one he had ridden in many battles, became so terrified by the roar of artillery that he seemed utterly powerless, and could not be moved by the severest spurring. The General was, therefore, obliged to borrow a horse from one of his staff—Captain Brownson. This was the horse; a very tall, light bay with a white nose, the General was riding when he was wounded.[9]

It is the author's opinion that horse color was chosen by the artist in order to highlight the officer. Most of the other officers are depicted at distant locations and mixed in with other troops (see E and F). Since General Hancock was already easily visible, the artist did not need to make him stand out any further.

Ⓒ 19th Massachusetts Infantry Regiment Following the 42nd New York Infantry Regiment

In most of the historic keys to the painting, these units were combined with the soldiers seen in View #0, B with only one number identifying the troops in this area. In the historic keys, both of these groups of men were supposed to represent parts of Colonel Hall's Brigade. It is difficult to determine exactly which unit was meant to be in which location because the keys changed from city to city. To further add to the confusion, the painting itself was also modified. In 1889 (see Chapter 4), extra flags were added to this part of the painting. Originally there were only two individual United States flags depicted: one here and one at View #0, B. As noted previously, a blue flag was added next to the national flags in View #0.

A white state flag was also added next to the national flag in this area. Since Massachusetts was the only state in this area with a white state flag, this unit must be the 19th Massachusetts.[10] Two flags were also added in front of the 19th Massachusetts. Since these flags are not unfurled, all that can be determined is that

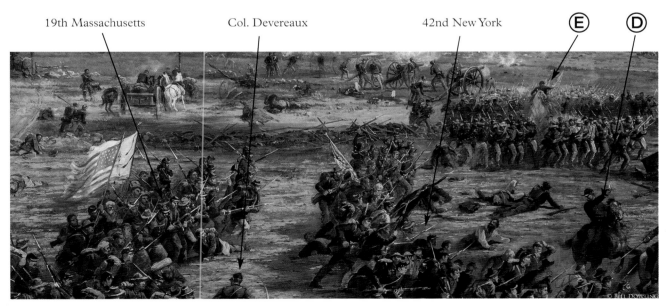

19th Massachusetts Col. Devereaux 42nd New York Ⓔ Ⓓ

Detail of the painting showing Hall's brigade. *BD*

Monument to the 19th Massachusetts at Gettysburg. *BD*

one is a blue state flag and the other is a United States flag. Most of the states in this part of the painting would have a blue state flag (Michigan, New York, and Pennsylvania) except Massachusetts. For this reason, flag color does not help our identification of this unit.

The Chicago key only named the 7th Michigan with Colonel Hall commanding (see View #0, B). The Philadelphia key listed "Colonel Hall," but does not identify which regiment he was leading. The New York key listed "3rd Div., 2d A.C., Col. Hall Com'dg. 19th Mass., Col. Devereaux com'dg, 42d New York, Col. Mallon, 7th Va., 7th Mich." This description errs in that Colonel Hall was actually only commanding 3rd Brigade of the 2nd Division of the 2nd Corps. Also, listing the 7th Virginia must be a typographical error. Hall's brigade included all the regiments listed above, plus the 59th New York and the 20th Massachusetts (and not the 7th Virginia, a Southern unit). Colonel Norman J. Hall was born in New York, so it is only natural that he is mentioned prominently in the New York key.

As discussed in Chapter 4, most of the changes to the Boston painting seem to match the descriptions in the New York key. The modern NPS designation matches the New York key, except the 42nd is in front of the 19th. On the key, the 19th Massachusetts is listed first. In reality and in the painting, the Massachusetts troops are following the New Yorkers, so the NPS key is historically accurate. The NPS description also matches the New York key in that the officers in command of these units are specifically named (Col. Arthur F. Devereaux of the 19th Massachusetts and Col. James E. Mallon of the 42nd New York). It is possible that the officer on foot, in front of the 19th holding a saber could represent Colonel Devereaux. In one of the most famous exchanges of the battle, Col. Devereux yelled to General Hancock, "See, General, they have broken through: the colors are coming over the stone wall: let me go in there." Hancock yelled back, "Go in there pretty God damned quick."[11]

Most of Hall's men would have been moving from south to north, not from east to west as they were shown in the painting. It is the author's opinion that they were depicted in this area for ease of viewing for the local audience. If the artist tried to put all of Hall's men approaching from the south, the Copse of Trees would block the view of these units. Many of these units moved directly through the Copse of Trees and would be hard to depict. The realistic depiction would also leave a fairly large area of the painting very close to the audience with no activity. Two of Hall's regiments, the 42nd New York and the 19th Massachusetts, were to the rear of the front line. These units would have approached the Angle heading northwest. By moving the position of these units slightly to the north, the artist has changed their heading to due west. This change would have also helped the artist fill up some dead space on the canvas. We will discuss the location of some of the other units in Hall's brigade in E and View #2, I.

Ⓓ Officer on a Brown Horse near Webb (Colonel Norman J. Hall)

This officer was listed as "General Gibbons [*sic*]" in the Chicago key. Brigadier General John Gibbon, however, would have been located farther to the south at the time of the High Water Mark. Starting with the Philadelphia key, Gibbon was listed as the officer on the white horse just to the south of this position (see E and J). There was no number for the officer on the brown horse in the Philadelphia key or the keys that were made in Gettysburg. On the New York key, this officer was labeled as "Gen. N. J. Hall, 19th Mass. & 42nd N.Y."

Although Norman J. Hall was only a Colonel at the time of the battle, the authors feel this is the more realistic designation for this officer. This label also fits with the positions of the units discussed in C and View #0, B.

Ⓔ Brigadier General John Gibbon, Commander of the 2nd Division, II Corps

General Gibbon was the commander of the 2nd Division of the II Corps (under General Hancock). He can be seen on a white horse, leading some of his men toward the Angle. The artist probably put the general on a white horse in order to make him more easily visible. Gibbon's three brigades were commanded by General Harrow, General Webb, and Colonel Hall. Gibbon's units were directly attacked by the

Brigadier General John Gibbon's statue at Gettysburg.
BD

Confederate division of General Pickett. General Gibbon was wounded in the neck just before the Confederates reach the High Water Mark. He was wounded south of the Copse of Trees near a tree that today is known as "the Gibbon Tree" (see J). This officer was identified as General Hays in the Chicago key, but this designation was clearly inaccurate. Brigadier General Alexander Hays and his men were located north of the Angle (View #5, #6, and #7). The Philadelphia key corrected this error, and labeled this officer as General Gibbon.

The New York key labeled these troops as "Gen. John Gibbons *[sic]* with 20th Mass. [Hall's brigade] & 19th ME [Harrow's brigade]." The exact designation of any unit in this area would be hard to determine. Units from Hall's brigade and Harrow's brigade were moving from south to north in order to stop a Confederate breakthrough. At this stage of the combat, soldiers from several different regiments were mixed together as they rushed northward to drive the Confederates out of the Angle. The front line units of Hall's brigade would have included the 20th Massachusetts, 7th Michigan, and the 59th New York. The second line of Hall's brigade would have been the 19th Massachusetts and the 42nd New York (as discussed in C). Brigadier General William Harrow's brigade included the 19th Maine, 15th Massachusetts, 1st Minnesota, and the 82nd New York. Since no exact regiment can be determined, let us simply state that you can see General Gibbon with a part of his division.

Ⓕ Major General Abner Doubleday and Staff

General Doubleday was the commander of the 3rd Division of the I Corps. Paul Philippoteaux interviewed General Doubleday as part of his research for the cyclorama. He can be seen on a white horse surrounded by his staff. Since the General is very far away, the white horse makes him much easier to identify.

General Doubleday's statue at Gettysburg. *BD*

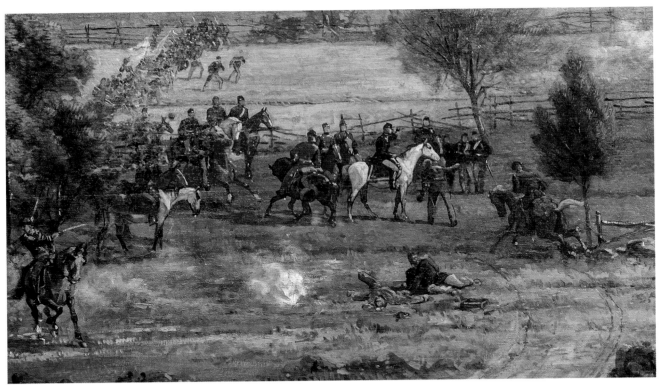

Detail of the painting showing General Doubleday (on a white horse) and staff. *BD*

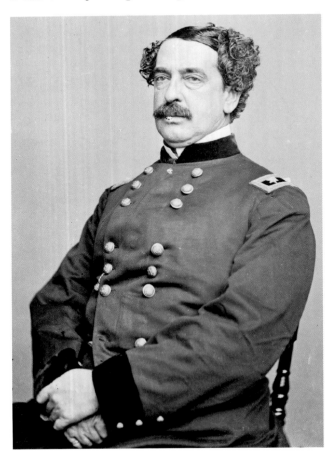

Major General Abner Doubleday. *LOC*

On July 3, Doubleday was in command of three brigades. The first two took heavy casualties on the first day of the battle. These brigades can be seen near the General in the painting acting as reserves. Doubleday's first brigade was commanded by Brig. Gen. Thomas A. Rowley. Doubleday's second brigade, under Col. Roy Stone, was commanded by Col. Edmund L. Dana because Stone was wounded on the first day of the battle.

General Doubleday's third brigade was a brigade of Vermont troops who were sent from Washington to bolster the Army of the Potomac. Under Brig. Gen. George J. Stannard, the brigade did not arrive until the second day of the battle. Because these troops were much fresher than Doubleday's other brigades, they were in a more advanced position at the start of Pickett's Charge (see View#2, M). The Vermont troops played an important role in repulsing Pickett's Charge. They pivoted to their right and fired into the flanks of Kemper's Confederate brigade. A few minutes later, they turned and attacked the Confederate brigades of Wilcox and Lang. We will describe this action in more detail in View #2 (see J, K, and L).[12]

Ⓖ Artillery Battery South of the Copse of Trees
There were two different batteries that occupied this area on July 3. At the start of the bombardment, Brown's 1st Rhode Island Light Artillery, Battery B, was in the area. This battery took severe losses on the second day of the battle, and was down to only four working guns on July 3. Lieutenant T. Fred Brown was wounded on July 2 and Lt. Walter S. Perrin was in command on July 3. The New York key described General Doubleday "in rear of R. I. Battery B." Brown's battery was composed of smooth-bore Napoleon cannon. These guns were made of bronze, and would have been gold in color. However, as noted in A, the artist only depicted one type of cannon in the painting. There was a famous incident during the cannonade where one of Brown's cannon was struck directly in the muzzle face by a Confederate shell. When the gunners tried to load the cannon, the shell got stuck in the end of the barrel. This shell became permanently lodged at the end of the barrel when the gun cooled. Today, this cannon is known as the "Gettysburg Gun," and is on display in the Rhode Island Statehouse in Providence.[13] By the end of the bombardment, this battery was almost totally destroyed.

Brown's battery was replaced by Capt. Andrew Cowan's battery (1st Battery, New York Light Artillery) sometime around the start of the infantry attack. Cowan's battery was comprised of six 3-inch Ordinance rifles. A famous incident from the battle is depicted in bas-relief on the side of their monument. At the height of the attack, units were rushed from the area south of the Copse of Trees into the Angle in order to push back the Confederates who had broken into the Union line (see E). When these troops vacated the stone wall in front of Cowan's battery, a squad of approximately forty Confederates, who had been pinned down in front of the Union line, saw an opportunity to seize Cowan's guns. As they charged toward the cannon, Cowan's men waited until the last possible moment and fired at their attackers at point-blank range. This massed canister fire annihilated the Confederate attackers. The inscription on the monument today reads "Double Canister at Ten Yards." For a visual representation of the effects of canister fire, see View # 5, C.

Another battery was located just south of this position, the 14th New York Battery. This battery was commanded by Capt. James M. Rorty and was comprised of four Parrott rifles. Rorty's battery was the

Ⓗ Location of the Pennsylvania State Memorial **Ⓘ** Artillery Line Commanded by Lt. Col. Freeman McGilverry

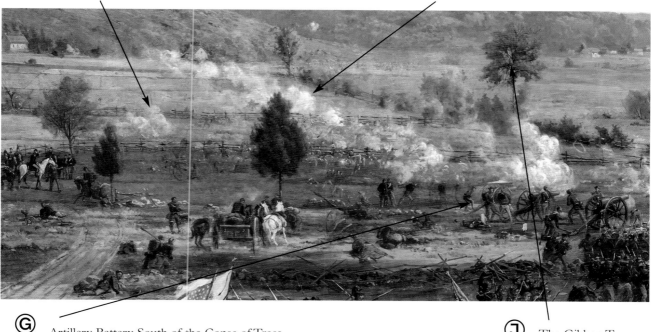

Ⓖ Artillery Battery South of the Copse of Trees **Ⓙ** The Gibbon Tree

Detail of the painting showing the area south of the Copse of Trees. *BD*

Detail of the plaque on the side of Cowan's battery monument. *BD*

only unit in the High Water Mark area that actually had Parrott rifles (see notes on A). Rorty's battery was severely damaged during the cannonade and charge. By the end, only one gun was still in action. Captain Rorty was killed and his replacement, Lt. Albert S. Sheldon, was also wounded during the fight.[14]

Ⓗ Location of the Pennsylvania State Memorial

The Pennsylvania State Memorial is located in this area today. In the modern pictures, you can see some woods to the east of the monument that are not present in the cyclorama. After the battle, the farmers cut down a lot of trees to repair their damaged fences and for other uses. As a result, there were fewer trees in the Tipton photographs than there were at the time of the battle.

The Pennsylvania State Memorial, modern. *BD*

Because of the scarcity of tree cover, some distant objects are visible in the painting that are not visible today (see K and O). Over the years, trees were left alone on the battlefield, and many areas of the park were overgrown with forests that were not there during the war. Starting in the 1990s, the NPS set out to return the foliage to its 1863 appearance. The tree cover today more accurately reflects the way the land would have looked at the time of the battle. Historic maps show a section of woods behind the Pennsylvania State Memorial that accurately matches what is present today.

Ⓘ Artillery Line, Commanded by Lt. Col. Freeman McGilvery

Starting in the area of the Pennsylvania Memorial and running south from there, the Union had a formidable line of artillery. A line of smoke created by these cannon firing can be seen in the painting. This line was commanded by Lt. Col. Freeman McGilvery (1st Volunteer Brigade, Artillery Reserve). McGilvery's artillery brigade was heavily engaged on the second day of the battle in the area around the Peach Orchard. On July 3, his guns were augmented by several other batteries from the artillery reserve and other corps. The positions of several batteries were shifted during the cannonade and Pickett's Charge. Both Cowan's battery and Wheeler's battery were moved into and out of this area at different times during the bombardment and the charge (see A and G). At any given time there were almost forty guns positioned in this area. When the Confederate infantry attack crossed the Emmitsburg Road, these cannon were in a perfect position to fire into the flank of Kemper's brigade (see View #2, H). This flanking fire caused many casualties on the right of Kemper's line. Later, when Wilcox and Lang

attacked, they headed straight toward this line of guns and were punished severely by artillery fire (see View #2, K).

Ⓙ The Gibbon Tree

This walnut tree is near the spot where General Gibbon was wounded in the shoulder during Pickett's Charge. The Licensed Battlefield Guides have passed down through the years that this is the very same tree that was present at the time of the battle.[15] Trees that can be proven to still stand are called "Witness Trees." There are no photographs from 1863 that clearly show this area or this tree. Some of the first photographs of this area were the ones taken by Tipton as part of the cyclorama creation process. A detailed examination of the Tipton photographs shows that this tree is clearly visible. The tree is fairly large and probably more than 19 years old. Thus the Tipton photographs seem to support the local guide lore.

General Hancock was wounded to the south of this tree as he was watching the Vermont troops attack the flank of Kemper's brigade. Today, there is a marker that denotes the site of Hancock's wounding on the west side of Hancock Avenue, south of the Gibbon Tree.

Ⓚ Weikert's Hill

This hill is not commonly mentioned in the different accounts of the battle. It was behind the lines and no fighting occurred there. It was owned by George Weikert, who had a nearby farm (see M). As discussed in H, there were more trees in this area in 1863 than in 1882 when the Tipton photographs were taken. The modern views of this area show that the NPS has restored the tree cover to its 1863 appearance.

The Gibbon tree, modern. *BD*

In the painting, numerous troops can be seen heading from this area toward the High Water Mark to assist in repulsing Pickett's Charge. Although the attack was repulsed before they could arrive, these troops represented thousands of men that the Confederates would have had to deal with. Most of these men would have been from Sedgwick's VI Corps of the Union army. Among these reinforcements, there would also

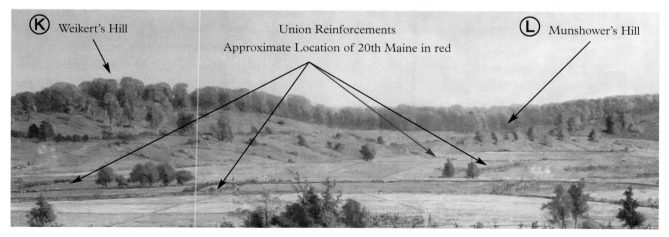

Detail of the painting showing Weikert's Hill and Munshower's Hill. *BD*

have been troops from the III and V corps as well. Today, the New Jersey Brigade (VI Corps, 1st Division, 1st Brigade) has a large monument on the north side of this hill.

Ⓛ Munshower's Hill

This small hill was part of the property of John Munshower. The Munshower farm was on the east side of the hill and is not visible in the painting. Major General John Sedgwick set up his VI Corps Headquarters in this area. Today, Sedgwick's equestrian monument and headquarters marker are located on this hill, which is sometimes called "Sedgwick's Knoll." The Chicago and Philadelphia keys denoted "General Sedgwick's Headquarters" in this area.

Visitors to the cyclorama frequently ask if you can see Colonel Joshua L. Chamberlain of the 20th Maine in the painting. In the book *The Killer Angels*[16], Chamberlain was depicted inside the Angle on Day 3 of the battle. In truth, the 20th Maine was moved from Big Round Top (see P) slightly closer to the center of the Union line, but not the whole way to the Angle. At the time of Pickett's repulse, Chamberlain would have been with the troops that can be seen in this area. Unfortunately, all of the units near Munshower's Hill are too small to identify individual regiments or brigades.

Ⓜ George Weikert Farm

The George Weikert farm still stands and is kept in its 1863 condition by the National Park Service. George's son, John, lived on a farm to the south and slightly to

Major General John Sedgwick. *LOC*

the west of his property (see O). The two farms were connected by a farm lane. [17] In the painting, there appears to be some additional buildings behind the George Weikert farm. These buildings probably represented the Masonheimer farm which was built after the war along the farm lane that connected the two Weikert farms. Since the Masonheimer farm was directly south of the George Weikert farm, the buildings seem to be part of the same farm. The Masonheimer farm is no longer in existence, but the remains of the foundation can still be found.[18]

Modern view of Munshower's Hill. *BD*

Ⓝ Little Round Top

Little Round Top was the scene of heavy fighting on the second day of the battle. On July 3, Union troops were firmly in control of this hill. Smoke can be seen on the crest of the hill coming from a Union artillery battery. This battery was under the command of Lt. Benjamin F. Rittenhouse. The original commander, Lt. Charles E. Hazlett, was killed on July 2 by a sharpshooter. Artillery shells from these guns were able to hit men from Pickett's division during the charge.

A signal flag is visible on the crest of Little Round Top. Messages from this signal station were sent to Cemetery Hill throughout the second and third day of the battle.[19] Before the restoration, it was very hard to see such intricate details. Today, you can see the flag on Cemetery Hill that would have received these messages (see View #7, K).

The historic keys went into more detail about the actions on Little Round Top. The Philadelphia key labeled this hill as "Summit where Generals Weed, Vincent, Colonel O'Rorke, and Lieutenant Hazlett were killed." All of these officers were killed or mortally wounded in the heavy fighting on July 2. Brigadier General Stephen H. Weed, like Lt. Hazlett, was killed by a sharpshooter on the second day. General Vincent was actually Col. Strong Vincent, who was posthumously promoted for his bravery at Gettysburg. The Chicago key listed all these officers and also mentioned the death of Colonel John Wheeler of the 20th Indiana. Colonel Wheeler was actually killed on Houck's Ridge (see Q) on July 2. This reference to Colonel Wheeler and his Indiana troops is another example of marketing the painting to the Midwestern audience.

Detail of the painting showing signal flags on Little Round Top. *BD*

The New York key specifically noted that Col. Patrick O'Rorke was in command of the 140th New York Regiment, a further illustration of local appeal. Of note, too, was that the New York key made references to the 20th Maine. There was a second number in the area of Little Round Top that mentioned "General Chamberlain and 20th ME. / Adams, Billings, and Linstead *[sic]* Killed." This reference was to the actions of the 20th Maine on July 2, commanded by Colonel Joshua Lawrence Chamberlain. The monument to the 20th Maine lists the soldiers who were killed or mortally wounded during the battle. On this list you can find Private Aaron Adams, Captain Charles Billings, and 1st Lieutenant Arad Linscott (probably misspelled on the key).

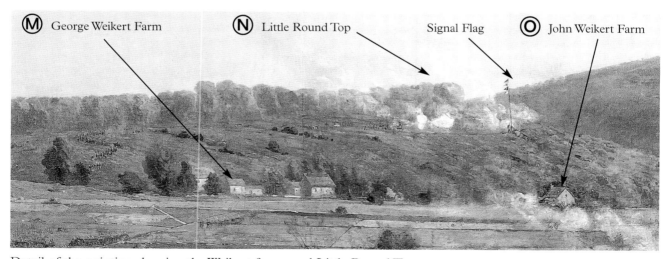

Ⓜ George Weikert Farm Ⓝ Little Round Top Signal Flag Ⓞ John Weikert Farm

Detail of the painting showing the Weikert farms and Little Round Top. *BD*

By the end of the war, Chamberlain attained the rank of General. He was also the Governor of Maine after the Civil War and would have been a well-known figure at the time the cycloramas were displayed, especially in the New England states. As discussed in Chapter 4, many of the suggestions that were made on the platform of the Boston painting about New England units were incorporated into the New York key.

Ⓞ John T. Weikert Farm

John Weikert was the son of George Weikert (see M). [20] This farm is no longer in existence. However, a newer farm was built soon after the war just east of the location of the John Weikert farm. This farm, sometimes called the Althoff farm, is still standing and is kept in its historic condition by the National Park Service. The Althoff farm's yellow house is just north of the Wheatfield Road across the road from the start of Crawford Avenue. A farm lane ran through some woods connected the two Weikert farms.[21] These woods were present in 1863, but were much smaller at the time of the Tipton photographs in 1882. In the painting, these two farms appear to be about the same distance away from the viewer. In reality, the John Weikert farm was about a quarter mile to the south. In the Tipton photographs, the artist could not tell exact distances of faraway objects. For this reason, the artist probably did not know to make John's farm farther away than George's. Today, the National Park Service maintains the historic tree lines. Because of these trees, the Altoff farm is not visible in the modern photographs.

Ⓟ Big Round Top

Big Round Top is one of the most prominent landmarks on the battlefield. Because it was heavily wooded at the time of the battle (and still is today), it was not a good military position. Cannon could not fire from its summit without removing numerous trees. On the second day of the battle, Confederate forces crossed Big Round Top on their way to attack Little Round Top. After the Confederate attacks were repulsed, Union forces occupied this hill for the remainder of the battle.

Ⓠ Houck's Ridge

This ridge runs southward from the eastern edge of the Wheatfield to the Devil's Den. There are some woods on this ridge and the north side of the Wheatfield that obscure our view of Devil's Den and the Wheatfield (see View #2, N). This area was the scene of heavy fighting on July 2. The area between Houck's Ridge and Little Round Top is now known as the Valley of Death.

The historic keys made several references to these distant areas. The Chicago key noted the "Grand Repulse of Longstreet by Penn. Reserves and Bucktails." Other keys noted Devil's Den (Philadelphia key) and the Valley of Death (Old Gettysburg key). The New York key also mentioned the 12th New Hampshire, 3rd and 4th Maine, as well as the 9th, 18th, 22nd, and 32nd Massachusetts. All of these units saw action in this general area on the second day of the battle. This seems to be another example of the New York copy using suggestions from the Boston audience.

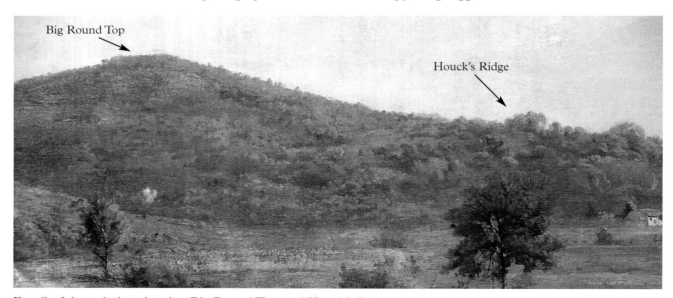

Detail of the painting showing Big Round Top and Houck's Ridge. *BD*

The New York copy also mentioned General A. P. Martin and Lieutenant A. Walcott. The authors were initially puzzled as to why the promoters mentioned these relatively obscure officers. At Gettysburg, Capt. Augustus P. Martin was the Chief of Artillery for the V Corps.[22] After the war he was promoted to General, so his title is accurate for the cyclorama viewers of the 1880s. In 1884, Martin was the mayor of Boston, so he would have been a well-known figure. The authors found his name listed in the Boston souvenir program as one of the veterans of the battle who had visited the painting.[23] Many of the viewers on the Boston platform may have asked about General Martin's location. In order to get mentioned in the key, it seems as though your status in 1884 was sometimes more important than your status in 1863.

At Gettysburg, Lieutenant Aaron Walcott commanded the 3rd Massachusetts Light Artillery, Battery C (5th Corps). Walcott's battery monument is along the driveway of the John Weikert farm (O). Like the other New England units listed, Walcott was probably mentioned because of his battery's Massachusetts ties.

Ⓡ George Trostle Farm

This farm was built after the battle by George Trostle, the son of Abraham and Catherine Trostle (see View #2, O)[24]

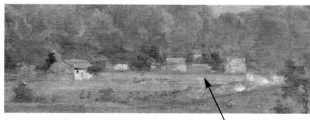

Detail of the painting showing the George Trostle farm. *BD*

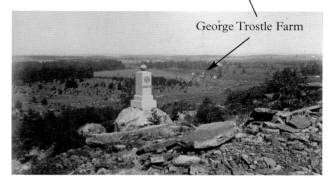

George Trostle Farm

George Trostle farm from Little Round Top. *Adams County Historical Society*

The George Trostle farm no longer exists. If it was still standing, it would be located on the north side of the Wheatfield road just across the road from the start of Ayres Avenue. This farm was visible in many of the historic photographs of the monuments taken from the crest of Little Round Top. Since this farm was not there at the time of the battle it should not be seen in the cyclorama painting. The artist, however, was not aware of these facts. Since it can be clearly seen in the 1882 Tipton photographs, the artist included it in the painting.

[1] Brown, *Cushing of Gettysburg*, 240.

[2] Report of Lieut. William Wheeler, *OR* 27, pt. 1, 753.

[3] Cole, *Civil War Artillery at Gettysburg: Organization, Equipment, Ammunition, and Operations*, 87-94.

[4] Interview with Paul Philippoteaux, *The New York Times*, May 14, 1882.

[5] Report of Major-General Winfield Scott Hancock, *OR* 27, pt. 1, 373

[6] *Ibid*, 376.

[7] *Ibid*.

[8] Roger D. Hunt and Jack Brown, *Brevet Brigadier Generals in Blue* (Gaithersburg, MD, 1990), 54.

[9] Almira R. Hancock, *Reminiscences of Winfield Scott Hancock* (New York, NY, 1887), 209.

[10] Editors of Time-Life Books, *Echoes of Glory, Arms & Equipment of the Union* (Alexandria, VA, 1998), 257.

[11] Laino, *Gettysburg Campaign Atlas*, 349; Trudeau, *Gettysburg: A Testing of Courage*, 499).

[12] Report of Major-General Doubleday, *OR* 27, pt. 1, 258-259.

[13] Frederick W. Hawthorne, *Gettysburg: Stories of Men and Monuments as Told by the Battlefield Guides* (Gettysburg, PA, 1988), 114-115.

[14] Report of Capt. John G. Hazard, *OR* 27, pt. 1, 477-481.

[15] Frederick W. Hawthorne, "140 Places Every Guide Should Know, Part 3," gettysburgdaily.com entry.

[16] Michael Shaara, *The Killer Angels* (Avenel, NJ, 1994), 201-202.

[17] Smith, *Farms at Gettysburg: The Fields of Battle*, 29.

[18] Personal observations from Tim Smith, Chris Brenneman, and Bill Dowling.

[19] Col. Bill Cameron, "The Woods are Full of Them, the Signal Corps at Gettysburg," in *Gettysburg Magazine* (July 1990), Issue 3, 9-15.

[20] Smith, *Farms at Gettysburg: The Fields of Battle*, 29.

[21] Examination of the Tipton photographs with the aid of Timothy H. Smith; gettysburgdaily.com, "The Weikert Lane from United States Avenue to the Wheatfield Road."

[22] Report of Capt. Augustus P. Martin, *OR* 27, pt. 1, 659-661.

[23] Souvenir Program, Boston, *Cyclorama of the Battle of Gettysburg*.

[24] Smith, *Farms at Gettysburg: The Fields of Battle*, 25.

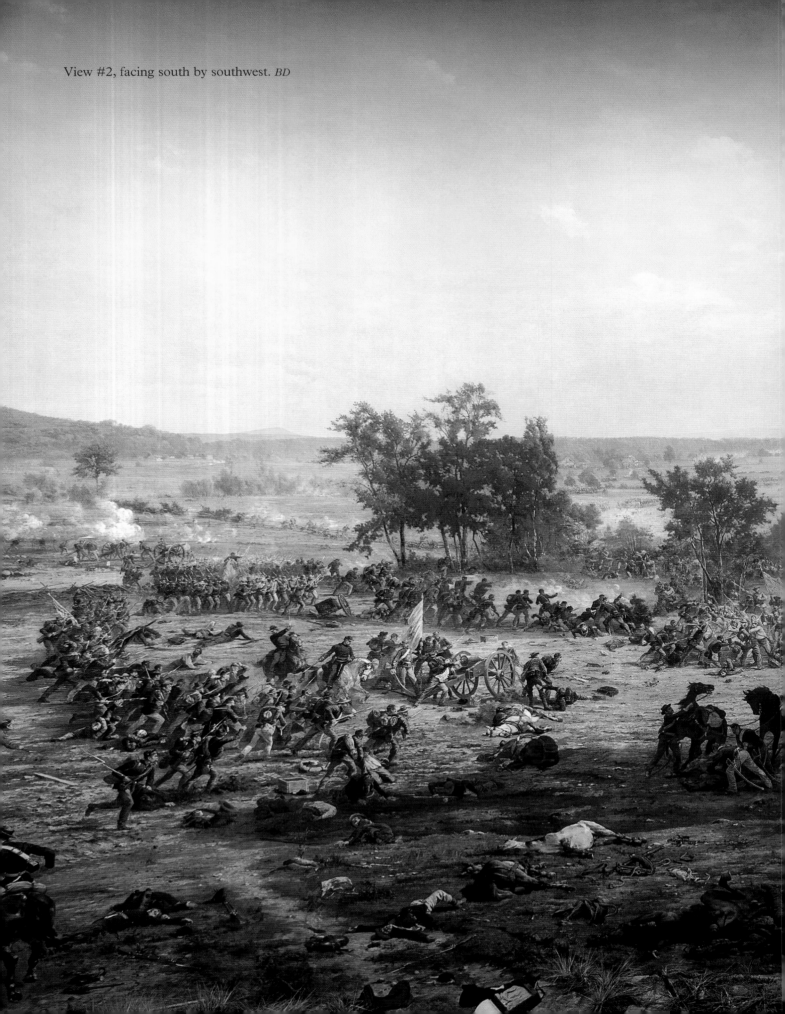

View #2, facing south by southwest. *BD*

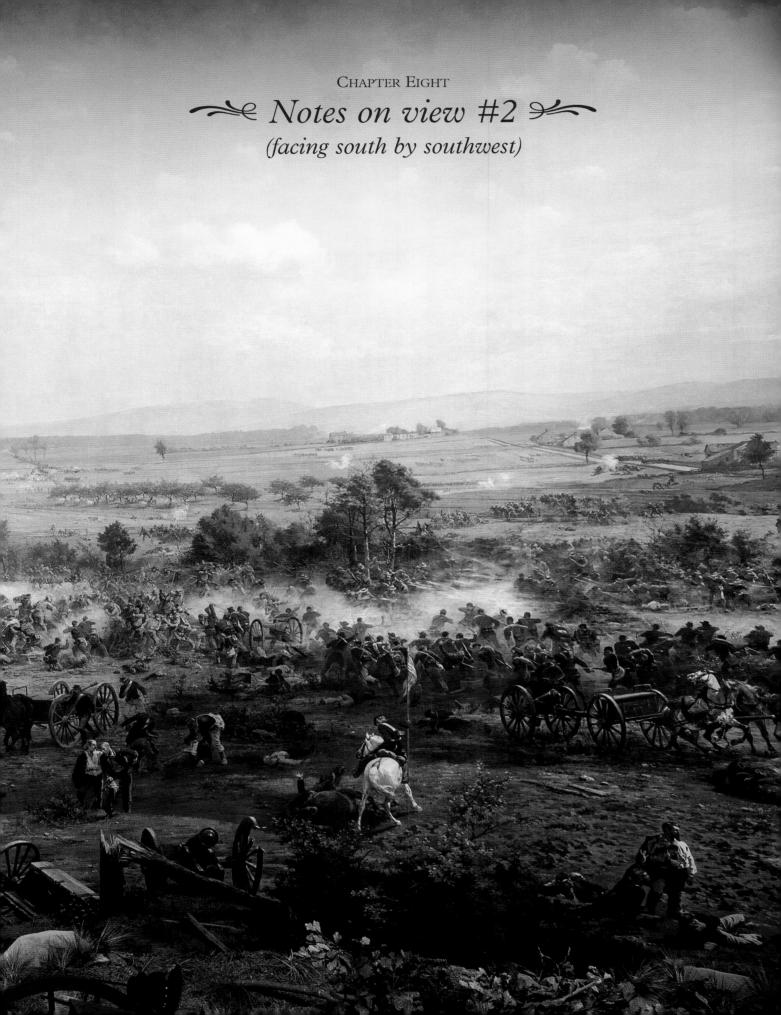

Notes on view #2

(facing south by southwest)

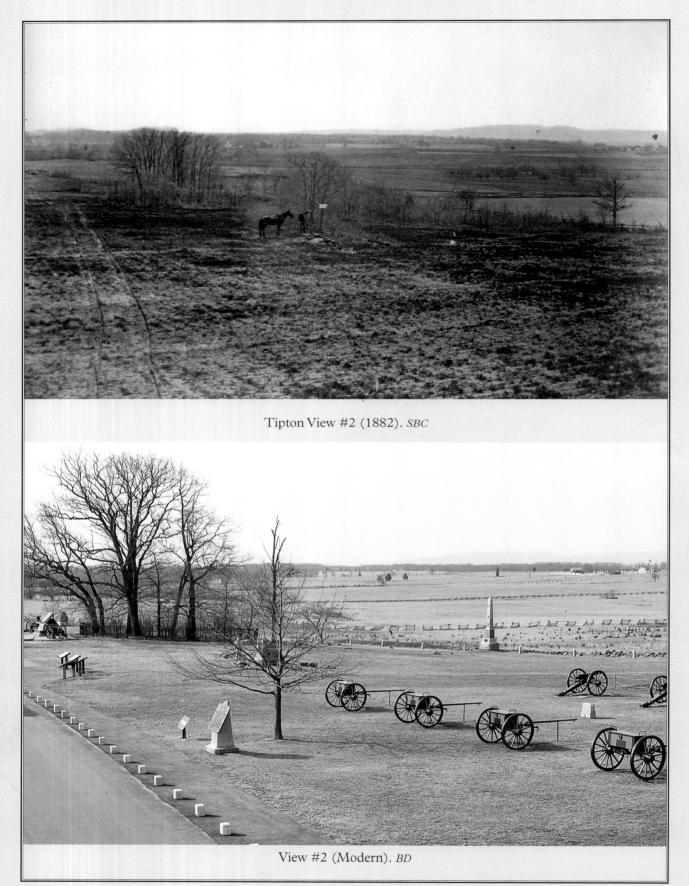

Tipton View #2 (1882). *SBC*

View #2 (Modern). *BD*

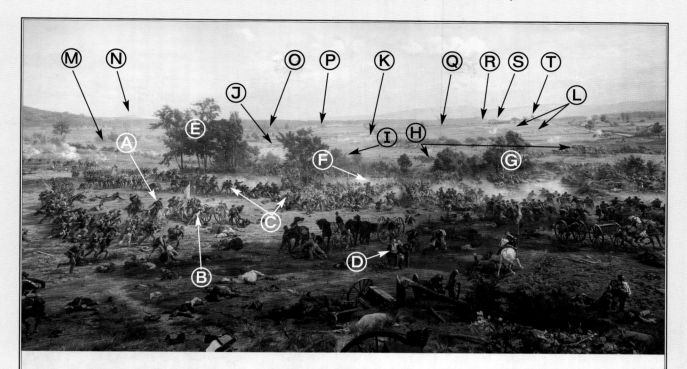

⧼ KEY ⧽

(A) Brigadier General Alexander S. Webb, Commander of the 2nd Brigade, 2nd Division, II Corps

(B) Death of Lt. Alonzo H. Cushing, Battery A, 4th U.S. Artillery

(C) Union Troops Engaged in the Angle

(D) Bird Brothers, Peter and Robert

(E) Copse of Trees

(F) Mortal Wounding of Confederate General Lewis Armistead, Brigade Commander, Pickett's Division

(G) 69th Pennsylvania Infantry Regiment

(H) Kemper's Brigade

(I) Unknown Unit in Front of the Stone Wall

(J) Stannard's Vermont Brigade

(K) Wilcox and Lang Engaged

(L) Wilcox and Lang Advance

(M) Codori/Trostle Thicket

(N) Distant Ridges and Hills

(O) Peter Trostle Farm (Abraham & Catherine Trostle)

(P) George Rose Farm

(Q) The Peach Orchard

(R) Site of the Wentz House

(S) Sherfy Barn (Joseph Sherfy Farm)

(T) Daniel Klingle Farm

Ⓐ Brigadier General Alexander S. Webb, Commander of the 2nd Brigade, 2nd Division, II Corps

General Webb commanded the Philadelphia Brigade, which was positioned in the Angle on July 3. His brigade consisted of the 69th, 71st, 72nd, and 106th Pennsylvania. All of these units can be seen in the painting (see C, G, View #0, B, and View #3, E). Webb's brigade was hit head-on by General Pickett's Confederate division. In the painting, General Webb can be seen near Lt. Alonzo H. Cushing (See B). General Webb is the officer riding a white horse, wearing a red sash.

General Webb received the Congressional Medal of Honor for his role in repulsing the Confederate attack on July 3.[1] The artist interviewed General Webb during his research for the painting. After the war, he served as the President of the College of the City of New York. Later, when the New York version of the cyclorama opened, Webb wrote a testimonial about the painting. In his testimonial he said, "It is as near perfection as possible." A copy of this testimonial, written on the letterhead of the College of the City of New York, is on display at the Gettysburg Visitor Center.[2]

Ⓑ Death of Lt. Alonzo H. Cushing, Battery A, 4th U.S. Artillery

Lieutenant Cushing was the commander of the 4th United States Light Artillery, Battery A. This battery was comprised of six three-inch Ordinance rifles. His guns were not Parrott rifles, which are depicted in the painting (see View #1, A). Cushing's guns were defending the Angle which would become the focus of the massive artillery bombardment that preceded the Confederate infantry assault. When the Confederate cannonade began, almost 150 enemy cannon were firing toward Cushing and his men. During almost two hours of continuous bombardment; Lt. Cushing and his men bravely returned fire. At three different times, cannon wheels were hit and had to be replaced. By the end of the bombardment, only two of the original six guns were fit for service. Most of Cushing's limber chests and caissons were destroyed (see View #3, G). Dozens of his artillery horses were killed or maimed. Near the beginning of the

Above: Detail of the painting showing General Webb and Lieutenant Cushing. *BD*

left: Brigadier General Alexander S. Webb. *LOC*

cannonade, Cushing sent three of his caissons to the rear for safety (see View #0, C). These caissons returned just before the infantry attack to resupply the guns.[3] Cushing himself was hit twice by shell fragments during the bombardment. He was hit in the shoulder, and then suffered a painful wound to the abdomen and groin area. These wounds appeared to be mortal, but Cushing refused to leave his post. He was so weakened by his wounds that he had to lean on a Sgt. Frederick Fuger for support.[4]

When the infantry assault began, Cushing moved his two remaining guns to the wall at the western side of the Angle. As the Confederates approached the wall,

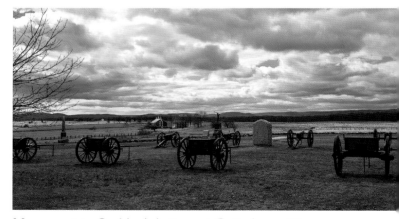

Monument to Cushing's battery at Gettysburg. *BD*

Cushing's guns blasted them at point blank range. Finally, as his guns were about to be overrun, Cushing was hit in the face by a bullet and killed instantly.[5] In 2014, Alonzo Cushing was finally awarded the Congressional Medal of Honor for his actions at Gettysburg.

In the painting, we can see Cushing clenching his wounded abdomen. This scene illustrates the fact that there is very little blood in the painting. The artist did not wish to shock his Victorian audience with blood and gore. However, it is a testament to the skill of the artist that he could convey the idea of violence and strife without showing the gory details. Cushing can be seen being supported by one of his men, pointing toward the oncoming Confederates. The soldier supporting Cushing is presumably Sgt. Fuger. There is some artistic license in this scene. Cushing was killed as the Confederates surged over the wall into the Angle. Several minutes later, General Armistead was mortally wounded. The artist moved Cushing back (to the east) so we can see the famous incident of his death, and still see the Confederate forces inside the Angle at their farthest point of penetration.

Some of the historic keys mentioned the death of Cushing and then mentioned other officers who were killed nearby. Some of these officers were killed on other days of the battle, and not in the area of the Angle. The New York Key mentioned "Gen. Ward, Cols. Merrill, Willard, and Paul Revere all killed near by." The Chicago key also added "Cols. Ellgood and Cross" to this list. Colonel George H. Ward, commander of the 15th Massachusetts, was killed on July 2 near the Codori farm (see View #3, H). Colonel Ward was posthumously promoted to the rank of brigadier general for his actions at Gettysburg.[6] Colonel Merrill was probably a typographical error. The only Colonel Merrill in the battle (Lt. Col. Charles E. Merrill) was not killed or wounded. Colonel Merrill commanded the 17th Maine (III Corps) and was engaged in the Wheatfield on day 2. However, Col. Eliakim Sherrill was killed on July 3 just north of the Angle (commanding Willard's brigade of Hay's division, II Corps). Colonel George L. Willard was killed on July 2 in the Codori/Trostle thicket (see M).[7] Colonel Paul J. Revere, commander of the 20th Massachusetts, was killed just south of the Copse of Trees by artillery fire on July 2 (see E).[8] Colonel Revere was the grandson of Paul Revere of Revolutionary War fame. The authors could not find a record of a Colonel Ellgood; however, Capt. Martin W. B. Ellegood was mortally wounded on July 2. Captain Ellegood was leading a detachment of the 1st Delaware that fought in the area of the Bliss barn (see View #5, D).[9] Finally Col. Edward E. Cross, commander of the 1st Brigade, 1st Division, II Corps, was killed on July 2 near the Wheatfield (see View #1, Q). Even though many of these officers were not killed "near by," the references to fallen officers in the historic keys seem to be attempts to market the painting to as many viewers as possible.

It is also interesting to note the yellow flag near Cushing. The artist made some mistakes with the depiction of flags (see View #0, B and View #3, D). This type of flag was used by the heavy artillery units that were converted into infantry by General Ulysses S. Grant in 1864. Instead of a large yellow flag, the artillery units at Gettysburg would have had smaller flags called guidons (see View #1, A).[10]

© Union Troops Engaged in the Angle

In this area of the painting, Union troops can be seen engaging the Confederates who are breaking into the Angle. Most of these troops would have belonged to the Philadelphia Brigade commanded by General Webb (69th, 71st, 72nd, and 106th Pennsylvania). The historic keys did not have specific designations for any of Webb's regiments except for the 71st Pennsylvania, which can be seen clearly in the painting to the north of this area (see View #3, E). The exact location of the other regiments is open to interpretation. In addition, the artist took some license in order to show as much action as possible. We will describe the actions of the other regiments and give the most probable location of the men from these units.

As the Confederates overran Cushing's battery, a temporary gap was created in the Union line at the stone wall. To the left of Cushing, by the Copse of Trees, the 69th Pennsylvania held on stubbornly to the stone wall. As the Confederates rushed into the Angle, the 69th was forced to bend back its right flank to avoid being totally surrounded (see G). Some of the companies on the right of the regiment were swept into hand-to-hand combat in the center of the angle. The Union troops engaged in the vicinity of General Armistead (see F) would include some of the companies from the right of the 69th Pennsylvania in addition to the gunners from Cushing's battery.

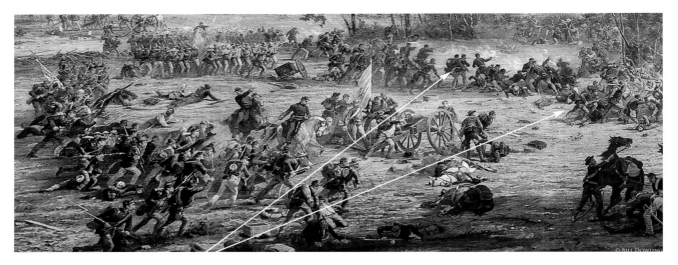

Detail of the painting showing parts of the 106th and 69th Pennsylvania Infantry assisting the gunners of Cushing's battery in hand-to-hand combat. *BD*

South of Cushing and his last gun, a part of the 106th Pennsylvania would have been engaged. Only three companies of the 106th would have been present (about 100 men) at the time of the Confederate breakthrough. The rest of the regiment was detached to Cemetery Hill on the evening of the 2nd.[11] The troops from the 106th Pennsylvania were probably involved in hand-to-hand combat closest to the Copse of Trees.

The final unit, the 72nd Pennsylvania, is more difficult to pinpoint. When the charge began, they were located behind (east of) Cushing's battery. In order to prevent a Confederate breakthrough, the 72nd Pennsylvania held its position at the crest of Cemetery

Ridge and traded fire with the Southerners who were over the wall. General Webb urged them to charge into the Angle, but they didn't recognize him and refused; he had only been in command of this brigade for a short time. At that moment, Colonel Hall's men from the 42nd New York and 19th Massachusetts charged into the Angle. Following, the 72nd charged into the melee and helped to drive the Confederates out of the Angle.[12] Hall's men would have been ahead of the Pennsylvanians' left flank.

Modern keys place the 72nd Pennsylvania behind the 42nd New York and the 19th Massachusetts (see View #0, B). The New York and Massachusetts troops did get into the angle in front of the left wing of the

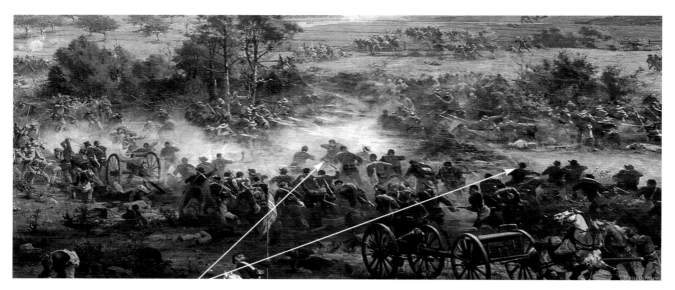

Detail of the painting showing parts of Webb's brigade in the Angle, possibly including the 72nd Pennsylvania. *BD*

72nd. However, these two regiments were never in a line parallel to, and in front of, the 72nd as depicted in the painting.[13] The historic keys designated the units in View #0, B as part of Hall's brigade. They did not have a listing for the 72nd Pennsylvania. It is possible that the artist meant to include the 72nd Pennsylvania with the troops involved in hand-to-hand fighting in the Angle. The artist took some license in order to show as much action as possible. Depending on what moment in time the artist was trying to depict, the interpretation of this area could vary. He may have wanted to keep some of the details vague so that the viewer could imagine a variety of incidents.

Ⓓ Bird Brothers, Peter and Robert

Peter and Robert Bird of the 24th Michigan were wounded on the first day of the battle fighting with the famous Iron Brigade. They would not have been in the Angle at the climax of Pickett's Charge. When Paul Philippoteaux and some of his assistants visited Gettysburg in 1882 to prepare for the cyclorama painting, the Bird brothers were also in town. The artist or one of his assistants made a sketch of the Bird brothers, and they were painted into all four versions of the Gettysburg cyclorama.[14] Interestingly, the Bird brothers are facing the viewers of the painting. They have their backs turned to the violent action that is happening right behind them. The artist depicted other specific individuals in the painting with a similar orientation (see View #3, B and View #5, A).

Detail of the painting showing Peter and Robert Bird of the 24th Michigan. *BD*

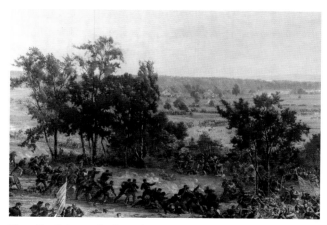

Detail of the painting showing the Copse of Trees. *BD*

The Copse of Trees, modern. *BD*

Ⓔ Copse of Trees

The Copse of Trees seemed to have been the visual aiming point for the Confederates on July 3. As they crossed the fields, their attacking lines seemed to converge toward this area. In 1863, this clump of trees covered more area than it does today. On the west side of the Copse, there were small trees and bushes that are sometimes called "the slashings" in the accounts of the battle. These "slashings" went from the Copse of Trees westward to the stone wall. They also continued along the wall for approximately another 100 feet north of the Copse of Trees. In the painting and historic pictures, you can see the slashing in these areas, and because of it, the 69th Pennsylvania, which was behind the stone wall west of the Copse, is almost totally obscured from view (see G).

By comparing the 1882 and modern photographs, we can see that the Copse of Trees is still in the same location. However, the trees themselves are about three

times taller than in 1882. Very few pictures were taken of this area immediately after the battle. We do not know if these are the exact same trees that were there in 1863.[15] It is probably safe to say that the trees today are at least the descendants of the original trees, if not actual "Witness Trees" (see View #1, J).

Today, there is an iron fence that protects the Copse of Trees. On the east side of the trees, there is a monument that commemorates the High Water Mark of the Confederacy. This monument looks like a large open book, and it lists all the units that were involved in the charge on July 3.

Ⓕ Mortal Wounding of Confederate General Lewis Armistead, Brigade Commander, Pickett's Division

Brigadier General Lewis A. Armistead was the commander of one of the three brigades that made up Pickett's Confederate division. The front line of the attack was comprised of Brig. Gen. James L. Kemper's brigade and Brig. Gen. Richard B. Garnett's brigade (with Kemper on their right). In support, General Armistead's brigade was behind Garnett. At the climax of the attack, General Armistead led several hundred of

his men over the stone wall into the Angle. In the painting, we can see General Armistead being mortally wounded near the farthest point of the Confederate breakthrough. This area, and moment in time, has come to be known as the "High Water Mark of the Confederacy" and is the focus of the painting.

Before the war, General Armistead was friends with Union General Hancock (see View #1, B). It is ironic that these two generals were fighting against each other at one of the most climactic moments of the war. When General Armistead was shot, he slumped over next to the wheel of one of Cushing's cannon. One of General Hancock's aides, Capt. Henry H. Bingham, found Armistead and helped the wounded General. This famous scene is depicted on the Masonic Friend to Friend Memorial in the National

Brigadier General Lewis A. Armistead. *LOC*

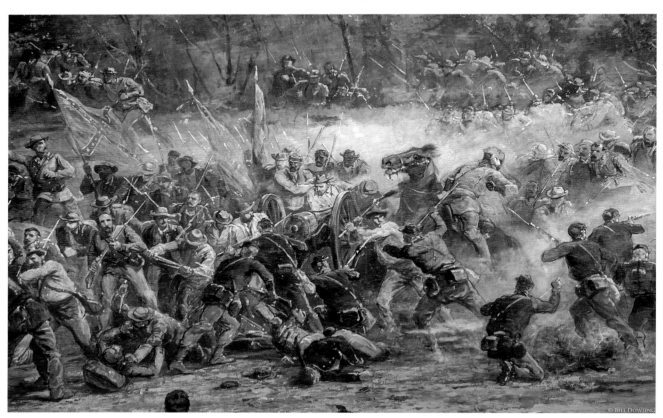

Detail of the painting showing the mortal wounding of General Armistead. *BD*

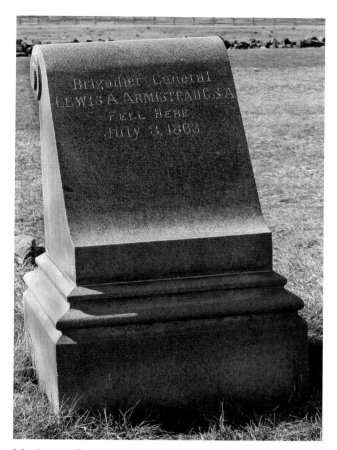

Marker at Gettysburg that denotes the spot where General Armistead fell. *BD*

Cemetery Annex. General Armistead died from his wounds a few days later at the George Spangler farm, located behind Power's Hill (see View#9, N).

In the first two versions of the Gettysburg cyclorama (Chicago and Boston), the artist mistakenly depicted General Armistead on horseback. In reality, he was on foot, with his sword in his hand and his hat on the end of his sword. Veterans who saw the cycloramas told the artist about this error, and it was corrected for the last two versions of the painting (Philadelphia and New York).

Upon close examination of the painting, we can see what appears to be a faint outline of the General's head just above the actual painted face. It seems as though the assistant who painted the General did not exactly follow what was sketched in on the canvas. As part of the restoration that was finished in 2008, this detail was discovered. Since the goal of the restoration was to return the painting to its original appearance, the restorers left this "error" the way it originally appeared.

Ⓖ 69th Pennsylvania Infantry Regiment

The 69th Pennsylvania was positioned in the Angle in front of the famous Copse of Trees and "the slashing" (see E). During the infantry attack, they were hit hard by Kemper and Garnett's Confederate brigades. To add to their firepower, many of the men picked up extra muskets that were discarded at the end of Day 2. Colonel Dennis O'Kane (see View #3, C) ordered the men to hold their fire until the enemy was within close range.[16] Their initial volleys staggered the Confederate attackers. Eventually, the sheer number of Confederates started to take a toll on the 69th. As the Confederates broke into the Angle, they got around the right end of the regiment. The soldiers on the far right of the unit were forced to bend back their line to keep the Confederates from getting into their rear. The fighting became hand-to-hand, and some of the companies on the far right were almost totally wiped out (some of these men are probably depicted in C). On their left, Confederates charged Cowan's battery

Monument to the 69th Pennsylvania at Gettysburg. *BD*

69th Pennsylvania, Battle Flags Visible

Parts of Kemper's Brigade

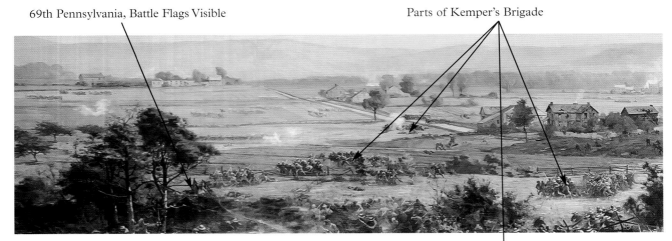

Detail of the painting showing the 69th Pennsylvania Infantry and Kemper's brigade *BD*

and temporarily got around their left as well (see View #1, G). At this point, the 69th Pennsylvania was almost totally surrounded.[17] In the painting, we are seeing this moment of the action.

The 69th Pennsylvania's flags can be seen sticking up above some of the small trees and bushes that make up "the slashings." To their front, they are being attacked by parts of Kemper's brigade. To their right and rear, men from Armistead's and Garnett's brigades are surging over the stone wall. Even though they had enemies on three sides, the 69th kept fighting. Eventually, Union reinforcements drove the Confederates out of the Angle. The brave stand of the 69th Pennsylvania helped prevent the Confederates from making a larger breakthrough on July 3.

Ⓗ Kemper's Brigade

Brigadier General James L. Kemper's brigade was on the right of Pickett's division on July 3. As they crossed the Emmitsburg Road, the Codori farm split Kemper's men from Garnett's and Armistead's brigades. As they approached the stone wall, Kemper's men were fighting against troops from Union General Gibbon's division. While engaging Gibbon's men, they were attacked on their flank (or the end of their line) by Vermont troops under Brig. Gen. George J. Stannard (see J). This flanking fire was particularly destructive. Some of Kemper's men tried to turn to counter this attack on their end, but the enemy fire was too destructive and they were soon forced back.

General Kemper was seriously wounded during the charge. At one point, Kemper was temporarily captured by some of the Vermont troops. His men managed to drive back the Union men and recover the general.[18] In another area of the painting, he can be seen being carried to the rear by Union troops (see View #3, D). This incident is not accurately depicted in the painting because he was never inside the Angle, and Union troops only managed to capture the general for a few moments. When the Confederates started their retreat back to Virginia, the general was too badly injured to be moved. Kemper was eventually captured in a Confederate hospital, but not until after the battle was over.[19]

In the painting, Kemper's men can be seen in several locations, such as crossing the Emmitsburg Road just south of the Codori farm. Kemper's men can also be seen in front of the stone wall, fighting the 69th Pennsylvania and the Vermonters. This is an example of artistic license. By the time Kemper's men were engaged, there would not be anyone still

Unknown Unit in Front of the Stone Wall

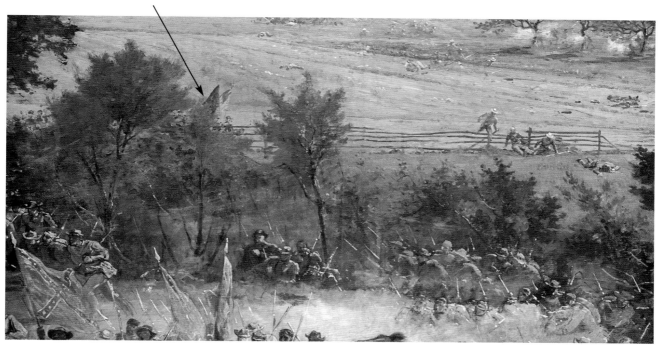

Detail of the painting showing an unknown group of Union infantry in front of the stone wall. *BD*

crossing the Emmitsburg Road. The artist was trying to depict two different phases of the charge in order to tell the entire story. The artist took similar license with several other Confederate units (see L and View #3, J).

Ⓘ Unknown Unit in Front of the Stone Wall

In this area of the painting, some union troops can be seen in front of the stone wall, attacking the flanks and rear of the Confederate attack. These troops are far ahead of the Vermont troops who are also moving to attack the Confederate flank (see J). These troops are very hard to see because of the foliage that makes up "the slashings" and the Copse of Trees. It is possible that these troops were meant to represent parts of Hall's and Harrow's brigades who were rushing toward the Angle to help repel the Confederate breakthrough (see View #1, E). In reality, these troops would be moving through the Copse of Trees and not on the other side of the stone wall. It is also possible that the artist was taking some artistic license and showing the Vermont troops in more than one location (see H and J).

Ⓙ Stannard's Vermont Brigade

At Gettysburg, Brig. Gen. George J. Stannard commanded a brigade of Vermont troops who were rushed from the defenses of Washington to bolster the Union army. His brigade consisted of the 12th, 13th, 14th, 15th and 16th Vermont. The 12th and 15th regiments were on detached duty guarding the Union wagon trains, so only three regiments were on hand at Gettysburg on July 3. When the Confederate attack began, the Vermont troops were posted near a small knoll just south of the Gibbon Tree (see View #1, J). As Kemper's Confederates passed the Codori farm, the 13th and 16th Vermont troops swung out and began firing into their flank .[20] This flanking fire was extremely destructive and one of the main reasons why the Confederate attack failed.

During Pickett's Charge, the brigades of Brig. Gen. Cadmus M. Wilcox and Col. David Lang were instructed to guard the right flank of the

Brigadier General George J. Stannard. *LOC*

Confederate attack. These brigades, however, were not ordered to advance until the main attack was already underway. When Pickett's division neared the Emmitsburg Road, they wheeled to the left (moved at an angle) in order to close up a gap between their division and Pettigrew's men. Wilcox and Lang's brigades did not see this move because of the smoke that covered the battlefield. When they crossed the Emmitsburg Road, they headed straight ahead towards the batteries of McGilvery's artillery line (see View #1, I). These batteries severely punished the Confederates as they advanced. By moving straight ahead, these troops began to pass to the south of Stannard's men who had been firing into the flank of Kemper's troops. At this point, the 16th Vermont made an about face and the 14th Vermont moved forward to support them. These maneuvers placed the Vermonters on the flank of Wilcox and Lang's men. This flanking fire, along with the frontal artillery fire, stopped the Confederate attack in its tracks. [21]

In the painting, we can see the Vermont troops firing into the flank of Kemper's brigade. At a distance, we can see other Vermont soldiers moving to the west to attack Wilcox and Lang's men. This action in the background is not entirely accurate. The Vermont regiments should be moving from north to south, not from east to west. This illustrates artistic license; if the artist had not made this adjustment, the troops attacking Kemper would block our view of the troops attacking Wilcox and Lang.

Further away, mounted officers can be seen leading the Vermont soldiers. The New York key mentioned "Gen. Stannard's grand charge with Vermont Brigade, Cols. Randolph [sic] and Veazey in advance." The 16th Vermont was led by Col. Wheelock G. Veazey. Colonel Francis V. Randall was the commander of the 13th Vermont, and he took over command of the brigade when General Stannard was wounded. [22]

Ⓚ Wilcox and Lang Engaged

Brigadier General Cadmus M. Wilcox commanded a brigade of Alabamians who were heavily engaged on the second day of the battle. Colonel David Lang commanded the only Confederate brigade from Florida at the battle of Gettysburg. Sometimes called Perry's brigade, they are named after General Perry who was wounded before the battle and not present.

Left: Detail of the painting showing Stannard's brigade. *BD*

Below: Detail of the painting showing Wilcox's and Lang's brigades engaged with Stannard's men. *BD*

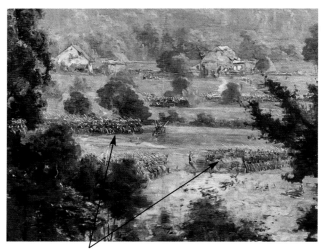

Stannard's Vermont Brigade Wilcox and Lang Engaged

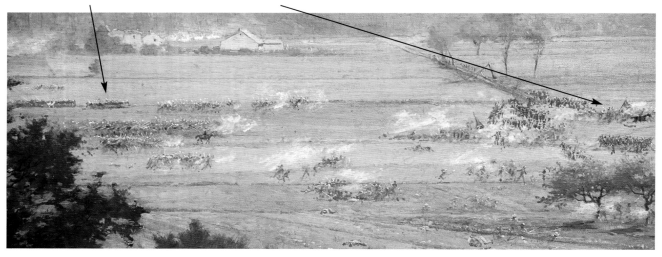

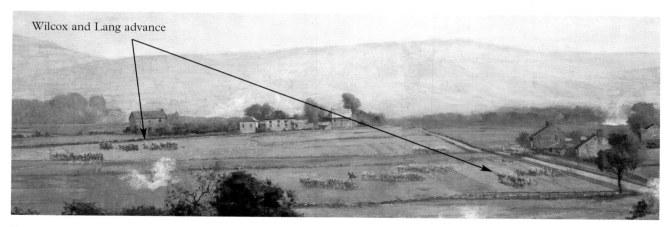

Detail of the painting showing Wilcox's and Lang's brigades crossing the Emmitsburg Road. BD

These Floridians were also heavily engaged on July 2. These brigades were assigned with the task of protecting the right flank of Pickett's Charge. Their attack started too late and in the smoke, they lost contact with Pickett's right (Kemper's brigade). Instead of wheeling to the left at the Emmitsburg Road, they continued straight ahead into McGilvery's artillery and Stannard's brigade.

As described above (see J), we can see these Confederate brigades going head-to-head with the 14th and 16th Vermont. Union artillery fire can be seen making numerous puffs of smoke as their shells explode among the Confederates. Wilcox's and Lang's men were too late to aid the main Confederate attack.

The actions of these two brigades only served to increase the Confederate casualties on July 3.

Ⓛ Wilcox and Lang Advance

In this area, we can see Wilcox's and Lang's brigades crossing the Emmitsburg Road in the area of the Rogers farm (see View #3, L) and the Klingle farm (see T). In another example artistic license, the Confederate units are shown at more than one stage of their advance in order to indicate the progress of the charge (see H).

Ⓜ Codori/Trostle Thicket

Just east of the Codori farm there was and still is a small spring. Located in some low marshy ground, this spring feeds a stream that eventually turns into Plum Run as it moves southward. This stream follows the

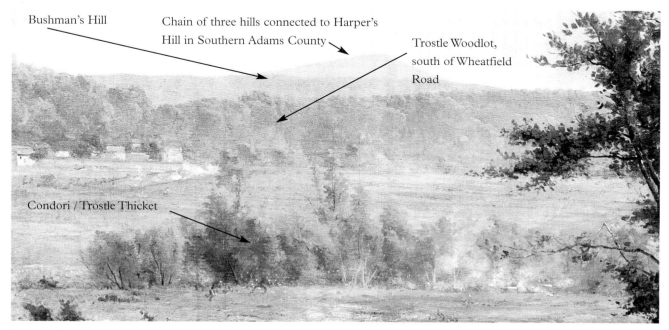

Detail of the painting showing the thicket in between the Codori and Trostle properties. BD

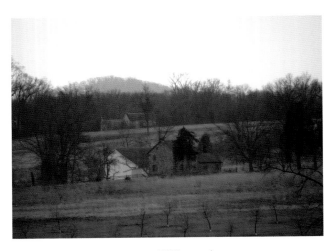

Distant hill near Harpers Hill, modern. *CB*

lowest ground through the valley between the Emmitsburg Road and Cemetery Ridge. Because of the marshy ground in this area, the farmers could not plant crops and a thicket of bushes and small trees grew along the stream. This thicket runs from the area east of the Codori farm (see View #3, H) southward to the Trostle farm (see O).

During the battle of July 2, Col. George L. Willard was killed in this thicket by an artillery shell (see B) as his men drove back the attacks of Brig. Gen. William Barksdale's Mississippians. Barksdale was mortally wounded in this area and died at the Hummelbaugh farm (View #0, K).[23] On July 3, Wilcox and Lang made it to the Codori/Trostle thicket before their attacks were repulsed by Union artillery fire and attacks from the Vermont brigade.

Ⓝ Distant Ridges and Hills

In the distance within the painting, three different hills and ridges can be seen. Closest to the viewer are some woods along small ridge, which are just north of the Wheatfield Road. These woods block our view of the famous Wheatfield which was the scene of heavy fighting on July 2. These trees form the border of Trostle's woods, which were owned by Peter Trostle (see O). Just to the east is the George Trostle farm, which did not exist in 1863 (see View #1, R). During the fighting on the second day of the battle, these woods served as a jumping-off point for Union troops as they launched attacks into the Wheatfield.

In the middle distance, a ridge can be seen that would be in the area of Bushman's Hill. This small hill is west and slightly south of Big Round Top. After Pickett's Charge on the third day, Union cavalry forces in this area launched an ill-fated attack on the Confederate's far right. In the older Gettysburg keys, this area was described as "Position of [Brig. Gen. Judson] Kilpatrick's Cavalry Division on left flank, where [Brig. Gen. Elon J.] Farnsworth made his charge and lost his life on the afternoon of the third day."

In the extreme distance we can see another hill. This hill is part of a chain of three hills in southern Adams County. The chain of hills runs north to south, starting with this unnamed hill. This chain of hills ends with Harper's Hill on the very southern edge of the county. The un-named hill in the painting is on the east side of modern Route 15, just south of the Barlow Greenmount Road overpass.[24]

Ⓞ Peter Trostle Farm (Abraham & Catherine Trostle)

This farm was owned by Peter Trostle and rented by his son and daughter-in-law (Abraham and Catherine). Today, this farm is kept in its 1863 condition by the National Park Service. Abraham was a troubled soul, who may have been in the local insane asylum at the time of the battle. Katherine Trostle would have been left to mind the farm with her nine children.[25] After the war, one of their sons built and lived in the George Trostle farm nearby (View #1, R).

On the second day of the battle, this farm was the scene of heavy fighting. When Maj. Gen. Daniel E. Sickles moved his III Corps out to the Emmitsburg

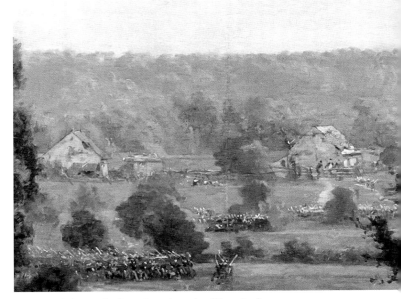

Detail of the painting showing the Trostle farm. *BD*

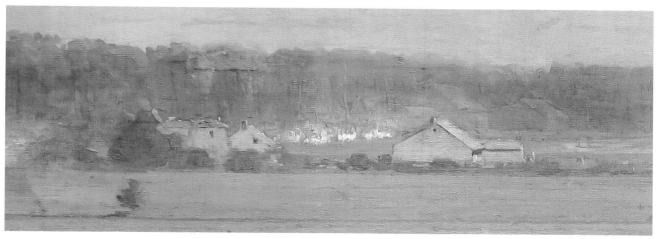

Detail of the painting showing the Rose farm. *BD*

Road on July, 2, he set up his headquarters in this area. He was sitting on a horse near the Trostle barn when a Confederate cannon ball shattered his leg. Several holes in the sides of the Trostle barn can still be seen today, and were caused by Confederate artillery fire. The Chicago key noted that "Gen. Sickles lost his leg" at this farm.

As Sickles' men were driven back from the Emmitsburg Road on July 2, some Union batteries attempted to hold off the Confederate advance. The Confederates shot many of the horses in these batteries in order to prevent the guns from being withdrawn. After the battle, one observer noted that there were 19 dead horses within 15 feet of the house.[26] Several famous pictures were taken after the battle showing the Trostle farmyard covered with dead artillery horses and other battle debris from this struggle.

The New York key mentioned that "[Capt. John] Bigelow's 9th Mass. and [Capt. Charles A.] Phillips 5th Mass. [Batteries] fought desperately" in this area. Once again, suggestions from the Massachusetts audience seemed to have found their way into the New York key. An examination of the souvenir program revealed that soldiers from the 5th and 9th Massachusetts Battery visited the Boston painting. One of these visitors, Charles W. Reed, received the Medal of Honor for helping the wounded Captain Bigelow off the field.[27]

Ⓟ George Rose Farm

The George Rose farm was inhabited by George's brother John Rose and his family at the time of the battle. The Rose property included the famous Wheatfield and Houck's Ridge, the scene of heavy fighting on July 2. The Rose property probably has the bloodiest history of any farm in the United States. Up to 9,000 men may have been casualties here, mostly on July 2. After the battle, up to 1,500 men were buried on the Rose property.[28]

In the painting, the Rose house and barn are visible. Today, the farmhouse still stands and is kept in its 1863 appearance by the National Park Service. The Rose barn was struck by lightning and collapsed in 1910. A large pile of rubble still remains there today.

Ⓠ The Peach Orchard

The Peach Orchard was owned by Joseph Sherfy at the time of the battle. His farm was located on the other side of the Emmitsburg Road from the orchard (see S and T). In the painting, only the tops of the peach trees are visible. With help from the Gettysburg Foundation, the NPS still maintains a peach orchard at the original location.

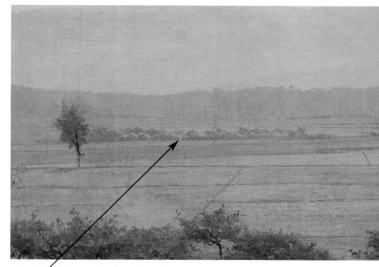

Detail of the painting showing the Peach Orchard. *BD*

The famous Peach Orchard was the scene of heavy fighting on the second day of the battle. The orchard sits on the highest part of a ridgeline that follows the Emmitsburg Road; this ridge is midway between Seminary Ridge and Cemetery Ridge. On July 2, Union General Sickles decided to move his III Corps off of Cemetery Ridge to occupy this rise of ground. Today, this movement is still one of the most debated decisions of the battle.

Late in the afternoon of the second day, Sickles' men were attacked by Confederates under the command of General Longstreet. Eventually, the men were driven back from the Peach Orchard and the Emmitsburg Road. The New York key mentioned several units that belonged to Sickles' corps including the "1st Mass., 2nd N.H., 16th Mass., 12th N.H., 26th Pa., and 11th Mass." Once again, we can see that the New York version of the cyclorama was being heavily marketed to New England visitors based on suggestions from the Boston platform.

Ⓡ Site of the Wentz House

John Wentz lived in a modest one-story house across the Emmitsburg Road from the Sherfy barn. John lived with his wife, Mary, and their daughter, Susan. The famous Peach Orchard was located to the north and south of his house. In the painting, the house is not visible. Our view of the house is probably blocked by the peach trees. Today, only the foundation of the Wentz house remains.

John Wentz's son, Henry Wentz, moved to Virginia before the war. He served in Taylor's Virginia battery as part of the Confederate army. On the second day, his

unit fired upon Union troops in the area of his father's house. On the third day, positioned near his father's home, his battery fired on Union troops during the bombardment that preceded Pickett's Charge.

During the battle John's wife and daughter left the house, but John stayed in the cellar. On the evening of the third day, Henry stopped at the house and found his father asleep in the cellar. Not wishing to disturb him, Henry left his father a note saying, "Good-bye and God bless you!"[29] Henry survived the war.

Ⓢ Sherfy Barn (Joseph Sherfy Farm)

Joseph Sherfy, owner of the famous Peach Orchard, lived with his wife, Mary, and their six children. The Sherfy's house and barn are located on the west side of the Emmitsburg Road. Today, the house and barn are kept in their 1863 condition by the National Park Service.

On July 2, intense fighting raged around the Sherfy farm. Many wounded Union soldiers took shelter in the barn. On July 3, during the artillery bombardment, "an errant federal shell ignited the barn

Below: Detail of the painting showing the Klingle farm with the Sherfy house in the background. *BD*

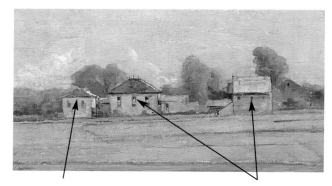

Joseph Sherfy House Daniel Klingle House and Barn

Site of Wentz House, not depicted on painting Sherfy Barn

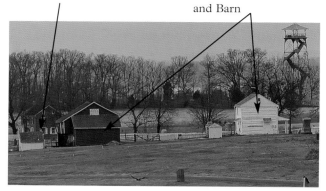

Detail of the painting showing the Sherfy barn and the area of the Wentz house. *BD*

Modern shot from the same angle showing Klingle and Sherfy farms. *BD*

and threatened to incinerate the occupants." Confederate artillerymen helped remove the wounded, but some bodies were found in the ashes after the battle. It is not known whether these soldiers died from their wounds or died as a result of the fire.[30] In the report of Capt. Patrick Hart's 15th New York battery he said "It was I [Hart's Battery] who caused his caissons to explode and set the barn on fire."[31] To be totally accurate, the Sherfy barn should be depicted as being on fire in the painting. However, the artist may not have known this story. The barn was rebuilt soon after the battle. Since it is clearly visible in the 1882 Tipton photographs, the artist included the barn in the painting. The Sherfy house is harder to spot because it blends in with the Klingle farm buildings located just to the north.

(T) Daniel Klingle Farm

The Klingle farm was located on the east side of the Emmitsburg Road, north of the famous Peach Orchard. Heavy fighting occurred in this area on the second day of the battle. Today, the original house and barn still stand. The National Park Service recently remodeled the Klingle house and removed some modern additions to return it to its 1863 appearance.

In the painting, the Klingle farm and the Sherfy house seem to blend together. This is caused by the angle at which we are looking down the Emmitsburg Road. In the modern photographs, we can see that the buildings line up perfectly with the painting. There appear to be extra buildings in the painting that are not visible today. Historic maps show additional out-buildings on both the Klingle and Sherfy properties.[32]

[1] Charles Teague, *Gettysburg by the Numbers* (Gettysburg, PA, 2006), 66.

[2] Gettysburg National Military Park, Display on Cyclorama Mezzanine.

[3] Brown, *Cushing of Gettysburg*, 234-235,237, and 241-242.

[4] *Ibid.*, 238.

[5] *Ibid.*, 250-251.

[6] Hunt and Brown, *Brevet Brigadier Generals in Blue*, 648.

[7] Report of Brig. Gen. Alexander Hays, *OR* 27, pt. 1, 453.

[8] Hawthorne, *Gettysburg: Stories of Men and Monuments as Told by the Battlefield Guides*, 112.

[9] Report of Lieut. John T. Dent, *OR* 27, pt. 1, 469.

[10] Editors of Time-Life Books, *Echoes of Glory, Arms & Equipment of the Union*, 266-267.

[11] Report of Brig. Gen. Alexander Webb, *OR*, 27, pt. 1, 427.

[12] *Ibid.*, 428.

[13] Laino, *Gettysburg Campaign Atlas*, 349; Brown, *Cushing of Gettysburg*, 254.

[14] Letter from Ronald E. Bird to Robert E. Davidson, Superintendent of the Gettysburg National Military Park, NPS Cyclorama File, Ref. #K1817.

[15] William A. Frassanito, *Early Photography at Gettysburg* (Gettysburg, PA, 1995), 234-240.

[16] Don Ernsberger, *At the Wall: The 69th Pennsylvania "Irish Volunteers" at Gettysburg* (U.S.A. 2006), 99.

[17] Ibid., 121-125.

[18] Kathy Georg Harrison and John W. Busey, *Nothing but Glory, Pickett's Division at Gettysburg* (Gettysburg, PA, 1987), 66.

[19] Trudeau, *Gettysburg: A Testing of Courage*, 560.

[20] Laino, *Gettysburg Campaign Atlas*, 349.

[21] *Ibid.*, 353-354; Report of Brig. Gen. George J. Stannard, OR *27*, pt. 1, 348-350.

[22] Report of Col. Francis V. Randall, *OR* 27, pt. 1, 353.

[23] Coddington, *The Gettysburg Campaign: A Study in Command*, 417-418; Trudeau, *Gettysburg: A Testing of Courage*, 389-392.

[24] Googleearth.com, map of Harper's Hill; personal observations by Chris Brenneman.

[25] Smith, *Farms at Gettysburg: The Fields of Battle*, 25-26; Carper and Hardoby, *The Gettysburg Battlefield Farmsteads Guide*, 33-34.

[26] *Ibid.*

[27] Trudeau, *Gettysburg: A Testing of Courage* 387; Souvenir Program, Boston, *Cyclorama of the Battle of Gettysburg*.

[28] Smith, *Farms at Gettysburg: The Fields of Battle*, 31; Carper and Hardoby, *The Gettysburg Battlefield Farmsteads Guide*, 29-30.

[29] Smith, *Farms at Gettysburg: The Fields of Battle*, 27; Carper and Hardoby, *The Gettysburg Battlefield Farmsteads Guide*, 31-32.

[30] Smith, *Farms at Gettysburg: The Fields of Battle*, 20-23.

[31] Report of Capt. Patrick Hart, *OR* 27, pt. 1, 888.

[32] Carper and Hardoby, *The Gettysburg Battlefield Farmsteads Guide*, 38; Desjardin, et. al., *The Battle of Gettysburg*.

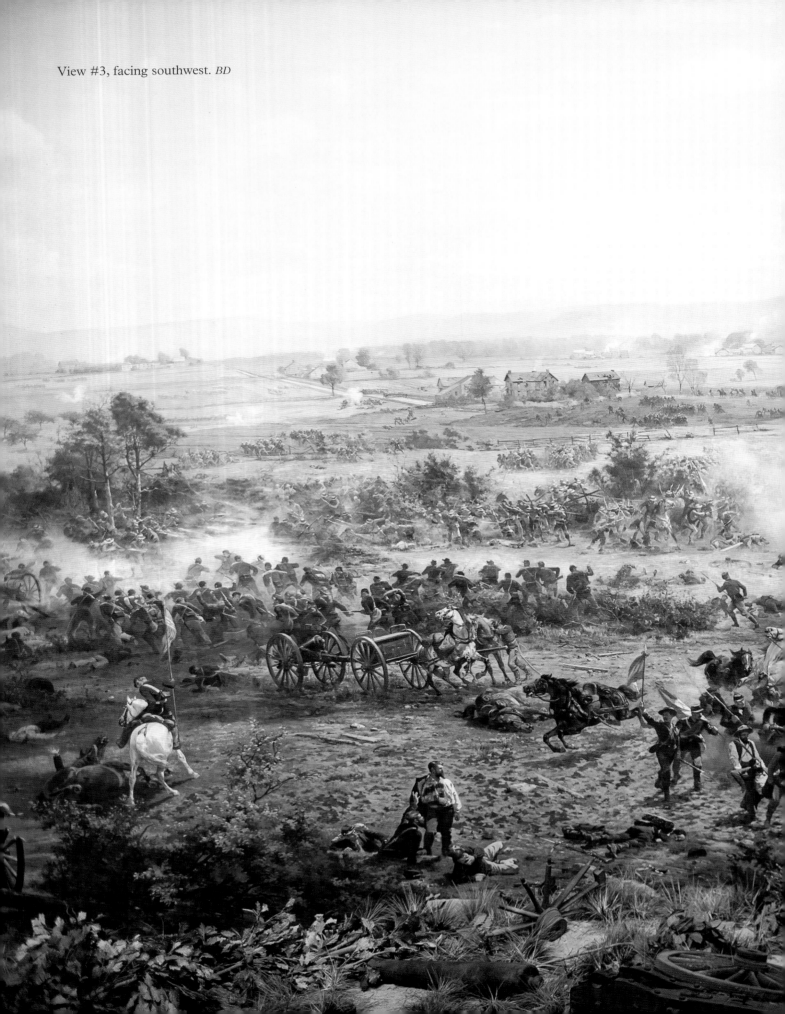

View #3, facing southwest. *BD*

Notes on view #3

(facing southwest)

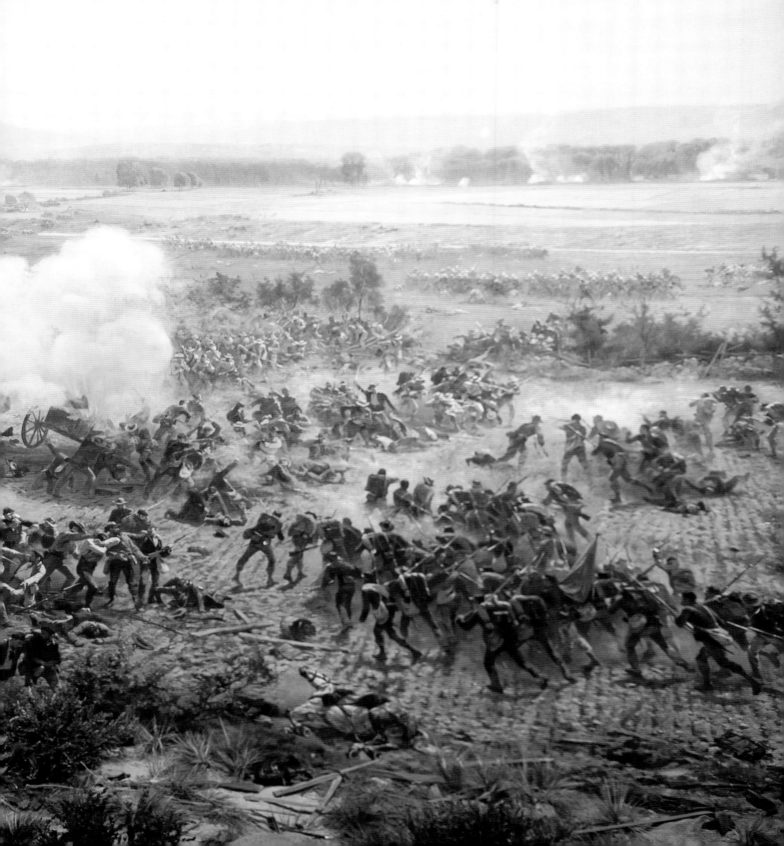

Tipton View #3 (1882). *SBC*

View #3 (Modern). *BD*

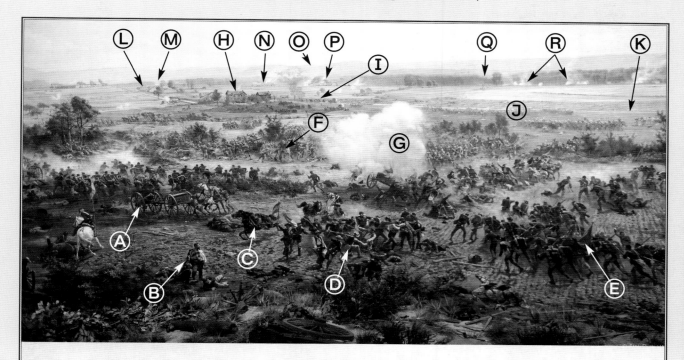

⌘ KEY ⌘

(A) Battery Wagon that was Changed into a Cannon

(B) Salvador Mège

(C) Colonel O'Kane's Horse

(D) Confederate Prisoners Being Taken to the Rear

(E) 71st Pennsylvania Infantry Regiment

(F) Confederate Brig. Gen. Richard B. Garnett Killed

(G) Exploding Limber Chest

(H) Nicholas Codori Farm

(I) Confederate Maj. Gen. George E. Pickett and Staff on the Emmitsburg Road

(J) Pickett's Confederate Division

(K) Emmitsburg Road

(L) Peter Rodgers Farm

(M) Washington Artillery of New Orleans

(N) John Staub Farm

(O) South Mountain Range

(P) Henry Spangler Farm

(Q) Seminary Ridge

(R) Batteries South of the Point of Woods

The Gettysburg Cyclorama: The Turning Point of the Civil War on Canvas

Ⓐ Battery Wagon that was Changed into a Cannon

As discussed in Chapter 4, changes were made to this section of the painting in 1889. Originally, a battery wagon appeared at this location. This wagon with a triangular roof can be seen in the historic photographs and key drawings from the first three versions of the painting. Battery wagons contained extra supplies that were needed to maintain an artillery battery in the field. It is possible that veterans may have pointed out that these battery wagons were usually kept to the rear of a battery's position (see View #7, B for an artillery wagon in the proper position). In the New York version, a caisson was painted in this area instead of a battery wagon. In 1889, the battery wagon in this version of the painting was changed into a cannon. This change was probably an attempt by the artist or the promoters to keep the Boston and the New York paintings equally authentic.

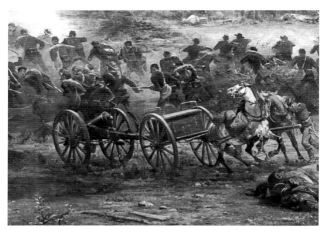

Detail of the painting showing the battery wagon that was turned into a cannon. *BD*

Ⓑ Salvador Mège

The recent discovery of a photograph of the artist with his team of assistants has helped the authors pinpoint Salvador Mège's image in the painting. Like the Bird brothers, the figures in this area are looking toward the viewing platform and away from the combat going on right behind them (see View #2, D). It is probable that some of the artist's other assistants are also depicted in the painting. In this area, several of the wounded soldiers on the ground near Mr. Mège could also be part of Philippoteaux's team. The man to the right of Mège could be one of the assistants in the photograph of Philippoteaux and his team (see Chapter 3); unfortunately we do not know his name.

Detail of the painting showing a group of wounded soldiers which may include one or more of Philippoteaux's assistants. *BD*

Ⓒ Colonel O'Kane's Horse

In this area a horse can be seen bolting out of the Angle. The Philadelphia key listed "Colonel O'Kane's horse." Colonel Dennis O'Kane was the commander of the 69th Pennsylvania (see View #2, G). As the Confederates approached the 69th, Colonel O'Kane gave a rousing talk. He told the men to reserve their fire until they could plainly distinguish the whites of their eyes. He reminded the men that they were fighting on the soil of their own state, and said, "Let your work this day be for victory or death." At the height of the attack, he was mortally wounded by a bullet to the abdomen. He was given medical attention at the Peter Frey farm (see View #0, E), but he died the next morning. Unfortunately, the authors have not been able to uncover any historic records which make a specific mention of his horse bolting to the rear during the

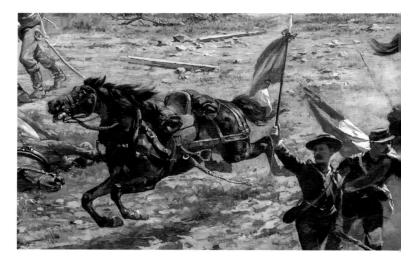

Detail of the painting showing Colonel O'Kane's horse. *BD*

attack on July 3. The 69th Pennsylvania lost so many officers at Gettysburg that by the end of the battle the regiment was commanded by Captain William Davis (see View #5, A).[1]

According to a story told by Charles H. Cobean, cyclorama lecturer from 1918 to 1942:

The horse...shown running wildly towards the rear, belonged to the colonel of the 69th Pennsylvania. This Colonel O'Kane had several regular mounts shot out from under him, and when his last horse was killed he cut this running horse out of the harness of a caisson. The colonel was killed in the fighting in the Angle, and the horse became frightened and bolted towards the rear. In this wild dash, the horse ran over and killed several men. I talked to a man who was blinded by the explosion of the powder caisson shown just back of the horse....he said the last thing in this world he saw was the explosion of the caisson and the Colonel's horse running to the rear.

To date, no historic accounts have been found that confirm this story, only oral tradition.[2] For more information on Cobean, the blind man, and the exploding caisson see G and BGC/AHG.[3]

Because the story of O'Kane's horse could not be verified, the authors started pursing other possible identifications. The Chicago key listed "Lt. Hazelton's Horse" in this location. There was a Lt. James B. Hazelton of the 1st New York Battery G, which fought near Little Round Top. Since, in Cobean's story, O'Kane supposedly commandeered an artillery horse, this could also be his horse.[4] The authors, however, have not been able to find any other connections between James B. Hazelton and Colonel O'Kane.

The authors have also identified Lt. William Cross Hazelton who served in the 8th Illinois Cavalry. Unfortunately, this unit was not present at Gettysburg on July 3. At the end of the war, William participated in the hunt for John Wilkes Booth. It is possible that this officer was mentioned in order to market the painting to the Chicago audience. There were very few Illinois units in the battle, and the promoters may have been stretching to mention anything of local interest (see K for more Illinois references). After the war, William was

a prominent citizen in a small community outside of Chicago that became known as Forest Glen. However, his biography notes that he was usually called "the Captain" by his friends after the war.[5] Finally, the authors found a Lieutenant John H. Hazelton that served in the 1st Vermont Cavalry at Gettysburg. This unit, however, was not in the area of the High Water Mark during the battle.

At this time, the authors have found some interesting stories but no specific historical accounts can be found that talk about O'Kane's or Hazelton's horse running through the Angle. Unless more information can be found, we cannot make a positive identification of the action in this part of the painting.

(D) Confederate Prisoners Being Taken to the Rear
In this area, Union soldiers are moving some Confederate prisoners to the rear. Some of the Union men are holding captured Confederate flags. The artist was not always accurate with the depiction of flags (as noted in View #0, B and View #2, B). The flags in this area appear to have two red horizontal stripes, with a white stripe in between. The authors speculate that these flags are meant to be the first Confederate national flag, "the Stars and Bars." These flags, however, should have a blue square in the upper corner with a ring of white stars. The first Confederate national flag was used at the beginning of the war. By the time of the battle, most Confederate regiments in the Army of Northern Virginia would have been carrying their famous battle flags, "the Southern Cross." Three of the Army of Northern Virginia's battle

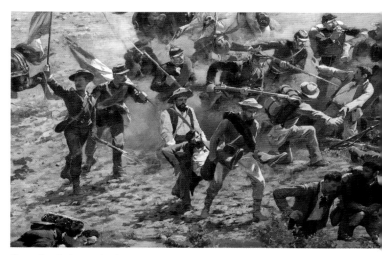

Detail of the painting showing Confederate prisoners being herded to the rear. *BD*

flags can be seen in front of General Armistead (see View #2, F). Union forces captured 42 Confederate flags during the battle, only two of which were of the "Stars and Bars" type, and one of these was not captured on this part of the battlefield. The rest of the captured flags were the more famous "Southern Cross" type.[6]

In the New York key it noted, "General Kemper carried to the rear. Since war, Gov. of Va." As discussed in View #2, H, Brig. Gen. James L. Kemper was temporarily captured by some of the Vermont troops who were attacking his right flank. One account states:

> While lying on the ground wounded, several Yankees accompanied by an officer loaded him onto a blanket and started carrying him off to their own rear. Some of Kemper's men noticed the abduction and came to his rescue. By "firing over" his body, they chased away the Union party and recovered their general.[7]

A comparison between the painting and pictures of General Kemper show an uncanny resemblance. It seems as though Philippoteaux was

Brigadier General James L. Kemper. *LOC*

using some artistic license in this area. While this incident may have really happened, it did not happen in this area of the battlefield. Also, the General was recovered by his own men and did not permanently fall into Union hands until after the battle was over. The artist may have felt this was an important incident to depict. As the post war Governor of Virginia, Kemper would have been a well-known figure. As we have seen in other areas, it was sometimes your status after the war that determined whether or not you were mentioned in the key.

Ⓔ 71st Pennsylvania Infantry Regiment

In this part of the painting, the 71st Pennsylvania can be seen charging into the angle in order to drive back the Confederate breakthrough. At the start of the charge, three companies of the 71st were stationed to the right of Cushing's guns at the bend in the wall that forms the Angle. The rest of the regiment was positioned to the rear, near the eastern edge of the Angle area. These troops would

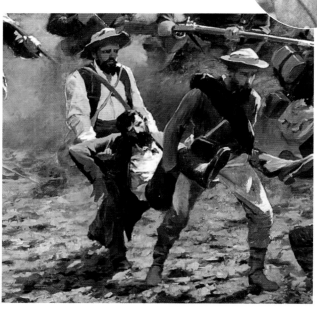

Detail of the painting showing a wounded General Kemper being carried by his own men. *BD*

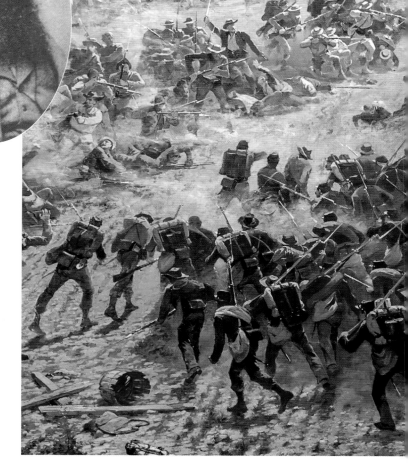

Monument to the 71st Pennsylvania at Gettysburg. *BD*

Detail of the painting showing the 71st Pennsylvania Infantry. *BD*

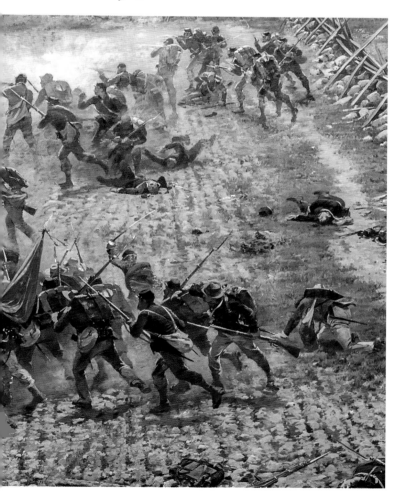

have been positioned to the left of Arnold's Battery (see View #6, D). When the Confederates reached the wall, they pushed back the three forward companies to the main line at the eastern edge of the Angle. Some of these troops may have even fought for a short time just north of the Angle, outside the wall (see View #4, A).[8] After firing a few volleys, the 71st, with the 72nd Pennsylvania to its left, charged into the Angle to help drive out the enemy.

Like the 72nd Pennsylvania, the 71st only had one flag at Gettysburg. The painting is accurate in that they were only carrying one flag. However, the flag in the painting is a solid blue Pennsylvania state flag. In reality, the 71st Pennsylvania had a state color that resembled a U.S. flag with the Pennsylvania seal in the blue area instead of stars. Their national flag had been lost in the Battle of Balls Bluff earlier in the war.[9]

Ⓕ Confederate Brig. Gen. Richard B. Garnett Killed

General Garnett can be seen in this area on a white horse. Garnett was one of a few Confederate officers who were mounted during the charge. Earlier in the Gettysburg campaign, he had hurt his leg when he was kicked by a horse. After the Battle of Kernstown, General Stonewall Jackson pressed charges against Garnett for ordering his brigade to retreat. Although Garnett was later cleared of all charges, he was still stinging from the slight to his reputation. Rather than sit out the charge, he chose to ride. This made Garnett an easy target and he was killed leading his men.

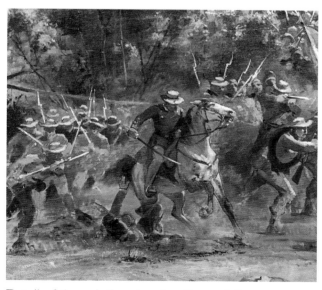

Detail of the painting showing General Garnett. *BD*

General Richard Brooke Garnett, or possibly his cousin Robert Selden Garnett. *LOC*

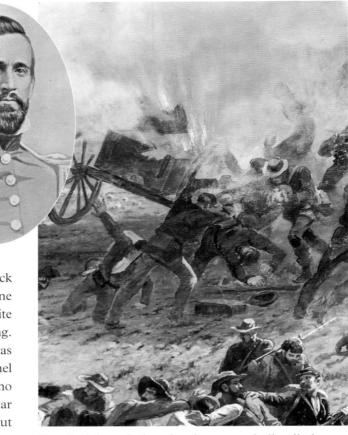

According to his aide, Captain John S. Jones, he was killed instantly by a musket ball through the brain near the stone wall that forms the western edge of the Angle. In the painting he seems to be over the stone wall, but he was probably killed on the west side of the wall just outside of the Angle.

In the painting General Garnett can be seen riding a white horse. However, one Confederate account stated that: "The last I saw of Gen. Garnett he was astride his large black horse in the forefront of the charge near the stone wall." This is another example of the artist using white horses to make an individual stand out in the painting.

The General's body was never found, and he was probably buried anonymously with his men. Colonel Hall claimed that Garnett's body was recovered, but no one knows where it was buried. Since he was killed near the Union line, it is possible that souvenir hunters cut the stars off of the general's uniform. General Hunt, a pre-war friend, claimed that he made a diligent search but could not find the body. The fact that Garnett's body was never found is ironic because today we are not sure if we even have a picture of the General. The picture that was commonly labeled as Richard Brooke Garnett may actually be his cousin Robert Selden Garnett. Garnett's sword was found many years later in a pawn shop in Baltimore. A fellow Confederate bought the sword and gave it to his family.[10]

Ⓖ Exploding Limber Chest

The historic keys labeled this area as "exploding caisson." In this part of the painting, we are actually seeing an exploding limber chest. These two-wheeled vehicles were attached to a cannon to form a four-wheeled vehicle when the cannon was being moved. The limber chest held an ammunition box that was used to supply the cannon. As described in View #0, C, a caisson was a four-wheeled vehicle with three ammunition boxes. Each cannon would have had a limber and a caisson. This particular limber would have been part of Cushing's battery that was stationed inside the Angle during Pickett's Charge. During the

Detail of the painting showing an exploding limber chest. *BD*

bombardment that preceded the charge, most of Cushing's limbers and caissons were destroyed by enemy fire. Since these wagons were packed with artillery projectiles, the explosions would have been quite dramatic. During the infantry attack, it is unlikely that a limber would have exploded. By this stage, most of the ammunition in the limber would have been expended, and rifle fire would not usually cause a limber to detonate. However, the artist is probably trying to show some of the action from the artillery bombardment, at which time numerous Union limbers and caissons exploded as a result of incoming Confederate artillery fire.

The New York key noted, "Exploding caisson near 28th Mass. Inf." This designation was not accurate. The 28th Massachusetts would have been part of the Irish Brigade in General Caldwell's division and would not have been this close to the front line (see View #0, D). However, in their position just behind Cemetery Ridge, numerous caissons and limbers would have been destroyed. This key notation is yet

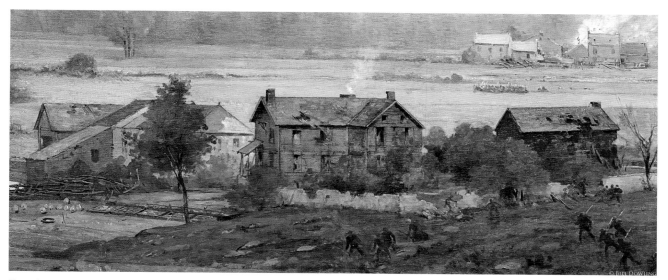

Detail of the painting showing the Codori farm. *BD*

another example of the New York Key marketing the painting to New England visitors.

In this part of the painting, there are numerous examples of the effects of enemy fire on the horses that were used to pull the limbers and caissons. These unfortunate animals suffered greatly during the bombardment and charge. After the battle, this area of the battlefield was littered with dozens of dead horses.

Ⓗ Nicholas Codori Farm

Located along the Emmitsburg Road, the Codori farm is one of the most noticeable landmarks on the battlefield. Owned by Nicholas Codori at the time of the battle, the farm was rented by tenants. During the infantry attack, the Codori building split the Confederates under General Pickett. Kemper's brigade would have crossed the Emmitsburg Road to the south of the farm while Garnett's and Armistead's men would have passed to the north of the farm.

The house still stands and has been kept in its historic condition by the National Park Service. At the time of the battle, the house would have been smaller; an addition was added onto the back of the house after the war. The painting also shows a post-war structure across the street from the Codori house that was used as a butcher shop, which no longer stands. Both of these modifications to the Codori property are visible in the Tipton photographs and are shown in the painting. The Codori barn looks different today than it does in the painting, as the original barn was rebuilt soon after the 1882 Tipton photographs.[11]

The Chicago key noted, "Codori house; wounded and sick at the windows." Even with extreme magnification, no figures can be found in the windows of the Boston painting. If these figures were present in the Chicago version, they may have been removed in the Boston painting. Considering the fact that this house was directly in between enemy lines, this would not have been a very safe place to observe the charge.

The New York key mentioned, "Gen. Geo. Ward, 15th Mass. Killed / Lt. Col. Joslyn *[sic]* commanding." Colonel George H. Ward and the 15th Massachusetts were stationed in an exposed position near the Codori farm on July 2. Knowing a Confederate attack was imminent, the 15th used the fences in this area to build a crude breastwork. Colonel Ward was mortally wounded and his men were forced back to Cemetery Ridge.[12] He was promoted posthumously to the rank of Brigadier General in 1865 for his bravery at Gettysburg.[13] The monument to the 15th Massachusetts features a bust of Colonel Ward. As noted in the key, Lt. Col. George C. Joslin took command of the regiment after Ward was killed. On July 3, the 15th Massachusetts was stationed south of the Copse of Trees. At the height of the attack, they rushed to the north and helped drive the Confederates out of the Angle (see View #1, E).

Major General George E. Pickett. *LOC*

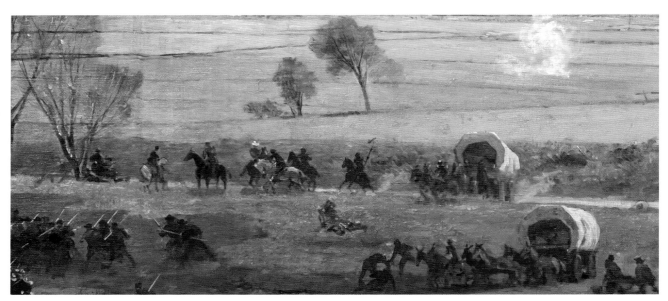

Detail of the painting showing General Pickett and staff. *BD*

Ⓘ Confederate Maj. Gen. George E. Pickett and Staff on the Emmitsburg Road

In the painting, General Pickett and his staff are located just north of the Codori farm on the Emmitsburg Road. In reality, the general was probably slightly south of this location in a less exposed position.[14] Pickett was the only general from his division who was not killed or wounded during the charge. Some post-war accounts criticized Pickett for not being closer to the front. As a division commander, he was responsible for coordinating his three brigades. In order to send and receive messages from his subordinates and his commander, he had to be in a relatively safe and easy to locate position. With these factors in mind, Pickett's position near the Codori Farm was appropriate for a division commander.[15]

Cyclorama lecturer Charles Cobean also told an interesting story about General Pickett: "I met Mrs. Pickett in Florida some years ago…. She told me that General Pickett rode the black horse to the end of the war, and it was kept at home after the war." LaSalle Corbell Pickett, General Pickett's widow, did view Boston version of the painting in Baltimore in 1911.[16] In the painting, the general does appear to be mounted on a black horse. We do not know whether the artist knew these details, but here may be one example of a general mounted on a horse of the correct color.

In this part of the painting, two covered wagons can be seen. This detail is probably not realistic. Any wagons in this area would have been easy targets for the Union artillery. Such large targets would have been quickly destroyed. None of the historic accounts mention any wagons in the middle of the charge.

Ⓙ Pickett's Confederate Division

In this part of the painting, Confederate forces can be seen crossing the Emmitsburg Road on their way to attack the center of the Union line. These troops represent General Garnett's brigade with General Armistead's brigade behind them. The artist is showing Pickett's division in two different locations. By the time of the High Water Mark, all of his men would have already closed in on the stone wall that formed the Angle. These troops are depicted again inside the Angle near General Armistead (View #2, F) and General Garnett (F). At the point where the Confederates reached their farthest breakthrough, everyone was already across the road. The depiction of these troops near the Emmitsburg Road is another case of artistic license. It was probably the artist's intention to show multiple phases of the charge in order to better portray the entire action of July 3.

Ⓚ Emmitsburg Road

The Emmitsburg Road is one of the ten roads that led into Gettysburg in 1863. A dirt road at the time of the battle, this road heads southwest as you leave the town. The road follows a slight rise of ground between Cemetery Ridge and Seminary Ridge. The highest part of this "mini ridge" is in the area of the famous Peach Orchard (see View #2, Q). On the second day, heavy

Pickett's Division The Emmitsburg Road

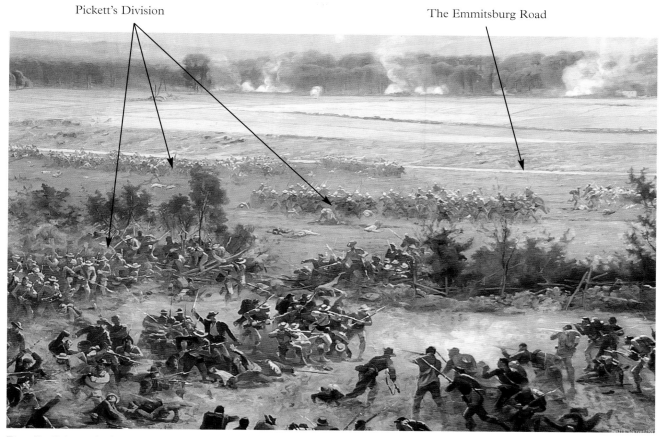

Detail of the painting showing Pickett's division crossing the Emmitsburg Road. *BD*

fighting raged around the Peach Orchard and the farms along the Emmitsburg Road when Union General Sickles moved his forces off of Cemetery Ridge.

On July 3, Confederate forces controlled the Peach Orchard, while the road north of that point remained between the opposing armies. Confederate batteries positioned near the Peach Orchard participated in the bombardment that preceded Pickett's Charge. During the charge, the slight rise at the Emmitsburg Road helped to shield the Confederate advance. Once they reached the road, however, the Confederates were hit by close range artillery and massed infantry fire.

In the Chicago key it mentioned that the Emmitsburg Road was "picketed by the 8th and 12th Ill. Cav.". These units would have been posted on the Emmitsburg Road on the night of July 1 and the morning of July 2. Since Illinois was only represented by three units at Gettysburg, the Chicago promoters wanted to mention as many as possible. The 82nd Illinois Infantry (XI Corps) was also present at Gettysburg, but is not pictured in the painting. The Chicago key lists "Lt. Hazelton's Horse" nearby (see

C). Investigations into this area found a Lt. William Cross Hazelton who served in the 8th Illinois Cavalry. The authors were not able to directly connect William Hazelton to the painting, but his Chicago roots could have helped him get mentioned in the key.

Josephine Miller posing with a loaf of bread and an oven at the Rodgers farm. *U.S. Army Heritage and Education Center, MOLLUS-MASS Vol. 91, page 4692, Identifier #RG6675*

Ⓛ Peter Rodgers Farm

The Rodgers farm no longer stands. At the time of the battle, it was a one-story log house. It was later torn down and replaced by the two-story frame house that can be seen in the Tipton photographs. Eventually, the frame house was torn down. Today, a plaque marks the former location of the Rodgers farm along the Emmitsburg Road. The fences around the Rodgers farm are painted white by the NPS, because in 1863, the farmers would have only bothered to paint the fences in the immediate area of their homes.

During the war, Peter and Susan Rogers lived in the house with their 27-year-old adopted granddaughter Josephine Miller. Before the fighting started on the second day, Josephine baked bread for the hungry Union soldiers. During the heavy fighting in this area on July 2, Peter and Josephine stayed in the cellar. Josephine cared for the wounded that evening and throughout the next day. At the dedication of the monument for the 1st Massachusetts Infantry, the survivors honored Josephine Miller by awarding her a gold badge.

The Rodgers farm was heavily damaged during the battle. Nine shells and cannon balls were said to have struck the house. After the battle, seventeen dead soldiers were found in the house and many more were buried in the yard.[17]

The Louisiana State Memorial at Gettysburg. *BD*

Peter Rodgers Farm

Washington Artillery of New Orleans

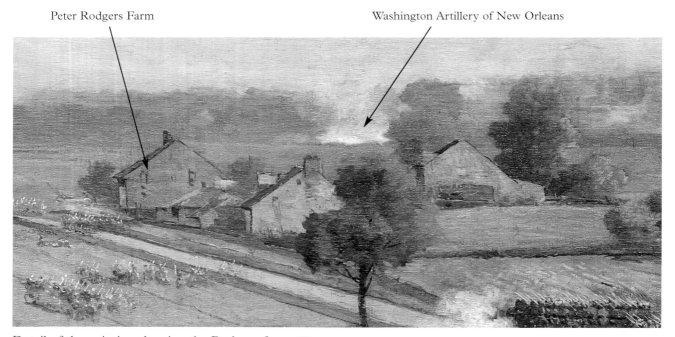

Detail of the painting showing the Rodgers farm. *BD*

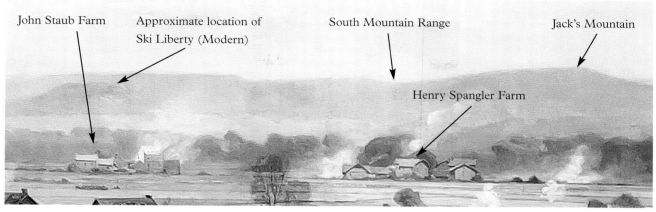

John Staub Farm · Approximate location of Ski Liberty (Modern) · South Mountain Range · Jack's Mountain · Henry Spangler Farm

Detail of the painting showing the Staub and Spangler farms. *BD*

Ⓜ Washington Artillery of New Orleans

In the Confederate army, an artillery battalion was a group of several batteries, usually about 16 guns. The Washington (Louisiana) Artillery Battalion was commanded by Maj. Benjamin F. Eshleman at the battle of Gettysburg. At the beginning of the cannonade, this battery fired two shots in rapid succession. These shots were the signal to the other Confederate batteries to open fire. Following these two shots, at about 1 p.m., up to 150 Confederate cannon began the bombardment.[18]

In reality, these guns were positioned on the west side of the Emmitsburg road in the area of the Sherfy and Klingle farms. In the painting, puffs of smoke from these cannon can be seen in the distance behind the Rodgers farm. These puffs of smoke are in the area of the Louisiana State Memorial on Seminary Ridge, west of the actual position of these cannon. The Louisiana State Memorial features a woman holding a flaming cannon ball to commemorate the Washington Artillery's role in the cannonade.

Also in the area of the distant smoke would be the farms of Christian Shefferer and James Warfield. Located at the intersection of West Confederate Avenue and the Millerstown Road, these farms are owned by the National Park Service. The Shefferer and Warfield farms, however, are too far distant to be seen in the painting.

On the second day of the battle, the Washington Artillery fired from Seminary Ridge at Union forces near the Peach Orchard. The New York key notes that these guns were "Randolph's R.I. Bat. Op [opponent] Nr [near] Sherfy's peach orchard." Captain George E. Randolph was the commander of the artillery for the 3rd Corps. On July 2, Randolph was wounded while commanding his guns in the area of the Peach Orchard. Randolph's cannon would have included the 1st Rhode Island Light Artillery, Battery E. This key entry is one more example of the New York key using suggestions from the Boston platform.

Ⓝ John Staub Farm

In the painting, the Staub farm can be seen in the extreme distance on Seminary Ridge. The Staub farm no longer exists. It was located on the east side of Seminary Ridge south of the Henry Spangler Farm. From General Longstreet's statue on modern West Confederate Avenue, the Staub farm would have been slightly to the north and approximately 200 yards to the east. In the painting, smoke can be seen in this area coming from some of the Confederate batteries that participated in the artillery bombardment before the charge.

Ⓞ South Mountain Range

Located about eight miles west of the town, a low ridge of mountains can be seen in the painting. The South Mountain Range runs south into Maryland and Virginia where it connects with the Blue Ridge Mountains. These mountains are one of the most important reasons why the battle happened in Gettysburg (next to the roads, see View #0, G). In the summer of 1863, General Lee decided to move his army into Pennsylvania. His goals were to gain supplies, take pressure off of war-torn Virginia, and force a decisive battle on Northern soil. At the start of the campaign, he used the Blue Ridge Mountains to screen his army's northward move. By blocking the mountain passes, the Confederates were able to keep

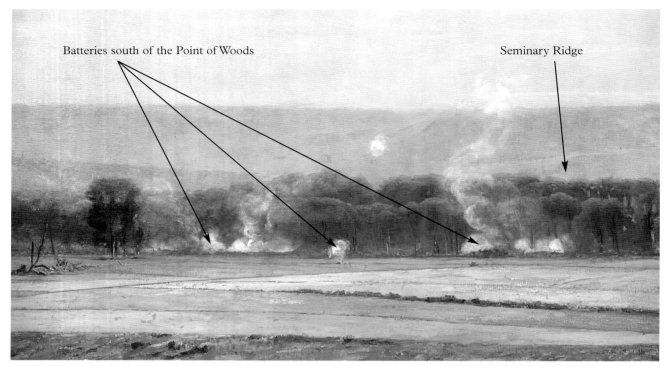

Detail of the painting showing artillery batteries south of the Point of Woods. *BD*

the Union army from observing their movement. Confederate forces were moving on the west side of the mountains as they entered Pennsylvania. When Lee decided to mass his forces on the east side of the mountains, the roads in Adams County led his army to Gettysburg. After the battle, Lee used these mountains to screen his movement back to Virginia. By blocking the mountain passes, he was able to slow down the Union pursuit of his army.

The two most important mountain passes in this area were the Cashtown pass and the Monterey Pass. The Cashtown Pass is located due west of the Seminary buildings (see View #6, J). The arrow that points to the South Mountains on the key is pointed toward the vicinity of the Monterey Pass. The larger eminence to the right of the arrow would be Jack's Mountain, near the town of Fairfield. The hill to the left of the arrow would be the present location of Ski Liberty.

Ⓟ Henry Spangler Farm

The Henry Spangler farm was rented by Jacob Echenrode at the time of the battle. Henry Spangler had purchased the farm in 1862. During the battle, Henry lived in his father's house along Baltimore Street near Culp's Hill (see View #8, O). After the Civil War, he moved into this house.[19]

The house still stands and is kept in its 1863 condition by the National Park Service. The woods along Seminary Ridge north and west of the farm were part of the Spangler property and are called Spangler's Woods today. Pickett's division would have occupied these woods during the cannonade that preceded the charge. During the battle, the right end of Pickett's division (under Kemper) would have started the charge just south of the Spangler house. The left end of the division would have been near the Point of Woods (see View #4, H for a description of the location now known as "the Point of Woods").

Ⓠ Seminary Ridge

Seminary Ridge is named after the Lutheran Theological Seminary (see View #6, J). Running parallel to Cemetery Ridge, the two ridges are a little less than one mile apart in the area of Pickett's Charge. On the second day of the battle, Confederate forces under General Longstreet used this wooded ridge to screen their movements before attacking the southern end of the Union line.

On July 3, Confederate artillery batteries massed on this ridge in preparation for the massive cannonade that preceded Pickett's Charge. The Southern infantry were positioned in the woods on Seminary Ridge and on the western side of the ridge in preparation for the

attack. After the cannons fell silent, a line of men one mile wide poured off of this ridge and headed toward the Union center. In the painting, this line of infantry stretches from the Spangler farm (P) to the area south of the McMillan farm (see View #5, F).

Ⓡ Batteries South of the Point of Woods

In this part of the painting, smoke can be seen rising from the location of several Confederate artillery batteries south of the Point of Woods (see View #4, H). These batteries would have been under the command of Maj. James Dearing, who was in charge of the artillery battalion that accompanied Pickett's division. The historic keys listed "Mason's [sic] Virginia artillery" and "Lynchburg battery, CSA" in this area. Dearing's battalion would have included the Richmond "Fayette" (Virginia) Artillery commanded by Capt. Miles C.

Macon and the Lynchburg (Virginia) Artillery under the command of Capt. Joseph G. Blount.

Colonel Edward Porter Alexander, who was in charge of the entire Confederate artillery bombardment, would have been observing the cannonade from this area as well. Some of the other batteries that participated in the bombardment can be seen on other parts of Seminary Ridge (see M, N, and View #4, K). In the New York key, the drawing seems to show a small group of men on horseback. These figures are labeled "General Longstreet and Staff." In the Boston copy, there are no figures in this area. Lieutenant General James Longstreet was known to have been in this area consulting with Colonel Alexander at the end of the bombardment.[20] At other times, General Longstreet was in the area of the Point of Woods (View #4, H).

[1] Ernsberger, *At the Wall: The 69th Pennsylvania "Irish Volunteers" at Gettysburg*, 99-100, and 123.

[2] Interview with Charles H. Cobean, Gettysburg National Military Park, Cyclorama File.

[3] Boardman and Porch, *The Battle of Gettysburg Cyclorama: A History and Guide*, 70-71.

[4] Gregory A. Mertz, *Interpretations of the Gettysburg Cyclorama*, April 19, 1983, Gettysburg National Military Park, Cyclorama File.

[5] Peter G. Beidler, *Army of the Potomac, The Civil War Letters of William Cross Hazelton of the Eighth Illinois Cavalry Regiment* (Seattle, WA, 2013), 194 and 205.

[6] Richard Rollins, *"The Damned Red Flags of the Rebellion", The Confederate Battle Flag at Gettysburg* (Redondo Beach, CA, 1997), 55, 60, and 67.

[7] Harrison and Busey, *Nothing but Glory, Pickett's Division at Gettysburg*, 66; Earl J. Hess, *Pickett's Charge – the Last Attack at Gettysburg.* (Chapel Hill, NC, 2001), 267.

[8] Brown, *Cushing of Gettysburg*, 254.

[9] Sauers, *Advance the Colors*, 195.

[10] Hess, *Pickett's Charge—the Last Attack at Gettysburg*, 41, 48, and 265-267; Harrison and Busey, *Nothing but Glory, Pickett's Division at Gettysburg*, 78-79.

[11] Frassanito, *Early Photography at Gettysburg*, 235; Smith, *Farms at Gettysburg: The Fields of Battle*, 15.

[12] Report of Lieut. Col. George C. Joslyn, *OR* 27, pt. 1, 423.

[13] Hunt and Brown, *Brevet Brigadier Generals in Blue*, 648.

[14] Thomas, *The Gettysburg Cyclorama: A Portrayal of the High Tide of the Confederacy*, 29.

[15] For a full discussion of Pickett's location during the charge see: Harrison and Busey, *Nothing but Glory, Pickett's Division at Gettysburg*, 128–134.

[16] Interview with Charles H. Cobean, Gettysburg National Military Park; Mertz, *Interpretations of the Gettysburg Cyclorama*, Gettysburg National Military Park, 25.

[17] Smith, *Farms at Gettysburg: The Fields of Battle*, 16-19.

[18] Hess, *Pickett's Charge- the Last Attack at Gettysburg*, 26 and 125.

[19] Smith, *Farms at Gettysburg: The Fields of Battle*, 43; Carper and Hardoby, *The Gettysburg Battlefield Farmsteads Guide*, 43-44.

[20] Carper and Hardoby, *The Gettysburg Battlefield Farmsteads Guide*, 43-44.

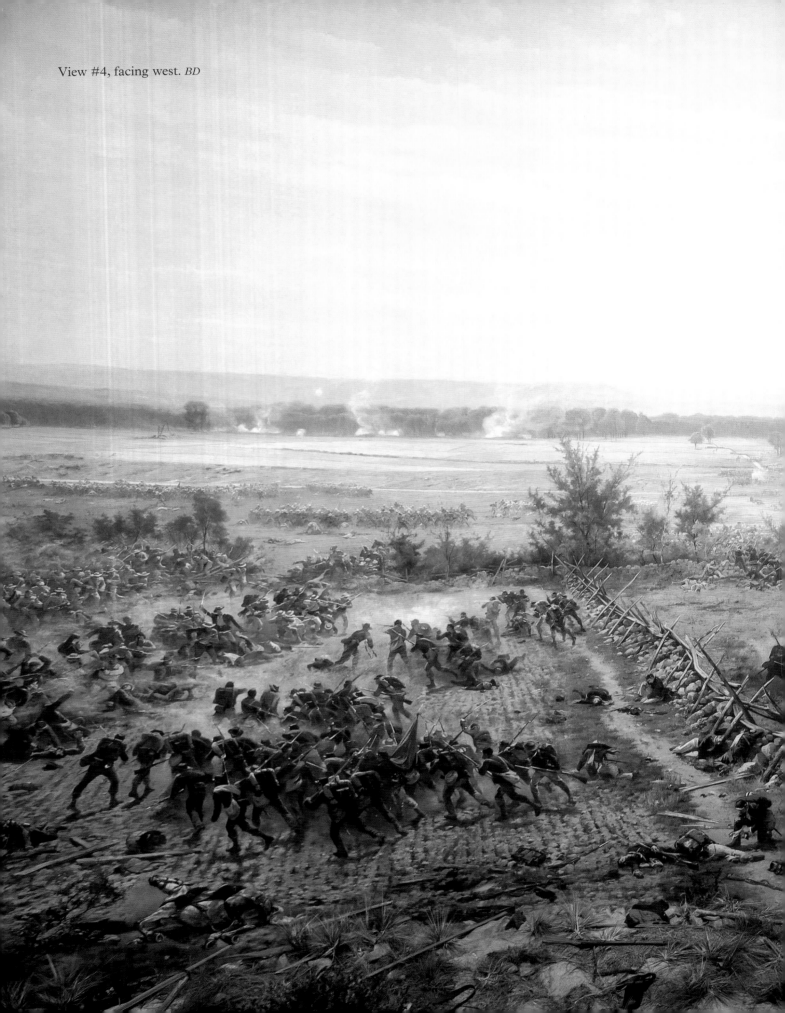

View #4, facing west. *BD*

Notes on view #4

(facing west)

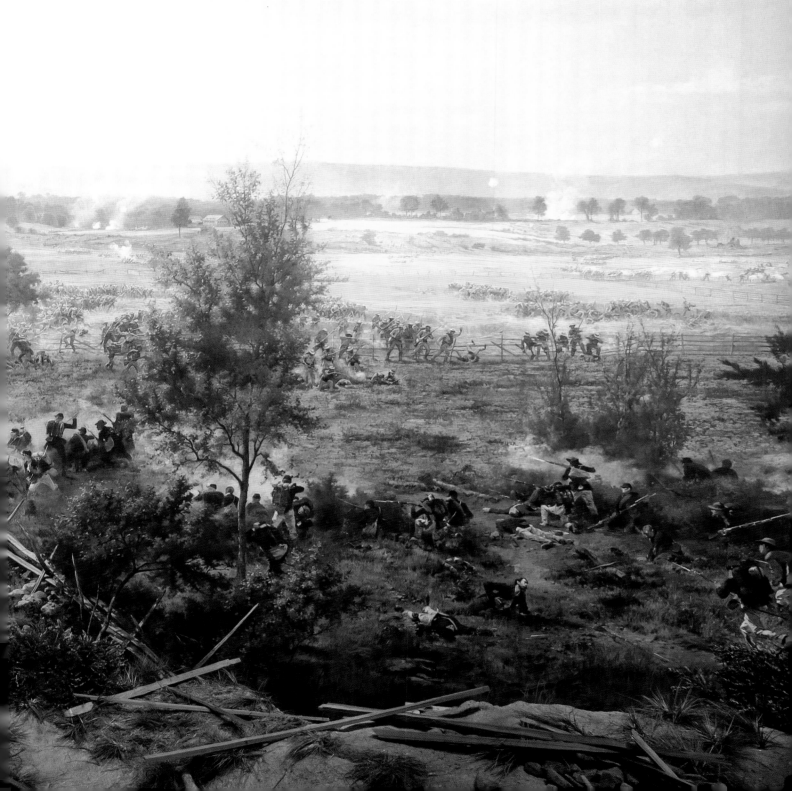

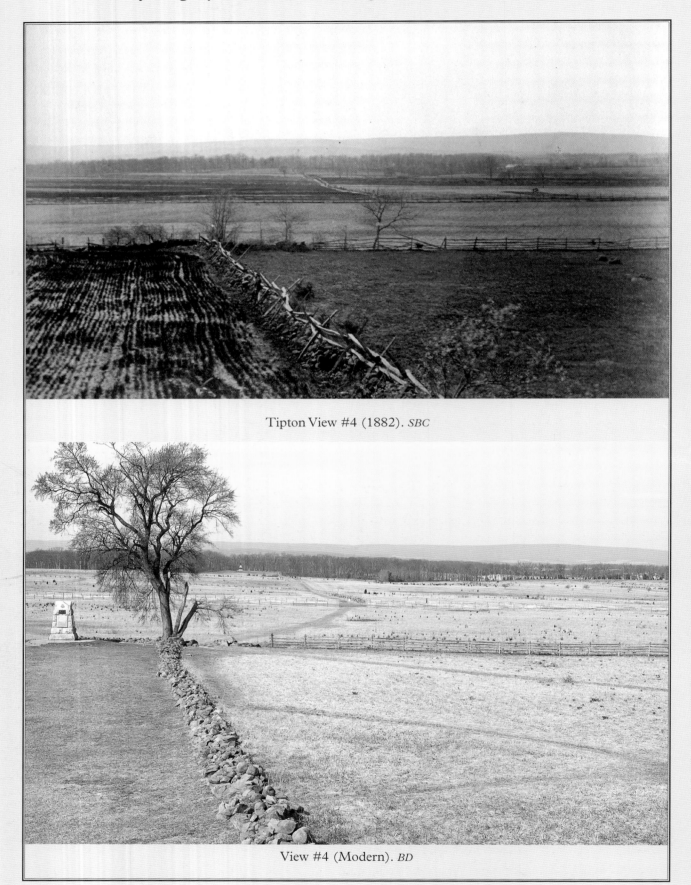

Tipton View #4 (1882). *SBC*

View #4 (Modern). *BD*

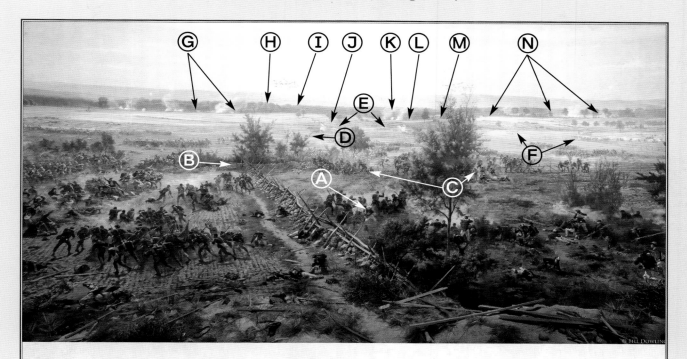

❧ KEY ❧

A Union Soldiers in Front of Stone Wall

B The Angle

C Fry's Brigade and Marshall's Brigade from Pettigrew's Division

D Fences along the Emmitsburg Road

E Scales' Brigade (Commanded by Col. W. Lee J. Lowrance)

F Lane's Brigade

G Buildings in the Trees South of the Point of Woods

H The Point of Woods

I Site of the Virginia State Memorial

J Path along a Fence Line

K Richmond Howitzers

L Confederate General Robert E. Lee, Commander of the Army of Northern Virginia, and Staff

M Emanuel Pitzer Farm

N Farms in the Extreme Distance, North of General Lee

The Gettysburg Cyclorama: The Turning Point of the Civil War on Canvas

Ⓐ Union Soldiers in Front of Stone Wall

In this part of the painting, we can see some Union troops in front of the stone wall. The historic keys listed these troops as a "portion of the 71st and 69th PA." At the height of Pickett's Charge, three companies of the 71st Pennsylvania were forced back, out of the Angle, to the regiment's main line at the eastern edge of the Angle (see View #3, E). Some of these troops may have fought for a very short time in front of the stone wall outside of the Angle before retiring to the other side of the wall.[1] It is possible that we are seeing this "moment in time" captured in the painting. Also at the height of the charge, several companies on the right end of the 69th Pennsylvania were overrun as the Confederates crossed the stone wall (see View #2, C and G). Many of these men were either killed or captured. It is possible, but unlikely, that some of these soldiers would have been present at this location north of the Angle.

It is also possible that the troops in this area were meant to represent the skirmish line of the Philadelphia Brigade, falling back in the face of the Confederate advance. The skirmish line was a thin group of men posted as a screen in front of the main line. During a large attack, the skirmishers would have given warning of the enemy advance and then rejoined the main line. The skirmish line would frequently be comprised of men from several different regiments, so it is possible that these troops could have been parts of the 69th and 71st Pennsylvania. However, the skirmishers would have quickly moved to the east side of the wall and rejoined their comrades.

Another important factor in this area of the painting is the diorama. In this section, the stone wall comes out of the painting and the "inner angle" is actually within the diorama. Some cyclorama artists used mannequins to represent people on the diorama. Paul Philippoteaux seems to have tried not to use these figures, probably believing that the audience would be able to tell that they were not real. It is possible that the artist moved some of the troops that should have been behind the stone wall forward in order to keep the diorama free of people. Of the four Gettysburg cycloramas, mannequins were only used in the final version.[2] An examination of the historic photographs of the New York version shows that the artist did resort to using a limited number of mannequins, mainly in the hospital area.

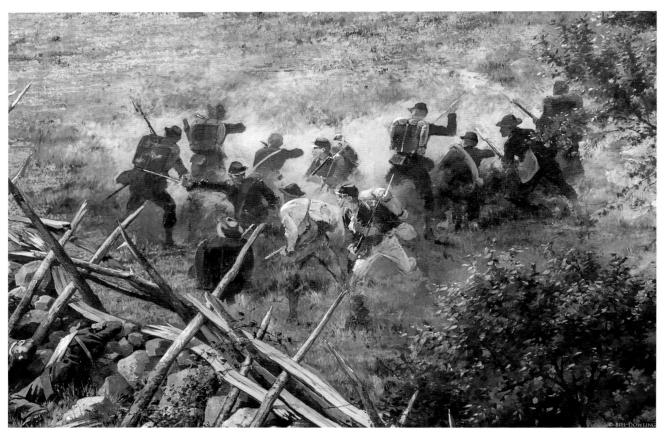

Detail of the painting showing Union troops in front of the stone wall. *BD*

When General Gibbon (View #1, E) saw the Chicago cyclorama, he wrote a letter describing the painting to Brig. Gen. Henry J. Hunt (View #9, D). In his letter, he is very complimentary of the painting. However, he does say that there are some problems with the military aspects. Gibbon states that

> the attacking force is <u>massed</u> and larger than it was, extends too far to my left, and instead of representing the <u>left</u> of my Div. coming up on the flank of the assaulting party they came up from the rear and men are represented as <u>leaving the stone wall</u> behind which they were posted and attacking from the <u>right</u>. (emphasis in original letter)[3]

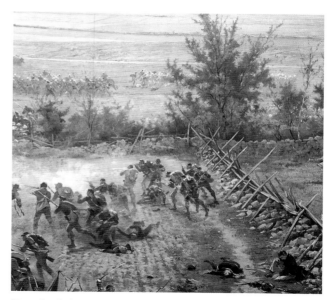

Detail of the painting showing the Angle. *BD*

The soldiers depicted in this part of the painting are probably the source of one of Gibbon's complaints. These troops appear to be "<u>leaving the stone wall</u>…and attacking from the <u>right</u>." It is the author's opinion that the artist may have placed these troops more for artistic reasons than any other factor. Any fighting on the west side of the wall would have been very brief. After all, any sane individual would want the protection of the stone wall during a heated battle.

Gibbon's complaint about the enemy being "<u>massed</u>" is probably caused by the artistic license of showing the same troops at different stages of the attack (as discussed in View #2, H and View #3, J). The forces "too far to my left" are probably Wilcox and Lang, advancing after the main attack (View #2, K and L). Gibbon would not have seen the advance of these forces because of heavy smoke and the fact that he was wounded during the main attack.

Finally, when Gibbon complained of "the <u>left</u> of my Div. coming up on the…rear" of the enemy, he is probably referencing the unidentified troops in front of the stone wall (View #2, I). In reality, these troops would have been on the east side of the stone wall. The units posted south of the Angle would have advanced through the Copse of Trees and engaged the Confederates inside the Angle.

Ⓑ The Angle

As described in the introduction, the stone wall in this area that runs from north to south turns and forms an angle. The Union troops inside this angle were farther to the west (and closer to the enemy) than their comrades north of the Angle. Known as "the Angle" or "the Bloody Angle," the entire area inside this bend in the stone wall is now one of the most famous pieces of land in American history. The letter in our key denotes the turn in the stone wall or the "outer angle." Everything from here south to the Copse of Trees would be considered part of the Angle area. From this point, the stone wall runs east before turning north at "the inner angle." Troops to the north of this point would not be considered in the Angle. In this book, we are denoting the outer turn in the wall <u>and</u> the area inside of it as "the Angle."

The point designated on the key becomes a good visual reference to show the border between the two wings of the attack. At the start of the charge, there was a space between Pickett's division and the divisions under Brig. Gen. J. Johnston Pettigrew and Maj. Gen. Isaac R. Trimble. As the Confederates approached the Union line, Pickett's men veered to the left in order to close the gap between the two wings of the attack. When they hit the Union line, almost all of Pickett's men attacked the area south of the turn in the wall (the outer angle). They managed to break into the Angle and this moment in time is now known as the "High Water Mark." Pettigrew's and Trimble's men attacked the Union men posted behind the stone wall north of the Angle. In this area, the Confederates had to cross more open ground in order to reach the Union line. Some brave men managed to reach the stone wall, but they could not break into the Union position.

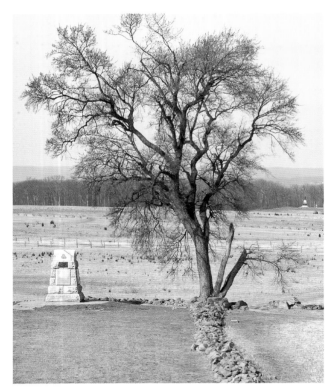

The Angle, modern. *BD*

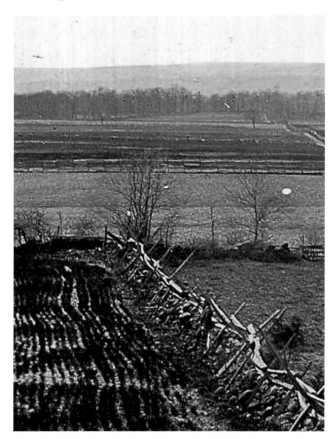

Detail of the Angle from Tipton's 1882 photographs. *SBC*

In the Tipton photographs, a small tree can be seen growing out of the stone wall at the outer angle. The same tree is still there today, and is now quite large. It is possible that this tree could be a "Witness Tree" (see View #1, J). If this is the case, it would have been quite small at the time of the battle. Unfortunately, Tipton was the first photographer to clearly document the inside of the Angle. Most of the pictures taken immediately after the battle were taken from the Emmitsburg Road, and do not have enough clarity to clearly pinpoint such a small tree.[4] At the very least, we can say that this tree has probably survived since 1882.

© Fry's Brigade and Marshall's Brigade from Pettigrew's Division

In many accounts of the fighting on July 3, General Pickett's division received most of the attention. To this day, the attack is commonly known as Pickett's Charge. Unfortunately, the divisions commanded by General Pettigrew and General Trimble are largely ignored. In much the same way, the Union men who repulsed these attacks also receive far less attention in the accounts of the battle. Immediately after the battle, the Richmond newspapers wrote the majority of the Southern accounts of the fighting. Since Pickett's division was comprised entirely of Virginians, the Richmond papers called the attack "Pickett's Charge" and this moniker has been used ever since. As discussed in the introduction, the charge should more accurately be called "Longstreet's Assault" or the "Pickett, Pettigrew, Trimble Charge," but the artist relied heavily on accounts from generals who were engaged south of the Angle (Webb, Doubleday, and Hancock).[5] In the first three versions of the painting, there appear to be fewer troops attacking the area north of the Angle than the area to the South. There also appear to be fewer defenders in the area north of the angle than the area to the south. In the New York version, the artist added more troops on both sides in the area north of the Angle. This change was probably a result of complaints from the veterans who fought in these areas.

The divisions commanded by Pettigrew and Trimble were comprised of soldiers from North Carolina, Tennessee, Alabama, Mississippi, and Virginia. These units suffered heavy casualties on the first day of the battle. Most of the units were not

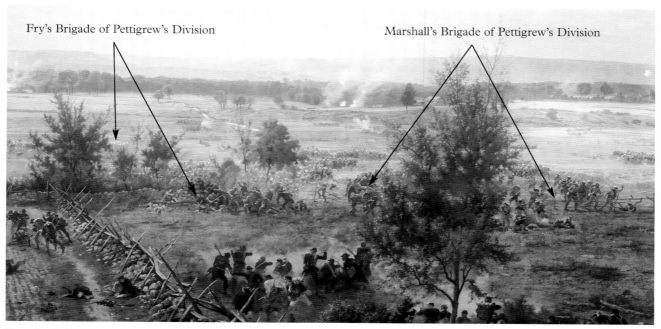

Fry's Brigade of Pettigrew's Division

Marshall's Brigade of Pettigrew's Division

Detail of the painting showing Fry's and Marshall's brigades. *BD*

commanded by their original leaders on July 3. General Pettigrew was commanding the division because Maj. Gen. Henry Heth was wounded on the first day. General Trimble was commanding two brigades from Maj. Gen. William D. Pender's division after Pender was mortally wounded on July 2. Colonel Birkett D. Fry was commanding Brig. Gen. James S. Archer's brigade after the general's capture on July 1. Colonel James K. Marshall was commanding Pettigrew's brigade because Pettigrew was now in charge of the division. With new commanders, and after suffering heavier casualties, these troops had significant disadvantages at the start of the charge. To make matters worse, they had significant obstacles to cross on their way toward the Union line. Stout fences on both sides of the Emmitsburg road slowed them down while they were in easy range of Union cannon and rifle fire (see D). To make matters worse, another fence divided the field between the road and the stone wall. In the painting, we can see the forward elements of Fry's and Marshall's brigades taking heavy casualties as they cross the final wooden fence (see View #5, B). Finally, the stone wall itself is farther east than it is in the area south of the Angle. Although these troops did not cross the stone wall, some of the men made it to the wall. Considering their condition and the difficulties they encountered, the attack by these troops was every bit as heroic as that of Pickett's men.

It is unfortunate that they are largely ignored in some accounts of the battle.

In the painting, the troops of Pettigrew's division are starting to attack the Union line at the same moment the Virginians are reaching the High Water Mark. Trimble's men can be seen following Pettigrew in order to support the northern half of the attack. Accounts of the battle vary on the exact timing of the two parts of the attack. Some accounts seem to match the timing depicted in the painting, with Pettigrew and Trimble attacking after Pickett. In other accounts, Pettigrew and Trimble were already being repulsed as General Armistead broke into the Angle. Some accounts have the two wings striking almost simultaneously. Many of the firsthand accounts of Pickett's Charge only focused on what was happening right in front of the story teller. In the smoke and confusion of the battle, the soldiers could not say for sure what was happening only 50 yards away. Due to the fog of war, we may never know the exact timing of the different parts of the attack.

The painting depicts troops from Colonel Fry's brigade of Tennesseans and Alabamians attacking the area just to the north of the Angle. The right side of Fry's line can be seen just to the south of the Angle. Some of Fry's men were able to fire into the Angle from the area just north of the wall and created a deadly crossfire during Armistead's breakthrough.

Colonel Fry was wounded and captured during the charge. To Fry's left, we can see Marshall's brigade of North Carolinians. Colonel Marshall was killed as his men charged the main Union line.[6]

Marshall's brigade included the 26th North Carolina Infantry regiment. Today, a marker on the field shows the point of the farthest advance of the 26th. In the painting, this marker would be located in the approximate area of the artist's self-portrait (see View #5, A). In reality, this marker should probably be slightly north of this position. Either way, this marker is slightly farther to the east than the marker that denotes the spot of Armistead's wounding. This monument reminds us that the North Carolinians were also part of Pickett's Charge, and they made it just as far or farther than the Virginians.

Ⓓ Fences on the Emmitsburg Road

Stout fences lined both sides of the Emmitsburg Road in 1863. In the painting, the fences start in the area denoted by the key letter and continue to the north of this point. South of this point, there are no fences.

These fences would play a role in slowing down the Confederate attack on July 3. Major General John F. Reynolds ordered his men to dismantle some of the fences along the road north of the Codori farm as they cut across the fields toward the Lutheran Seminary on the first day. On July 2, some of the fences in the area of the Codori farm were torn down by Union troops (see View #3, H). These soldiers, which included the 15th Massachusetts, used the fence rails to build a crude breastwork. From these accounts, we know that there were gaps in the fences along the road. Unfortunately, no one took pictures of these fences immediately after the battle, so it is impossible to say exactly where they ended.[7] Confederate reports from Pickett's division made fewer references to being hindered by fences than the men from Pettigrew's division.[8]

For example, Lieut. Col. S. G. Sheppard of the 7th Tennessee (Fry's brigade) reported that "within 180 or 200 yards of his works, we came to a lane enclosed by two stout post and plank fences. This was a very great obstruction to us, but the men rushed over as rapidly as they could, and advanced directly upon the enemy's works."[9]

The depiction of the fencing in the painting may be slightly inaccurate, although we will never know for sure. Opinions vary on exactly where the fences ended (see Chapter 3). It is probable that the fences were still standing on the road farther to the south than what is depicted in the painting, but they definitely had some gaps near the Codori farm.

Ⓔ Scales' Brigade (Commanded by Col. W. Lee J. Lowrance)

Supporting Pettigrew's division were two brigades under the command of General Trimble. On their right,

Scales Brigade of Trimble's Division

Fences on the Emmitsburg Road

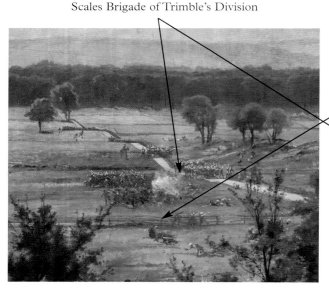

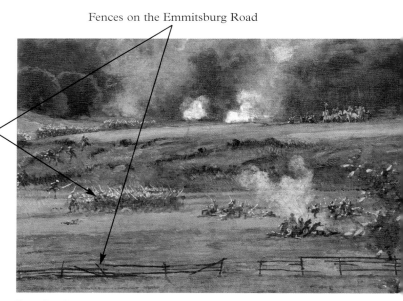

Detail of the painting showing Scales' brigade. *BD*

Detail of the painting showing more of Scales' brigade. *BD*

Scales' brigade of North Carolinians followed the brigades of Fry and Marshall. On their left, Lane's brigade of North Carolinians supported the brigades of Davis and Brockenbrough (see View #5, E and I). Scales' brigade took severe casualties on July 1 during its attack against Union troops in the area of the Lutheran Seminary (see View #6, J). Brigadier General Alfred M. Scales was severely wounded, and Colonel Lowrance was in charge of the brigade on July 3.

In the painting, the troops under Col. Lowrance can be seen advancing from Seminary Ridge in order to support Pettigrew's forces. They advanced toward the Union position until they got close to the stone wall. The Union men behind the stone wall hit them with massed rifle and cannon fire. Eventually these troops were forced to retire after suffering heavy casualties.

There may be some artistic license in this part of the painting similar to what we have seen for some of the other Confederate units (see View #2 H & L, and View #3, J). Some of the men depicted are just leaving Seminary Ridge, while others have already reached the Emmitsburg Road. The author may have been trying to show different stages of the charge by depicting the same units more than once.

(F) Lane's Brigade

The other brigade in General Trimble's division was commanded by Brig. Gen. James H. Lane. Like Scales' brigade, these North Carolinians were supporting Pettigrew's division. Lane's men would have started the charge on Scales' left. As they crossed the Emmitsburg Road, they followed Davis' brigade (View #5, E) and attacked toward the Brian barn (see View #6, E).

As discussed in C, more troops were added to the Southern attack north of the Angle in the New York version of the painting. Most of the extra forces seem to belong to Lane's brigade and Davis' brigade. The artist probably made these changes to address criticisms from both Northern and Southern veterans that there weren't enough men in this part of the painting.

(G) Buildings in the Trees South of the Point of Woods

In the same area as the Confederate batteries south of the Point of Woods (View #3, R), two distant building can be seen on Seminary Ridge in the painting. These

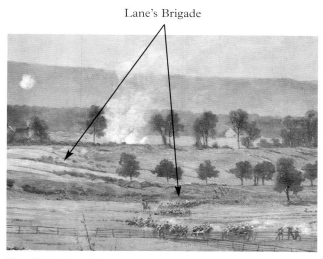

Lane's Brigade

Detail of the painting showing Lane's brigade. *BD*

building are not actually on Seminary Ridge; they are well past (west of) the ridge, and are not visible in the summer. However, when the artist had Tipton take photographs of the battlefield in the spring of 1882, there were no leaves on the trees. Without the intervening foliage, these buildings must have been visible. By using historic maps of this area, the authors have identified an out-building from the Emanuel Pitzer farm (see M) and, to the north, the John Edward Plank farm. Today, there are other farms in this area, and the intervening forest is too dense to see through, even in when there are no leaves on the trees.

As noted in a *Scientific American* article on the

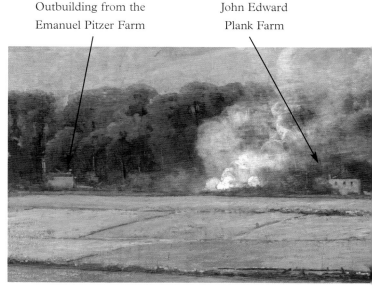

Outbuilding from the John Edward
Emanuel Pitzer Farm Plank Farm

Detail of the painting showing distant buildings in the trees south of the Point of Woods. *BD*

creation of cycloramas, the artist would usually take three sets of pictures of the terrain. Each set would have been identical, except the camera would have been focused on objects at short, medium, and long range.[10] It seems unlikely that Philippoteaux had Tipton take all three sets of photographs because only the mid-range photographs have survived (see Chapter 3). These two buildings cannot be identified in the surviving copies of the Tipton photographs, but there may have been more detail visible in the original glass-plate negatives. It is also possible that the artist simply took notes about some of these distant buildings while he was visiting Gettysburg and included them in the painting.

Ⓗ The Point of Woods

In this area, two fences met and formed the northeastern corner of Spangler's Woods (see View #3, P). To the north of this area, the woods on Seminary Ridge were farther to the west and thus farther from the enemy. Because the Point of Woods was closer to the enemy, it became an observation point for several prominent Confederate generals to observe the charge.

Lieutenant General James Longstreet was known to be in this area before the cannonade on July 3. During the bombardment, he rode southward and consulted with Colonel Alexander about the effectiveness of the cannonade (see View #3, R). When it was time to give the order to General Pickett to start the charge, Longstreet was near the Point of Woods. General Longstreet was not in favor of making this attack, but General Lee overruled him. When Pickett asked if he should start the attack, Longstreet was so overcome by emotion that he could only nod.[11] At the end of the charge, General Lee rode out to this location and tried to restore order to his broken divisions. It was near this spot where Lee told his men "It is all my fault."[12] On the battlefield today, there is a footpath that leads from the Virginia State Memorial to this area.

This area also helps to illustrate the gap between the two wings of the Confederate attack. This point marked the left of Pickett's division. The right of Pettigrew's and Trimble's divisions would be several hundred yards to the north. In the painting, Pettigrew's right would be north of the Virginia Monument near the fence line in the painting (J).

Ⓘ Site of the Virginia State Memorial

The Virginia State Memorial, with an equestrian statue of General Robert E. Lee, sits at this location on the battlefield today. Marking the center of Pickett's Charge, the monument is approximately one mile from

Point of Woods Site of the Virginia Monument Path along a Fence Line

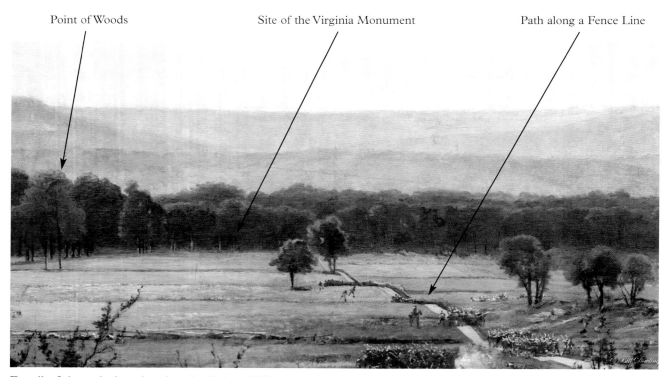

Detail of the painting showing the Point of Woods and the area of the Virginia Memorial. *BD*

Virginia State Memorial at Gettysburg with statue of General Lee. *BD*

the equestrian statue of General Meade (see View #8, G). The Virginia Memorial, dedicated in 1917, was the first Confederate state memorial to be placed on the battlefield.[13] By all accounts it is one of the finest representations of General Lee ever created.

Ⓙ Path along a Fence Line

In the painting, a path follows the fence which denotes the southern boundary of the Bliss farm (see #5, D). The NPS mows this path, and it is still visible today. When one looks at this area today, it helps to illustrate the rolling nature of the ground west of the Emmitsburg Road. If you stand at ground level and look at this fence, it seems to disappear several times as it crosses the fields. During the attack, the right flank of Pettigrew's division would have been close to this path and fence line.

Some of the historic keys mislabeled this path as the "Hagerstown Road" (Chicago) or "Millerstown Road" (Philadelphia). The modern Millerstown Road is located to the south of the path in the painting. The road is an extension of the Wheatfield Road, crossing the Emmitsburg Road near the Sherfy barn (see View #2, S) and heading west to Seminary Ridge. The modern Millerstown Road then turns into Pumping Station Road. In 1863, the Millerstown Road turned into a series of small country roads and farm lanes that eventually led to Fairfield.

When it was first founded, the town of Fairfield was sometimes called Millerstown. The term "Millerstown Road" was sometimes used in place of the Fairfield Road.[14] The same road was also sometimes called the Hagerstown Road at the time of the battle. However, the Fairfield Road crossed Seminary Ridge just south of the Seminary buildings (see View #6, J), which is well north of this area.

The New York key labeled this path as the "Side road to Millerstown." This label may have been more accurate. The historic maps of the battlefield do not show a farm lane in this area; however, by 1882, local residents may have been using this path as a shortcut across the fields to the Fairfield Road. By following this path, a traveler could have gotten on the farm lane at the Emanuel Pitzer farm (see M) which connects with the Fairfield Road well south of town. This shortcut would have saved travelers time by keeping them from going north into the town only to head south down the Fairfield Road. By the time of the 1882 Tipton photographs, the path was clearly visible.

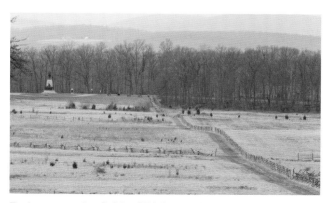

Path across the field of Pickett's Charge, modern. *BD*

Path across the field of Pickett's charge in 1882 Tipton photograph. *SBC*

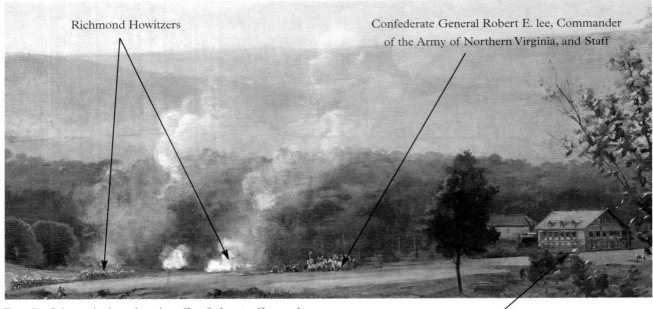

Richmond Howitzers

Confederate General Robert E. lee, Commander
of the Army of Northern Virginia, and Staff

Detail of the painting showing Confederate General
Robert E. Lee, Commander of the Army of Northern
Virginia, and Staff. *BD*

Ⓚ Richmond Howitzers

In this part of the painting smoke can be seen rising
from a Confederate battery. The historic keys labeled
this unit as the "Richmond Howitzers." On July 3, the
1st Richmond Howitzers were stationed slightly to the
south of this area. Commanded by Capt. Edward S.
McCarthy, this battery was comprised of two
Napoleons and two three-inch rifles.

The New York key labeled this unit as "Grime's
Norfolk Battery." This reference is probably to the
Norfolk (Virginia) Light Artillery Blues under the
command of Capt. Charles R. Grandy. However, this
battery did not participate in the bombardment on July
3. Earlier in the war, some of these same artillerymen
served with Grimes's battery. Captain Cary F. Grimes
was killed in the Battle of Antietam in 1862.[15] After
Grimes's death, the battery was reorganized and some of
the men became part of the new battery under Grandy.

Ⓛ Confederate General Robert E. Lee, Commander of the Army of Northern Virginia, and Staff

In the painting, General Robert E. Lee and his staff can
be seen in this area. With extreme magnification, the
viewer can pick out Lee's white hair and light-colored
horse, Traveler. During the bombardment and the
charge, General Lee rode southward along Seminary

Emanual Pitzer Farm

Pitzer farm on the west side of Seminary Ridge,
modern. *BD*

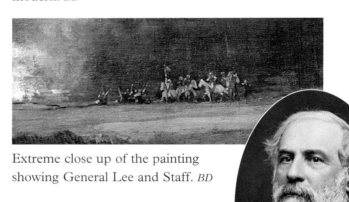

Extreme close up of the painting
showing General Lee and Staff. *BD*

General Robert E. Lee. *LOC*

Ridge. By the end of the charge, he
was at the Point of Woods (H) trying to
rally his despondent troops as they
returned from the unsuccessful charge.

Ⓜ Emanuel Pitzer Farm

Like the buildings that can be seen on Seminary Ridge to the south (see G), the Pitzer farm is actually several hundred yards west of the ridge. In the summer, this farm is not visible from Cemetery Ridge. However, when there are no leaves on the trees, one can clearly see it. In the Tipton photographs, the artist could clearly see this farm. Since the artist could not ascertain the exact distance, he put it in the painting on Seminary Ridge.

Today, this farm still stands and can be clearly seen from Cemetery Ridge when there are no leaves on the trees. Called Brown's ranch today, there is an easement on the property to protect its historic nature. During the battle, this farm was the headquarters for Confederate General A. P. Hill. Generals Lee, Longstreet, and Pickett may have met here to finalize the plan of attack on July 3.[16]

Ⓝ Farms in the Extreme Distance, North of General Lee

In the painting, several farms can be seen in the distance behind Seminary Ridge. The buildings are too distant to be positively identified. Today, there are many modern buildings behind Seminary Ridge that make it difficult to ascertain exactly what might have been visible in 1863. Furthermore, the artist may have had problems determining the exact distance to these farms (see G and M). A study of the historic maps shows several farms in this area, close to the Fairfield Road. The Samuel Dixon farm is probably the first farm visible to the north of the Pitzer farm. A farm owned by Henry Meals is probably the next set of building to the north. The third group of buildings to the north, are most likely meant to represent the George Arnold farm (rented by John Horning). There were several other farms in this area including (from south to north): the farms of George Culp, Peter Stallsmith (rented by William Keefauver), John Herbst, and Emanuel Harman. Depending on the exact contour of the land, it is possible that one of these other farms is actually represented in the painting.

Detail of the painting showing the first farm north of General Lee which is probably the Samuel Dixon farm. *SBC*

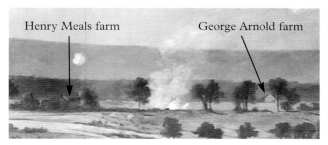

Henry Meals farm George Arnold farm

Detail of the painting showing the second farm in the distance north of General Lee which is probably the Henry Meals farm. The third farm north of Lee is probably the George Arnold farm (rented by John Horning). *BD*

Henry J. Hunt Papers, 1862-1888, Guilder-Lehrman Collection; Boardman and Porch, *The Battle of Gettysburg Cyclorama: A History and Guide*, 25-26.

[4] Frassanito, *Early Photography at Gettysburg*, 234-237.

[5] Boardman and Porch, *The Battle of Gettysburg Cyclorama: A History and Guide*, 23.

[6] Report of Brig. Gen. Joseph R. Davis, *OR* 27, pt. 2, 651; Hess, *Pickett's Charge – the Last Attack at Gettysburg*, 497.

[7] Frassanito, *Early Photography at Gettysburg*, 238–239.

[8] Hess, *Pickett's Charge – the Last Attack at Gettysburg*, 78-79.

[9] Report of Lieut. Col. S. G. Shepard, *OR* 27, pt. 2, 647.

[10] Editors of Scientific American, "The Cyclorama", *Scientific American*, New York, November 6, 1886, 296.

[11] Hess, *Pickett's Charge- the Last Attack at Gettysburg*, 161.

[12] *Ibid.*, 326-327; Coddington, *The Gettysburg Campaign: A Study in Command*, 526-527.

[13] Hawthorne, *Stories of Men and Monuments*, 38.

[14] Sarah Sites Thomas, Tim Smith, Gary Kross, and Dean S. Thomas, *Fairfield in the Civil War* (Gettysburg, PA, 2011), 14-15.

[15] Virginia National Guard Historical Society website, vnghs.org, entry on Grimes Battery.

[16] Carper and Hardoby, *The Gettysburg Battlefield Farmsteads Guide*, 45–46.

[1] Brown, *Cushing of Gettysburg*, 254.

[2] Stirring Battle Scene in the Cyclorama, *Brooklyn Daily Eagle*, October 2, 1886.

[3] General John Gibbon, letter to Henry J. Hunt, September 6, 1884.

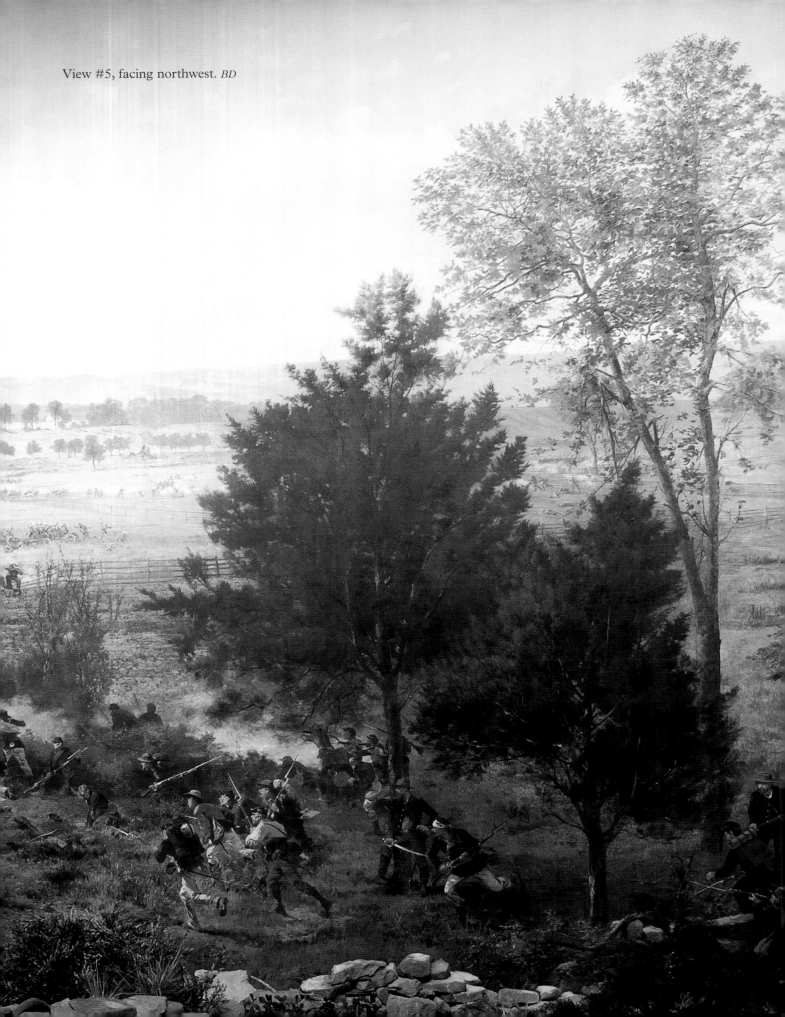

View #5, facing northwest. *BD*

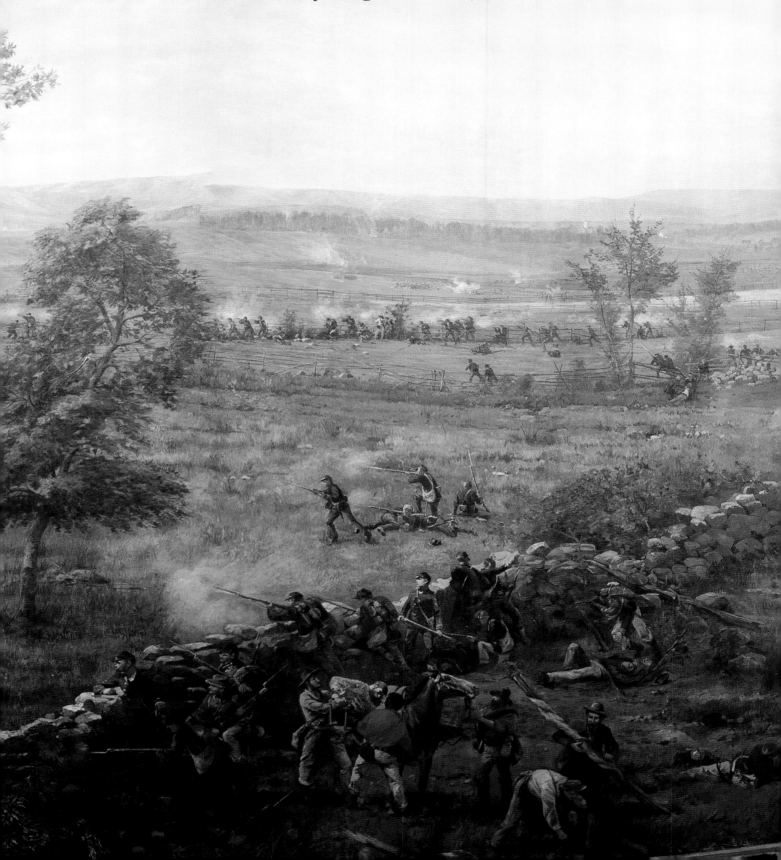

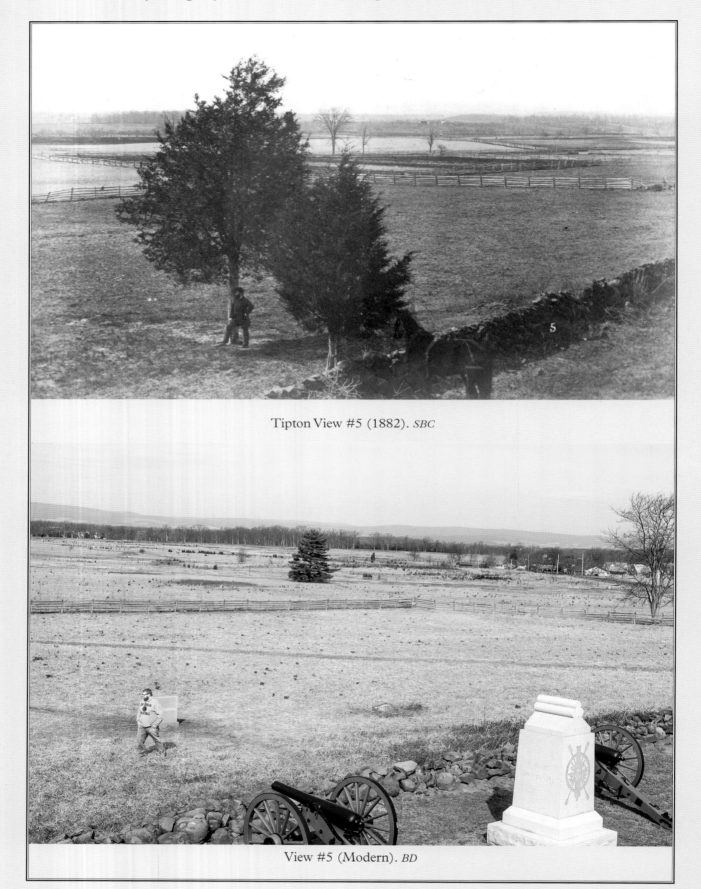

Tipton View #5 (1882). *SBC*

View #5 (Modern). *BD*

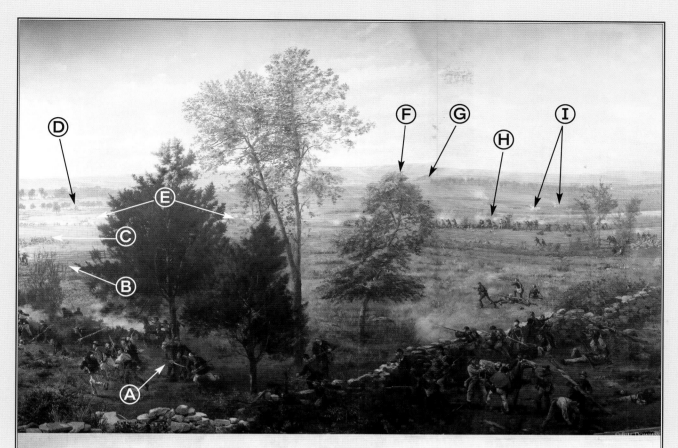

⚡ KEY ⚡

Ⓐ Paul Philippoteaux, Cyclorama Artist

Ⓑ Fence Between the Emmitsburg Road and the Union Line

Ⓒ The Effects of Canister Fire

Ⓓ Bliss Farm Site-Buildings Burned on July 3

Ⓔ Davis' Brigade (Pettigrew's Division)

Ⓕ David McMillan Farm (Hidden by Trees)

Ⓖ McPherson's Ridge

Ⓗ 8th Ohio Volunteer Infantry or Union Skirmish Line

Ⓘ Brockenbrough's Brigade

The Gettysburg Cyclorama: The Turning Point of the Civil War on Canvas

Ⓐ Paul Philippoteaux, Cyclorama Artist

In this part of the painting we can see the self-portrait of Paul Philippoteaux, the main artist responsible for creating *The Battle of Gettysburg* Cyclorama. A surviving photograph, taken by William Tipton, shows Philippoteaux posing next to his own image within the painting (see Chapter 2 and 3). This photograph was inscribed to "Ch. Willoughby, souvenir of affection, Paul Philippoteaux, Boston, 1884." This picture was part of a series of photographs taken by Tipton and sent to cyclorama financier, Charles Willoughby. Unfortunately, any other photographs taken as part of this series have not survived. All of Mr. Willoughby's other records and pictures relating to cycloramas and his businesses were destroyed after his death.

It appears as if only the artist, Tipton, and Willoughby were aware of artist's self-portrait in the painting. It was not until 30 years later that the artist's self-portrait became public knowledge. About one year after the painting opened in the East Cemetery Hill building, the manager of the building, Thomas Fryer, invited the artist to visit Gettysburg. Not only did Philippoteaux verify that this was one of his own paintings, but he pointed out his self-portrait. According to an interview with Mr. Fryer's daughter, Mrs. Etta Fryer: "In cases where several artists were engaged on a painting, the European practice was to paint in the likeness of the artist rather than a name, as the presence of a name would appear to take credit for the entire work." This statement implies that the artist's assistants may also be depicted in the painting (see Chapter 3, and View #3, B).

In all of the historic keys, the figure leaning against the tree was identified as a Union officer, and this figure was not identified as Philippoteaux until after 1913. In the Philadelphia key, the officer was listed as "Capt. Davis, 69th Pennsylvania Volunteers." Captain William Davis took command of the 69th Pennsylvania on July 3 after Colonel O'Kane and all the other higher ranking officers were killed or wounded. As noted in View #4, A, it is improbable that many soldiers from the 69th would have been at this location. It is possible that some of the men in this area were part of the Union skirmish line. It is also possible that the artist simply made a mistake by putting members of the 69th this far north of their position.

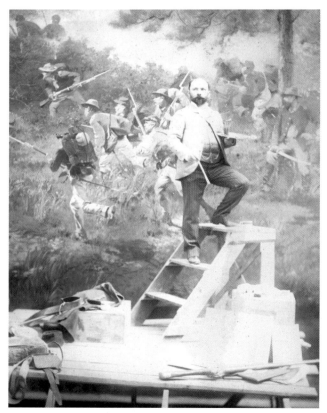

Detail of the painting showing the self-portrait of artist Paul Philippoteaux. *BD*

Paul Philippoteaux posing next to his self-portrait in the painting. *SBC*

The Effects of Canister Fire

Fence Between Emmitsburg Road and The Stone Wall

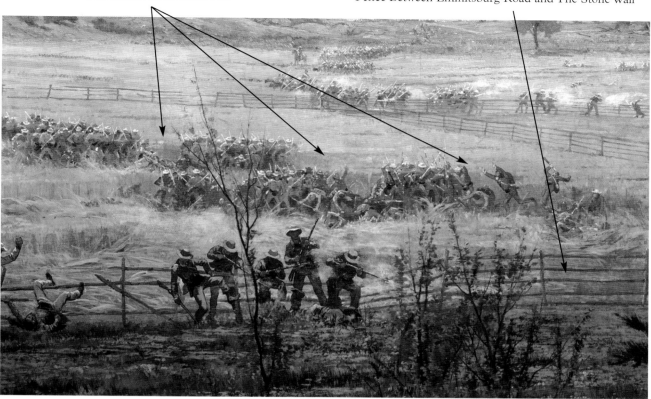

Detail of the painting showing the fence between the Emmitsburg Road and the stone wall. Also visible, the effects of Union canister fire on the Confederate line. *BD*

The Chicago and New York keys labeled this officer as "Lieutenant Montgomery commanding the 69th Pennsylvania" or "…commanding 69th Penn. Skirmishers." A search of the records from the 69th Pennsylvania showed no record of a Lieutenant Montgomery. A search of all Pennsylvania troops at Gettysburg showed only two Lieutenant Montgomerys present as Gettysburg, and these men were not in the area of the Angle on July 3. Perhaps Philippoteaux simply made up a name in order to conceal his self-portrait. In the words of NPS park historian Gregory Mertz in a 1983 report: "Could it be that Philippoteaux pointed out very few features and figures in the painting, causing various people to draw their own interpretations about the cycloramas, some logical and some blatantly wrong? These are some of the problems one faces when interpreting the cyclorama."[1]

B Fence Between the Emmitsburg Road and the Union Line

In this area, a post and rail fence ran parallel to the stone wall occupied by the Union defenders. As they crossed the two fences at the Emmitsburg Road, the Confederates suffered heavy losses from massed Union small-arms fire and close-range artillery fire. Those soldiers still on their feet rushed toward the Union line. When they reached this third fence, the attacking force was badly disorganized. Once they crossed this fence, only small groups of men remained on their feet. Following their battle flags, small groups of men made it close to the stone wall before they were finally shot down or captured. Up to ten Confederate flags were captured between this fence and the stone wall.[2] In the painting, the Confederates are just starting to cross this fence line in several places (see also, View #4, C).

C The Effects of Canister Fire

As discussed in View #0, C, Civil War artillery could fire four kinds of ammunition. At close range, the artillery fired ammunition known as canister. Canister ammunition consisted of a hollow tin can filled with large iron balls between the size of a marble and a golf ball. When the cannon was fired, the tin can would break apart and the iron balls would spread out like a

giant shotgun blast. At close range, 400 yards or less, this ammunition could cut a wide path through an enemy line. At less than 200 yards, the gunners would switch to double canister. By putting two cans of iron balls in the cannon, the shotgun-like blasts would be even more devastating. In the painting, we can see canister blasts from Union cannon (see View #6, D) cutting a path through the Confederate attackers. The final type of ammunition, solid shot, will be discussed in View #6, C.

Ⓓ Bliss Farm Site-Buildings Burned on July 3

Located between the opposing armies, the William Bliss farm was hotly contested on both July 2 and 3. Skirmishers from both armies sought to control this farm for two days. Whichever side controlled the Bliss property engaged in sharp-shooting against the main line of the enemy. This farm changed hands up to ten times.[3] Finally, on the morning of July 3, Union troops burned the house and barn to prevent another Confederate occupation of the property. In the painting, the still-smoking remains of the barn can be seen. Today, two mounds of earth are all that remain of the Bliss farm.

In the historic keys, it listed "Burning Building: Bliss' Place." In the New York key it noted "Burning of the Bliss homestead by the 14th Conn. Vols. Maj. Bush and Capt. Dalton." A search of historic records does not show a Bush or Dalton with the 14th Connecticut. However, the barn was burned down by a detachment of the 14th led by Maj. Theodore Ellis and his adjutant Lt. Frederick B. Doten (who was promoted to Captain in October 1863). It is possible that Doten was simply misspelled as Dalton. An interesting incident took

The remains of Bliss farm today. The monument to the 14th Connecticut infantry is visible in front of the mound at the former site of the Bliss barn. *BD*

Monument to the 14th Connecticut at the Bliss farm. *BD*

Detail of the painting showing the smoking remains of the Bliss farm. *BD*

Bas-Relief on the monument to the 12th New Jersey showing the fighting at the Bliss barn. *BD*

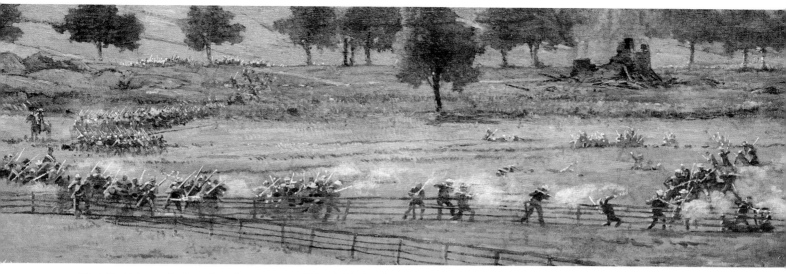

Detail of the painting showing a part of Davis' brigade. *BD*

place just before the Bliss property was burned. A Sergeant asked Lt. Doten permission to take some chickens that were "captured" from the Bliss farm. Major Ellis wrote that permission "was upon this occasion granted." There is little doubt that these "captured" chickens were soon lunch for the hungry soldiers.[4]

Soldiers from the 1st Delaware and the 12th New Jersey also fought for control of the Bliss house and barn before it was eventually burned. Some of the historic keys referenced attacks on the Bliss farm by the 12th New Jersey (see View #6, F). Today, there are small monuments near the remains of the Bliss buildings that commemorate the actions of the 14th Connecticut, 1st Delaware, and 12th New Jersey.

Ⓔ Davis' Brigade (Pettigrew's Division)

The troops depicted in this part of the painting are probably part of the brigade commanded by Brig. Gen. Joseph R. Davis from Pettigrew's division. Comprised of troops from Mississippi and North Carolina, these troops took heavy losses on July 1. Davis' brigade was the second from the far left of the attack when it began. When Brockenbrough's brigade fell back (see I), Davis became the left flank of Pettigrew's division. This brigade suffered heavy losses from both frontal and flanking fire. Despite heavy casualties, some of the men from Davis' brigade made it to the Brian barn before their advance was repulsed.

In the painting, it is hard to positively identify exactly which troops are supposed to belong to which brigade. Most of the keys only labeled these men as being part of Pettigrew's and Trimble's divisions. Some of the men in this area could also be parts of Lane's brigade (View #4, F), which was in support of Davis and Marshall. In this part of the painting, there does not seem to be enough troops to represent the six brigades under Pettigrew and Trimble. The troops in this area of the painting are also quite spread out. Photographs of the New York version seemed to show more Confederate troops north of the Angle. Perhaps the artist was addressing complaints from some of the veterans who came to see the earlier versions of the painting. The same seems to be true of the Northern defenders in the area north of the stone wall (see View #6, A).

Some of the old Gettysburg keys noted "General Pettigrew wounded" in this area. Pettigrew was wounded in the hand during the attack on July 3. It is unclear exactly where he was located at the time of his wounding. Pettigrew was mortally wounded at the end of the Gettysburg campaign during a rear-guard action at Falling Waters on July 13.[5]

General Trimble was also wounded during the attack. He received a bullet to his left leg. The leg was later amputated at the Samuel Cobean farm (see View #6, O). General Trimble, like General Kemper, was too badly wounded to be taken back to Virginia. After the battle, he was taken prisoner by Union forces. At one point, both captured generals were cared for at the Lutheran Seminary (see View #6, J). The generals were eventually exchanged, but never again saw active service.[6]

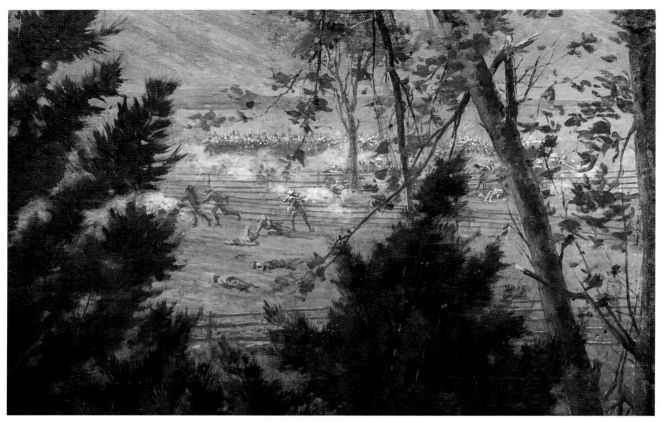

Detail of the painting showing more of Davis' brigade. *BD*

Ⓕ David McMillan Farm (Hidden by Trees)

In this part of the painting, the top of a small tree blocks the view of the David McMillan farm. Located on Seminary Ridge, the McMillan house is still there today, although some modern additions have been added onto the house and the barn no longer stands. The house is private property, but is protected by easements. On July 3, Confederate artillery near the McMillan farm would have participated in the bombardment before the charge. When the charge began, the far left flank of the attack stepped off Seminary Ridge just south of the McMillan farm (Brockenbrough's brigade, see I).

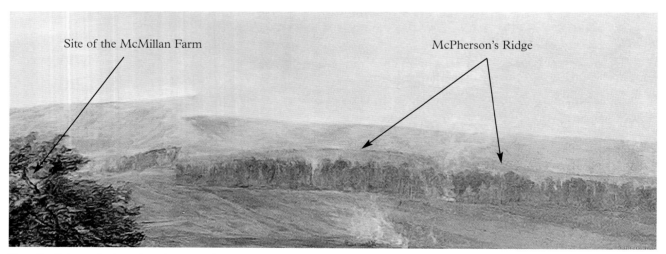

Detail of the painting showing the site of the McMillan farm and McPherson's Ridge (site of heavy fighting on July 1). *BD*

Notes on view #5 (facing northwest)

Ⓖ McPherson's Ridge

In the extreme distance of the painting, just beyond Seminary Ridge, another small ridge can be seen. This is probably McPherson's Ridge, the site of heavy fighting on July 1. Some of the keys make reference to the actions of July 1 in this area. Descriptions such as "General Reynolds killed" and "Opening the engagement by Buford's Cavalry and Cutler's 1st Brig. 1st A.C." could be found in the historic keys. It is interesting to note that the New York key mentioned Brig. Gen. Lysander Cutler's brigade because this brigade was comprised mostly of New York units (most Union brigades were made up of men from several different states).

Ⓗ 8th Ohio Volunteer Infantry or Union Skirmish Line

The soldiers in advance of the main Union line were listed differently in the various keys. In some of the historic keys, there was no designation for these troops. In the Philadelphia key, these troops were listed as the "Charge of Smyth's Brigade." In the older Gettysburg keys and the modern key, these troops are labeled as the "8th Ohio Volunteer Infantry." It is the authors' opinion that neither designation is entirely accurate.

Colonel Thomas A. Smyth's brigade was the 2nd Brigade of the 3rd Division (Hays' division) of the II Corps (Hancock's corps) of the Army of the Potomac. Smyth's brigade was comprised of the 14th Connecticut, 1st Delaware, 12th New Jersey, and 108th New York. This brigade was manning the stone wall north of the Angle when the Confederates attacked. There is no record of Smyth's brigade leaving the cover of the stone wall until after the attack was over. As the Confederates retreated, men from Smyth's brigade rushed forward and captured numerous flags and took hundreds of prisoners. On the second and early on the third day, different units from Smyth's brigade charged forward in order to capture the Bliss farm (see D, and View #6, F). It is possible that the artist was trying to show one of these actions. As discussed in View #4, A, the main line of battle was always protected by a thin line of men posted in front of the main line. This skirmish line, several hundred yards in front of the main line, protected the main line from enemy sharpshooters. In the event of a full-scale attack, the skirmishers would have retreated to the main line. It is the authors' opinion that a more realistic label for these soldiers would be "Skirmish line from Smyth's brigade falling back to the main line."

The more recent label of the 8th Ohio Infantry also has some problems. The 8th Ohio was stationed in an advanced position on July 3, but they would have been located to the north of their position in the painting. The actual position of the 8th Ohio was along a fence line northwest of the Brian farm (see View #6, G). Ironically, the monument to the 8th Ohio was also placed too far to the south of the position where they did their hardest fighting.[7]

On July 2, the 8th Ohio was detached from its brigade to serve on the skirmish line. Their commander, Lt. Col. Franklin Sawyer, was ordered to hold the skirmish line at all hazards. Near the end of the day, the rest of the brigade was called away to help on the east side of Cemetery Hill (Carroll's 1st Brigade of Hays' 3rd Division of the II Corps). At the end of the second day, Col. Samuel S. Carroll's brigade was ordered to stay on East Cemetery Hill in order to bolster the Union XI Corps. Faithful to his orders, Lt. Col. Sawyer stayed in his advanced position several

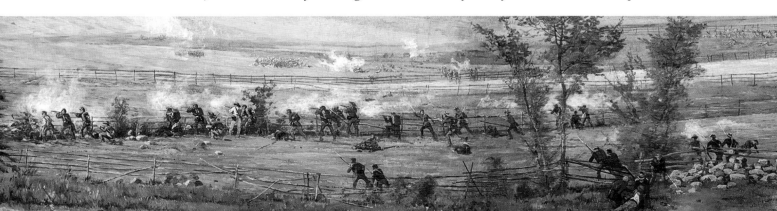

Detail of the painting showing the Union skirmish line, possibly including the 8th Ohio. *BD*

hundred yards west of Cemetery Hill. During the massive cannonade that preceded Pickett's Charge, the 8th Ohio was stuck in no-man's-land between the two opposing armies.[8] Once the infantry attack began, the story of the 8th Ohio was closely linked to the story of Brockenbrough's Confederate brigade, which will be discussed in the next entry.

Ⓘ Brockenbrough's Brigade

Colonel John M. Brockenbrough's brigade was the left flank of the attack on July 3. Its line would have started just to the south of the McMillan farm (see F). This small brigade was comprised of soldiers from Virginia. On July 1, this brigade only had about 800 men (roughly half the size of a normal brigade). On the first day, they were engaged in heavy fighting on McPherson's Ridge. On July 3, they had only about 500 men ready for battle. To add to their problems, this brigade also had poor leadership. For reasons that have never been fully explained, Col. Brockenbrough put half the brigade under the command of Col. Robert M. Mayo. At the very start of the charge, things were

already starting to go wrong for this brigade. They started the charge late and had to hurry to catch up with the unit on their right (Davis's brigade).[9]

As soon as they stepped out into the open, Brockenbrough's men started to take heavy fire from approximately 30 Union cannon on Cemetery Hill. These cannon had a clear view of the left end of the Confederate attack. However, the trees of Zeigler's Grove (see View #7, G) blocked their view of the rest of the attack. For this reason, these unfortunate Confederates were hit by concentrated artillery fire. This massed fire quickly started to wreak havoc in Brockenbrough's small brigade.

Meanwhile, the 8th Ohio was laying low in the fields directly in front of Brockenbrough's advance. Colonel Sawyer had only 200 or fewer men to face the oncoming threat. Instead of retreating, Sawyer decided to follow his orders and hold the line at all hazards. He ordered the entire regiment to wait until the Virginians were at close range, before giving them a volley from their muskets. Brockenbrough's men were already starting to come unglued when the 8th Ohio rose up

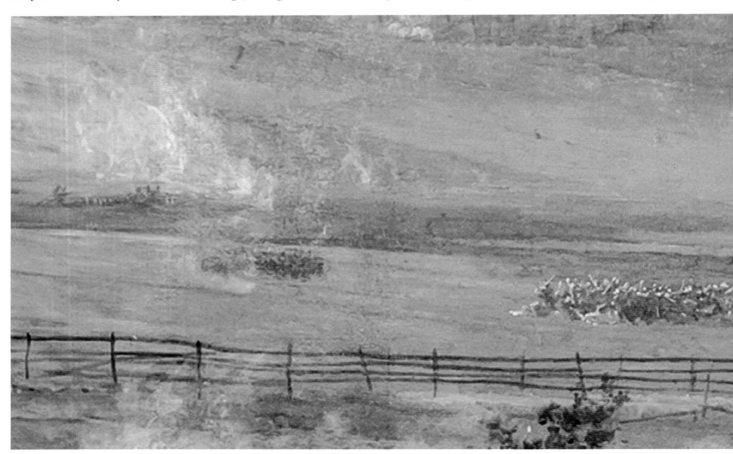

Detail of the painting showing Brockenbrough's brigade. *BD*

and fired at them at close range. This sudden attack was too much for the frazzled Confederates. Brockenbrough's brigade broke and started running back to Seminary Ridge.[10]

Once the threat was eliminated to their front, the men from the 8th Ohio started to fire into the flank of Davis' and Lane's brigades. This flanking fire was extremely deadly. As the Confederates approached the Union line, parts of several other units linked up with the Ohioans to fire into the Confederate flank. The 8th Ohio was aided by men from the 1st Massachusetts Sharpshooters, the 126th New York, and the 108th New York.[11] Brigadier General James H. Lane reported that, "My left was very much exposed, and a column of the enemy's infantry was thrown forward in that direction, which enfiladed my whole line. This forced me to withdraw my brigade."[12] In combination with the flanking maneuver made by the Vermont brigade (View #2, J), both ends of the Pickett's Charge were quickly ravaged.

[1] Mertz, *Interpretations of the Gettysburg Cyclorama*, 2-4; Alfred Mongin, *Gettysburg Cyclorama*, June, 1968, Gettysburg National Military Park, Cyclorama File, 46.

[2] Trudeau, *Gettysburg: A Testing of Courage*, 512.

[3] Elwood Christ, *The Struggle for the Bliss Farm*, "Over a Wide, Hot...Crimson Plain" (Gettysburg, PA, 1993), 81.

[4] *Ibid.*, 76.

[5] Hess, *Pickett's Charge- the Last Attack at Gettysburg*, 311, 347.

[6] *Ibid.*, 256-257 and 376-377; Coco, *A Strange and Blighted Land- Gettysburg: The Aftermath of Battle*, 190, 221.

[7] Keith Snipes, "The Improper Placement of the 8th Ohio Monument: A Study of Words and Maps," In *Gettysburg Magazine* (July, 2006), Issue 35.

[8] Hess, *Pickett's Charge- the Last Attack at Gettysburg*, 110-113.

[9] Coddington, *The Gettysburg Campaign: A Study in Command*, 490-491.

[10] Hess, *Pickett's Charge- the Last Attack at Gettysburg*, 188-190.

[11] *Ibid.*, 215-218; Report of Lieut. Col. Franklin Sawyer, *OR* 27, pt. 1, 461-462.

[12] Report of Brig. Gen. James H. Lane, *OR*, pt. 2, 666.

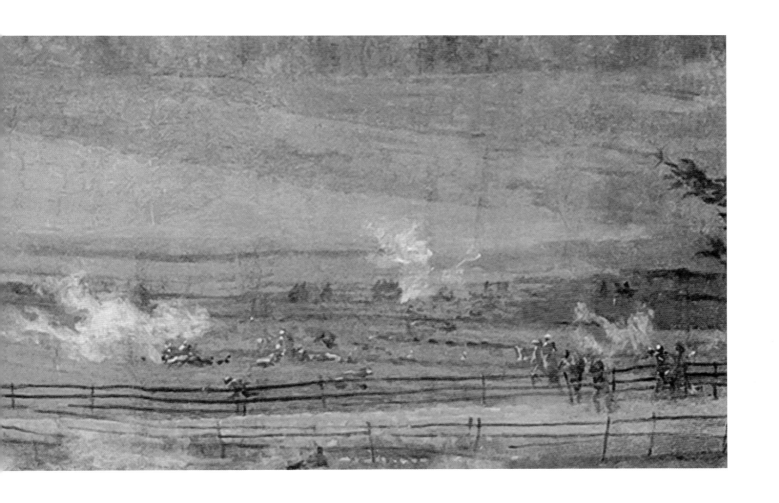

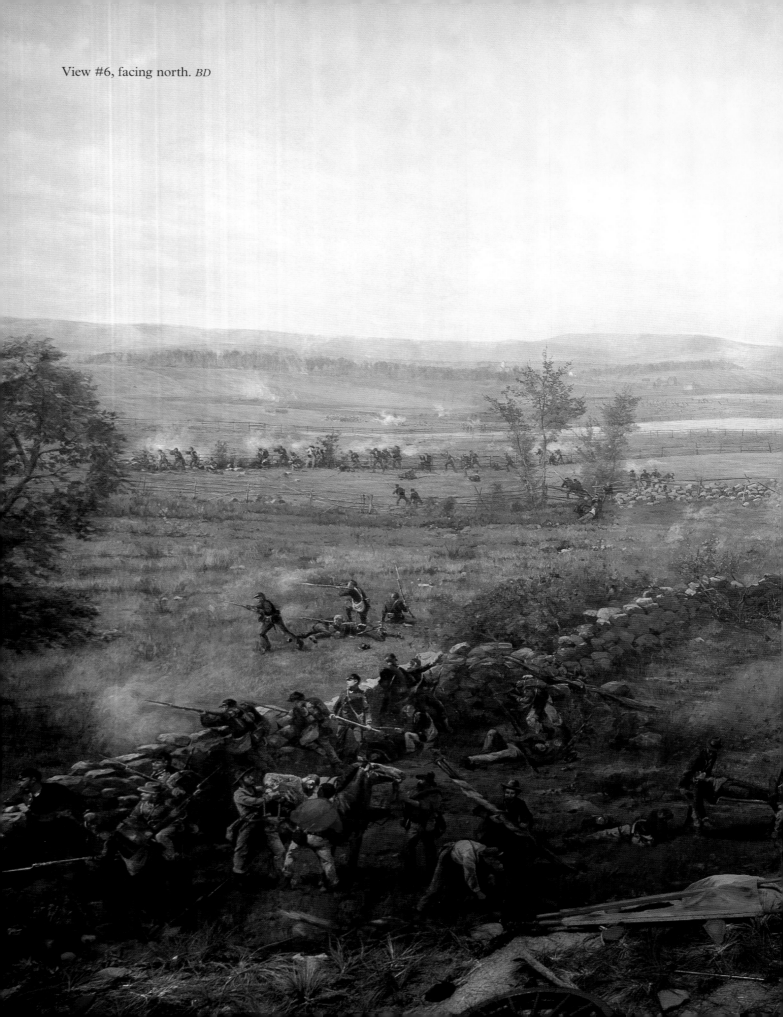

View #6, facing north. *BD*

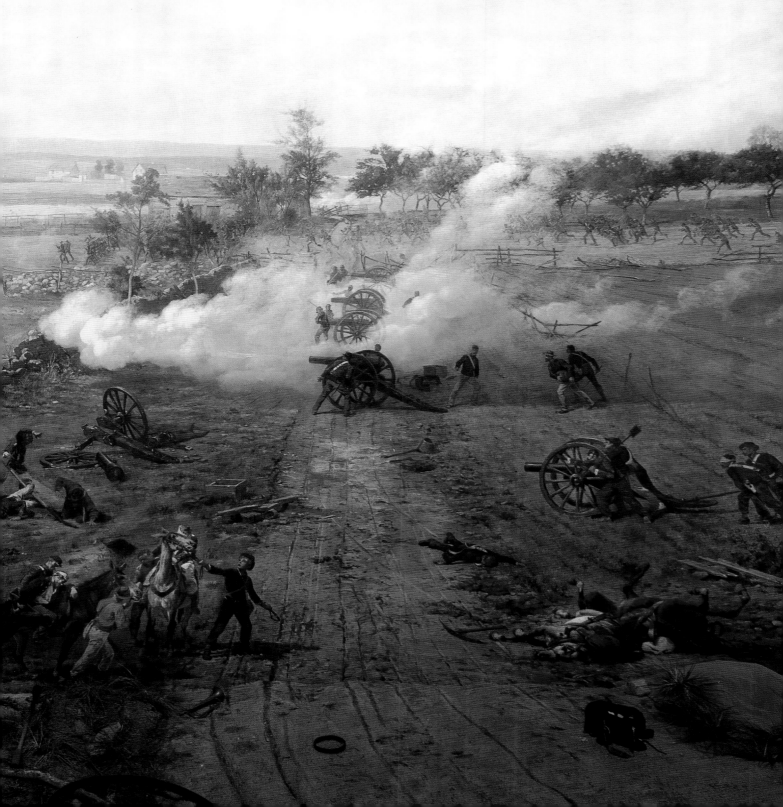

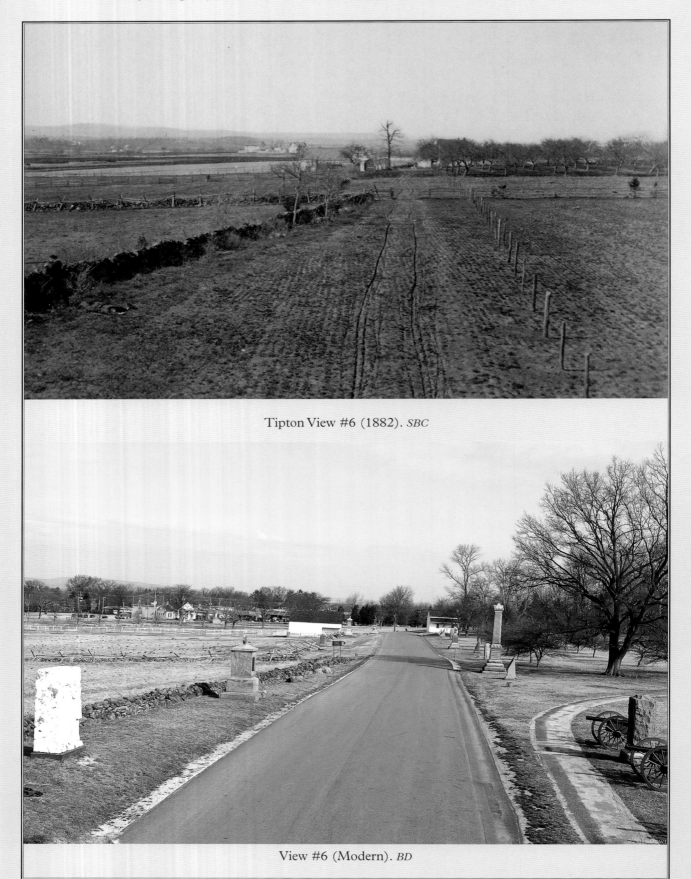

Tipton View #6 (1882). *SBC*

View #6 (Modern). *BD*

❧ KEY ❧

A Stone Wall North of the Angle

B European Style Stretchers (*Cacolet*)

C Solid Shot Plowing into the Ground

D Arnold's Battery A., 1st Rhode Island Light Artillery

E Brian Barn/Abraham Brian Farm

F 12th New Jersey Infantry

G Actual Position of the 8th Ohio Infantry

H William Johns Farm

I Town of Gettysburg and Woodruff's Battery

J Lutheran Theological Seminary

K Casper Henry Dustman Farm

L Oak Ridge Seminary (Elias Sheads House)

M Samuel Foulk House and Smithy

N Oak Hill/Oak Ridge

O Moses McClean Farm and Samuel Cobean Farm

Ⓐ Stone Wall North of the Angle

In this part of the painting, some troops can be seen along the wall leading north from the Angle. These men would belong to Brig. Gen. Alexander Hays' 3rd Division of the II Corps. In the Chicago key, an officer south of the Copse of Trees was labeled as General Hays, but this is not likely because his troops were all north of the Angle. In subsequent keys, the officer to the south was more accurately labeled as General Gibbon (see View #1, E) and General Hays was not listed on the key. Besides omitting General Hays, the artist also omitted most of his division. There are not many infantry soldiers depicted north of the Angle. This may have led to some complaints by the veterans who came to see the painting. In the New York version, more troops were added in this area. One of the pieces of the New York version that has survived shows some of these extra troops that are not in the Boston version (see Chapter 2). In the New York key it listed, "1st Delaware, 12th New Jersey, 14th Conn. at stone wall, 108th N.Y. Vols." The addition of more troops may have been an attempt to rectify some of the criticisms that were being made of earlier versions. On the opposing side, more troops were also added to Pettigrew's and Trimble's brigades in the New York version.

The Union troops listed above are part of Hays' second brigade under Col. Thomas A. Smyth. Hays' division would have included two other brigades. His first brigade (under Col. Samuel S. Carroll) was on detached service on the other side of Cemetery Hill. Hays' third brigade was originally commanded by Col. George L. Willard who was killed on July 2 (see View #2, M and B). These troops were directly behind Smyth's men and under the command of Col. Eliakim Sherrill, who was mortally wounded during the attack on July 3 (also mentioned in View #2, B). The troops from Willard's brigade are barely depicted in the painting. A few of these soldiers may be found in the area of Meade's headquarters, but there are not enough men to represent an entire brigade (see View #8, J).

Before the 2008 restoration, there was severe damage to this part of the painting. Today, the painting measures 377 feet in circumference. Before this damaged area was restored, the painting only measured 359 feet in circumference. Most of the missing 18 feet came from this part of the painting. By analyzing the

Detail of the painting showing Union troops at the stone wall north of the Angle. *BD*

Notes on view #6 (facing north)

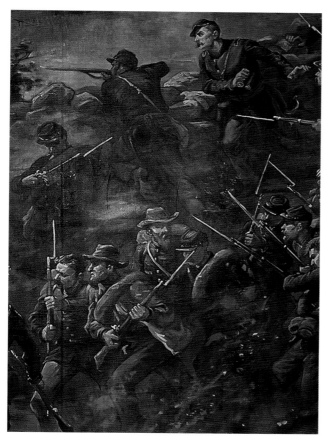

A piece of the New York cyclorama that has survived and is in storage in the National Park archives. *BD*

gridlines under the paint, the restorers were able to map out the missing areas and determine what needed to be fixed (see illustrations in Chapter 2).

Because there was some canvas missing, the stone wall did not look right in this part of the painting. There was a strange bend in the wall shaped like an "h". A piece of the wall was moved to the right to cover up another damaged area. This piece covered up another damaged area that contained a stretcher as well as the bearer carrying the back end of the stretcher. The front stretcher-bearer had two blue buckets painted into his hands to depict him as carrying something. As part of the 2008 restoration, the wall piece was moved back to its proper location. The damaged areas above the wall had to be recreated. The restoration team also recreated the missing stretcher and the other stretcher-bearer. Today, this part of the painting is back to its original appearance.

Ⓑ European Style Stretchers (Cacolet)

In the painting, we can see a European style of stretcher known as a *cacolet*. Consisting of two chairs mounted on either side of a mule, a *cacolet* was used to carry wounded to the rear. Several more, some of which are were also being used to move supplies, can be seen in the field hospital

Monument to the 14th Connecticut at Gettysburg. *BD*

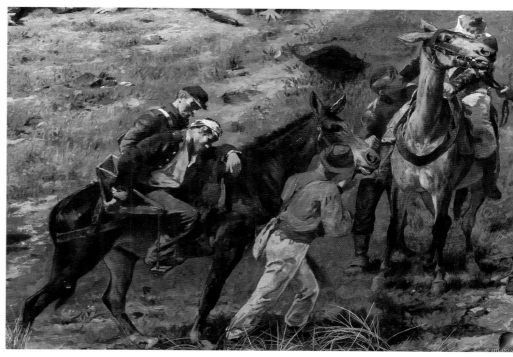

Detail of the painting showing a French-style stretcher called a *cacolet* (also visible on previous page). *BD*

scene. This type of stretcher, used in Europe, was rarely used in the American Civil War.[1] The artist made a mistake by depicting *cacolets* in the painting. *The Battle of Gettysburg* was the first American battle painted by Paul Philippoteaux, a Frenchman, so it is understandable that he would make some mistakes.

In the Chicago version of the painting, the artist was criticized for making the uniforms look "too French." Apparently, the backpacks looked too large and square to be the kind used by the Union army. Also, many of the troops had white pants. In the Boston version, the backpacks were improved, but there were still many Union soldiers with white pants. It is the authors' opinion that the use of light-colored pants may be an artistic tool to help keep the individual figures separate from each other. If the large masses of men all had the exact same color uniforms, they might blend together into one mass of arms and legs. Since the historic photographs of the Philadelphia and New York versions are in black and white, it is impossible to tell if the artist continued to improve on the uniforms and backpacks.

Over the years, the artist was also criticized for the large "French" straw stacks and the European poppies growing in the field of wheat. We will discuss these features in more detail in View #8 and #9.

Ⓒ Solid Shot Plowing into the Ground

As discussed in View #0, C, and View #5, C, Civil War artillery could fire four kinds of ammunition. The final kind, solid shot, was simply a solid piece of iron. Solid shot was usually used against buildings and fortifications. It could also be used to shatter enemy cannon, which was called counter-battery fire. Sometimes an exploding shell would malfunction and not detonate, effectively turning it into solid shot. Confederate artillery fuses were known to be unreliable. In some cases, the fuses would cause the shells to detonate prematurely. For this reason, the Confederates did not like to fire over their own infantry. Some of the guns that participated in the bombardment would only

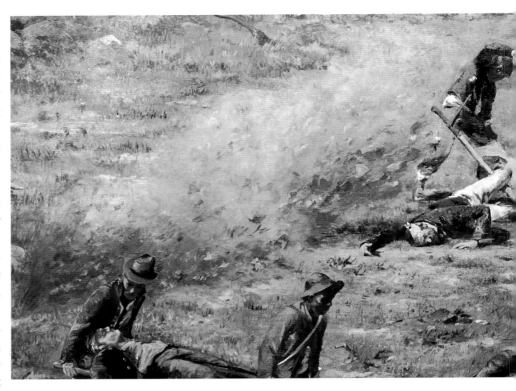

Detail of the painting showing the effects of solid shot. *BD*

use solid shot for this reason. In the painting, we can see a solid shot tearing into the ground and kicking up dirt near some men carrying a stretcher.

Ⓓ Arnold's Battery A., 1st Rhode Island Light Artillery

Captain William A. Arnold was in command of the 1st Rhode Island Light Artillery, Battery A at Gettysburg. His battery was comprised of six three-inch rifles, and during the cannonade this battery took heavy casualties. Several of Arnold's guns were dismounted by enemy fire. In the painting and the diorama, we can see several disabled guns in this area. By the start of the infantry attack, the battery was almost out of ammunition and had to be withdrawn.

Several batteries from the artillery reserve were sent to this area to take Arnold's place. However, only Arnold's battery was listed on the historic keys. The guns from the artillery reserve arrived near the end of the infantry assault and helped repel the Confederates. Captain Robert H. Fitzhugh was sent with two batteries from his brigade in the artillery reserve. Fitzhugh personally commanded the 1st New York Light Artillery, Battery K with the 11th New York

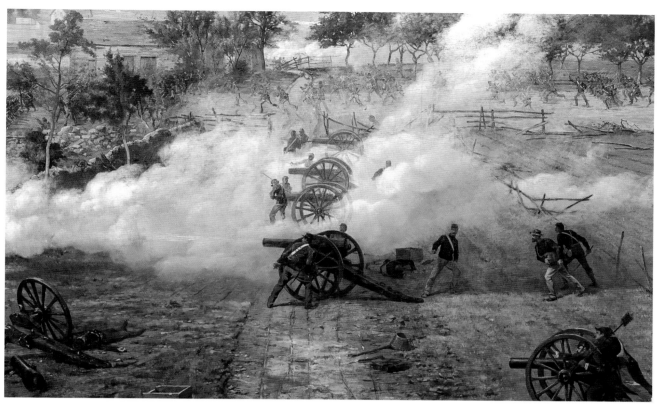

Detail of the painting showing Arnold's battery. *BD*

Battery attached (six three-inch rifles). Supporting Fitzhugh were the guns of Lt. Augustin N. Parsons' 1st New Jersey Light Artillery, Battery A (six Parrott rifles).[2] The 5th United States Light Artillery, Battery C, was also sent to this area. Comprised of six Napoleons, the battery was commanded by Lt. Gulian V. Weir.[3] Depending on the exact "moment in time" that the artist was depicting, these guns could belong to several different batteries.

The Philadelphia key listed "Major Bigelow's two guns" at the northern end of the line of cannon. In reality, Bigelow's guns would have been just north of

the Brian property (see I). Bigelow's battery was also mentioned in the area of the Trostle farm (View #2, O) where they made a heroic stand on July 2. By July 3, Bigelow's 9th Massachusetts Battery was down to only two guns. Captain John Bigelow was wounded on the second day, and Lt. Richard S. Milton was in command on July 3.

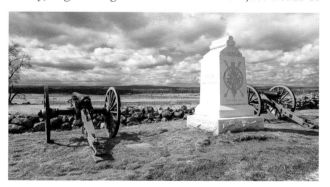

Monument to Arnold's battery at Gettysburg. *BD*

Bas-relief on the monument to Fitzhugh's battery at Gettysburg. *BD*

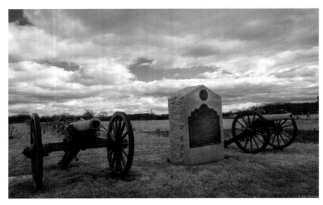

Monument to Weir's battery at Gettysburg. *BD*

The cannon shown firing in this part of the painting portray the various stages of loading and firing these weapons. Behind these guns, we can see the limbers and caissons deployed for battle (see View #7, B). In the painting, the cannon closest to our position is being pushed back into place after the recoil from firing the gun. The next cannon is firing the canister that is hitting the men in View #5, C. The artist made one minor mistake in this area: the man who is pulling the lanyard (a rope attached to a friction primer that fired the gun) should be on the left side of the cannon and not the right.[4] This mistake is understandable. If the man with the lanyard was on the near side of the cannon, it would be hard to see what he was doing in the painting. The men around two of the next three cannon are in the process of sponging out the barrel and loading the cannon. This process can also be seen in the bas-relief on the monument to Fitzhugh's battery. Behind the gun line, men can be seen bring up more ammunition from the limbers and caissons. In this way, all of the various stages of the firing process are illustrated in the painting.

As noted in Chapter 4, there appears to be more smoke in front of this battery in the original pictures of the Boston painting. More troops may have been added in this area in 1889, but the historic pictures from 1886 do not have enough resolution to say for certain.

Ⓔ Brian Barn/Abraham Brian Farm

In the painting, we can see the Abraham Brian barn, but we cannot see the Brian house. Before the painting was modified in 1889, our view of the house was obscured by smoke from Arnold's battery (as discussed in Chapter 3 and 4). When the painting was updated,

more details were added in this area but the house is still not visible. Our view of the house is obscured by the smoke from Woodruff's battery (see I) and trees of Brian's orchard (View #7, F). The house and barn are still there today, and kept to their 1863 appearance by the National Park Service. During the infantry attack, Mississippians under General Davis managed to make it to the Brian barn before being driven back. Today, there is a marker to the 11th Mississippi that marks the end of their advance just south of the Brian barn.

Abraham Brian was one of approximately 200 free black citizens of the town at the time of the battle. On some maps, you will see his last name spelled as "Brien" or "Bryan;" the true spelling is unknown. At the time of the battle, the Brian family had fled town for fear of being captured by the Confederates and being sent south as slaves. During the battle, the Brian house became the headquarters for General Hays, the commander of the 3rd Division of the II Corps.[5]

Ⓕ 12th New Jersey Infantry

The 12th New Jersey Infantry was stationed along the wall just south of the Brian barn. Most units at the battle were armed with rifled muskets. The rifling, or grooves in the barrel, caused the projectile to spin. Like the rifled cannon, a rifled musket had a greater range and accuracy than a smooth-bore weapon. At the Battle of Gettysburg, over 80 percent of the soldiers were equipped with rifled muskets.[6] The 12th New Jersey, however, was one of the units that still had smooth-bore muskets. In order to offset the shorter range and decreased accuracy, these units fired a special type of ammunition called "buck and ball." Consisting of one large ball and three small buck shot,

Monument to the 12th New Jersey Infantry at Gettysburg. *BD*

Brian farm, modern. *BD*

Abraham Brian Barn Abraham Brian House (not visible in the painting)

Detail of the painting showing the Brian farm. *BD* 12th New Jersey Infantry

this type of ammunition was particularly deadly at short range. The 12th New Jersey had the nickname "the Buck and Ball Regiment," and this kind of ammunition is displayed on the top of their monument. When the Confederates began their charge on July 3, the men in the 12th started to break apart their ammunition and load their guns with buckshot only. This tactic effectively created an entire regiment that was armed with shotguns. As the attack approached their portion of the line, the 12th waited until the enemy was within 50 yards and then fired one massed volley. With 12-15 buckshot loaded in each gun, this volley caused massive damage.[7] In the area in front of

the 12th New Jersey, the Confederate attack was stopped dead in its tracks.

In the painting, men from the 12th New Jersey can be seen charging toward the stone wall. Some of the men even seem to be charging out in front of the wall. This would not have happened until the very end of the charge when they would have gone out to gather prisoners and flags. The Chicago key listed this as "Charge of the 12th New Jersey, Col. R.S. Thompson." In addition, in the historic photographs of the Chicago version, a mounted officer can be seen in this area labeled, "Our Col. Thompson." This officer was not visible in the Boston version. The Chicago key also

listed the Brian farm as being "House defended by our Col. Thompson." At Gettysburg, the 12th was commanded by Maj. John T. Hill. However, a search of the historical records revealed a Capt. Richard S. Thompson in the 12th New Jersey. On the morning of July 3, Captain Thompson was in command of about 200 men who charged forward and seized the Bliss farm (see #5, D). Perhaps this is the charge that was being described in the Chicago key.[8]

Captain Thompson never officially reached the rank of colonel. It is possible however, that he may have become an "honorary colonel" after the war. It is also interesting to note that the Chicago key referred to him as "our" Colonel Thompson. In a 1983 report by Park Service Historian Gregory Mertz, he speculated that Thompson might have been a lecturer at the Chicago cyclorama. As a lecturer, he may have been referred to as "our colonel."[9] Unless more information can be found, we can only speculate about the reasons behind such references to Thompson.

Ⓖ Actual Position of the 8th Ohio Infantry

As discussed in View #5, H and I, the 8th Ohio would have been positioned in front of the Union line, well north of the Brian farm. The fence line marked in the key denotes the area in which the 8th Ohio would have

Monument to the 8th Ohio at Gettysburg. *BD*

Parts of Brockenbrough's Brigade Retreating
(View #5, I)

Actual Position of the 8th Ohio Infantry

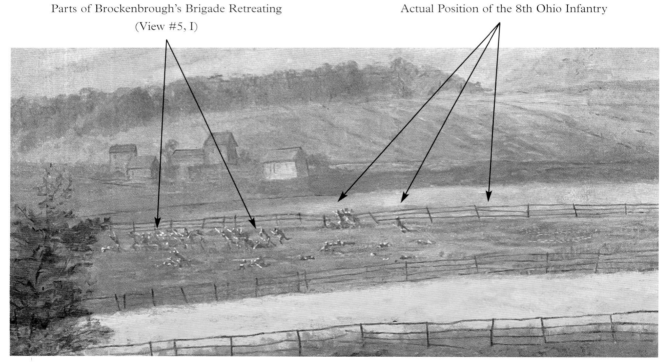

Detail of the painting showing Brockenbrough's brigade retreating. *BD*

fought with Brockenbrough's men. In the painting, we can see some Southern troops in retreat in this area. After driving back Brockenbrough's small brigade, the Ohio troops would have started to fire into the flank of Davis's and Lane's attackers. At the end of the attack the 8th Ohio moved forward and took prisoners. Their final position was closer to the position of their monument on the field today.[10]

(H) William Johns Farm

The William Johns farm did not exist during the battle. Built in the 1870s, it is visible in the Tipton photographs. Like the George Trostle farm (View #1, R) the artist did not know this was a new farm, so it was painted into the scene. The Johns house still stands and is located on Johns Avenue.[11] The house is private property and still has its 1880s appearance. Many of the historic keys listed the boundary for the Town of Gettysburg as starting at the Johns farm. In reality, the southern edge of town was well to the north of this farm.

In the painting, we can see some of the town in the distance, just to the right of the Brian barn (see next entry, I). In the extreme distance, to the right of the Johns farm, we can see a farm that belonged to Samuel Cobean. This farm was located north of the town on Oak Ridge and will be discussed in more detail later in this section (see O).

Modern view of the William Johns house. *BD*

(I) Town of Gettysburg and Woodruff's Battery

Above and to the right of the Brian barn, in the extreme distance of the work, we can see the Town of Gettysburg, although it is difficult to see without some source of magnification. On several of the historic keys, the town was listed in this area. However, some of the other historic keys denoted the boundaries of the edge of town near the William Johns farm.

In the middle distance, to the right of the Brian barn, we can see some cannon that would belong to Woodruff's battery. Lieutenant George A. Woodruff was in command of the 1st United States Light Artillery, Battery A at Gettysburg. Comprised of six Napoleons, this battery was positioned just north of the

William Johns Farm Samual Cobean Farm

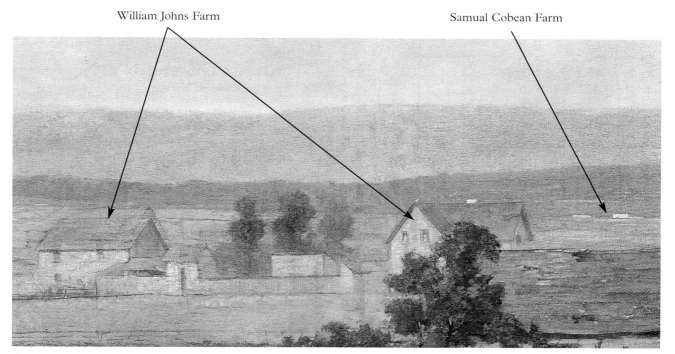

Detail of the painting showing the William Johns farm with the Cobean farm (see O) in the background. *BD*

175

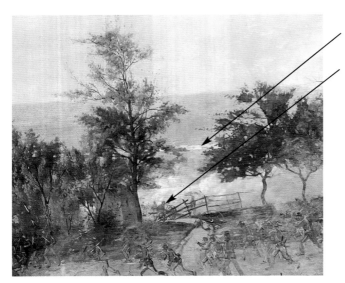

Town of Gettysburg

Woodruff's Battery

Detail of the painting showing Woodruff's battery and the Town of Gettysburg in the distance. *BD*

Monument to Woodruff's battery at Gettysburg. *BD*

Brian farm. Also positioned in this area were the two remaining guns from Bigelow's battery (see D and View #2, O).

During the infantry attack, Woodruff's battery was able to fire canister diagonally into the Confederate attack, causing massive damage. On July 3, they took heavy casualties, including Lieutenant Woodruff, who was mortally wounded near the end of the attack. Lieutenant Tully McCrea was in command of the battery by the end of the day. Woodruff's commander, Captain Hazard, wrote in his report: "Lieutenant Woodruff was an able soldier, distinguished for his excellent judgment and firmness of execution, and his loss is one which cannot easily be replaced. He expired on July 4, and, at his own request, was buried on the field on which he had yielded his life to his country."[12]

Ⓙ Lutheran Theological Seminary

The main building of the Lutheran Theological Seminary can be clearly seen in the painting. This building is called Schmucker Hall, after the Reverend Samuel S. Schmucker who founded the seminary. During the battle, the white cupola on top of this building served as an observation point for generals from both armies. On the morning of July 1, Union Brig. Gen. John Buford used the cupola to observe the fighting. At about 10:00 a.m., Maj. Gen. John F. Reynolds, commander of the Union I Corps, arrived to support Buford's cavalry. The two generals conferred near the seminary before Reynolds led his men into the

fighting around McPherson's woods. Minutes later, Reynolds was killed. He would be the highest-ranking officer killed in the battle. By the end of the day, Confederate forces captured Seminary Ridge and the cupola was used by Confederate generals on July 2 and 3. This building was also used as a hospital by both armies and continued being used as such until September of 1863.[13] Today, this building is now a museum operated by the Lutheran Theological Seminary and the Adams County Historical Society.

The historic keys listed "Opening Battle" in this area. The New York key also noted: "Seminary Tower, near HQ of Gen. Lee, Gen. Reynolds killed. Calif's [Calef's], Hall's ME., and Reynolds's N.Y. Batteries." General Lee's headquarters was located just north of this building on the west side of Seminary Ridge at the widow Mary Thompson house (not visible in the painting). The three batteries listed all fought in this area on the first day. Lieutenant John H. Calef commanded the 2nd United States Light Artillery, Battery A under General Buford. The other two batteries were part of General Reynolds's I Corps. Captain James A. Hall was in command of the 2nd Maine Light Artillery, Battery B and Capt. Gilbert Reynolds was in command of the 1st New York Light Artillery, Battery L with Battery E attached.

Ⓚ Casper Henry Dustman Farm

A farm belonging to Casper Henry Dustman sat on the east side of Seminary Ridge, just north of the

Chambersburg Pike. This farm no longer exists. Today, the Appalachian Brewing Company is located on the site of the Dustman farm. Just west of the Dustman farm, on the other side of the ridge, would have been the Mary Thompson house. This house and the orchard on the south side of the Chambersburg Pike became the headquarters for General Robert E. Lee on July 2 and 3. Across the street from the Mary Thompson house was the house of her son, James H. Thompson. Just south of the James Thompson house was a house owned by Casper Henry Dustman that was rented by Alexander Riggs at the time of the battle. The Riggs house and both Thompson houses are not visible in the painting. The Riggs house no longer exists. Both the James and Mary Thompson houses still stand and are close to their 1863 appearance. The Mary Thompson house was a small privately owned museum. In 2014, the Civil War Trust purchased Lee's headquarters and the nearby properties. In the next few years this area will be returned to its 1863 appearance.

There was a famous photograph taken by Mathew Brady on July 15 1863, from a position near the Dustman farm. The photograph was taken facing east, toward the Town of Gettysburg. In the right half of this photograph, we can clearly see the Sheads and the Foulk houses in the foreground (see L and M).[14]

Ⓛ Oak Ridge Seminary (Elias Sheads House)

This house was owned by Elias Sheads. At the time of the battle, this house was called the Oak Ridge Seminary, a finishing school for girls run by Carrie

Sheads. A famous story about this house involved Col. Charles Wheelock of the 97th New York. Near the end of the first day, as Union troops were being driven back from Seminary Ridge and through town, Colonel Wheelock stopped at the Sheads house. Soon afterward, Confederate troops surrounded the house, which was being used by Union men as a hospital. A Confederate sergeant demanded that Colonel Wheelock surrender his sword. This request was obstinately refused, but just then, additional Northern prisoners were brought in and the Confederates were distracted. Minutes later, the sergeant again demanded the sword and Wheelock told him that he has already given it to another captor. Actually, the sword had been hidden by Carrie Sheads under the folds of her skirt. She later hid the sword under a mattress for safe-keeping. After the battle, Colonel Wheelock managed to escape and recovered his sword.[15]

The Sheads house still stands today and has its historic appearance. It is private property, with a small store inside. Near the front window on the top floor, there is a piece of a cannon shell stuck in the wall. This is one of several houses in Gettysburg that have cannon shells stuck in the walls. In reality, the shell went through the brick wall of the home, but after the battle, a cannon shell was placed in the hole and mortared into place.

Ⓜ Samuel Foulk House and Smithy

Besides the Sheads house, there was only one other property on the Chambersburg Pike between the town and Seminary Ridge at the time of the battle. The Foulk

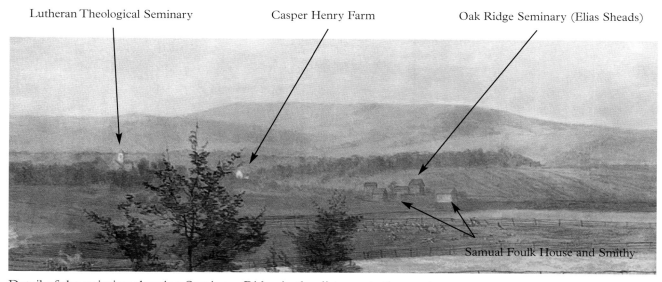

Lutheran Theological Seminary Casper Henry Farm Oak Ridge Seminary (Elias Sheads)

Samual Foulk House and Smithy

Detail of the painting showing Seminary Ridge in the distance to the north. *BD*

The Sheads house, modern. *BD*

house was across the street from the Sheads house on the south side of the pike. Just east of the house, Samuel Foulk had a small smithy. In the painting, the buildings that make up the Sheads and Foulk properties can be clearly seen in the distance east of Seminary Ridge. The Foulk house and smithy no longer stand.

Ⓝ Oak Hill/Oak Ridge

As Seminary Ridge runs northward, it turns into Oak Ridge which then leads to Oak Hill. In the painting, the open area on the ridgeline is Oak Ridge and the partially tree-covered area to the north is Oak Hill. On the first day of the battle, there was heavy fighting in this area as Union forces tried to stop the Confederates who were converging on the town from the west and north. The Union soldiers in this area managed to fight back multiple Confederate attacks before they were eventually overwhelmed and forced to fall back through the town. Today, the Peace Light Memorial sits on top of Oak Hill. This large monument has an eternally burning flame that is meant to symbolize eternal peace

Historic photograph taken by Mathew Brady 7/15/1863, right half of 2 plate shot. *LOC*

between the north and the south. The NPS maintains the historic tree line to its 1863 appearance.

In the Chicago key it listed "Charge of the "Iron Brigade"; Gen. Fairchild, of Wis., lost his arm; Gen. Paul lost his eyes, and Gen. J. S. Robinson wounded." Brigadier General Gabriel R. Paul did lose sight in both eyes as a result of the wounds he received on Oak Ridge, but the description of the wounding of the other officers was not entirely accurate. Colonel Lucius Fairchild of the 2nd Wisconsin did lose his arm as a

result of the fighting on July 1. However, his actions with the Iron Brigade would have taken place south of this area on McPherson's Ridge (View #5, G). After Gettysburg, Colonel Fairchild would be promoted to general, and after the war would serve as Governor of Wisconsin from 1866-1872.[16]

Colonel James S. Robinson was also wounded on July 1, but his injuries happened on the northern edge of town and not on Oak Ridge. Robinson, like Fairchild, would be promoted to general later in the war. After the war, both officers would become noted politicians. Robinson served in Congress as Representative from Ohio from 1881-1885 and the Secretary of State of Ohio from 1885-1889.[17] Robinson was mentioned twice in the Chicago key (see View #0, K). It seems that the mention of these two officers in the Chicago key was a case of marketing the painting to the Midwestern audience.

The New York key noted that "Sergeant Morris killed. Monuments 12th and 13th Mass., now located. Cols. J. L. Bates and S. H. Leonard wounded. Gen. Fairchild lost arm. Gen. Paul lost both eyes. Gen. Dudley right leg." Most of the additional references in this key were to officers from New England units, as we have seen many times in the New York key. It is interesting that the New York key mentioned the monuments to the 12th and 13th Massachusetts Regiments. Massachusetts was the first state to appropriate funds for monument construction. Dedicated in the fall of 1885, they would have been two of the earliest monuments on the field when the painting debuted in 1886. Sergeant Roland B. Morris was the color bearer of the 13th Massachusetts Infantry. He was killed in the fighting on July 1, and his likeness is depicted on the monument to the 13th Massachusetts.[18] Colonel James L. Bates and Col. Samuel H. Leonard were the commanders of the 12th and 13th Massachusetts, and were both wounded on July 1. Lieutenant Colonel William W. Dudley of the 19th Indiana lost a leg as a result of his wounds at Gettysburg. Dudley fought with the Iron Brigade south of this area on McPherson's Ridge. Like Fairchild and Robinson, Dudley was eventually promoted to the rank of general. He also served in politics after the Civil War, holding the rank of U.S. Marshal, and U.S. Commissioner of Pensions from 1881-1884.[19] Once again, Dudley was probably mentioned in the key because he was a well-known figure in 1886.

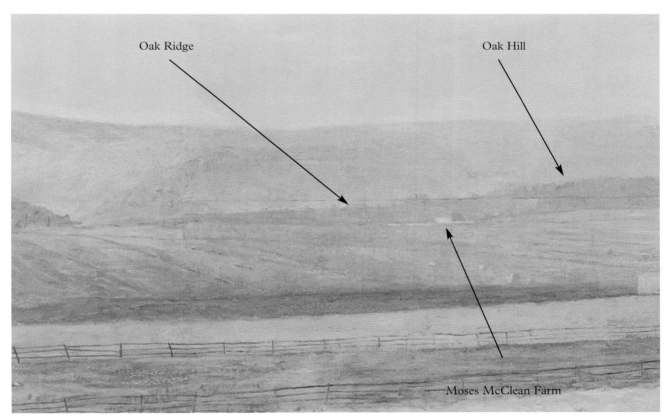

Detail of the painting showing Oak Hill in the distance. *BD*

Monument to the 12th Massachusetts at Gettysburg. *BD*

Monument to the 13th Massachusetts at Gettysburg. *BD*

The Moses McClean farm, modern. *BD*

◎ **Moses McClean Farm and Samuel Cobean Farm**

The Moses McClean farm is on the east side of Oak Ridge near Oak Hill. At the time of the battle, a tenant, David H. Beams, lived in the McClean house. David Beams was serving with the 165th Pennsylvania, which was not at Gettysburg during the battle. His wife, Harriet, and their three-year-old daughter were forced to flee the house on July 1, when it was occupied by Confederate forces. The farm, still there today, is kept to its 1863 appearance by the National Park Service.

North of the McClean farm, also on the eastern side of the ridge, was the Samuel Cobean farm. Today, this farm is off of the Biglerville road. The NPS uses it as an administration building. The house and barn are kept in their 1863 appearance by the NPS. During the battle, the house and barn were struck several times by artillery shells. A solid shot is still embedded in a wall inside the house. The Cobean farm was used as a hospital for both Union and Confederate forces. General Trimble's leg was amputated at this site after he was wounded in the charge on July 3. [20]

[1] Thomas, *The Gettysburg Cyclorama: A portrayal of the high tide of the Confederacy*, 45.

[2] Report of Capt. Robert H. Fitzhugh, *OR* 27, pt. 1, 896.

[3] Report of Capt. Gulian V. Weir, *OR* 27, pt. 1, 880.

[4] George W. Newton, *Silent Sentinels- A Reference Guide to the Artillery at Gettysburg* (New York, NY, 2005), 53-56.

[5] Carper and Hardoby, *The Gettysburg Battlefield Farmsteads Guide*, 47–48.

[6] Teague, *Gettysburg by the Numbers*, 47.

[7] Hawthorne, *Gettysburg: Stories of Men and Monuments as Told by the Battlefield Guides*, 126.

[8] Ernsberger, *At the Wall: The 69th Pennsylvania "Irish Volunteers" at Gettysburg*, 86.

[9] Mertz, *Interpretations of the Gettysburg Cyclorama*, 5-6.

[10] Keith Snipes, "The Improper Placement of the 8th Ohio Monument: A Study of Words and Maps," In *Gettysburg Magazine*.

[11] Authors' examination of the photographs with the aid of Elwood Christ.

[12] Report of Capt. John G. Hazard, *OR* 27, pt. 1, 480-481.

[13] William A. Frassanito, *Gettysburg- A Journey in Time* (Gettysburg, PA, 1975), 79; Coco, *A Strange and Blighted Land- Gettysburg: The Aftermath of Battle*, 189-190; Ltsg.edu (Lutheran Theological Seminary Gettysburg), entry on history and heritage; seminaryridgemuseum.org - entry for the history of the seminary on July 1.

[14] Frassanito, *Gettysburg- A Journey in Time*, 74-75.

[15] *Ibid.*, 76.

[16] Warner, *Generals in Blue*, 147-148.

[17] *Ibid.*, 406-407.

[18] Hawthorne, *Gettysburg: Stories of Men and Monuments as Told by the Battlefield Guides*, 29.

[19] Hunt and Brown, Brevet *Brigadier Generals in Blue*, 176.

[20] Smith, *Farms at Gettysburg: The Fields of Battle*, 10-11; Hess, *Pickett's Charge – the Last Attack at Gettysburg*, 343.

Samuel Cobean farm, modern (see page 175 for Cobean farm in the painting). *BD*

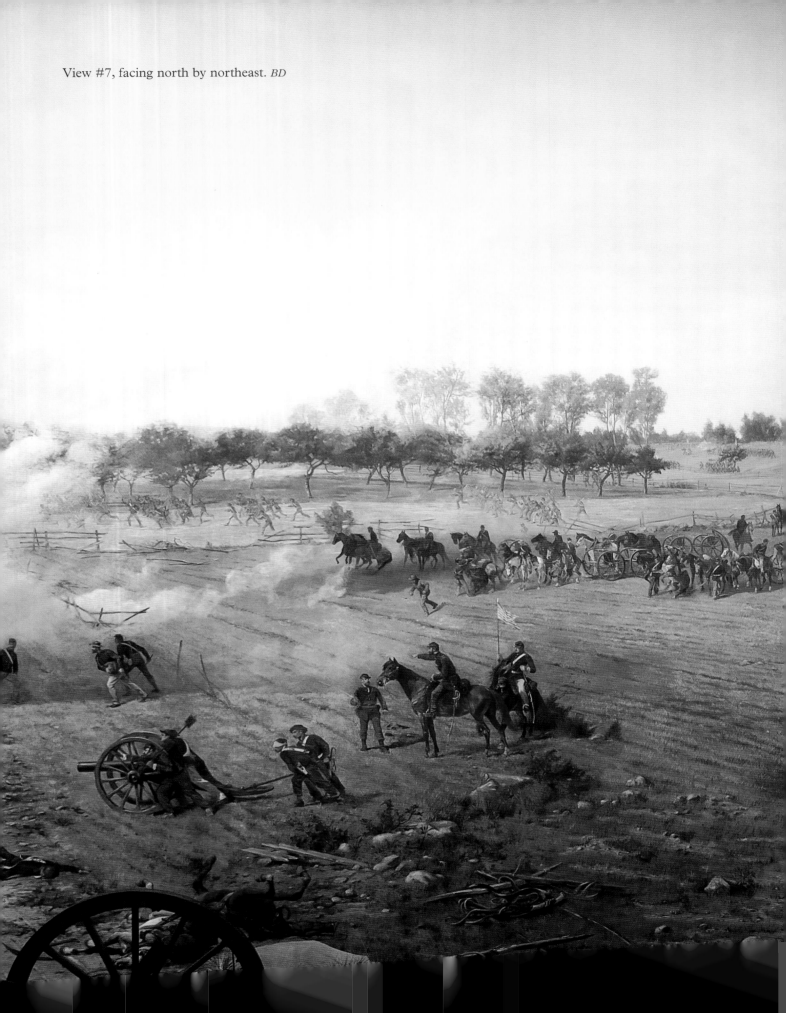

View #7, facing north by northeast. *BD*

Notes on view #7

(facing north by northeast)

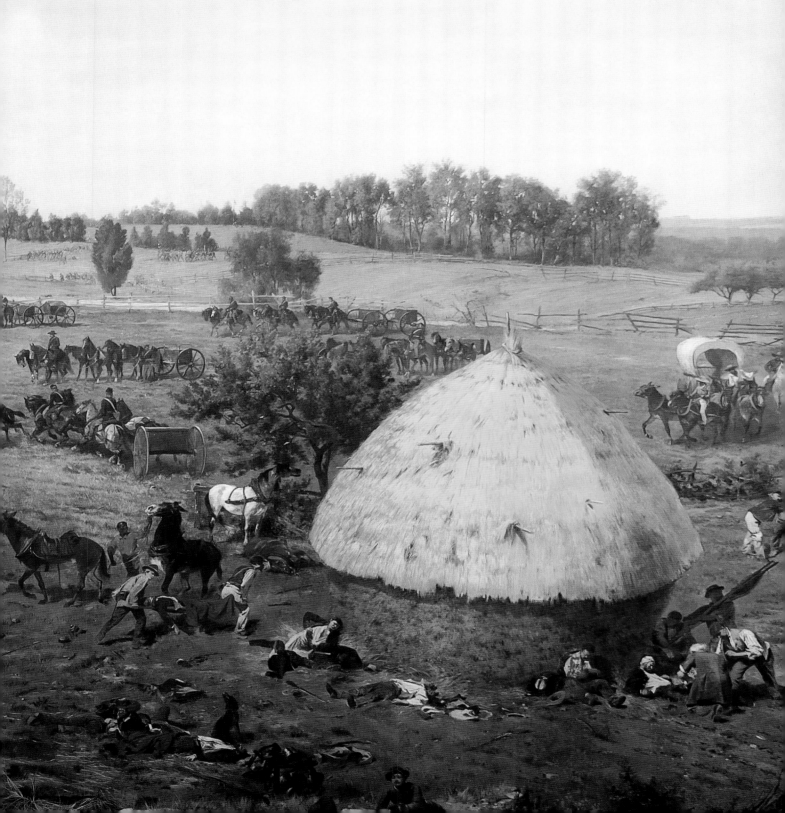

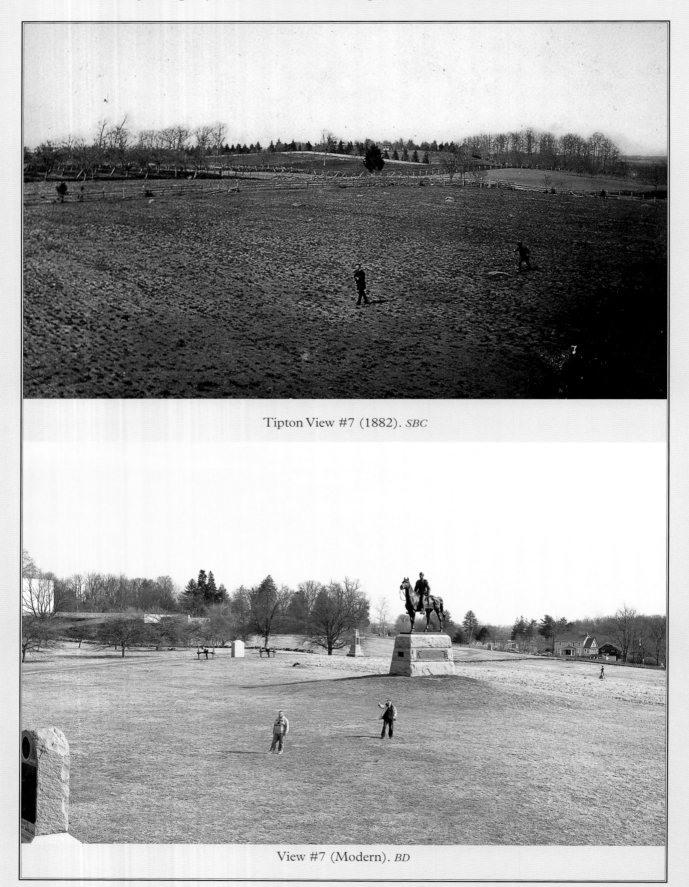

Tipton View #7 (1882). *SBC*

View #7 (Modern). *BD*

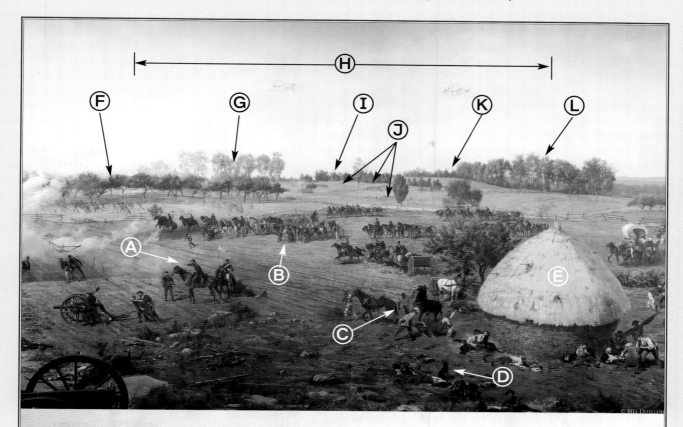

❧ KEY ❧

Ⓐ Captain John G. Hazard, II Corps Chief of Artillery

Ⓑ Arnold's Battery Limbers and Caissons

Ⓒ Black Hospital Attendants and Teamsters

Ⓓ Dog in the Painting

Ⓔ Hay or Straw Stacks

Ⓕ Brian's Apple Orchard

Ⓖ Zeigler's Grove

Ⓗ Cemetery Hill

Ⓘ Row of Evergreen Trees

Ⓙ Units in the Distance on Cemetery Hill

Ⓚ Signal Station on Cemetery Hill

Ⓛ Trees on the South Side of Cemetery Hill

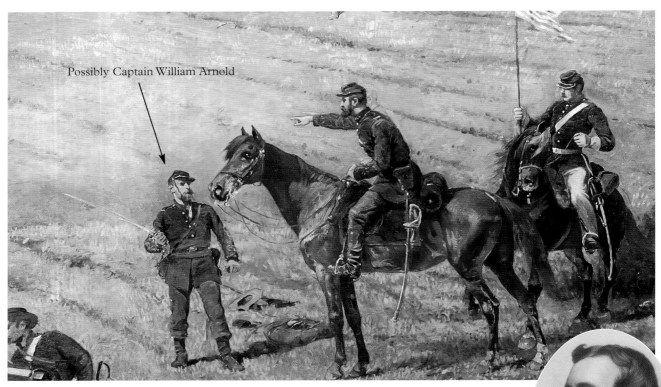

Possibly Captain William Arnold

Detail of the painting showing Captain Hazard. *BD*

Ⓐ Captain John G. Hazard, II Corps Chief of Artillery

Captain Hazard was the Chief of Artillery for the Union II Corps. Hazard commanded an artillery brigade that was comprised of five batteries: Arnold's battery (View #6, D), Woodruff's battery (View #6, I), Cushing's battery (View #2, B), Brown's battery, and Rorty's battery (View #1, G). Captain Hazard's position around the Angle was the main target for the Confederate bombardment on July 3. His men took severe losses. By the end of the cannonade, Arnold's and Brown's batteries had to be replaced. Cushing's and Rorty's batteries were almost totally destroyed, but they kept their remaining guns in action. Their losses were so severe that, after the battle, the remaining men and guns of Hazard's brigade had to be consolidated from five batteries down to three.[1]

In the painting, Captain Hazard is talking to an officer on foot, possibly Captain Arnold. Of the original five battery commanders, Arnold was the only one not killed or wounded during the battle. In the last two versions of the painting Brig. Gen. Henry J. Hunt is shown at this location (see View #9, D) and Captain Hazard is not mentioned.

Ⓑ Arnold's Battery Limbers and Caissons

In this part of the painting, we can see the limbers and caissons from Arnold's battery. As discussed in View #6 D, depending on the moment in time depicted, some of these artillery forces could also belong to Fitzhugh's, Parsons's, or Weir's batteries. The painting accurately depicts the disposition of an artillery battery in action. The limbers are parked behind the guns with enough room to turn the team of horses and attach the limbers to the cannon in the event that the guns need to be withdrawn. The caissons are usually parked behind the limbers.[2] In the cyclorama, we can see some of the artillery men running ammunition from the limbers and caissons to the cannon.

Even farther to the rear is the battery wagon. This wagon holds extra supplies for the entire battery.[3] In the event of danger, this wagon would be sent away from the front lines. The wagon depicted in this area is in proper alignment with the rest of the

Above: Captain John G. Hazard. *LOC*

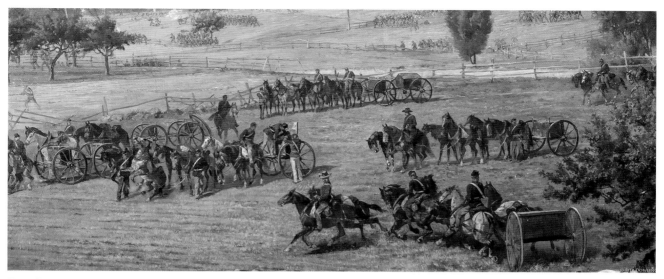

Detail of the painting showing Arnold's battery's limbers and caissons. *BD*

Detail of the painting showing a
battery wagon. *BD*

Detail of the painting showing a
limber chest with the lid opening
on the wrong side. *BD*

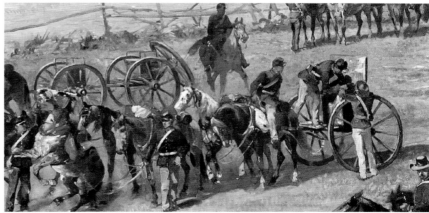

battery. At one time, there was another battery wagon depicted in the painting (discussed in View #3, A and Chapter 4). It is the author's opinion that veterans may have complained about that battery wagon being too close to the front line in the middle of the Angle. These complaints may have encouraged the promoters of the painting to have that wagon changed into a cannon.

The artist made one mistake in this area. Artillerymen can be seen retrieving ammunition from a limber chest. The lid of the limber chest is opening the wrong way. The lid always opened toward the enemy, so as to shield the contents of the ammunition box from any incoming fire.

© Black Hospital Attendants and Teamsters

In this section, we can see several black men helping the Union soldiers. Most of these men are helping with the wounded or serving as teamsters with the wagons. There are no black soldiers depicted in the painting. Visitors to the cyclorama frequently ask about these individuals. Although hundreds of thousands of black men eventually served in the Union army, the painting was accurate in that there were no black combat soldiers at the Battle of Gettysburg. President Lincoln's issuance of the Emancipation Proclamation on January 1, 1863, opened the door for blacks to serve in the

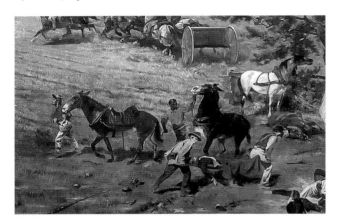

army. However, it took time to recruit and train new soldiers. There were also prejudices which had to be overcome before these troops would be allowed to fight in battle. The unit portrayed in the movie *Glory*, the 54th Massachusetts, would see its first combat on July 18, 1863, in South Carolina.[4] After this action, black troops started to be used in other battles. In the Army of the Potomac, the Union army that fought at Gettysburg, black troops were not engaged in combat until 1864.

Although there were no black combat troops at Gettysburg, the painting is accurate in that there were thousands of black laborers serving with the supply trains and hospital units. In the painting, we can see black men helping load *cacolets* (the French form of stretchers discussed in View #6, B) and carrying traditional stretchers. We can also see black men driving wagons (see View #8, F).

Left: Detail of the painting showing black hospital attendant. *BD*

Below: Detail of the painting showing black hospital attendant with a cacolet. *BD*

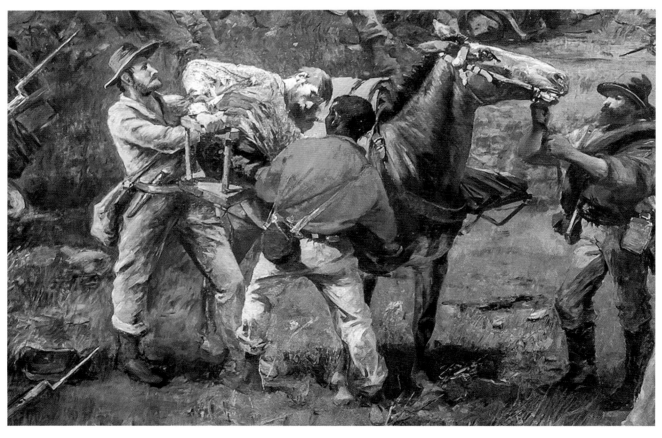

Ⓓ Dog in the Painting

There is only one dog depicted in the painting. We can see this dog howling near what is presumably his dead or wounded master. It was common for dogs to follow certain regiments in camp and on the march. One unit, the 11th Pennsylvania, even put their faithful companion dog, Sally, on their monument.[5]

One story that was told on the cyclorama platform in the early 1900s is that the dog actually belonged to Paul Philippoteaux. Although this is an interesting story, there is no documentation to back it up.[6] Perhaps someday we will find the artist's diary and see if there is any truth to some of these interesting tales that have been told over the years.

Detail of the painting showing a dog near a wounded soldier. *BD*

Sallie the dog from the Monument to the 11th Pennsylvania at Gettysburg. *BD*

Ⓔ Hay or Straw Stacks

We can see large stacks of hay or straw in several different parts of the painting. For many years, visitors to the cyclorama platform were told that these were French style haystacks and should not have been in the painting. An examination of historic photographs, however, shows numerous haystacks of this sort on the battlefield (see Chapter 3). Anecdotal evidence from Gettysburg residents also confirms that these types of haystacks were commonly used in Gettysburg in the 1800s.[7] It is not surprising that these types of haystacks were used considering the German and Scotch-Irish backgrounds of most local residents at that time.

In the historic photographs, the stacks seemed to be large mounds of hay. They did not have the "mushroom" shape that can be seen in the painting. The reason for this shape was that soldiers were cutting away some of the hay to use as bedding for their wounded comrades (see View #8, K). Farmers visiting the cyclorama also noted that the animals would eat from the bottom first, giving it this shape.

Another interesting facet of these haystacks can be found in the historic pictures, which included some of the diorama that led down to the painting. In the Chicago version of the painting, a large hay stack was seen on the diorama. Historic accounts tell us that the stairs up to the platform emerged out of this haystack.

Detail of the painting showing hay or straw stacks. *BD*

Detail of the Leister barn from the 1882 Tipton photographs. *SBC*

It seemed that many of the cycloramas used a structure on the diorama itself to help conceal the entrance to the viewing platform. In the photographs of the Boston cyclorama, a hut or lean-to was visible in this part of the diorama. The hut on the Boston version could also be seen in the key drawing. This hut was very similar to a hut on the diorama of the *Battle of Waterloo* cyclorama which is still on display in Belgium in a historic building that was built around 1900. It is also interesting to note that the area below and directly to the right of Captain Arnold is a "dead zone" in the painting. The artist did not put any people or objects in this area because they would be blocked from view by the stairwell and these large objects that concealed it.

Photograph of haystack near the Leister barn, in a C. J. Tyson stereo view from 1867. *SBC*

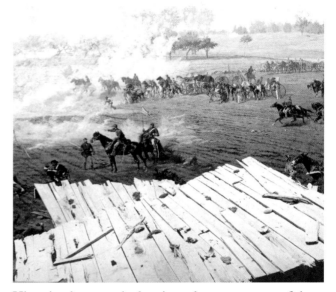

Historic photograph showing a lean-to as part of the Boston diorama. *SBC*

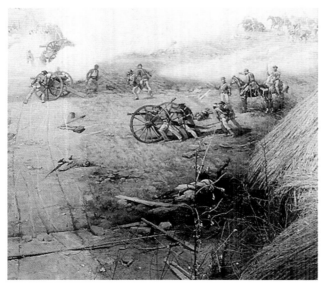

Historic photograph showing a haystack as part of the Chicago diorama. *SBC*

Lean-to that helps to disguise the stairs up to the viewing platform at the Waterloo cyclorama, modern.
Greg Goodell

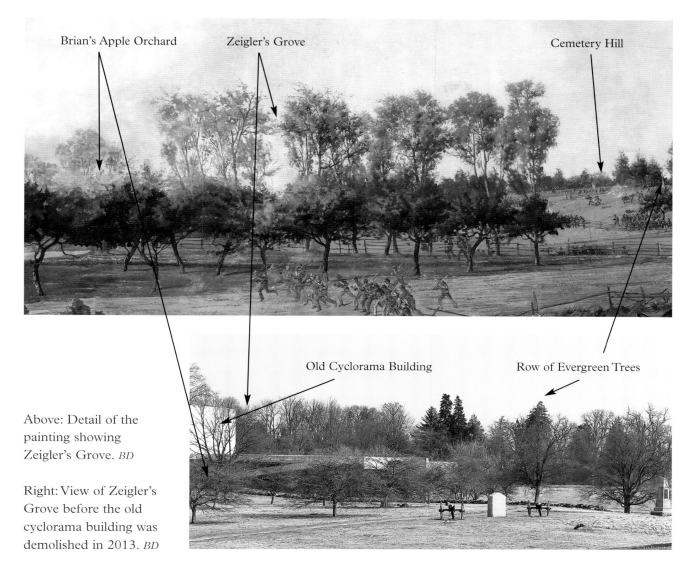

Above: Detail of the painting showing Zeigler's Grove. *BD*

Right: View of Zeigler's Grove before the old cyclorama building was demolished in 2013. *BD*

Ⓕ Brian's Apple Orchard

This orchard belonged to the owner of the adjacent farm, Abraham Brian (see View #6, E). In the painting, the trees on the left side of the orchard block our view of the Brian house. Most farmers in Gettysburg had orchards on their properties. In those days, the farmers lived off of their land and would grow a variety of crops. Brian's orchard sits in the area where Cemetery Ridge transitions into Cemetery Hill. Today the NPS maintains an apple orchard at this location.

Ⓖ Zeigler's Grove

At the time of the battle, a group of larger trees on the west side of Cemetery Hill just north of the Brian orchard was known as Zeigler's grove. The National Park Service still maintains a grove of large trees in this area. David Zeigler owned a farm at the base of

Cemetery Hill north of the Brian farm. This farm, which is not visible in the painting, was occupied by a tenant at the time of the battle. Today, the Zeigler farm no longer exists.[8]

The Mission 66 cyclorama building was located in Zeigler's grove. This building held the cyclorama from 1962 until it was torn down in the spring of 2013. In the comparison photographs, taken by the authors in March of 2012, the old cyclorama building is clearly visible.

Ⓗ Cemetery Hill

Cemetery Hill was the heart of the Union line at Gettysburg, the bend in the giant "fish hook"-shaped line. The hill was named after the Evergreen Cemetery which was located on the top and east side of the hill, and is still an active cemetery. Today, this cemetery also

covers much of the south side of the hill. After the battle, the Soldier's National Cemetery was created on the northwest side of the hill. It was at the dedication of this cemetery on November 19, 1863 that President Abraham Lincoln gave his famous Gettysburg Address.

At the time of the battle, most of the hill was open fields. The hill was occupied by Union artillery and troops from the Union XI Corps, as well as a division from the I Corps. The historic keys noted "Cemetery Hill" and "East Cemetery Hill," although the east side of the hill is not visible in the painting. The Chicago key noted "General O. O. Howard Comd'g." Major General Oliver Otis Howard was the commander of the Union XI Corps that was occupying this part of the Union line. The New York key also mentioned "Hall's Me. Bat., Underwood's 33rd Mass. Inf., McCartney's 1st Mass. Bat." Once more, we find specific mention of New England units in the New York key, probably a result of feedback from visitors to the Boston painting. The 33rd Massachusetts Infantry was part of the XI Corps and was stationed on the east side of the hill. Captain James A. Hall's battery from the Union I Corps was badly damaged on July 1 (Hall's battery is also mentioned in View #6, J). On July 2, the battery fought on Cemetery Hill until it was sent to the rear to refit, and was replaced by a fresh battery.[9] Captain William H. McCartney's battery from the Union VI Corps was sent to Cemetery Hill on July 3 to replace a battery that had expended all of its ammunition.[10]

(I) Row of Evergreen Trees

A row of evergreen trees was planted as part of the decoration of the Soldier's National Cemetery. By the time of the artist's visit in 1882, these trees were fairly large. Philippoteaux must not have been made aware that these trees were not present during the battle. Since they were visible in the Tipton photographs, the artist painted them into the cyclorama. These trees are still standing today and are quite large. They are clearly visible in the modern photographs taken in the spring of 2012.

(J) Units in the Distance on Cemetery Hill

In this part of the painting, we can see several groups of Union troops on the west side of Cemetery Hill. The troops in this area included the 2nd Division of the I Corps under the command of Brig. Gen. John C.

Detail of the painting showing troops on Cemetery Hill, probably from the I and XI corps. *BD*

Detail of the painting showing troops on Cemetery Hill, probably from the I Corps. *BD*

Robinson (not to be confused with Col. James S. Robinson mentioned the Chicago key). This division consisted of the brigades commanded by Brig. Gen. Henry Baxter and Brig. Gen. Gabriel R. Paul. On July 3, these troops were in a supporting role after taking heavy casualties on July 1. Paul's brigade was under the command of Col. Peter Lyle after Paul was blinded on July 1 (mentioned in View #6, N).

Some of the troops depicted in this area could also represent the 73rd Pennsylvania and other units from the XI Corps. The 73rd would have occupied the west side of Cemetery Hill in the area where the XI Corps and the II Corps lines met. In the painting, these troops would probably be the men visible farthest to the left.

Detail of the painting showing a signal station on Cemetery Hill. *BD*

Ⓚ Signal Station on Cemetery Hill

In this area, we can see a signal flag and a signal station. This signal station was very hard to see before the painting was restored in 2008 because the painting was so dirty. The signal corps men were able to communicate directly with the station on top of Little Round Top (see View #1, N). These messages would have been quickly relayed to General Meade at the Lydia Leister house. During the bombardment, Meade was forced to abandon his headquarters. At this time, an attempt was made to set up another signal station on Powers' Hill (see View #9, N) to keep the lines of communication open.[11] The cyclorama painting illustrates the fact that these three key pieces of high ground had clear lines of sight from one to the other.

The only key that mentioned this signal station was the New York key. This brings up the question of whether this feature may have been added in 1889. The historic photographs of the painting from 1886 do not have enough resolution to clearly identify something as small and far away as this signal station. It is possible that this feature may have been added in 1889, but we cannot say for sure.

Ⓛ Trees on the South Side of Cemetery Hill

At the time of the battle, there was a small forest on the south side of Cemetery Hill. In the painting, these trees block our view of the Evergreen Cemetery and East Cemetery Hill. Today, the Evergreen Cemetery has grown larger. This area is more open and occupied by modern graves. The famous gatehouse of the Evergreen Cemetery was, and still is, located on the other side of the hill. The gatehouse is kept close to its historic appearance by the Evergreen Cemetery Association. Even if this small forest was not there in 1863, the crest of the hill would probably have blocked our view of the gatehouse.

[1] Report of Capt. John G. Hazard, *OR* 27, pt. 1, 478-481.

[2] Newton, *Silent Sentinels- A Reference Guide to the Artillery at Gettysburg*, 30-37 and 60-61.

[3] Cole, *Civil War Artillery at Gettysburg: Organization, Equipment, Ammunition, and Operations*, 108-110.

[4] Massachusetts Historical Society,www.masshist.org, entry for 54th Regiment Massachusetts Volunteer Infantry.

[5] Hawthorne, *Gettysburg: Stories of Men and Monuments as Told by the Battlefield Guides*, 32.

[6] Mertz, *Interpretations of the Gettysburg Cyclorama*, 10.

[7] *Ibid.*, 9.

[8] Frassanito, *Early Photography at Gettysburg*, 180.

[9] Report of Captain James A. Hall, *OR* 27, pt. 1, 359-360.

[10] Report of Capt. William H. McCartney, *OR* 27, pt. 1, 688-689.

[11] Cameron, "The Woods are Full of Them, the Sign Signal Corps at Gettysburg," 9-15.

Signal Station on Cemetery Hill

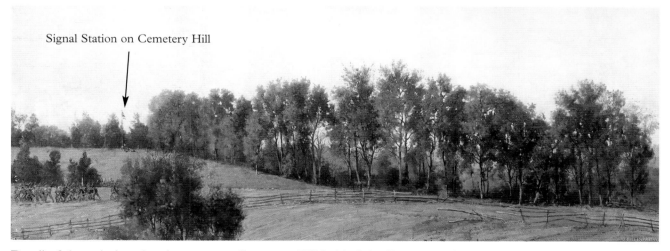

Detail of the painting showing trees on Cemetery Hill behind the Evergreen Cemetery. *BD*

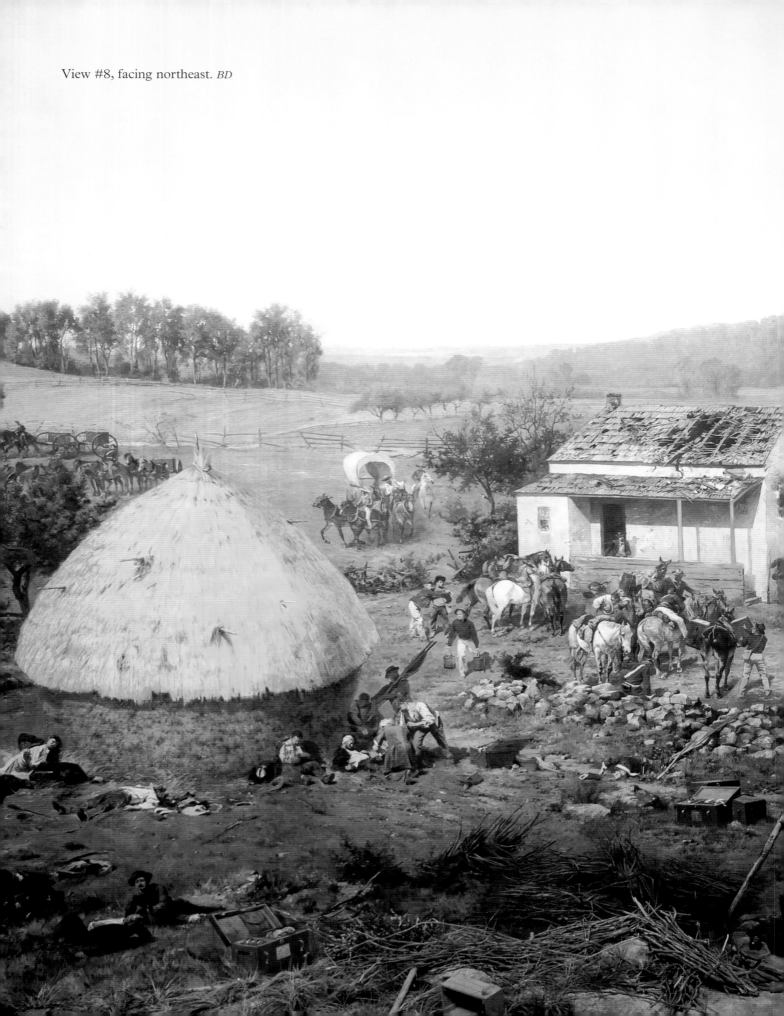

View #8, facing northeast. *BD*

Notes on view #8

(facing northeast)

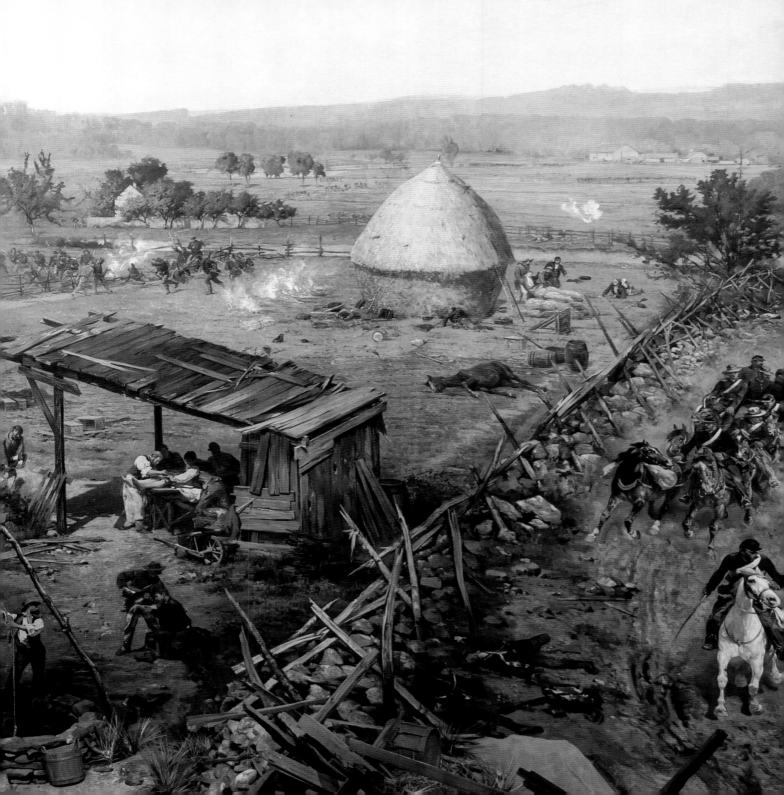

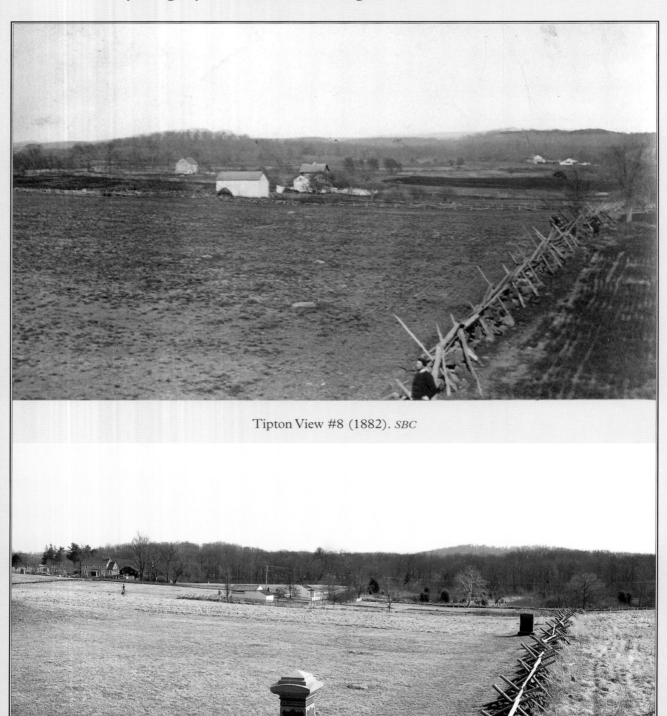

Tipton View #8 (1882). *SBC*

View #8 (Modern). *BD*

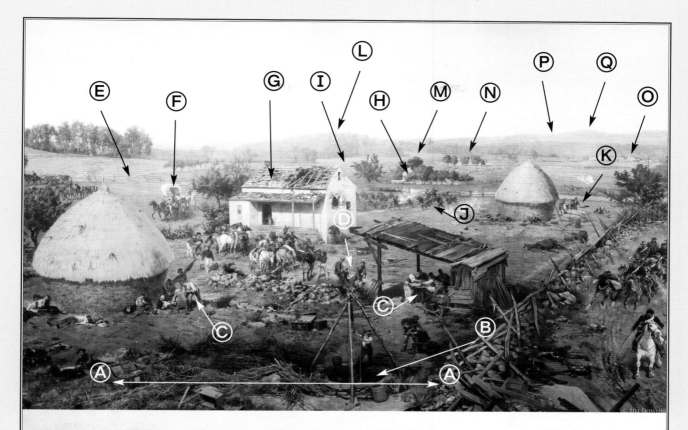

～⊱ KEY ⊰～

Ⓐ Field Hospital Scene, Creatively Inserted by the Artist

Ⓑ Well

Ⓒ Doctors Caring for the Wounded

Ⓓ Image of Abraham Lincoln

Ⓔ Taneytown Road

Ⓕ Camp Wagons

Ⓖ General Meade's Headquarters (Lydia Leister Farm), Moved by Artist

Ⓗ Actual Location of General Meade's Headquarters (The Lydia Leister House and Barn)

Ⓘ Catherine Guinn House (Not Visible)

Ⓙ Troops Behind Meade's Headquarters

Ⓚ Men Cutting Hay for Bedding

Ⓛ Culp's Hill

Ⓜ Pardee Field

Ⓝ Spangler's Spring

Ⓞ Abraham Spangler Farm

Ⓟ East Cavalry Field

Ⓠ Wolf's Hill

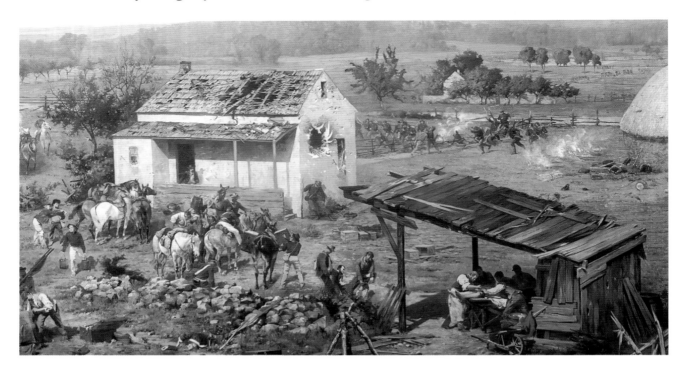

Ⓐ Field Hospital Scene, Creatively Inserted by the Artist

As discussed in Chapter 2, the artist moved General Meade's headquarters closer to the viewer in the last three versions of the painting. At the same time, the artist moved this hospital scene closer to the viewer. The real location of General Meade's headquarters was farther to the rear at the Lydia Leister house (see G and H). The lean-to and well would have also been located near the real Leister house. Historic accounts note that the well was polluted by dead horses and a new well had to be excavated after the battle.[1] Historic pictures also seem to show a small lean-to structure near the front of the house.[2]

In this area, the artist also creatively inserted a field hospital scene. In reality, field hospitals were not this close to the front lines; most of them would have been on the farms farther to the rear on Taneytown Road. However, the artist probably wanted the viewer to get an idea of the activities that were going on behind the lines. Since there was no combat occurring in this area, inserting a hospital scene was a good way to liven up an otherwise quiet part of the painting. We can also see several more examples of *cacolets*, the French style stretchers that the artist incorrectly used in an American battle scene (see View #6, B). Some of the *cacolets* are being used to move large green boxes of supplies, while others are moving wounded soldiers.

Detail of the painting showing a hospital scene near Meade's headquarters. *BD*

Ⓑ Well

The well in the painting is interesting because it is only half-shown, while the other half was a planned part of a physical diorama that met up with the canvas. In

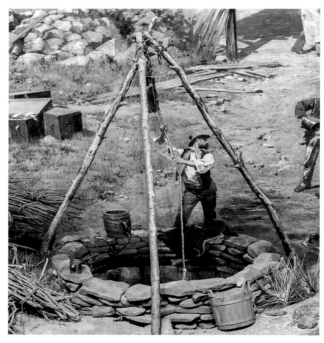

Detail of the painting showing a well that is half in the painting and half on the diorama. *BD*

addition, only two of the three legs of the tripod that support the pulley are in the painting. The third leg of the tripod was also to be part of the diorama. As discussed in Chapters 2 and 3, the older buildings in Gettysburg which housed the painting did not have dioramas. Since half of a well would have looked strange, some canvas was added to the bottom of the painting and the other half of the well was painted in. The third leg of the tripod was not painted in and there was only a two-legged "tripod" supporting the pulley. This was the best possible arrangement with the materials at hand. When the painting was restored, the extra canvas was removed from the bottom of painting. The diorama now includes real rocks that make up the other half of the well and a third leg of the tripod which is made out of real wood. To further add to the realism, real pieces of rope hang from the painting into the well. Pins go through the canvas to secure the ropes in place. Visitors to the cyclorama frequently have trouble figuring out exactly where the diorama ends and the painting starts. The well, being half-painted and half-constructed, is a good visual reference point to show spectators the effectiveness of the transition from diorama to canvas.

Ⓒ Doctors Caring for the Wounded

As discussed in Chapter 3, a local doctor named David Study lived on Baltimore Street at the time of the battle. His house no longer exists; it was located at the site of the modern Hall of Presidents Museum. Local lore tells us that Dr. Study helped care for the wounded during and after the battle. Oral tradition, dating back to the original Gettysburg cyclorama building, suggested that the artist may have depicted Dr. Study in the painting. The story supposedly came from the doctor performing surgery in the lean-to. According to this unnamed source, Doctor Study is the older balding man helping the wounded near the haystack.[3]

Ⓓ Image of Abraham Lincoln

Oral tradition also tells us that the artist put the image of President Abraham Lincoln in the painting. Just above the well, a figure that looks like Lincoln can be seen being carried to the hospital. According to these stories, the artist said that he included the wounded president as a symbol of a wounded nation. It is possible that Philippoteaux told this story when he visited Gettysburg soon after the East Cemetery Hill

Detail of the painting showing a doctor who might Doctor Study. *BD*

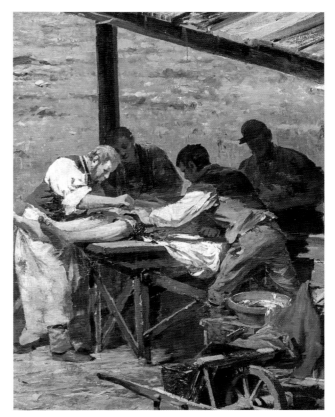

Detail of the painting showing a doctor operating under a lean-to. *BD*

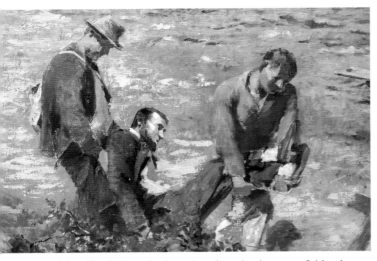

Detail of the painting showing the image of Abraham Lincoln. *BD*

building was completed; however, no documentation exists to support this theory.[4] Visual evidence, however, strongly suggests that it is indeed the image of Lincoln.

Ⓔ Taneytown Road

In this part of the painting, the Taneytown Road is closer to the viewer (farther west) than it should be. When the artist moved Meade's headquarters closer to the viewer he also moved the road. All of the other terrain features in the painting accurately reflect the

Taneytown Road

Detail of the painting showing camp wagons. *BD*

true topography of the battlefield. In reality, the road should be on the other (east) side of Meade's actual headquarters (see H). The Taneytown Road is accurately depicted in View #9 and #0 (see View #0, G). At the border between View #8 and View #9, the road suddenly gets closer to the viewer.

Ⓕ Camp Wagons

In the historic keys, these wagons were labeled as "Camp Wagons used as ambulances, carrying off the wounded." We can see black teamsters driving the wagons (as discussed in View #7, C). These same kinds of wagons would also have been used to haul supplies and ammunition for the armies (see View #9, H). The wagons were pulled by teams of four to six mules or draft horses. Civil War armies also had specially made ambulance wagons with several "shelves" inside so that multiple stretchers could be moved in one wagon. However, in a battle as large as Gettysburg, these ambulances were quickly filled to capacity and any other wagons available would also be used to transport the wounded.[5]

Ⓖ General Meade's Headquarters (Lydia Leister Farm), Moved by Artist

As discussed in Chapter 2, after the debut of the Chicago cyclorama, the artist was asked to move General Meade's headquarters closer to the viewer. In the process, the orientation of the house was also changed. The front door of the real headquarters building (the Lydia Leister house) faces south. The building depicted has a front door that faces west. The location of this house in the painting is close to the location of General Meade's equestrian statue on the battlefield today.

In the painting, we can see that the house has been heavily damaged by artillery fire. During the bombardment, many of the Confederate shells were over-shooting the main Union line and landing on the back of Cemetery Ridge. Seventeen horses were killed during the bombardment in this area alone. Shells damaged the front porch and the roof rafters of the house.[6] The painting makes it appear as if a cannon ball has ripped through the bricks in the side of the house. In reality, however, the Leister house was made entirely of wood.

The artillery fire was so severe, Meade was forced to abandon his headquarters and moved to General Slocum's headquarters near Powers' Hill (see View #9, J and N). Near the end of the bombardment, Meade

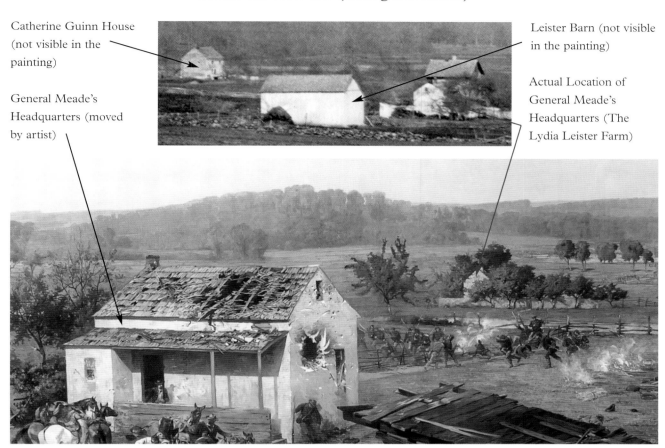

Catherine Guinn House (not visible in the painting)

Leister Barn (not visible in the painting)

General Meade's Headquarters (moved by artist)

Actual Location of General Meade's Headquarters (The Lydia Leister Farm)

Meade's headquarters in the 1882 Tipton photograph compared with the same part of the painting. *SBC and BD*

headed back toward the center of the Union line. He met his staff, which included his son George, near the Taneytown Road. Accompanied by his staff, Meade was moving toward the High Water Mark when he learned that the Pickett's Charge had been repulsed (see View #0, A).[7]

Ⓗ Actual Location of General Meade's Headquarters (The Lydia Leister House and Barn)

At the time of the battle, the widow Lydia Leister lived in this modest house with her six children. When the fighting started, Lydia and her children went to Maryland to seek temporary shelter from the battle. During her absence, her house became the headquarters for the Union commander, General Meade. On the night of July 2, Meade and his senior generals had a council of war and decided to stay and fight in Gettysburg on July 3. Her house was severely damaged by artillery fire on July 3, and almost all of her possessions were destroyed, including her fences and crops. In an interview with a newspaper

correspondent, she specifically mentioned losing "about two ton of hay" and "two lots of wheat." Her hay and wheat fields are clearly depicted in the painting (see View #7, E and View #9, C).[8]

The historic Tipton photographs clearly showed the Leister barn; however, it is not visible in the painting. In the Chicago version, which showed the Leister house at its proper location, the barn was visible in the painting (see comparison photographs). Also visible in the Tipton photograph was a two-story addition that was added on to the east side of the Leister house after the war.[9] The Leister house was purchased in 1888 by the Gettysburg Battlefield Memorial Association and the two-story addition was removed (as discussed in Chapter 3).

Ⓘ Catherine Guinn House (Not Visible)

The Catherine Guinn farm was just north of the Leister farm, east of the Taneytown Road, and was visible in the Chicago version of the painting. As a result of moving the Leister house in the Boston version, the Guinn house was no longer visible.

Catherine Guinn House in Chicago Version

Actual Location of General Meade's Headquarters
(The Lydia Leister House and Barn)

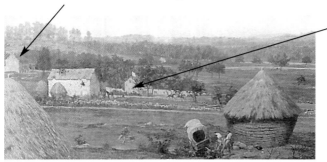

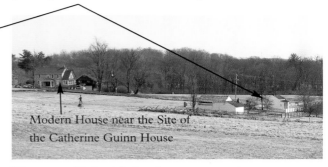

Modern House near the Site of
the Catherine Guinn House

Detail of a historic picture of the Chicago cyclorama showing the area of Meade's headquarters. *SBC*

The area of Meade's headquarters, modern. *BD*

Catherine Guinn also owned a barn that was directly across the road from the Leister house. This barn was not visible in the Tipton photographs and is not included in any of the versions of the painting.

During the battle, the elderly Katie Guinn stayed home in order to protect her property. Even though she was in her 70s, she managed to chase away any soldiers she found lurking near her house. Her house was hit thirteen times by artillery shells, including one that landed in a bureau near a chair where she was sitting. By 1890, her house had been torn down and a new house was built next to the Taneytown Road.[10] A non-historic house, which is used by the park rangers, is located there today. This house is scheduled to be torn down in the near future, and the landscape will be restored to its 1863 appearance.

Ⓙ Troops Behind Meade's Headquarters

Approximately one regiment of Union soldiers are visible in the painting behind Meade's headquarters. In reality, an entire brigade was stationed just behind the main line on July 3. The soldiers shown are probably part of Brig. Gen. Alexander Hays' division (3rd Division, II Army Corps). As discussed in View #6, A, the painting does not depict many of Hays' men. In the New York version, more men were added along the stone wall in order to off-set this inaccuracy. The troops along the stone wall represent Hays' second brigade under Col. Thomas A. Smyth. Hays' third brigade under Col. Eliakim Sherrill was in support of Smyth's brigade. However, the painting does not show enough men to properly depict an entire brigade. Colonel Sherrill was in command of the brigade after

Detail of the painting showing Union troops behind Meade's headquarters. *BD*

Colonel George Willard was killed leading his men on July 2. Colonel Sherrill was killed on July 3 during Pickett's Charge. The deaths of both these officers were mentioned in the key entry for Cushing as being "killed nearby" (see View #2, B). Willard's brigade was comprised of the 39th, 111th, 125th and 126th New York Regiments. The 125th New York Infantry would have been stationed closest to this area, in support of Smyth's men.[11]

Ⓚ Men Cutting Hay for Bedding

In this part of the painting, we can see Union soldiers cutting hay off one of the stacks in order to make bedding for their wounded comrades. Due to the fact that they are cutting the hay at head level, this helps to give the stacks a distinctive "mushroom" shape. We can also see that some of the nearby hay has been set on fire by Confederate artillery shells (at right in the image above). These scenes show how the widow Leister lost two tons of hay during the battle.

Detail of the painting showing men cutting hay for bedding. *BD*

Ⓛ Culp's Hill

Culp's Hill was the right end of the Union line on July 2 and 3, or the barb of the famous "fish hook." On July 2, many of the Union defenders on Culp's Hill were sent to help repulse General Longstreet's massive attack on the Union left. Pursuant to orders, Confederates under the command of General Ewell attacked Culp's Hill near dusk and managed to make a lodgment on the lower slopes of the hill. Fortunately for the Union, the troops who were left behind had constructed breastworks for added protection. These defenses, coupled with the high ground and the coming darkness, helped one brigade of Union troops hold off three brigades of Confederate attackers. Overnight, many of the Union men who were sent to the left returned to the right and bolstered the defenses on the top and sides of Culp's Hill. Overnight, General Ewell also reinforced his men on the hill. It was Lee's plan to continue to attack the ends of the Union line on July 3.

At first light on July 3, Union artillery on Powers' Hill (see View #9, N) bombarded the Confederates on the lower slopes of Culp's Hill starting the combat for the day. The Confederates repeatedly tried to take the top of the hill, but the well-entrenched Union men could not be moved. The combat lasted for over seven hours until the Confederates were finally forced to retreat after suffering heavy losses. Although it was not as famous as Little Round Top, the action on Culp's Hill was every bit as important. Culp's Hill is taller than Cemetery Hill and if the Confederates could have taken the hill, the entire Union "fish hook" would have been in jeopardy. Furthermore, the Baltimore Pike runs directly behind Culp's Hill. This road was the main Union supply line. If the Confederates had taken this road, the Union army would have been forced to fall back toward its base of supplies in Westminster, Maryland.

Culp's Hill was labeled incorrectly on some of the historic keys. Some labeled the east side of Cemetery Hill as being Culp's Hill. Other keys had the number for Powers' Hill over Culp's Hill. The key descriptions also noted "12th A.C., Gen. Williams Comd'g." Major General Henry W. Slocum was the commander of the XII Corps. Brigadier General Alpheus S. Williams was the commander of the 1st Division of the XII Corps. However, early in the battle, Slocum thought that he was in command of the right wing of the Union army. During this time, Williams was placed in command of the corps.[12] On July 2, most of the units from the right wing were sent to reinforce the Union left. The only units under Slocum's control were the men of the XII Corps. It took some time for this arrangement to be sorted out, and Williams was in command of the XII Corps for most of the battle.

Ⓜ Pardee Field

This open meadow on the slopes of the lower part of Culp's Hill was the scene of heavy fighting on July 3. Starting at dawn, Union cannon on Powers' Hill were able to hit Confederates in this area. Confederates under the command of Brig. Gen. George H. "Maryland" Steuart made several attempts to cross this field and drive the Union defenders off the top and side of the hill. After repeated attempts to storm the Union position, the Confederates were forced to fall back.

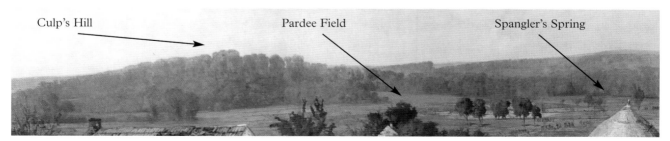

Culp's Hill Pardee Field Spangler's Spring

Detail of the painting showing Culp's Hill. *BD*

Marker at Pardee Field in Gettysburg. *BD*

Above left: Monument to the 2nd Massachusetts at Gettysburg. *BD*

Above right: Monument to the 27th Indiana at Gettysburg. *BD*

This field was named after Lt. Col. Ario Pardee, Jr., commander of the 147th Pennsylvania. His men helped to defend this area on July 3. After the war, in 1905, a large boulder was brought to Gettysburg from Pardee's hometown and was placed in the middle of this field with the words "Pardee Field" written on the side.[13]

Ⓝ Spangler's Spring

Named after the owner of the property (see O), the spring in this area was a popular spot for people from the town to have picnics before the war.[14] This low-lying area was a no-mans-land between the two armies on July 3. Late that morning, there was a futile attack across this open field by two Union regiments. The original intent of the Union commanders was to probe the Confederate lines looking for weak spots. As the orders were passed down the chain of command, they were altered to order an attack on the Confederate line. When Lt. Col. Charles R. Mudge, commander of the 2nd Massachusetts, received these orders, he was quoted as saying "Well, it is murder, but it's the order." Mudge followed his orders and led the 2nd Massachusetts and the 27th Indiana across an open field against a well-protected

Confederate force in the woods at the base of Culp's Hill.[15] Within a matter of minutes, Mudge was killed, and the two regiments suffered heavy casualties (killed, captured, or wounded). The 2nd Massachusetts lost forty-three percent of the regiment (136 casualties out of 316 men), including forty-five men who were killed or mortally wounded. The 27th Indiana lost about one-third of their regiment (110 casualties out of 339 men).[16]

On the New York key it noted for Culp's Hill: "Base of hill, Col. Chas. R. Mudge and 2nd Mass. Sacrificed" and "grand charge of 27th Ind., 3rd Wis., and 2nd Mass. 114 officers and men left, Col. Gelray lost arm." These extra details in the New York key were probably some of the "notes on the sayings of the multitudes" that were taken on the platform of the Boston painting. As noted in View #6, N, Massachusetts was the first state to appropriate funds for monument construction. The 2nd Massachusetts monument, dedicated in 1879, was the first regimental monument placed outside of the National Cemetery.[17] The story of Colonel Mudge and the charge of the 2nd Massachusetts would have been well known by the Boston audiences in 1884. The Boston audiences would have also known the story of "Colonel Gelray." Second Lieutenant Joseph W. Gelray of the 2nd Massachusetts lost his right arm as a result of the wound he received near Spangler's Spring on July 3. For his actions at Gettysburg, he was promoted the next day to first lieutenant. Joseph Gelray continued to serve for the rest of the war, eventually reaching the rank of lieutenant colonel.[18]

It is not clear where the New York key got the figure "114 officers and men left." The monument to the 2nd Massachusetts shows about 180 survivors of the charge. It is also interesting that the 3rd Wisconsin was included as part of the charge. The 3rd Wisconsin was part of the same brigade as the 2nd Massachusetts and 27th Indiana (Brig. Gen. Thomas H. Ruger's brigade of the Union XII Corps), but they did not participate in the charge across Spangler's Spring. For the entire battle, the 3rd Wisconsin only lost about four percent of their strength (10 casualties out of 260 men).[19]

Ⓞ Abraham Spangler Farm

This house was purchased by Abraham Spangler in 1827. Abraham, however, lived on a farm on the Chambersburg Pike west of Gettysburg. The house was occupied by his son, Henry Spangler. At the time

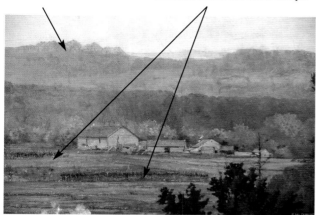

Wolf's Hill Union reinforcements from the 12th Corps

Detail of the painting showing the Spangler farm. *BD*

of the battle, Henry had recently purchased a farm on Seminary Ridge (see View #3, P) which he was renting to Jacob Echenrode. Henry eventually moved onto the farm he had purchased, but not until after the war. The Spangler house still stands. The house is private property and still looks similar to the way it appeared in 1863.[20]

In this part of the painting, we can see Union forces in the distance marching toward the High Water Mark area. The older Gettysburg keys labeled these units as Brig. Gen. Henry H. Lockwood's brigade and Col. Archibald L. McDougal's brigade from the Union XII Corps.

Ⓟ East Cavalry Field

At the same time as the artillery bombardment of July 3, a furious cavalry battle was taking place several miles east and slightly north of the High Water Mark. Confederate cavalry under the command of Maj. Gen. James Ewell Brown (J.E.B.) Stuart were attempting to get behind the Union army. If Pickett's Charge had succeeded, Stuart's cavalry could have been in position to attack retreating Union forces. Union cavalry under the command of Brig. Gen. David McMurtrie Gregg engaged Stuart's troopers. With help from a Michigan cavalry brigade under the command of Brig. Gen. George Armstrong Custer, Gregg was able to stop Stuart.[21] The Chicago key noted "Custer's grand cavalry charge." The promoters of the Chicago painting wanted to highlight the actions of a Michigan unit and their famous commander in order to market the painting to a Midwestern audience. In the painting,

East Cavalry Battlefield, as it is known today, is not visible. The arrow on the key points toward the approximate location: three miles east by northeast of the High Water Mark.

Ⓠ Wolf's Hill

In this part of the painting, Wolf's Hill can be seen in the distance. In some of the historic keys, this hill was mislabeled as Powers' Hill (see View #9, N). Wolf's hill is beyond the Union right on the other side of Rock Creek from Culp's Hill. In order to guard against a Confederate attempt to get around the right flank, a Union brigade under the command of Brig. Gen. Thomas H. Neill (VI Army Corps) was stationed to the south of this area. Today, this part of the battlefield is known as "Lost Avenue" because there are no roads leading to the monuments to Neill's Brigade.

[1] Smith, *Farms at Gettysburg: The Fields of Battle*, 41.

[2] Frassanito, *Early Photography at Gettysburg*, 220-221.

[3] Mertz, *Interpretations of the Gettysburg Cyclorama*, 9.

[4] *Ibid.*, 9-10.

[5] Coco, *A Strange and Blighted Land- Gettysburg: The Aftermath of Battle*, 154-159.

[6] Smith, *Farms at Gettysburg: The Fields of Battle*, 40-41.

[7] Coddington, *The Gettysburg Campaign: A Study in Command*, 495-496 and 531-531.

[8] Smith, *Farms at Gettysburg: The Fields of Battle*, 40-41.

[9] *Ibid.*, 39; Frassanito, *Early Photography at Gettysburg*, 224.

[10] Smith, *Farms at Gettysburg: The Fields of Battle*, 38-39; Carper and Hardoby, *The Gettysburg Battlefield Farmsteads Guide*, 51-52.

[11] Coddington, *The Gettysburg Campaign: A Study in Command*, 509.

[12] Trudeau, *Gettysburg: A Testing of Courage*, 254-255.

[13] Kathy Georg Harrison, *The Location of Monuments, Markers, and Tablets on the Battlefield of Gettysburg* (Gettysburg, PA, 1993), 51.

[14] Smith, *Farms at Gettysburg: The Fields of Battle*, 43.

[15] Coddington, *The Gettysburg Campaign: A Study in Command*, 473-475.

[16] John W. Busey and David G. Martin, *Regimental Strengths and Losses at Gettysburg* (Hightstown, NJ, 2005), 142.

[17] Hawthorne, *Gettysburg: Stories of Men and Monuments as Told by the Battlefield Guides*, 88-89.

[18] Arlingtoncemetery.net, entry on Joseph W. Gelray.

[19] Busey and Martin, *Regimental Strengths and Losses at Gettysburg*, 142.

[20] Smith, *Farms at Gettysburg: The Fields of Battle*, 7 and 43.

[21] Coddington, *The Gettysburg Campaign: A Study in Command*, 520-523.

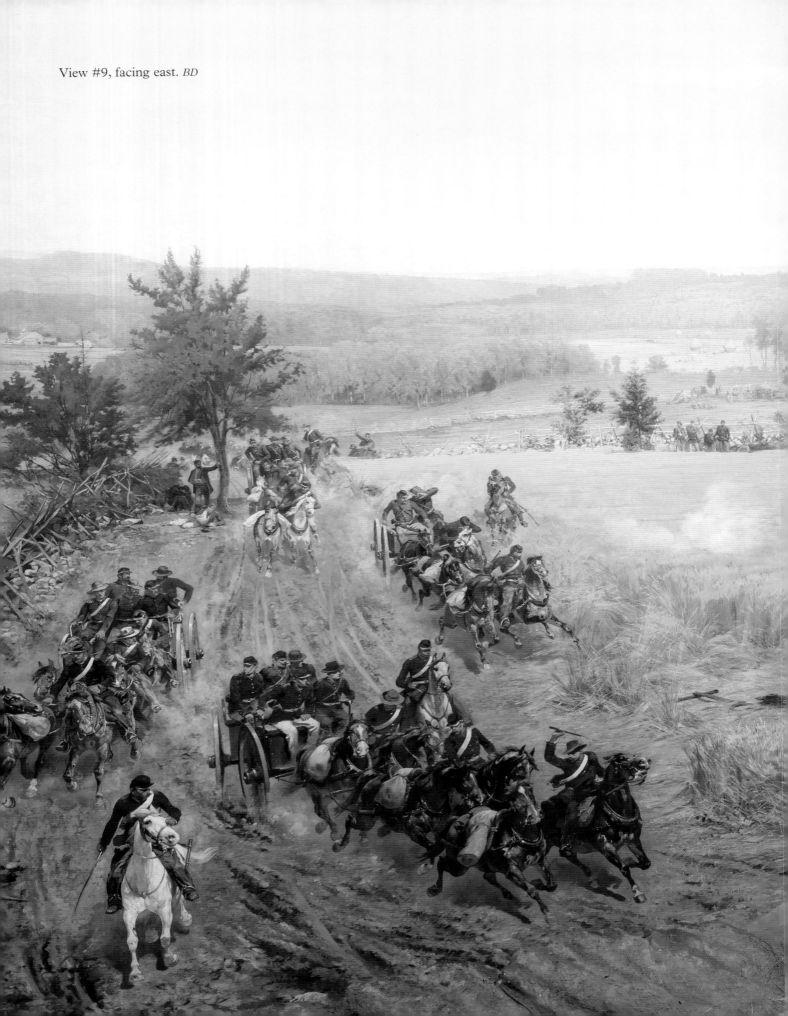

View #9, facing east. *BD*

Notes on view #9

(facing east)

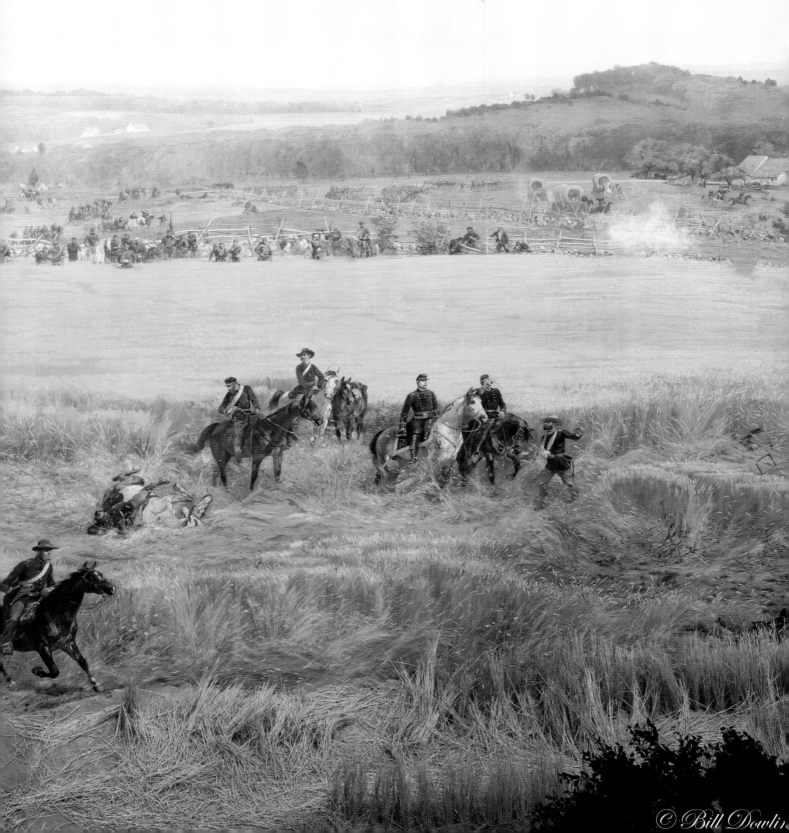

© Bill Dowlin

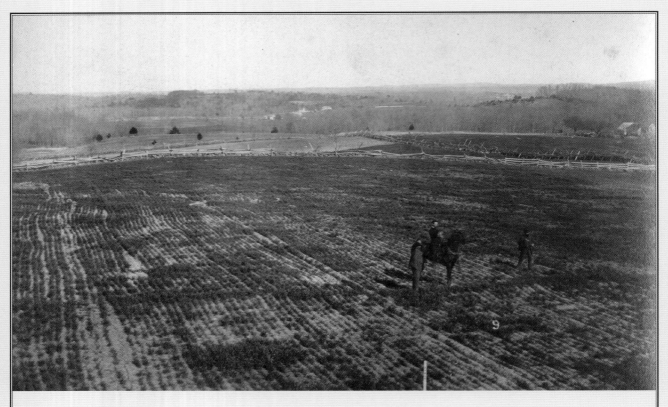

Tipton View #9 (1882). *SBC*

View #9 (Modern). *BD*

Notes on view #9 (facing east)

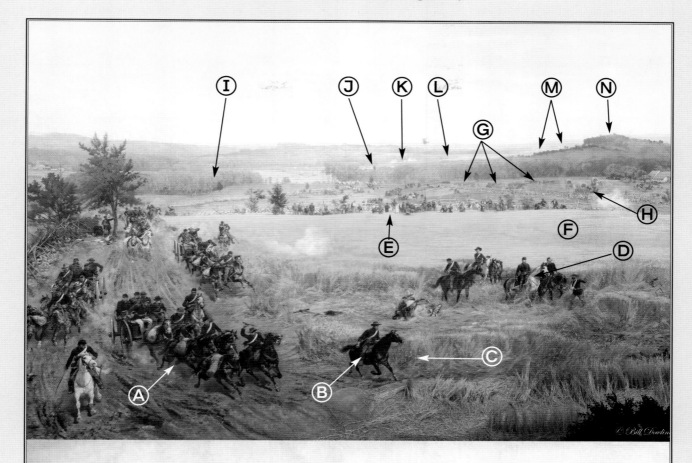

❧ KEY ❧

Ⓐ Portion of Wheeler's 13th New York Battery

Ⓑ Colonel Edward B. Fowler Commanding 14th Brooklyn

Ⓒ Poppies in a Field of Wheat

Ⓓ Brigadier General Henry J. Hunt, Chief of Union Artillery, and Staff

Ⓔ Union Provost Guard

Ⓕ War Correspondent in New York Version

Ⓖ Union Reinforcements

Ⓗ Ammunition Train

Ⓘ Location of the NPS Visitors Center and Restored Cyclorama

Ⓙ Nathaniel L. Lightner Farm

Ⓚ James McAllister Farm

Ⓛ Baltimore Pike

Ⓜ Farms in the Extreme Distance near Baltimore Pike

Ⓝ Powers' Hill

The Gettysburg Cyclorama: The Turning Point of the Civil War on Canvas

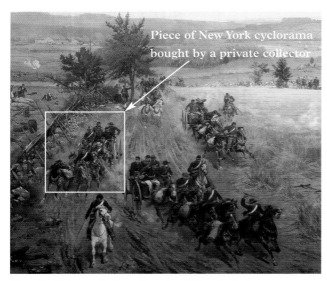

Detail of the painting showing Wheeler's battery moving into action. *BD*

Ⓐ **Portion of Wheeler's 13th New York Battery**
In this area, we can see a part of Lt. William Wheeler's battery. The rest of this battery is visible in View #1, A. The artillery soldiers in this area can be seen riding on top of the caissons as the battery is rushed to the front.

As previously discussed, the New York cyclorama was eventually cut into pieces. The NPS has two of these pieces in the park archive (see View #0, E and View #6, A). Another surviving piece, which came from his area in the painting, has recently been identified. This piece shows a complete caisson rushing toward the front (see detail). This recently discovered section of the New York painting was listed for sale a few years ago at an art auction. This piece was purchased by a private collector who is having it restored.[1]

In the painting, this battery is travelling on one of

Detail of the painting showing Colonel Edward B. Fowler. *BD*

several dirt roads that run through the Union position. This dirt road curves and then connects to another dirt road that runs south to north through the middle of the painting. At the time of the battle, no roads were present at these locations. Today, modern Hancock Avenue runs south to north at the location of the main dirt road. Although no official road existed in 1863, thousands of men and horses would have undoubtedly made their own paths in the most heavily trafficked areas. In the 1882 Tipton photographs, ruts were seen in these areas where either farmers or tourists were travelling with carts and wagons.

Ⓑ **Colonel Edward B. Fowler Commanding 14th Brooklyn**
In the New York key it specifically listed "Colonel E.B. Fowler commanding Brooklyn 14th." Since the New York version was first shown in Brooklyn, it is little wonder that Colonel Fowler was specifically mentioned in this key. A reporter for the *Brooklyn Daily Eagle* noted that Colonel Fowler was "immediately recognizable."[2] The 14th Brooklyn, also known as the 84th New York, was the only Union regiment named after a city and not a state. These soldiers were heavily engaged on July 1. On July 2 and 3, they were stationed on Culp's Hill. It is unlikely that Colonel Fowler would have been present in the area during this part of the battle. However, for the sake of marketing the painting to a local audience, the promoters probably took some liberties and decided to include Colonel Fowler in the key. All of the other keys did not specifically label this officer. Perhaps, in the other keys, this officer represented Lieutenant Wheeler of the 13th New York Battery.

Ⓒ **Poppies in a Field of Wheat**
In the painting, we can see red corn poppies growing in the field of wheat. As discussed in BGC/AHG, these flowers, while common in Europe, did not grow in the United States. However, with an entire field of golden wheat, the flowers helped give the field depth by breaking up the monotony of only one color. The artist could have used a similar type of American flower to achieve the same effect.[3]

It is also interesting to note that this field is not the famous Wheatfield where thousands of men fought on July 2 (see View #2, N). The older keys that were made when the painting first came to Gettysburg first

mentioned this was not the famous Wheatfield. Visitors to the cyclorama frequently ask about this field. Perhaps the proprietors of the East Cemetery Hill building were trying to head-off some of these questions.

Note how the wheat is being trampled by all the soldiers moving through this area. It is not surprising that Mrs. Leister complained that her two lots of wheat were totally destroyed (see View #8, H).

Ⓓ Brigadier General Henry J. Hunt, Chief of Union Artillery, and Staff

General Hunt was the Chief of Artillery for the Union army at Gettysburg. During the battle of Gettysburg, General Hunt did an excellent job of placing and coordinating the artillery for the Union. At numerous times during the battle, General Hunt sent batteries in the nick of time to help stop Confederate advances. On July 3, he had his gunners conserve ammunition during the cannonade so that they would be able to deal with the infantry attack Hunt anticipated. Once he determined that the Union return-fire was doing little damage to the Confederate artillery, he ordered the Union artillery to cease fire. As the Union guns stopped returning fire, the Confederates took this as a sign that the Union artillery had been weakened. Soon after the Union guns fell silent, the Confederate infantry attack began. Much to the dismay of the Confederates, they soon discovered that the Union artillery was not disabled and suffered heavy losses.

In this part of the painting, we can see General Hunt and some of his staff. In the last two versions of the painting, Hunt is moved to a position on the north side of the viewing platform, near the location of Captain Hazard in the Boston version (see View #7, A). In the New York and Philadelphia versions, General Hancock and his staff are in the field of wheat at Hunt's

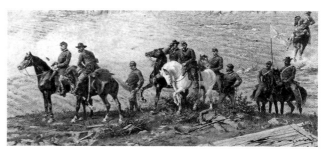

Detail of the New York cyclorama showing General Hunt and staff. *SBC*

position (see View #1, B).

In the Chicago key it listed "Gen. Hunt and Col. Osborn." Major Thomas W. Osborn was the Chief of Artillery for the XI Corps at Gettysburg. Osborn reached the rank of colonel by the end of the war, but he was still a major at Gettysburg.[4] In his letter to Henry Hunt describing the Chicago cyclorama, General Gibbon noted: "Maj. Osborn is along side of you speaking to a wounded arty. [artillery] officer on foot."[5] Near the end of the cannonade, General Hunt was conferring with Major Osborn on Cemetery Hill when he came up with the idea of ordering his guns to cease fire. Major Osborn would have probably stayed with his guns and not have moved this far south during Pickett's Charge.

In the New York painting, there were more officers around General Hunt. The key listed (with a few misspellings): "Gen. Hunt; 2, Capt. N.J. Craig; 3, Lieut. Bessell; 4, E.R. Warner; 5, Lieut. Worth." In his official report of the battle, General Hunt mentioned several of these officers as having performed "with intelligence and gallantry." Captain **J. N.** Craig was Hunt's Assistant Adjutant-General. Hunt noted that Lt. C. E. **Bissell** "was my only aide, and was,

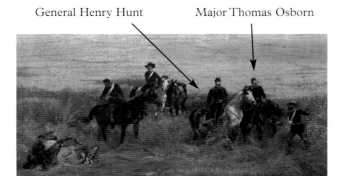

General Henry Hunt Major Thomas Osborn

Detail of the painting showing General Hunt. *BD*

Brigadier General Henry J. Hunt. *LOC*

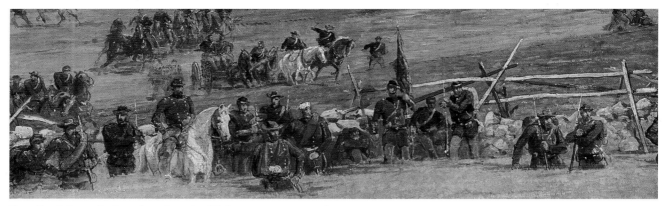

Detail of the painting showing the Union provost guard. *BD*

therefore, busily employed. He was much exposed, his duties keeping him more or less under fire at every point at which attacks were made." Lieutenant Colonel E. R. Warner, Inspector of Artillery, performed "much of the labor required in the reorganization of batteries withdrawn from the field and replacing them." Hunt noted that Warner's duties were performed "with his accustomed energy and thoroughness."[6] Lieutenant W. S. Worth was also on Hunt's staff but was not specifically mentioned in his official report.

Like the staff officers near General Hancock (see View #1, B), the faces of Hunt's staff are clearer in the New York version than in the Boston version. Since the New York version was painted in the United States, it is entirely possible that the officers either posed for or submitted pictures for Philippoteaux and his team to use during the creation of the New York painting.

E Union Provost Guard

In this part of the painting we can see a line of soldiers well behind the main line. These men are in position where the army's provost guard was usually located. The purpose of the provost guard was to prevent straggling, catch deserters, and round up enemy prisoners. At the battle, Brig. Gen. Marsena R. Patrick was the Provost Marshall General for the Union army (see View #0, J).

In the various keys there were several colorful descriptions of these troops such as: "Line of wounded soldiers to shoot deserters," and "Wounded of the 148th Pa. Inf. Vol. stationed to shoot deserters." While both of these descriptions are interesting, deserters were rarely shot in the Civil War. In most cases, the provost guard would capture deserters and they would

be punished in some other fashion. It is true, however, that wounded soldiers were sometimes used as provost guards.[7] The 148th Pennsylvania was part of General Caldwell's division of the II Corps. They were commanded by Lt. Col. Robert McFarlane. It is possible that the officer at the center of the line is meant to represent either Lieutenant Colonel McFarlane or General Patrick.

As discussed in Chapter 3, there are several "ghost" figures that were penciled in but never painted. At the right end of their line, near the dirt road, these figures are barely visible.

F War Correspondent in New York Version

In the New York version of the painting, there was a lone figure on a horse in the field of wheat. The key description labeled him as "Hon. Charles Coffin, War Correspondent of the *Boston Journal*." Charles or Carleton Coffin was a famous newspaper correspondent, who followed several different armies and was present at many of the major battles of the war. He served throughout the war from Bull Run to Appomattox. He was known for the speed and accuracy of his reports. After the war, he wrote several famous books about the war and his experiences travelling with the soldiers. By 1884, he was a famous figure in Boston. The souvenir program from Boston listed him as one of the veterans of the battle who visited the cyclorama.[8] His fellow Bostonians may have suggested that he be put into the cyclorama and the promoters

Detail of the New York cyclorama showing Charles Coffin, War Correspondent of the *Boston Journal*. *SBC*

of the painting seemed to have heeded this advice. Coffin made his way into the New York version. Historic accounts placed Coffin in the area of Meade's headquarters on July 3. During the cannonade, Coffin took shelter on the cellar steps behind the Leister house. When the cannonade ended, he emerged and watched the charge. As soon as the battle ended, he rode 28 miles in a driving rainstorm, boarded a train to Baltimore, and managed to get out one of the first reports of the battle.[9]

Ⓖ Union Reinforcements

These troops were probably parts of the Union III and VI corps being rushed toward the High Water Mark in order to prevent a Confederate breakthrough. Most of these troops would be moving cross-country (see View #1, K) and not on the Taneytown Road. It is possible that before the painting was changed in 1889, the delineators in Boston may have said General Meade was among these distant forces (see Chapter 4 and View #0, A and E).

Detail of the painting showing Union reinforcements. *BD*

Ⓗ Ammunition Train

All of the historic keys mentioned "D. W. Flagler, chief ordnance officer, with reserve ammunition." Captain Daniel Webster Flagler was the Chief Ordnance Officer for the Army of the Potomac at Gettysburg. It was his job to make sure the various army corps were properly supplied with ammunition. In the painting, we can see wagons heading toward the front, presumably loaded with extra ammunition. In reality, Captain Flagler would not have been driving a wagon to the front lines. His job required him to be in the rear, supervising the logistics of supplying an army of 90,000. In the battle, the Union army expended up to four million small arms rounds and over 30,000 artillery shells.[10]

In October of 1863, he became an inspector at the West Point Foundry in New York. As part of this job, he

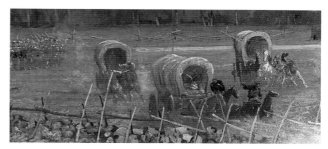

Detail of the painting showing the Union ammunition train. *BD*

inspected the Parrott rifles that were being manufactured there. Several of the Parrott rifles on the battlefield today bear his D. W. F. initials. After the war, he was the commander of Rock Island Arsenal, Illinois, for 15 years. He also commanded the Frankford Arsenal outside of Philadelphia and the arsenal in Watertown Massachusetts. He went on to become the Chief of Ordnance for the entire United States Army until his death in 1899. It is interesting to note that Captain Flagler served near all four of the cities in which the cycloramas were originally displayed. His obituary in the *New York Times* dated March 30, 1899, stated: "He was one of the most popular officers in the army."[11] His popularity, along with the location of his various commands, helped explain why he was specifically mentioned in all of the historic keys.

Ⓘ Location of the NPS Visitors Center and Restored Cyclorama

Today, the Gettysburg National Military Park Museum and Visitors Center is located in this area. The new home of *The Battle of Gettysburg* Cyclorama opened in 2008 after the painting was completely restored. This site was chosen because it was behind the main Union line, and no combat occurred in this area. Areas where soldiers actually fought have been restored to their 1863 appearance by moving the Visitors Center off Cemetery Ridge. The multimillion dollar project that restored the

Detail of the painting showing the location of the new Gettysburg National Military Park Visitors Center. *BD*

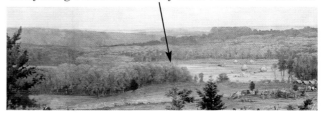

The new Gettysburg National Military Park Visitors Center. *BD*

painting and created the new Visitors Center was funded by the Gettysburg Foundation, the non-profit partner of the Gettysburg National Military Park.

Ⓙ Nathaniel L. Lightner Farm

This farm still exists and is privately owned, and parts of the house still have an 1863 appearance. Nathaniel Lightner bought this house from Solomon Powers, the owner of the nearby hill (see N). During the battle, the house was used as a hospital, and continued to be used in that way until August. The Lightner family fled town during the battle. When they returned, they had to live for a time in their carpentry shop. When they were finally allowed back into their home, it was so contaminated by being used as a hospital that it made the family sick. Eventually the Lightners had to completely gut the interior of the house in order to make it livable again.[12]

General Slocum, commander of the Union XII Corps, used the Lightner farm as his headquarters. During the artillery bombardment that preceded Pickett's Charge, General Meade traveled to this farm because it was no longer safe at the Leister house. Meade had hoped that a signal station to maintain communications with the rest of the army could have been set up on Powers' Hill. When he found out that communications could not be immediately re-

Nathaniel L. Lightner Farm James McAllister Farm

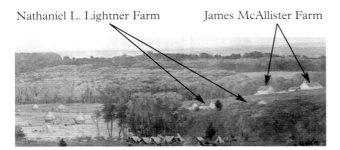

Detail of the painting showing the Lightner and McAllister farms. *BD*

established, Meade traveled back to the center of the Union line (see View #0, A).[13]

Ⓚ James McAllister Farm

This farm included a mill that was in the woods behind the farm. The mill was powered by a waterwheel in nearby Rock Creek. In order to run the waterwheel, there was a dam that created a pond north of the mill. This pond and marshy area upstream from the dam created a sort of "water hazard" that helped protect the Union right from an enemy turning movement. To further bolster the flank, on July 3, troops were sent to occupy the area from the mill to the edge of Wolf's Hill (see View #8, Q).

The owner of the farm, James McAllister, was a staunch abolitionist. Before the war, the mill was a stop on the Underground Railroad. After the battle, like almost every building in the area, the farm and mill were used as a hospital.[14] The McAllister farm no longer stands. There are still some remains of the mill-race and the dam on Rock Creek.

Ⓛ Baltimore Pike

The Baltimore Pike was the main supply line for the Union Army. From Gettysburg, the pike ran south to Westminster Maryland; the main supply base for the Army of the Potomac. From Westminster, the Baltimore Pike continued on to Baltimore and Washington. For these reasons, it is perhaps the most important of the ten roads that led to Gettysburg in 1863. As a pike, the road was made of packed gravel. By the standards of 1863, this was a good road for moving large amounts of men and supplies. Along with the Harrisburg Pike running north from town, and the York Pike and Chambersburg Pike running east to west, four of the ten roads into Gettysburg were improved roads. The other six roads were dirt roads, which were far less efficient. If Confederate forces had succeeded in controlling the Baltimore Pike on the night of July 2, Meade may have been forced to withdraw his army. It was probably J. E. B. Stuart's goal to threaten this road when he moved east of town on July 3. Stuart's movements started the battle on what is now known as East Cavalry Field (see View #8, P).

Ⓜ Farms in the Extreme Distance near Baltimore Pike

There are several farms visible on the Baltimore Pike in the extreme distance to the south. These farms are too far

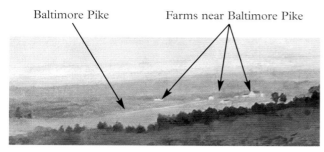

Baltimore Pike Farms near Baltimore Pike

Detail of the painting showing farms to the south on the Baltimore Pike. *BD*

Powers' Hill, modern. *BD*

away to be positively identified. By using historical maps, the authors were able to find several farms that might be represented in the painting. The house on the left, sitting back off the pike, is probably the John Harner farm. The first house along the road might be the Fleming Hoke house. However, because it was close to Rock Creek on lower ground, the Hoke house was probably blocked by Powers' Hill. The first farm along the road is probably the John Bushman farm. The other buildings that we can see in the painting were probably built after the war. By studying the 1872 *Atlas of Adams County*, the authors were able to find several more buildings in this area at the time, including two farms, a church, and a school.

Ⓝ Powers' Hill

This hill was owned by a local stonecutter named Solomon Powers. At the time of the battle, Solomon lived in town, having recently moved after selling his farm to Nathaniel Lightner. Mr. Powers owned several quarries, one of which was on the hill that bears his name. His quarry on Powers' Hill provided the stone for the Evergreen Cemetery gatehouse that was built in 1855.[15]

Several of the historic keys erred by labeling Culp's Hill as Powers' Hill. The Chicago key specifically noted that this area included the "headquarters of Gen. Slocum, comd'g the right of lines." This reference was pointing out Slocum's role as wing commander (see J and View #8, L).

Powers' Hill guarded the rear of the Union army. If the Union had been forced to retreat from Gettysburg,

Detail of the painting showing Powers' Hill. *BD*

men on this hill would have protected the army as it moved down the Baltimore Pike. On July 3, there were three Union artillery batteries stationed on this hill. These batteries were commanded by Lt. Charles A. Atwell, Capt. James H. Rigby, and Lt. Charles E. Winegar. From this hill, they protected the Union flank and rear. On the morning of July 3, these guns bombarded Confederates on the slopes of Culp's Hill. Powers' Hill has recently been cleared of its non-historic tree cover by the NPS. Once again, a visitor can see the commanding position that the cannons on this hill enjoyed.

[1] Personal interviews with Sue Boardman and David Olin.

[2] "Stirring Battle Scene in the Cyclorama," *Brooklyn Daily Eagle*, October 2, 1886.

[3] Boardman and Porch, *The Battle of Gettysburg Cyclorama: A History and Guide*, 72.

[4] *Biographical Directory of the United States Congress*. Entry on Osborn, Thomas Ward, (1833-1898), http://bioguide.congress.gov

[5] General John Gibbon, letter to Henry J. Hunt, September 6, 1884.

[6] Report of Brig. Gen. Henry J. Hunt, *OR* 27, pt. 1, 242.

[7] Mertz, *Interpretations of the Gettysburg Cyclorama*, 13–14.

[8] Souvenir Program, Boston, *Cyclorama of the Battle of Gettysburg*.

[9] Jim Slade and John Alexander, *Firestorm at Gettysburg: Civilian Voices* (Atglen, PA, 1998), 124.

[10] Mark A. Snell, "We Marched and Fought This Battle without Baggage or Wagons: The Army of the Potomac's Logisticians during the Gettysburg Campaign," The Gettysburg Seminar Papers, *Mr. Lincoln's Army: The Army of the Potomac in the Gettysburg Campaign*. nps.gov

[11] Arlingtoncemetery.net, entry on Daniel Webster Flagler.

[12] Smith, *Farms at Gettysburg: The Fields of Battle*, 45; Carper and Hardoby, *The Gettysburg Battlefield Farmsteads Guide*, 65–66.

[13] Coddington, *The Gettysburg Campaign: A Study in Command*, 495–496.

[14] Smith, *Farms at Gettysburg: The Fields of Battle*, 46.

[15] Brian A. Kennell, *Beyond the Gatehouse: Gettysburg's Evergreen Cemetery* (Fort Washington, PA, 2000), 78-79.

Bibliography

Bibliography for Chapters 1-3
BOOKS:
Mimi Colligan, *Canvas Documentaries*. Victoria, Australia: Melbourne University Press, 2002.

Bernard Comment, *The Painted Panorama*. New York: Harry N. Abrams, Inc. Publishers, 1999.

Ralph Hyde, *Panoramania! The Art and Entertainment of the 'All-Embracing' View*. London: Trefoil Publications, 1988.

Stephan Oettermann, *The Panorama: History of a Mass Medium*. New York: Zone Books, 1997.

Albert Hopkins, *Magic: Stage Illusions and Scientific Diversions*. New York: Arno Press, 1977.

ARCHIVES:
Gettysburg National Military Park: Cyclorama File (see next section for full citation)

JOURNALS:
"The Cyclorama." *Scientific American*, LV, 19 (1886): 286; 296.

"The Cyclorama Platform." *The Inland Architect and Builder,* vol. 1, 6, (1883): 84.

Alma Hill Jamison, "A History of the Cyclorama." *Atlanta Historical Bulletin*, 10 (July 1937): 58-75.
MAGAZINES:
Theodore R. Davis. "How a Great Panorama is Made." *St. Nicholas: An Illustrated Magazine*, XIV, pt. 1 (November 1886-April 1887): 99-112.

Robert Wernick. "Getting a Glimpse of History from a Grandstand Seat." *Smithsonian*, vol. 16, 5 (August 1985): 68-85.

Kathleen R. Georg. "Tipton Panorama Photos of Gettysburg." *Military Images*, vol. VI, 2 (October 1984): 15- 25.

Don Johnson and Sue Boardman. "The Gettysburg Cyclorama." *Blue & Gray Magazine*, vol. XXV, 3 (Fall 2008): 41-43.
MISCELLANEOUS SOURCE:
Yasmina Boudhar, "On the track of a 19th century French artist of international renown: Paul Dominique Philippoteaux (1846-1923)," (see next section for full citation)

NEWSPAPERS:
"Watching Pickett's Charge," *New York Times* (March 05, 1887), 3.

"The Battle of Shiloh," *The Washington Post* (April 04, 1888), 8.

"Falsifying History," *The Washington Post* (July 5, 1888), 6.

"Panorama in New York," *New York Times* (May 14, 1882), 12.

"The Battle of Vicksburg," *New York Times* (June 8, 1886), 5.

"To Picture Niagara Falls," *New York Times* (June 21, 1886), 1.

"The Panorama of a Battle," *New York Times* (September 17, 1882), 6.

"Expensive Scumbling," *New York Times* (December 12, 1886), 11.

"Gettysburg Again on View," *New York Times* (December 24, 1887), 3.

"Famous Panorama Cut up for Tents," Gettysburg *Star and Sentinel* (August 1, 1906).

"Cyclorama Rejuvenated," *Boston Herald* (August 22, 1889).

"In the New Cyclorama Building," Perry, Iowa *Chief* (November 26, 1886).

"Under Falling Walls," Davenport, Iowa *Morning Tribune* (March 10, 1889).

"The Battle of Gettysburg Panorama in Chicago," St. Joseph, Michigan *Traveler Herald* (March 28, 1885).

"To Bring the Big Cyclorama to Gettysburg," *The Gettysburg Compiler* (March 19, 1910).

"Cyclorama Acquired by Park Service," *Star and Sentinel* (April 4, 1942).

"Sold for $1: Famous Painting which was hoped would be brought to Gettysburg Sold to Chicago Junk Dealer," *Adams County News* (September 17, 1910).

"A Day at the Fair," Decatur, Illinois *Republican* (August 29, 1889).

"The Gettysburg Panorama," Perry, Iowa *Chief* (September 9, 1887).

"Destructive Storm and Extreme Heat," Lima, Ohio *Allen County Democrat,* (April 8, 1893).

"Cyclorama of the Battle of Gettysburg at the Fair," Sandusky, Ohio *Register* (September 18, 1894).

"The Side Show goes Dignified," Sheboygan, Wisconsin *Press* (July 1, 1933).

"Spend $400,000 on Dallas Fair," Mexia, Texas *Weekly Herald* (July 11, 1930).

"The Cyclorama," Waterloo, Iowa *Daily Courier* (June 10, 1892).

"Battle of Gettysburg at Stark County's Fair," Massillon, Ohio *The Independent* (September 24, 1886).

"Cyclorama Making," Davenport, Iowa *Daily Leader* (May 21, 1898).

"Our Great Fair," Frederick, Maryland *News* (October 7, 1893).

"Battle Picture," Oxford Junction, Iowa *The Oxford Mirror* (October 10, 1886).

"Great Battle Picture," Freeborn County, Minnesota *Standard* (January 26, 1887).

"The Panoramas Growth," Olean, New York *Democrat* (April 22, 1887).

"The Extensive and Profitable 'Buckeye' Panorama Business," Oxford Junction, Iowa, *The Oxford Mirror* (October 1, 1886).

"Battle Scene Takes Two Years to Paint," Oakland, California *Tribune* (January 24, 1913).

"Famous Painting on View," *The Washington Post* (February 20. 1912).

"Paul Philippoteaux, Painter of the Cyclorama of the Battle of Gettysburg," Wellsboro, Pennsylvania *Agitator* (January 3, 1888).

Entertainment Agency Advertisement, New York *Brooklyn Eagle* (March 3, 1889).

"Twenty Years Later," Chicago *Daily News* (October 24, 1863).

Announcement of Cyclorama's Opening, *Chicago Journal* (October 13, 1883).

"A Triumph of Realistic Painting," *Chicago Tribune* (December 2, 1883).

"Latest About Cyclorama," *Gettysburg Compiler* (May 4, 1910).

"Cyclorama will be Sold," *Gettysburg Times* (May 22, 1936).

"Stirring Battle Scene in the Cyclorama," New York *Brooklyn Eagle* (October 2, 1886), 1.

"Prominent Visitors at the First Exhibit of the Cyclorama," New York *Brooklyn Eagle* (October 16, 1886), 1.

"An Artist's Work," New York *Brooklyn Eagle* (November 18, 1886), 3.

"Selling Out the Cyclorama," New York *Brooklyn Eagle* (December 2, 1886), 4.

"Meade and Gettysburg," New York *Brooklyn Eagle* (December 19, 1886), 7.

"The Cyclorama," New York *Brooklyn Eagle* (February 13, 1887), 5.

"The Crucifixion a Subject for Cycloramic Illustration," New York *Brooklyn Eagle* (June 24, 1888), 15.

"Buried by the Cyclorama Roof," New York *Brooklyn Eagle* (March 8, 1889), 6.

"Watching Pickett's Charge," *New York Times* (March 5, 1887).

"Gettysburg Will Be Removed," *New York Times* (July 11, 1889).

"Moving a Cyclorama," *Boston Daily Globe* (December 7, 1890).

"Sayings at the Cyclorama," *Boston Daily Globe*, (August 19, 1885), 4.

"The Battle of Gettysburg," *Frank Leslie's Illustrated* (July 5, 1884).

"With Blind Eyes," Elyria, Ohio *Democrat* (August 23, 1888).

"Tornado at Sioux City," Centralia, Wisconsin *Enterprise and Tribune* (June 23, 1894).

Bibliography for Chapters 4-15
BOOKS:
Peter G. Beidler, *Army of the Potomac: The Civil War Letters of William Cross Hazelton of the Eighth Illinois Cavalry Regiment*. Seattle, WA: Coffeetown Press, 2013.

Sue Boardman and Kathryn Porch, *The Battle of Gettysburg Cyclorama: A History and Guide*. Gettysburg, PA: Thomas Publications, 2008.

Kent Masterson Brown, *Cushing of Gettysburg: The Story of a Union Artillery Commander*. Lexington, KY: The University Press of Kentucky, 1993.

Bibliography

John W. Busey and David G. Martin, *Regimental Strengths and Losses at Gettysburg.* Hightstown, NJ: Longstreet House, 2005.

Elwood Christ, *The Struggle for the Bliss Farm: "Over a Wide, Hot…Crimson Plain."* Gettysburg, PA: Thomas Publications, 1987, 1993.

Freeman Cleaves, *Meade of Gettysburg.* Norman, OK: University of Oklahoma Press, 1960.

Gregory A. Coco, *A Strange and Blighted Land- Gettysburg: The Publications,* 1995.

Edwin B. Coddington, *The Gettysburg Campaign: A Study in Command.* New York, NY: Touchstone/Simon & Schuster, 1968.

Philip M. Cole, *Civil War Artillery at Gettysburg: Organization, Equipment, Ammunition, and Operations.* Orrtanna, PA: Colecraft Industries, 2002.

Time-Life Books (Eds.). *Echoes of Glory, Arms & Equipment of the Union.* Alexandria, VA: Time-Life Books, 1998.

Don Ernsberger, *At the Wall: The 69th Pennsylvania "Irish Volunteers" at Gettysburg.* U.S.A. Don Ernsberger with Xlibris Corporation, 2006.

William A. Frassanito, *Early Photography at Gettysburg.* Gettysburg, PA: Thomas Publications, 1995.

William A. Frassanito, *Gettysburg—A Journey in Time.* Gettysburg, PA: Thomas Publications, 1975.

Earl J. Hess, *Pickett's Charge: The Last Attack at Gettysburg.* Chapel Hill, NC: The University of North Carolina Press, 2001.

Almira R. Hancock, *Reminiscences of Winfield Scott Hancock.* New York, NY: C. L. Webster, 1887.

Kathy Georg Harrison, *The Location of Monuments, Markers, and Tablets on the Battlefield of Gettysburg.* Gettysburg, PA: Thomas Publications, 1993.

Kathy Georg Harrison and John W. Busey, *Nothing but Glory, Pickett's Division at Gettysburg.* Gettysburg, PA: Thomas Publications, 1993.

Frederick W. Hawthorne, *Gettysburg: Stories of Men and Monuments as Told by the Battlefield Guides.* Gettysburg PA: The Association of Licensed Battlefield Guides, 1988.

Roger D. Hunt and Jack Brown. *Brevet Brigadier Generals in Blue.* Gaithersburg, MD: Olde Soldier Books, Inc., 1990, revised edition 1997.

Brian A. Kennell, *Beyond the Gatehouse: Gettysburg's Evergreen Cemetery.* Fort Washington, PA: Evergreen Cemetery Association, 2000.

George W. Newton, *Silent Sentinels—A Reference Guide to the Artillery at Gettysburg.* New York, NY: Savas Beatie, LLC, 2005.

Harry W. Pfanz, *Gettysburg—The First Day.* Chapel Hill, NC: The University of North Carolina Press, 2001.

Richard Rollins, *"The Damned Red Flags of the Rebellion:" The Confederate Battle Flag at Gettysburg.* Redondo Beach, CA: Rank and File Publications, 1997.

Richard A. Sauers, *Advance the Colors.* Harrisburg, PA: PA Capitol Preservation Committee, 1987.

Michael Shaara, *The Killer Angels.* Avenel, NJ: Wing Books, 1994.

Jim Slade and John Alexander, *Firestorm at Gettysburg: Civilian Voices.* Atglen, PA: Schiffer Publishing Ltd., 1998.

Timothy H. Smith, *Farms at Gettysburg: The Fields of Battle.* Gettysburg, PA: Thomas Publications, 2007.

Charles Teague, *Gettysburg by the Numbers.* Gettysburg, PA: Adams County Historical Society.

Dean S. Thomas, *The Gettysburg Cyclorama: A Portrayal of the High Tide of the Confederacy.* Gettysburg, PA: Thomas Publications, 1989.

Sarah Sites Thomas, Tim Smith, Gary Kross, and Dean S. Thomas, *Fairfield in the Civil War.* Gettysburg, PA: Thomas Publications, 2011).

Noah A. Trudeau, *Gettysburg: A Testing of Courage.* New York, NY: Harper Collins Publishers, 2002.

United States War Department. *The War of the Rebellion: A Compilation of the Official Records of the Union and Confederate Armies.* 70 vols. In 128 parts. (Series 1, vol. 27, parts 1 and 2), Washington, D. C.: Government Printing Office, 1880-1901.

Ezra, J. Warner, *Generals in Blue.* Baton Rouge, LA: Louisiana State University Press, 1964.

ARCHIVES AND SPECIAL COLLECTIONS:

Gettysburg National Military Park Archives: Cyclorama File
Interview with Charles H. Cobean.

Letter from Ronald E. Bird to Robert E. Davidson, Superintendent of the Gettysburg National Military Park. Ref. # K1817.

Gregory, A. Mertz, *Interpretations of the Gettysburg Cyclorama,* April 19, 1983.

Alfred Mongin, Correspondence of 1933-1965, and final report, *Gettysburg Cyclorama,* June, 1968.

Promotional flier, "The Battle of Gettysburg Cyclorama has Reopened", donated by Chris Geddes to Gettysburg National Military Park, November 21, 2006, Archives #B-65.

Gilder-Lehman Collection on deposit at the Pierpont Morgan Library in New York City:
General John Gibbon, letter to Henry J. Hunt, September 6, 1884. *Henry J. Hunt Papers, 1862-1888.*

New York Public Library, Manuscripts and Archives Division:
Paul Philippoteaux, December 31, 1886. Letter to the Editor in New York *Century Magazine,* Century Company Records 1871-1924, Box 129.

MAP SETS:

Denise Carper and Renae Hardoby, *The Gettysburg Battlefield Farmsteads Guide.* Gettysburg, PA: Friends of the National Parks at Gettysburg, 2000.

Thomas A. Desjardin, Gerald Bennett, Charles Fennell, Scott Hartwig, Harry Pfanz, Timothy Smith, and Wayne Motts, *The Battle of Gettysburg,* Gettysburg, PA: A project of the Friends of the National Parks at Gettysburg, 1998.

Adams County Atlas of 1872, "Research Print, Cumberland, Middletown, Cashtown, 1872." South Portland, ME: Historic Map Works, 2014.

Philip Laino, *Gettysburg Campaign Atlas.* Dayton, OH: Gatehouse Press, 2009.

MAGAZINES:

Col. Bill Cameron, "The Woods are Full of Them, the Signal Corps at Gettysburg." *Gettysburg Magazine,* (July 1990): Issue 3.

Keith Snipes, "The Improper Placement of the 8th Ohio Monument: A Study of Words and Maps." *Gettysburg Magazine* (July, 2006): Issue 35.

"The Cyclorama," *Scientific American,* (November 6, 1886).

MISCELLANEOUS SOURCES:

Boudhar, Yasmina, "On the track of a 19th century French artist of international renown: Paul Dominique Philippoteaux (1846-1923)," (Graduate thesis under the supervision of professors Claire Barbillon and Michael Colardelle, Ecole du Louvre).

Souvenir Program, Boston 1884-1891, *Cyclorama of the Battle of Gettysburg,* Gettysburg, PA: The Gettysburg Foundation, 2008.

NEWSPAPERS:
Boston Herald
Brooklyn Daily Eagle
New York Times

WEBSITES:

Entry on Joseph W. Gelray, arlingtoncemetery.net

Entry on Daniel Webster Flagler, arlingtoncemetery.net

Entry on Thomas Ward Osborn (1833-1898), Biographical Directory of the United States Congress, bioguide.congress.gov

"140 Places Every Guide Should Know Part 3: Gettysburg LBG Fred Hawthorne," gettysburgdaily.com

"The Weikert Lane from United States Avenue to the Wheatfield Road," gettysburgdaily.com

Map of Harper's Hill in Adams County, PA, googleearth.com

Entry on history and heritage of Lutheran Theological Seminary, Gettysburg, ltsg.edu

Entry on the 54th Regiment, masshist.org (Massachusetts Historical Society).

Mark A. Snell, "We Marched and Fought This Battle Without Baggage or Wagons: The Army of the Potomac's Logisticians During the Gettysburg Campaign." The Gettysburg Seminar Papers, Mr. Lincoln's Army: The Army of the Potomac in the Gettysburg Campaign, nps.gov

Entry on the history of the seminary for July 1, seminaryridgemuseum.org

Entry on the Rose farm and the Wentz farm, stonesentinels.com

Entry on Grimes Battery, vnghs.org (Virginia National Guard Historical Society).

⤳ Index ⤴

Index